SHOOTING
TO
KILL

SHOOTING TO KILL

HOW AN INDEPENDENT PRODUCER BLASTS THROUGH THE BARRIERS TO MAKE MOVIES THAT MATTER

Christine VACHON

with David Edelstein

Quill

An Imprint of HarperCollinsPublishers

HarperCollins books may be purchased for educational, business, or sales promotional use. For information please write: Special Markets Department, HarperCollins Publishers Inc., 10 East 53rd Street, New York, NY 10022.

First Avon Books edition published 1998.

Reprinted in Quill 2002.

Library of Congress Cataloging-in-Publication Data

Vachon, Christine.
 Shooting to kill : how an independent producer blasts through the barriers to make movies that matter / Christine Vachon with David Edelstein.
 p. cm.
 Includes index.
 1. Vachon, Christine. 2. Independent filmmakers—United States—Biography. 3. Low budget motion pictures. I. Edelstein, David. II. Title.
PN1998.3.V32A3 1998 98-8026
791.43'0232'092—dc21 CIP

ISBN 0-380-79854-9

07 08 09 RRD 10 9 8

DEDICATION
FOR
MARLENE McCARTY

IN MEMORY OF
MARIE FRANÇOISE FOURESTIER VACHON
1934–1992
AND
JOHN FELIX VACHON
1914–1975

ACKNOWLEDGMENTS

Many people put themselves out for this book. Thanks especially to my office-mates and partners: Pam Koffler, Bradford Simpson, Katie Roumel, and Eva Kolodner, all of whose comments and contributions are reflected (brilliantly) herein. Laird Adamson, my assistant, runs daily marathons on my behalf. My colleagues at Good Machine, Ted Hope, James Schamus, and David Linde have been free with their time, advice, and expertise. Thanks to those who agreed to talk about what they do and how they do it: James Lyons, Mark Tusk, Joyce George, Marcus Hu, Tom Kalin, Randy Poster, Todd Haynes, Kerry Barden, and Ann Goulder. John Sloss talked about what he does and also did it, as my able lawyer. Thanks also to my agent, Sydelle Kramer, who had the idea for this book, and my editor at Avon, Charlotte Abbott. David Edelstein thanks Josh Horwitz and (especially, eternally) Rachel Klayman.

CONTENTS

SHOOTING TO KILL

CHAPTER 1

A DAY IN THE LIFE

On the way to my office in Manhattan today, I passed a movie shoot on the street, and was hailed by the second assistant director, a hearty girl from the Bronx I used to work with. "It's this nightmare low-budget movie," she explained, and then started the litany: "I mean, it's eight o'clock, and crew call's in twenty minutes, and there isn't any coffee, and everyone is late, and the grip truck went to the wrong location and the APOC just quit, the sides aren't here, and the D.P. wants a light we didn't order . . ."

"STOP!" I said. "I can't hear this!" Low-budget film-making is like childbirth. You have to repress the horror or you'll never do it again. I bid her good-bye and continued on my way, past the $800,000 dollar movie set where the crew looked like a bunch of thirteen-year-olds with tool belts and baseball caps. A lone production assistant desperately tried to keep an eye on two open vehicles while homeless people milled around, attentive. The craft

2 SHOOTING TO KILL

service table—the mandated food and drink station—was especially grim: a jar of iced tea mix, a black banana, a handful of broken chips, some used paper cups. That sums it up, I thought: a pathetic table in the middle of nowhere with nothing on it you'd eat in a million years.

This is the romantic world of low-budget filmmaking. It's the world in which I've toiled for fifteen wearisome, exhilarating years, working for little money on the kinds of movies that seldom end up at the local multiplex. And unless someone gives me forty million dollars to make a picture about bisexual rockers, or a sympathetic pedophile, or a woman who wakes up one day and realizes that modern society is slowly poisoning her to death, it's the world in which I'll stay. That I'm forever "independent" makes me a little sad—until I arrive at my office and see the posters for the films I've produced, provacative and risky films, on which I've felt like an intimate collaborator: *Poison, Swoon, Kids, Safe, I Shot Andy Warhol, Go Fish, Velvet Goldmine*. Hollywood producers often have to eat worse than black bananas.

The office of my company, Killer Films, is packed with assistants and interns and is woefully short on working air conditioners. My desk is a mess, strewn with papers relating to ten or more projects, some in development, some in pre and postproduction, and some on the verge of release. All they have in common is my name as a producer.

The job of producer is one of the great mysteries of the movie-making process. When I'm asked what producers do, I say, "What *don't* they do?" I develop scripts; I raise money; I put together budgets; I negotiate with stars willing to work for said (generally meager) budgets; I match directors with cinematographers, cinematographers with production designers, production designers with location managers; I make sure that a shoot is on schedule, on budget, on track; I hold hands; I stroke egos. I once had to bail an actor out of jail (for gay-bashing, no less). I give interviews explaining what producers do, especially producers of independent, low-budget movies by directors who struggle to put their singular visions on the screen, however much of a challenge those visions might pose for the so-called mass audience. I sit here at my desk with the phone ringing, the fax machine clicking, the assistants and interns running in and out, getting a buzz from the power.

And sometimes I sit here stunned at my powerlessness. Basically,

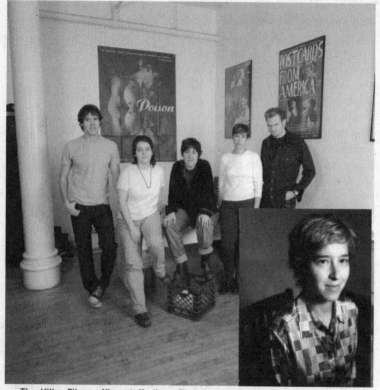

The Killer Films office staff: (L to R) Laird Adamson, Katie Roumel, Me, Eva Kolodner, Brad Simpson INSET: Pamela Koffler

a low-budget movie is a crisis waiting to happen. You stretch every one of your resources to its limit, and then you constantly push that limit. You have to be creative on your feet, because if something goes wrong (and something always goes wrong), you can't just throw money at it. You have to take scary leaps off high buildings, knowing that the landing might be hard.

I'm fortunate to have had a miraculously easy landing with the first feature I produced, a movie written and directed by Todd Haynes called *Poison*. The theme was transgression, and the approach was the opposite of straight. The film consisted of three different stories woven together, each shot in a different style: a black and white horror film, a mock-documentary, and a lush, homosexual prison romance. In script form, it was just tough to read. Half

its funding came from Todd's extended family and their Los Angeles friends (among them, amazingly enough, Sherwood Schwartz, the creator of *Gilligan's Island* and *The Brady Bunch*), the other half from foundations and arts agencies, including (and most notoriously) the National Endowment for the Arts. What nearly brought the endowment down would help us make our names.

The movie had won a prize at the 1991 U.S. (Sundance) Film Festival in Park City, Utah, and had been picked up by a small distributor, Zeitgeist. We were anticipating a tiny art house release. Then, an amazing thing happened: Two weeks before the scheduled release, the Reverend Donald Wildmon, an antipornography activist and the head of the American Family Association, saw a favorable review in *Variety* that mentioned the film's homoeroticism and also cited its partial NEA funding. So he sent letters to every member of the Senate and the House, saying, in effect, "Are you aware that this film, which was made with your tax dollars, is filthy, pornographic, and homosexual?"

The upshot was chaos. Our phones literally did not stop ringing. We made all the papers. We made *Entertainment Tonight*. Previously, performance artists like Karen Finley had come under fire for using taxpayers' money to do naughty things with yams and chocolate syrup, but movies capture the public and media's interest in a way that "minority" arts don't. This was the first time the wrath of the Religious Right was being directed at something that more than a handful of people at a time could actually see—something that could actually show up *in your hometown*. The head of the NEA, John Frohnmeyer—that poor fellow, banished shortly thereafter—came out in support of *Poison*. He organized a screening in Washington, D.C., after which a member of the Far Right was quoted in the *Washington Post* as saying that the movie was so filthy she wanted to take a bath in Clorox.

The bottom line was a fifty-thousand-dollar opening weekend at the Angelika Film Center in New York City—a record that wasn't broken for years.

Poison is a good example of how it's easiest to make a movie when you don't know what you're doing. Ignorance makes you fearless. I didn't know how risky limited partnerships were. I didn't know that we shouldn't have gone into production without all the money in hand that we needed to finish the film. I didn't know that a thousand dollars for production design was a bad joke, and that the costume

Poison made the Far Right go CRAZY.

designer would be spending nights in my apartment sewing prison uniforms. If I knew then what I know now, I never would have made the movie. That's the paradox of low-low-budget filmmaking. You have to expect the worst, plan for the worst, and repress all thoughts about the worst.

All first independent features are done with sleight of hand. They're built on contradictions, and their driving force has to be passion for the project. That's the exhortation under every how-to in this book.

I've been passionate about movies all my life. My parents took me to *Patton* when I was seven years old: They liked it, they thought I ought to see it. In Manhattan, where I grew up, there were theaters nearby—the Thalia and the Metro—that showed movies in repertory such as *Rules of the Game* and *The 400 Blows*. The mid-seventies was the tail of the last great era in American filmmaking, the time of *The Conversation, Mean Streets,* and *Nashville,* when mainstream directors and writers could still wrestle with difficult truths, and pose questions for which they had no easy answers. Video hadn't arrived yet: If you loved a movie and wanted to watch a scene again, you had to go back and sit through the whole thing. I sat through *The Poseidon Adventure* five times.

As an undergraduate at Brown, I could study film only through

the semiotics department, which meant an immersion in theory. I spent a year in Paris studying with Julia Kristeva and Christian Metz and going to lectures by Michel Foucault, then returned to Brown to make the requisite impenetrable student movie. Did all that semiotics and structuralism have an impact on my producing? I don't know, but I did see some interesting stuff: Straub, Robbe-Grillet, Rivette's *Celine and Julie Go Boating*—films that might be hard to sit through now but that deepened my understanding of the medium. I've gotten into trouble with colleagues for saying that the aesthetic of some young directors seems closer to *Three's Company* and *Full House* than to Renoir or Truffaut, but I can't retract my underlying conviction that the more you know about the history of film, the better you can imagine its possibilities.

I didn't go to film school. I know, lots of people learn the basics there. The problem is that everyone who comes out says, "I want to be a director." *Somebody* has to make the coffee.

When I came back to New York in the summer of '83, I made a lot of coffee. Thus began a series of jobs that I hoped would teach me all I needed to know to make independent films. I wanted to understand the structure of a movie crew. (I was, after all, a structuralist.) As a gofer, I'd go-fer drinks, props, equipment, and, at the behest of one notorious producer, cocaine. On an independent movie, you can usually get a job without having any prior experience as long as you're willing to work for free. (I paid the rent by working all night as a freelance copy editor for high-priced law firms. In the eighties, you could make twenty-five bucks an hour just for sitting around and waiting for some jittery associate to drop a brief on your desk at three in the morning.)

I had a lot of jobs: assistant editor, location scout on music videos, second-unit coordinator, second assistant director. One of the most useful in terms of my future producing was script supervisor. That's the person who sits with a fat, annotated copy of the shooting script and a Polaroid, making sure there's continuity from one shot or sequence to the next and that you're getting all the coverage you need. I was stationed by the camera all the time, so I learned how a low-budget film gets "covered"—how you can shoot a scene with a minimum number of takes and angles. Bare-bones movies tend to skimp on coverage, because film stock is often the greatest expense. On a studio picture, it's the opposite—film is the least expensive thing in the budget, a fraction of a big star's salary.

The movie I remember most from those early years is *Parting Glances*, a superb-looking gay drama made for a few hundred thousand and released in 1986. I did a lot of jobs on that one, including acting as an extra in the party scene. They needed someone to synchronize the sound on what they'd shot every day, so the director, Bill Sherwood, would come back from filming at one in the morning and watch dailies with me.

Hard as it is to believe, there weren't many models at the time for a micro-budget movie with a gay theme shot with money the director had raised himself. (Bill would stop shooting when he ran out of funds and start again months later.) Some of the financing came from gay men—five thousand dollars here, ten there—who wanted to see their lives depicted onscreen for the first time. (Some investors got parts in the movie in exchange for their money.) And some of it came from Bill's parents, who cherished him, and who I figured were well-to-do. They weren't especially—which I learned when I went to Battle Creek, Michigan, for his funeral in 1990, after his death from AIDS. He couldn't get another movie made, but his legacy is indelible. He said, "Okay, I've got an apartment, I've got friends who can act," and he made a movie on his own terms. The tremendous, pitch-in attitude he inspired is still, for me, the essence of the independent scene—even though it isn't present as much nowadays, with so many low-budget films being shot and so much competition for talent.

For a long time I didn't quite realize that I wanted to be where the money was. I thought I'd be an assistant director, the person who schedules the movie and runs the set, reprimands people and yells, "Quiet!" and "Roll sound!" and directs all the extras and makes the stunts happen. It's a terrible job, but it's also kind of fun, because you're the center of it all. On the other hand, you end up being a lightning rod for anxiety on the set, which is exhausting.

Everything changed when, in 1987, a college friend, Barry Ellsworth, found a generous private donor, and asked if I wanted to form a production company with him and another Brown alumnus, Todd Haynes. I had known Todd vaguely at Brown, but apparently he had been kind of scared of me. I had worked in the school cafeteria as a short-order cook. I made the omelets. No one else wanted to do that because it was really high pressure—*twoeggsovereasysixpancakesthreeomelets*—but I found it exciting, a rehearsal for being a producer. I was a mean short-order cook, though. You had

to step up and say what you wanted and move on, and if you didn't obey my rules you had to go to the back of the line.

Whatever Todd's fears about my nature, he wasn't about to pass up a (small) salary and a chance to produce and direct provocative, experimental shorts that would be a step up from the primitive, just-me-and-my-camera work that characterized the New York avant-garde of that era. Actually, there were two camps in the New York independent scene. People were making either super experimental films, which were often like watching paint dry for two hours, or slick calling-card movies that were essentially mini-Hollywood pictures. There was little in between. We wanted to make films that were both avant-garde and entertaining—such as *Blue Velvet,* which had just come out and seemed to signal a new direction. One of the strongest mandates of the company was to change people's perception that "experimental" was synonymous with "excruciating." Still, we were semiotics majors, concerned with the "means of production," so we called ourselves "Apparatus." We wrote an incredibly pretentious statement of purpose, which I'd quote from if I hadn't burned it.

The project that Todd was finishing up when we started Apparatus was a forty-three-minute stop-action film (co-written with Cynthia Schneider) he'd made over a summer in a graduate program at Bard College. It was called *Superstar: The Karen Carpenter Story,* starred a bunch of Barbie dolls, and charted the rise of the pop group the Carpenters as the lead singer wasted away from anorexia nervosa. The night he first screened it changed my life. It was astonishing on so many levels. It was incredibly entertaining, and when you watch a lot of movies in a semiotics class, you start to worry that maybe that's not the point. It was also brilliant and searching, a meditation on identity and the destructive pressures of environment. When it began, there were gasps and laughs from the audience, because it was so funny and perfect to have Karen Carpenter played by a Barbie doll. But at the end, when the doll turned around and half her face was gone, carved away by weight loss, it wasn't so funny anymore, and some people actually burst into tears. Watching *Superstar,* I thought, "This is the kind of filmmaking I want to be involved in." Todd remembers that I said to him: "I want to produce your next film."

Superstar was triumphantly received at Sundance and other film festivals, but we could never screen it commercially because Richard Carpenter and his lawyers served Todd with an order to cease and desist distribution. They wouldn't give permission to use the original

music that served as the devastatingly ironic soundtrack. This, of course, has helped to cement the picture's status as a cult item, something that shows up now and then in bootleg on the black market, or under the counters at hipper video stores. It also planted Todd—and, hence, Apparatus—in the consciousness of critics and members of the alternative media. In the next three years, leading up to *Poison*, we cut our teeth on a series of risky shorts that played regularly at small venues all over New York City (places such as the Collective for Living Cinema, most of which, alas, no longer exist). People would submit their scripts to us as if applying for a grant, and we'd produce the ones we liked for twenty to thirty thousand dollars. We made a couple of really bad films. But we also made some that were very, very good.

Apparatus set the tone for what I'm doing now. When I started working in independent films, I thought that the way that you had to run a production was in a state of crisis. That's what I was taught. The offices where I worked were hysterical places: The producer screamed at the line producer, who screamed at the coordinator, who screamed at the office production assistant, who screamed at the intern. There was a lot of finger-pointing: "*This* didn't get done! It's your fault, your fault, *your* fault!" You were constantly darting out of the line of fire; you'd leave at night shaken, sick to your stomach, needing a drink. Many people think that if you're not in a state of crisis on a movie, you're not really working.

I learned from Todd that it didn't have to be that way. When we started making movies together, he said, "Don't yell at me and I won't yell at you. Let's just not be like that." I was amazed. In part it's simply a matter of respecting other human beings. But it's also good business: The amount of time spent trying to blame somebody else is simply not worth it. The bottom line is, *you cannot be a producer unless you understand that it's all your fault*. Nobody wants to feel culpable for something gone wrong, but if you're the boss, you have to be the boss all the way. You take a deep breath and accept responsibility for every stupid little thing. And once people stop fearing that they're going to be targeted for blame, they start thinking for themselves, and they're no longer paralyzed by the thought that they're going to screw up and someone's going to scream at them.

That said, I yell at people all the time.

◦ ◦ ◦

In this book, I'm going to tell you what producers do and how you can do it, too. But first I'm going to tell you what this producer does—what I did today, in fact, to give you a sense of the range.

9 A.M.

Velvet Goldmine, Todd Haynes' musical about the birth of "glam" rock in the early seventies, is being edited elsewhere in Manhattan. We're breathing a little easier because a rough video assembly was shown to financiers a few days ago, it looked sensational, and— here's the really important part—they released our salaries, which had been held as insurance against the movie's completion.

In a couple of weeks, *Kiss Me, Guido,* a comedy about a pair of unlikely roommates (one gay, one working-class macho Italian) will open; many days there are reports on my desk of media screenings in New York and Los Angeles. The superimportant critics usually won't disclose what they think, but editors and feature writers will often stop to chat with the publicist, and you can get a sense of how the movie will ultimately be received. ("It's very charming and funny," says one writer in today's report. "Overall, I thought it was weak," says another.)

Another picture that's done and waiting to go is the directorial debut of the photographer Cindy Sherman, a low-budget horror film called *Office Killer.* On my desk sit a series of hilarious exploitation-movie posters that feature a strangled model in secretarial garb and catch-phrases such as "While You Were Out . . ." and "Working Here Can Be Murder."

My partner, Pam Koffler, and I have a number of scripts in development. One is a true-life account of the murder of a young Nebraska woman who pretended to be a man (to be called *Take It Like A Man).* Then there are biographies of the designer Halston and Betty Page, the S&M centerfold of yore. *The Michael Alig Story* is a true-life black comedy about the murder of a Puerto Rican club-kid. We've also op- tioned a tumultuous Hollywood novel, Bruce Wagner's *I'm Losing You,* which we're going to shoot in LA with Bruce as director. Most visibly, we're gearing up for shooting what is now titled *Happiness,* an amazing ensemble drama on the theme of erotic fixation from the writer-director of *Welcome to the Dollhouse.*

The distributor, October Films, had told us that we'd get a me- dium-range budget to make *Happiness,* and that the sum would not be cast-contingent. But when Patricia Arquette dropped out (be- cause of an illness in her family), October got cold feet. Now, they say they'll only give us the agreed-upon sum if we sign one of their

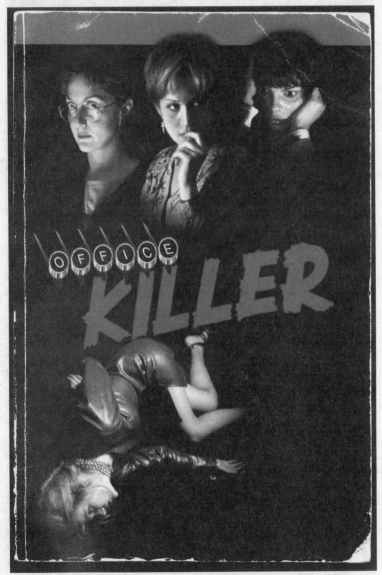

This is the B-Movie poster idea we ended up using for *Office Killer*.

The super-talented Dylan Baker as Bill in *Happiness*

"approved" stars to play Bill, the psychiatrist who, in the course of the film, drugs a pair of little boys and has (off-camera) sex with them. The list of actors they provided featured some odd names (Tom Cruise?). Todd Solondz chose three; none could decline fast enough. Big-name actors often lament that they don't take enough risks, but no star is breaking down our door to play a child-molester. (On the other hand, young actresses are flying themselves in from the West Coast to audition for the character of Joy, the seeming ditz who reveals unexpected layers of obsessiveness and vulnerability.) Without a star to play Bill, October's offer drops by a couple of million, take it or leave it.

10:03 A.M.

Todd Solondz says take it, take it. He didn't have stars in *Welcome to the Dollhouse*. He doesn't need the added pressure. He sits at my desk while Pam and I explain what it means to do the film with around two-thirds of what was already a miniscule budget. It might mean fewer shooting days— No, he says, let's cut something else. Okay: It might mean that the sequence set in a Florida retirement community will have to be reconceived, or else moved to the Catskills or New Jersey. He's not sure about that one, either. Well, then: Good-bye to separate offices for the production—we'll have to cram everyone into this one.

More significantly, it might mean that Todd Solondz will have to reconceive the film and that we'll all have to take salary cuts. It turns out, however, that for Todd, this is the least important obstacle. "If the movie does well, then give me a part of that because I'll feel I've earned it; I've done my job," he says, in his oddly passionate drone. "This is such a risky movie." After *Welcome to the Dollhouse,* a lot of companies pursued him; he could have made a relatively big-budget picture with real stars. But he wrote a nonjudgmental film about a pedophile. He's my kind of filmmaker.

10:40 A.M.

Todd leaves to audition more actors in a local church basement while Pam makes phone calls to nail down a designer, a director of photography, and a location manager. One big agency has aggressively advised their clients that participating in this sordid film (in any capacity, even technical) will do grave damage to their careers. I hit the roof and call one of the offending agents, who says, "Hey, that's what I do." When a script arrives from the same agency, I have my assistant fire off a letter that says we're no longer accepting their submissions. Hey, that's what I do.

11:20 A.M.

Todd Haynes has returned from England (where he spent six months shooting *Velvet Goldmine*) to discover that his Brooklyn apartment had been overrun by rats. On Friday, the biggest rat he ever saw got caught in a glue trap in his bathroom. Day and night it screams. Meanwhile, he has been peeing in a bottle and dumping the contents into the kitchen sink. I offer to send an intern to dispose of the vermin, which is the least I can do, given that Todd has yet to participate in the editing of the movie and his physical and mental health are paramount. Then Jim, Todd's ex-boyfriend (and the editor of *Velvet Goldmine*) comes over, carries the agonized rodent downstairs in a bag and—with great regret—bludgeons it to death with a bottle. Still shaken, Jim goes upstairs and finds another rat, bigger than the first, in another glue trap. This he beats to death with less hesitation. I follow all this avidly. When a movie is in process, you can't be too involved in the lives of your principal players.

11:45 A.M.

Music rights are one of my biggest headaches today. In *Velvet Goldmine*, there's a scene in which Ewan MacGregor and Jonathan Rhys-Myers lip-sync to Lou Reed's "Satellite of Love." It turns out that the number might cost as much as fifty thousand dollars. This

means we'll need to squeeze more money from our backers, or we won't get the song. The executive producers are starting to get edgy: I'm getting faxes filled with veiled threats. Meanwhile, *Kiss Me, Guido* has turned into a licensing nightmare. In one of the film's funnier scenes, the mismatched roommates watch *The Sound of Music* on TV. It turns out that to feature the clip, we not only need the permission of the studio, but of all the actors who appear. And not just Julie Andrews—every little Von Trapp child. I don't know what we'll do if one of them got religion in the last thirty-two years and doesn't want to be seen in a movie that embraces the homosexual lifestyle. My coproducer, Ira Deutchman, and I get our lawyer, John Sloss, on it, pronto.

1 P.M.

Today we do something out of the ordinary. Pam and I have lunch with a real Hollywood movie star: Shirley MacLaine, who wants to make her directorial debut on a slight but compelling script about an alienated young boy who likes to dress up as a girl. John Hart, the producer who works across the hall, has invited Pam and me to join him on the project. My hopes are not high, so I'm not broken up when Shirley and I don't connect. She doesn't seem to get what Killer Films—or most independent films—are about. She thinks a "little movie" costs ten million dollars. (Try a tenth of that.) Later, Pam gently suggests that I didn't do a great job of hiding what I was feeling, which was insulted. That's probably why Pam and I make a good team—she's good at letting someone know she likes them and even better at not letting them know she doesn't. Actually, although I wouldn't want to produce for Shirley MacLaine, I wasn't immune to her aura. When we traded stories about our childhoods and she referred, in passing, to her kid brother, Warren, I was starstruck: Warren . . . Warren Beatty! She grew up with Warren Beatty!

3:30 P.M.

Good news when I come back from lunch. *The Sound of Music* kids are all represented by one lawyer, which will mean a lot fewer hours spent tracking them down and waiting for letters of release to be signed.

3:42 P.M.

My relief is interrupted by a summons: I'm being sued by DuArt, a leading New York lab. It's their screwup, but it's one more thing I have to call my lawyer back about. This all began with Kim Pierce, who shot a short student film we're now developing into *Take It Like*

a Man. Kim had it processed at DuArt, but didn't have enough money to get it out—a typical student scenario. DuArt holds a lot of student negatives prisoner, which is their right. So I called the company and proposed paying half of the four thousand dollars Kim owed in return for the work print, which we could then edit into a trailer to show to potential investors. DuArt would keep the negative. The company agreed, but somehow that agreement got lost in the system, and now they're suing me for the other two thousand. What a waste of time.

4 P.M.

There is outside interest in *Take It Like a Man,* of a sort. Pam and I go out for coffee with a guy who'd called us up out of nowhere—a representative for what one lawyer referred to as "high-net-worth individuals." The man wants to invest in the movie, which at this point has a budget of under a million dollars. Limited partnerships, as I'll discuss later, are not so common these days, partly because the tax incentives are gone and partly because would-be investors have learned that they have a good chance of losing their children's college tuitions. But this guy grew up in Nebraska, where the incident on which the film is based took place; he'd seen *I Shot Andy Warhol* at Sundance and liked it; and he wanted an entrée into the biz. Pam and I politely ignore his casting suggestions: Limited partners make no creative decisions, and can be a pain if they have ambitions in that area. In fact, we say nothing at all to encourage him. But he's so convinced that this will make a great film, and so determined to break into movies, that he does all the selling. We sit and listen as he talks himself into investing.

5 P.M.

Back in the office, I call Lindsay Law, head of Fox Searchlight, to sound him out on what he thinks of the second draft of *Simply Halston* that Dan Minahan (who cowrote *I Shot Andy Warhol*) has just delivered. I think Dan nailed Halston on this draft—he got under the designer's prickly behavior and found the human being who created the persona. He made Halston sympathetic and the writing became a lot livelier. Lindsay and I talk for a long time; I tell him that I think the middle's soft, but that the last act has a hundred times more tension. Lindsay agrees. My sense is that, pending rewrites, he could be poised to give us a go-ahead. I call Dan and tell him Lindsay liked it, and Dan feels better. He can go to work on that soft middle.

Development of *Simply Halston* has been intense, because there

are a couple of other seventies, Studio 54-type projects out there that we're competing with. No, that's not true, we're not really competing with them—they aren't all the same. But studios and the media will lump them together, the way that *I Shot Andy Warhol* got lumped together with *Basquiat*. Rather than argue with a distributor about why the comparison doesn't make sense, you have to deal with it—because if you don't, you're apt to get the plug pulled on your picture. Dan was supposed to deliver his second draft two weeks earlier, but he was late, and Lindsay was livid because those two other projects had a jump on us. He had gambled on Dan's script, and he was feeling as if he'd lost the gamble. Usually I protect a writer from that kind of pressure, but I let Dan know because we were all up against it. After he got over the shock he went to work. Now the mood is upbeat. We have a shot at "competing" again. As dumb as that sounds.

5:30 P.M.

A messenger arrives bearing tidings of great joy. It's the deal memo from October Films: The green light on *Happiness*! When Todd returns from auditioning actors, we present him with our prize. "Now it's real," he says, awed. "Now it's scary. Now I'm really gonna do it."

This was a good day, overall. No matter how many lawsuits, pointless meetings, budget crises, and stray bits of nonsense this office has had to endure, we got a green light on a feature motion picture—which is only the thirteenth time we've had that happen. We're no longer in that gray limbo where we have to convince agents and actors and creative personnel that the deal is done. We can begin the job of building a team. We can go for it, secure in the knowledge that we haven't made one aesthetic decision as a result of being umbilically attached to a marketing department.

I don't want to sound snotty about the marketing aspect of movies. While it's true that, in the best of all possible worlds, independent films are genuinely alternative, genuinely original visions, there's no such thing as an absolutely independent film. There's still an economy at work: The movie has to go into the marketplace, and people have to want to see it. Much of the money I get comes from Hollywood sources, and not because they want to underwrite my brilliant career. To do what I do, I have to believe that the films I produce

will be so vital that they will find an audience—or else will create one of their own.

There's a joke about an art professor who begins his first lecture saying: "You might not know much about art, but you know what you like. Well, after taking this course you still won't know much about art—but you'll know what *I* like." Actually, knowing what a decent professor likes is about as much as you can hope for when the subject isn't math or science. And because making movies is such a peculiar activity, in which art and commerce and psychology get all mixed up, the most useful instruction I can offer is by way of illustration, not prescription.

In other words, when you read this book, you'll learn about producing by learning what *I* like. You'll read about my experiences in the areas of development, budgeting, casting, shooting, editing, releasing, and of course, fighting those battles with artistic personnel and studio executives, with names occasionally omitted—not to protect the cretinous, but to ensure that after writing a book about producing I can continue to produce. You'll find heavily annotated budgets and contracts, along with my own production diaries written in the heat of such tumultuous shoots as *I Shot Andy Warhol* and *Velvet Goldmine*. You'll get a sense of what it's like in the trenches, which is the best preparation for being there I know of.

There's a mystique about the movies. You walk down the street and see a film shooting—as I did this morning—and there's a phalanx of people there to keep you away. You can sort of glimpse the actors, and there's a crane, and the crew, and everyone's doing their thing. You think, "Wow, there's a movie." This book will demystify the process without, I hope, demystifying it too much. Not just anyone can make low-budget movies that matter—it takes incredible nerves, and passion, and, oh yes, talent. It takes knowing everything, but not knowing so much that you're not prepared to take the leap off that high building—the leap of faith. The director, at times, has the luxury of despairing, but the producer does not, or else the whole thing will spiral out of control.

The one thing that all great producers have in common is the courage of their convictions. A part of me loves reading articles about alleged monster producers, like the guy who has a special button on his phone that means: MORE STRING CHEESE NOW! Making movies is an immoderate activity. You have to stay sane and also embrace the madness if you want to shoot to kill.

DEVELOPMENT: THE IMMACULATE CONCEPTION

Development, which encompasses conception, writing, budgeting, and even casting, is the most nebulous area in moviemaking, and the one least likely to lend itself to a "how to" manual. It's also the most essential. Whole wings of major studios are devoted to acquiring and developing new properties. Those toiling at the job range from lowly readers who pore over unsolicited screenplays and galleys of forthcoming books, to vice presidents whose sole function it is to sit in meetings and pose annoying questions. In the independent cinema, development is less bureaucratized, more piecemeal, and far more impressionistic. There's another significant difference: The rights to a novel or life story or popular song that can be bought with a studio's pin money can be a budget-breaker on your one-hundred-thousand-dollar chamber drama.

At this level, clearly, development and budgeting go hand in hand. When trying to decide if I'm going to

make a film, I don't just think about what it's going to say but who it's going to say it to, and then I try to budget accordingly. That said, this isn't a book about shooting gutbucket horror pictures for the direct-to-video market. The marketplace does not have to dictate your aesthetics—that way lies trauma, or, at least, Troma. I once participated in a development panel, organized by the Independent Feature Project, with a guy who complained that first-time independent filmmakers were making too many uncommercial films. "They should be making movies that are more commercial!" he declared. Well, duh. "If any of us knew what was commercial," I interjected, "we wouldn't be on this stupid panel at the IFP, we'd be in our houses in Bermuda."

Commercial is buy low, sell high. What's commercial in an independent movie? Julie Dash's *Daughters of the Dust,* a slow-moving, turn-of-the-century poetic drama about descendants of slaves on a remote island struggling to maintain their West African heritage racked up two million dollars with no advertising budget whatsoever. Who could have predicted that? All it had on paper was a young writer-director with a burning desire to tell a story that had never been told before. On the other hand, I knew a couple of guys who put years into what they thought would be a crowd-pleasing horror picture called *The Refrigerator*. It turned out to be entertaining—the fridge was the portal of hell—but the film went pretty much nowhere.

THE SEED

A lot of people ask me where I find scripts. At this point, most find me. Agents, directors, and writers know the kind of movies I do, and send things my way that they think fit my agenda. Of course, I try not to have an agenda. After *Poison* and *Swoon,* I was dubbed "the Queen of Queer Cinema," an appellation I loathe. Then I was attacked by a lesbian writer for only making movies with gay men—this after I'd produced just two features! When I took on the lesbian love story *Go Fish,* some people suggested it was a strategy to prove that my tastes extended beyond boy movies. You never can win. I'd never make a film solely because it's edgy or provocative or features a gay subject, and I'd never refuse to make a film solely because it doesn't. But there is one common denominator. I tend to work with

writer-directors who consider themselves *auteurs*. Every one has been totally obsessed with what he or she is trying to say, and has taken enormous pleasure in that obsession. I wouldn't work with someone who thought it was just a job, or was in it solely to grab the brass ring. Making movies is one of the greatest (pre)occupations in the world. It can be murderously difficult, but when everything comes together—when those words on the page take on a cinematic life—it's alchemy. On the other hand, few things depress me as much as a set on which no one gives a damn about the film. Imagine lavishing so much time, grief, and money on a project that means nothing to you but a paycheck.

I can't be more emphatic: Throw your resources behind a script with which you're proud to be associated—and associated for a long time. Then make sure that the director is someone you could tolerate being stuck with on a desert island for a year, because that's what it's going to feel like. Then ask yourself: Is it possible to do this movie for the money I can raise? How much *can* I raise? Ten thousand? Fifty? A quarter of a million?

If your budget is really, really low (the largest number above is really, really low), look around and see what you have access to—what you can bring to the picture that won't cost you anything—and then write a screenplay with those elements. Your grandmother might own a beautiful beach house or a cabin in the woods. Tony Chan's parents had a Chinese restaurant, which meant that late at night he could use it for nothing. Shooting when the place was closed, he made *Combination Platter*. Your script should emerge organically, from your heart, but conviction and convenience can go together. Tony Chan really wanted to make a movie about the experience of the people he saw every day in that restaurant.

It's hard to determine at what point your budget *becomes* your aesthetic—when the physical limitations of what you can do shapes your mise-en-scène, the style of the performances, and the story you choose to tell. But the smart writer-directors are at least thinking about the budget when writing the script. The reason *Swoon* and *Poison* and *Go Fish* are important to see—besides the fact that they're brilliant masterpieces—is that they're good examples of how to make a low budget work in favor of a film instead of as an obstacle. In each case, the budget was built into the film's conception.

The visually rigorous Tom Kalin

On *Swoon* we were complimented for forcing an intimacy with the child murderers by using so many close-ups. Now, Tom Kalin, the writer-director, is one of the most visually rigorous people I've worked with, and those close-ups were largely an aesthetic decision. Largely. It's also easier and cheaper to light small spaces than it is to light big ones. On *Poison*, Todd Haynes had a similarly resourceful strategy. He wanted to tell three stories, and the third had to be expensive looking—told in the lush style of a Douglas Sirk melodrama, such as *Magnificent Obsession* or *Imitation of Life*. That meant there wouldn't be a lot of money left for the other two stories. So the first was conceived as a rough documentary, with mostly talking heads. The second was shot as a B horror picture, in black and white, with a lot of hand-held camera work. The contrast among the three stories was extremely effective. And you never got the feeling you were watching something dirt-cheap—although believe me, you were.

Go Fish came to me over the transom. (My office is one of the few that looks at a project that way.) The movie was half done: The director, Rose Troche, had run out of money. It was one of the rare occasions when I saw something and *just knew* there was an audience hungering for it. Here was a lesbian movie that was not about coming out—the coming out was over—but about life and romance and hanging out and having sex. The script was good, the actors appealing, and Rose had a certain visual panache. Part of the film's charm was that—and I mean this with all due respect—the people who made it didn't entirely know what they were doing. They also didn't know they didn't know, which is probably why they got as far

as they did before they came to me. Although Rose had never made a movie before, she had terrific instincts, and she'd managed to make the picture's very amateurishness part of its appeal. "Developing" that film in midstream meant weighing what we had and not imposing slicker criteria on what was best kept raggedy. On the other hand, the film needed to get finished and come off semicoherently. It was a balancing act. The result, I think, is that *Go Fish* is one of those movies whose flaws you gladly forgive because it's so sweet-natured: "Ah, so it's in black-and-white . . . so it's a little out of focus . . . Who cares?"

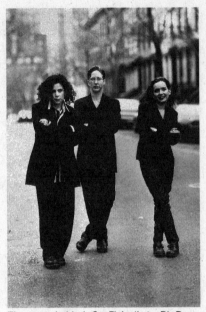

The team behind *Go Fish*: (L to R) Rose Troche, V.S. Brodie and Guin Turner

Other projects reach me in the form of novels, memoirs, or—my favorite—true crime stories. More and more books read as though the author has been thinking about a film sale from the inception.

Some agents advise authors that if they want to sell their book to the movies they should have nothing to do with the project, because it will just lead to heartbreak. "You're going to see your fabulous little book turned into Hollywood nonsense," they say. "So take the money and run." I understand that point of view when I see what's happened to some books. I'm sure that Scott Spencer isn't thrilled to be thought of as the guy who wrote Franco Zeffirelli's *Endless Love,* and that John Updike doesn't want to be known for penning the barf scenes in George Miller's *The Witches of Eastwick*. On the other hand, you can often get an option on a book that's a hot property because the author doesn't want it to end up in the paws of Joe Mogul. He or she might want someone who will treat it with respect and not turn the characters into stick figures or slap on a bogus upbeat ending.

Other authors want a chance to write the screenplay or to have

a strong say in the making of the film—who's in it, who directs it. That can be good in terms of getting the rights and not so good if the author wants to exercise too much creative control in a medium in which he or she has little or no firsthand experience. Most authors, however glorious their prose styles, haven't a clue about what constitutes film syntax. A lot of them are hungry to learn, though, because movies are the mother lode.

Whether you acquire a property can be a matter of luck and timing. That number one bestseller was likely optioned for six figures before it was even published, but there's a universe beyond the current *New York Times* list.

Most publishers have a person who deals specifically with movie rights. You can call and ask if the book has been optioned. You'll probably be referred to the author's agent or to someone at the agent's office who handles subsidiary rights. Many times, if it's not a recent work, that person will tell you yes, the book was bought by ABC a few years back to be turned into a Movie of the Week, but they let the option lapse. If the big money has already been paid and the book has been around for a while, the author might be more inclined to let you have the film rights for a pittance.

On the other hand, a studio could have bought the rights, bankrolled a script they ended up hating, and then put the project into turnaround—the lazy susan of the filmmaking world. If the studio still owns the project and you want those rights, you'll have to reimburse the studio for what it paid initially, often along with its development costs. That's prohibitive for many independent producers. Still, it's worth going after anything you're interested in, because you just never know. What you shouldn't do is go ahead and adapt a story and assume you'll get the rights. I know two different directors who optimistically made unlicensed short films of J. D. Salinger's "A Perfect Day for Banana Fish." Outside of festivals and private screenings, neither work will ever be seen—at least until the copyright expires, in about half a century.

Some well-established independent producers have "overhead" deals with studios, which then have the right of first refusal on any project they handle. In effect, their development is subsidized: With their monthly stipend, they can run their offices and acquire the rights to a property without a lot of fuss. There's no such thing as a free lunch, though. If all your money comes from one entity, you have to be careful that you can still protect your director's choices.

ARRESTED DEVELOPMENT

Most of the movies I've produced have had extended periods of development. After I'd done *Poison* and was on the map, Tom Kalin, an acclaimed avant-garde filmmaker who had no experience with narrative, received a fifty-thousand-dollar grant (those were the days!) and approached me about making a film with two linked stories. The first would be a homoerotically obsessive take on the Leopold and Loeb murder; the second focused on a fatal explosion aboard a battleship—an event that Navy investigators initially blamed on a jealous homosexual. We couldn't get enough information on the second story, which ultimately didn't have the same resonance. So we went with Leopold and Loeb, the subject of other famous films but none as charged as *Swoon*.

Tom would fax me pages of the script in progress. "Am I crazy to start with this scene?" he'd ask. Or, "Do you get a sense of who these people are?" Like many writers, he says that when he works he feels blindfolded—fumbling along, bumping into walls. He's extremely vulnerable, and he wants someone he can trust to look at the material and not say, "Yuck." Or if they do, to say "Yuck" constructively. If you cultivate that kind of relationship with a writer, he or she won't be embarrassed to show you something outlandish—something that might be atrocious but might also be genuinely inspired. Tom ended up coming into the office after ten o'clock many nights to use the computer. He'd sleep on the couch. That's another thing a producer can do, if he or she is so inclined: provide food, shelter, and office equipment.

We knew we'd use up the fifty thousand dollars after about ten days of shooting, so we selected only certain scenes to film. Then Tom said, "We've done all the shots of people against white walls that we can get away with." Production ground to a halt. It was actually good to stop at that point, because when we put together a cut of what we had it was a revelation. There were still vestiges of Tom's original intention, which was to make an impressionistic work, almost a riff on Leopold and Loeb instead of a true narrative. But the story was also there, in tantalizing fragments, and the story parts worked best. The film was fighting itself. So Tom, who was gaining confidence in his ability to be a narrative filmmaker, wrote scenes that would fill in the gaps. He learned to jettison stuff that

Craig Chester's sterling performance as Nathan Leopold added much to _Swoon._

was only there because it was arty and atmospheric and to punch up the scenes that would move the story forward.

The process was even more touch-and-go with Mary Harron, an award-winning documentary and TV director. A friend of a friend, Mary came to me with an idea for a documentary about Valerie Solanas, the young woman who shot and nearly killed Andy Warhol in the late sixties. Tom Kalin and I shared Mary's fascination with Solanas, the author of the book _S.C.U.M. Manifesto,_ a play called _Up Your Ass,_ and other works of man-hating vitriol. But we both felt she'd chosen the wrong form. Valerie's dead, Andy's dead: Where's the documentary? All that most Warhol people remembered about Solanas was that she was weird. We thought there was a narrative in Mary's material that was screaming to get out.

Tom became my coproducer on what was ultimately _I Shot Andy Warhol._ Development meant seeing that Mary had what she needed to write the script—which was fairly easy, since she had a lot of experience researching documentaries and had a great assistant. She dug up Solanas' college yearbook and discovered that Valerie had lied about her age. She found published accounts of the Warhol

"Factory" days in newspapers and magazines. She extracted the (limited) recollections of Solanas from people who had been around the Factory. And she had *S.C.U.M. Manifesto* and *Up Your Ass*.

Our most important function at this stage was to remind her that, while she had to respect the facts, she also had to tell a story; that the story had to have characters; and that the characters' lives had to move forward in a way that would keep the audience moving with them. We told her that as hard as it might be for a documentarian of integrity to make things up, she was going

Director Mary Harron confers with her star

to have to rearrange events, change the order of scenes, and inflate or deflate the characters' roles depending on the story she decided to tell.

That story emerged slowly. There was too much narration—the action wasn't happening in the present tense. We had many sessions with Mary in which we went through the script page by page. *What's happening with the story here? This scene is confusing. This scene is repetitive. Why is this character coming in here? The climactic action is here but it needs to be here.* In some ways, as Tom has pointed out, when you're developing a script you're like a psychiatrist reflecting the writer's thoughts back to him or her: *Well, what do you think? What do you want to say?* You ask simple questions to try to keep them from straying off course. Then, Mary hooked up with a cowriter, Dan Minahan, and the script began to acquire a life of its own.

A lot of producers organize readings, in which actors come in and sit in a long row and declaim for an invited audience. On *Warhol* this was especially helpful. We learned what parts of the screenplay dragged; what was funny that we didn't know was funny; and that an actor's reading could cant the whole script in a new direction. I

don't like going to readings that aren't connected to my own projects—I find them really dull. But I think it's extremely useful for a writer to hear his or her words spoken out loud.

There was another variable. For a while, we were developing the script to secure funding from a now-defunct division of October Films called Autumn—which meant that we were mainly trying to satisfy the person in charge. This happens a lot: You end up tailoring your project to suit the tastes (or, in some cases, the dopey whims) of a financier or studio executive. When that person leaves the scene, or when you have to move on to another source, all bets are suddenly off, and you have to endure a new set of challenges from a new (and possibly dopier) element. No script will ever please everyone. Ultimately, the writer has to have the courage of his or her convictions.

Autumn eventually decided not to move forward, and we were lucky enough to land at American Playhouse.

After solving its structural problems, our main concern about *Warhol* became the fact that its protagonist was a paranoid schizophrenic—not your usual heroine material. Who could identify with such a person?

That begs the question: Who is the audience? In most mainstream films, you're supposed to care intensely about one or two characters and hate everyone else. But when Valerie was being called a "cunt" by Ondine, Mary didn't take sides. She adored them all—the freaks, the bitches, the crazies. That's one of the reasons the film evoked the period so effectively. It put you in the middle of the madness—without handing you a compass—and your reaction to Valerie depended on whatever baggage you brought with you. Some people said she made their skin crawl; others loved her. And casting played a role in making her palatable. Lili Taylor had so much physical charm and grace that she could look adorable even in a filthy raincoat shooting Andy Warhol.

So who is the audience? People who can live with that tension, who can say, as Tom does, "So-called 'heartwarming' movies do not necessarily warm my heart."

WRITES OF PASSAGE

The input I have on a script varies with each writer/director. Some want to show me everything and have their hands held, others want

to be left alone. A producer has two functions in this period: one is to create a space in which the writer feels safe and comfortable writing; and the other is to mediate between said writer and whatever entity has provided development money. As I've mentioned, things got testy on *Simply Halston* when the studio, Fox Searchlight, perceived that there were competing projects and wanted to see material faster than the writer could generate it. I can't force a script out of a writer: It's either done or it isn't. On the other hand, with *Simply Halston* I had to shift away from insulating the writer to giving him a pretty severe wake-up call. It wasn't fair *not* to tell him that if he didn't deliver, the whole thing could fall apart. It was a lot of pressure, and sometimes increasing the pressure backfires, but if he'd taken an extra six weeks it would have jeopardized his movie. (It was also fortunate that running Fox Searchlight was Lindsay Law, the former head of American Playhouse, who is unusually sympathetic to writers, and with whom the writer and I had an established relationship.)

Incidentally, a huge difference between low-budget and Hollywood-studio development is that in Hollywood, executives are very casual about throwing a writer off a script and bringing in someone else; often, by the time the picture is made, there are eight people vying for screenplay credit. I've had companies suggest that I replace writers on projects, but at this level the script and the writer—and the director—don't usually exist independently of one another. You're only making the film because the script is right and the director is ready, not because you've hired your stars, built your sets, and are locked into a start date.

It's hard to imagine what Hollywood would have made of Todd Haynes' first draft of *Velvet Goldmine*, which was 200 pages and went in a hundred different directions. It was clear that it needed a tremendous amount of restructuring, and I made comments about whatever caught my eye—the idea being not to overwhelm him with criticism, but to give him an impetus to move forward. It helps that Todd has a clear idea of what needs to be done. The process is like looking at various cuts of a film. You enter into a relationship with the director or the writer where you ask yourself: At what point can I be useful? And at what point should I save my eyes, so that later on I'll have a fresh perspective? On *Velvet Goldmine*—which is being edited as I write this—I know I've forfeited that perspective,

because I've been so close to the process. I'm going to have to count on the kindness of strangers now.

If the studios found Todd Haynes' script brilliant but difficult, they found Todd Solondz's script brilliant but impossible. After *Welcome to the Dollhouse,* an art-house smash, scores of executives wanted to be in business with him, but as soon as they arrived at the part of the script where the not-unsympathetic protagonist begins drugging and carrying off little boys, the dollar signs faded from their eyes.

When Todd was making *Welcome to the Dollhouse,* then called *The Middle Child,* he phoned our office a couple times for advice, because he was having a hellish time. Pam and I try to have an open-door policy, so that producers can call us if they've gotten in over their heads or if there's some aspect of the filmmaking process that they don't understand. When *Dollhouse* came out, I found myself envious, wishing I'd produced it. I phoned Todd and asked him to lunch, which turned out to be a lot of fun.

Todd Solondz takes "geek-chic" to the extreme. He's also convinced that he'll have a heart attack before he's forty (no reason that I can see—both parents are still alive). But despite those quirks, he manages to instill confidence. Todd reminds me of stories I've heard about Truman Capote: that when he was writing *In Cold Blood* he would knock on the doors of suspicious Midwesterners and somehow they would let in this weird little guy and pour out their hearts. At our lunch, he told me he wasn't really working on anything. But not too many months later, he called and said, "I have this script. Will you read it?" What he'd written was the sort of twisted erotic roundelay that almost never shows up on the screen. I called him back and said, "Yes! I want to jump into this!" Sometimes "development" is like falling off a log.

RIGHTS AND WRONGS

Before I talk about rights and permissions, I have to add the usual disclaimers: I'm not an attorney; this is no substitute for legal advice; hire a lawyer. This area gets very complicated, especially when you start thinking about filming someone's life story, or basing your

Glitter Kids galore, from the opening of *Velvet Goldmine*

movie on anything with even a vague similarity to an actual person or event.

Because of the resemblance between the central figure of *Velvet Goldmine*, Brian Slade, and certain glam-rockers, the movie was a huge can of worms legally speaking. There are so many shades of gray with this type of project that every lawyer will give you a different take on whether you may go ahead without permissions or if you should make changes to ensure that a character is completely unrecognizable. Of course, I could produce a film tomorrow called *The David Bowie Story* or *The Bryan Ferry Story* and, since they're public figures, that would be perfectly legal. (Think of all the TV movies that get churned out about celebrities in the news: Woody Allen and Mia Farrow, Tonya Harding and Nancy Kerrigan, Amy Fisher and Joey Buttafuoco.) I wouldn't, of course, be allowed to use any of Ferry's or Bowie's music unless I had permission and I paid for it.

In a way, it's almost harder to do what we did in *Velvet Goldmine*, a fictionalized account in which the characters have something in

common with real people but live their own lives. Brian Slade snorts cocaine in the movie: does that mean we have to prove that all those glam-rockers did, too? We ran into some of the same issues with *I Shot Andy Warhol*, which had a lot of characters based on people still alive. Fortunately, Bridgid Berlin couldn't accuse us of slandering her when we showed her injecting speed into her thigh, because she did that for real on camera in *Chelsea Girls*.

So let's say you want to make a movie about a woman who has been in the news and is therefore considered a public figure. You don't have to buy the rights to her story, but if you're able to, it might make your movie better. If you don't, she probably won't sit and talk to you, so all that you'll know is what everyone else knows. You won't have the intimate details—the relationship with her mother, say, or what her best friend thought of the whole scandal. For that kind of access, I think it's worth spending the money.

On the other hand, you have to set boundaries. Tom Kalin and I worked hard to get the rights to the story of the relationship between a legendary rock singer and an artist who has since died. We paid the singer a big (for us) option fee for her recollections, memorabilia, and the rights to her music, and all she asked for was script approval—which she strongly implied would be no big deal, just a formality. She was an artist, too: How could she be obstructive?

Easy. It became increasingly clear that she hadn't wanted the movie made in the first place, but had agreed to the project because she really needed the cash. Yes, it was dumb to give her veto power over the script, but there was no other way she would have accepted the deal. It was a crap shoot and we crapped out.

Stonewall, an account of the tumultuous Greenwich Village uprising that is said to have launched the gay liberation movement, was the ultimate life-story nightmare. We bought the rights to a book by Martin Duberman, whose research formed the basis of the script. But to maintain the integrity and authenticity of the film, we wanted to hear from as many people who were involved as possible. This created several problems. The first was that there's a lot of dispute about who did what. There are three different organizations of Stonewall veterans, each claiming that it is the only one that represents the genuine participants and that the other two are bogus and run by people who pretend that they were there but weren't. It was difficult to deal with all of the groups, so I tried to choose the one that was the least insane. Still, different people had wildly different

Stonewall was the ultimate life-story nightmare.

accounts: "It was raining!" "It wasn't raining!" "It was 200 people!" "It was 500 people!" "It was 1000 people!" "It was a glorified bar brawl!" "It was a riot!" "The Black Panthers came over!" And each queen who came in to talk with us would say about the person who was leaving: "Is *she* still dogging you on that story? She wasn't even there!"

One thing you learn is that people who have been eyewitnesses to momentous historical events can be very proprietary about them. Stonewall was a revolution of the disenfranchised, and the memories of some of its participants are still the most important things in their lives. Add to this the fact that when a movie company comes around—even a low-budget, independent movie company—they smell money. We were naïve and spread our net too wide: We thought that the Stonewall veterans would be excited to talk to us, to contribute to the first depiction of the event on the screen. We thought wrong.

The morning of the *Stonewall* premiere at New York's Gay and Lesbian Film Festival, a group of transvestites called and said that if they didn't all get tickets, they would picket the opening. I said, "There's no way I'll give in to their tawdry demands!" So they went ahead and picketed. Guests who entered the theater were surrounded by drag queens chanting and holding up signs that said, "We've been exploited!" "Christine Vachon is exploiting us!"

To my enormous irritation, they came to the party afterwards.

HOW TO PITCH ME

• Never NEVER give me the _____ meets _____ pitch. This may work in Hollywood, but I find it insulting. It also demeans your own film—it makes it seem as if it cannot stand on its own. And more often than not, it sounds ridiculous. *Seven* meets *The Princess Bride. Pulp Fiction* meets *Go Fish*. Please.

• AND NEVER compare your film to *Mean Streets*. If I get another pitch that invokes *Mean Streets,* I might have to stop accepting unsolicited scripts. Scorsese's film is brilliant and one of the seminal indie success stories, but it might have done more harm than good—judging from all the half-finished "guys from the neighborhood" films with narratives that spiral toward the inevitably tragic conclusion that come my way. I don't want to make movies that are like other movies. And I hope that the filmmakers I work with are not trying simply to rehash elements from financially successful films. Do that song and dance when you pitch to Paramount.

• Know something about the company you're pitching to and tailor your pitch accordingly. Form letters are a bad idea. When I get a letter that begins "Dear Sir," I usually don't get to the second line. If I'm going to take the time to consider your script, I hope you have taken the time to learn something about my work. And by the way, sending your script to everyone in the Hollywood Creative Directory is a *bad* idea. One of the reasons I sometimes consider implementing a "no unsolicited scripts" policy (which my colleagues at Good Machine have adopted) is because we receive so many scripts from people who obviously have no idea what kind of movies we make—*Rambo* rip-offs, spy thrillers, horror films about giant squids. I have more important things to do than wade through that kind of junk. And yet . . . I keep on accepting all scripts (sometimes over my staff's objections) because I know that the next one could be amazing . . .

• Be concise.

• Don't gush. (Sometimes people come off more like stalkers than writers.)

• Don't be too cocky. (i.e., "This film must—will—get made. The only question is whether you will be a part of it.")

• Don't name-drop unless you can back it up. If you say you're friends with Ethan Hawke, he'd better at least have heard of you. Hey, it's okay not to have industry connections. Sometimes it's better. After all, if you're such big buddies with all these powerful people, why aren't they producing your script? Do they think it sucks?

• Don't tell me who's reading it—i.e., "Parker Posey's people are reading it!" Anyone can read anything. But it does make a difference if someone is *attached*. These days actors often sign what are known as "letters of intent," which are basically agreements to appear in the film if and when it gets financed.

• Don't try to sell yourself as the next sensation—save it for Sundance. I like people who are on the level, selling their project and not their history.

• Do include a synopsis. I'm much more likely to read a script if it has an interesting treatment with it.

• Spell check. Seems obvious, right? You'd be serprized.

• Include a self-addressed, stamped envelope.

• If you send something special to get my attention, be clever. Money doesn't impress me—anyone can order five hundred dollars worth of sushi from Nobu. (One of my production partners once received that with a submission.) I don't want bribes. But an interesting photo or prop is likely to raise my interest and make my staff look more closely at the script. Just make sure that it relates to your project.

• Be patient! At any given moment, Killer Films has two movies in some stage of production or post and several projects in development. The five of us on staff sometimes feel as if we're just treading water, and the scripts pile up around us. We try to read everything, but it takes TIME.

• Rejection is inevitable in this business. It's not personal. Sometimes people regard me as a *deus ex machina* who can MAKE THINGS HAPPEN. If my company (or any of the indie production companies in New York—Good Machine, the Shooting Gallery, and so on) says no, don't despair. There are many aspiring producers out there who might jump at the chance to make your script. That's one of the reasons I encourage people who want to make moves actually to work in production. Get hands-on experience, meet other comers. I started out as a PA along with Todd Haynes and Ted Hope. When I first met Nick Gomez (*Laws of Gravity, Illtown*) he was a film editor. His producer, Larry Meistrich, was a Second Assistant Director for me. The sharp Second AD you're working with could someday end up as your coproducer. Working on a set gives you experience and connections you'll never get in film school.

CHAPTER 3

THE BUDGET:
MAKING IT COUNT

If you spend any time producing movies, you learn to read a budget like a novel. In those seemingly impenetrable figures is a story of compromise, anguish, optimism, delusion, and sometimes even genius. Why is one number so huge and another so teeny? Why are more resources concentrated in costumes than in set-building, or vice versa? Where's the contingency—the ten percent you have to set aside for the inevitable overruns and emergencies? Who do they think they're kidding? In the details, you discern a thousand different choices, some smart, some dumb, many excruciating.

When do you prepare a budget? As soon as the script is done. Before you start to look for money. In any case, it has to be ready as soon as a financing entity expresses interest in your script. If you don't know how much you'll need, no one will take you seriously.

I always assemble three budgets: the dream budget, the less-than-dream budget, and the bad-dream budget.

The dream budget will likely be out of reach unless you can attract a seriously bankable actor. The less-than-dream budget is the one with all the fat squeezed out but still some room to breathe. It hurts to have to lay it aside, which most of the time you will. The bad-dream budget is like climbing Mount Everest with a Swiss Army knife. You'd better get in shape.

The budget is never big enough, but that's not always a bad thing. Years ago, the theater director Peter Sellars was hired to mount his first Broadway production, a brontasaurean musical from which he was subsequently fired. Reflecting on that debacle, he pointed out that, for the first time in his life, his budget was so large that whenever a problem arose, he could simply throw money at it. He said he'd never done less honest, creative work in his life. I imagine that David Lynch would say similar things about *Dune*. The point is, problem-solving for the sake of your budget can be enormously creative. In the course of figuring out how to get from A to F without resorting to B, C, D, and E, you're forced to make the kind of imaginative leaps that are at the heart of most great artistic endeavors.

The other reason that small budgets can be healthy is that the pressure is much lower to be *boffo* in the marketplace. If you are lucky, your one-million-dollar picture can have a moderately successful run in two or three big cities, pick up a moderate cable sale, rack up moderate overseas numbers, ship a moderate number of video units, and leave you moderately in the black—and immoderately primed to tackle your next project.

As I said in the previous chapter, on development, you have to budget with your audience in mind. I also suggested that in some cases you should let your budget be your aesthetic, which means making its limitations work in your favor. On the other hand, I recall an animated conversation with a friend, Steve Woolley, the producer of *The Crying Game,* who took a contrary stance. "Oh, yes," he said, "I can hear people saying: '*The Crying Game!* What a great movie— and it came in under budget!'" I thought: The man's got a point. But there has to be a balance. Something always seems *off* about a movie in which the budget has swollen so grotesquely that form leaves content in the dust. Stephen knows that well. He wrote a blood-curdling—and hilarious—diary called *Absolute Disaster,* which chronicles the out-of-control shooting of the musical *Absolute Beginners.*

Sometimes producers lie about their budgets. This is because the real figure can be used against them. Personnel will want more money. The press won't respect their *cojones*. Bogus low figures are widely circulated as macho badges of indie honor, and then used to make everyone else feel as if they're not resourceful enough. The most famous suspect number is for Robert Rodriguez's *El Mariachi*, which he claims to have made for seven thousand dollars. Maybe that's what it was *shot* for, assuming the actors were paid nothing. But to get *El Mariachi* (or a movie like *Go Fish* or *The Brothers McMullen*) up to the standard where even an indie audience will endure it costs between $75,000 and $150,000. Postproduction means a blowup from 16-to 35-millimeter film, along with a remix that has lots of ADR (additional dialogue recording) to compensate for the usual pathetic sound. Often, distributors will commission a whole new soundtrack. The writer Joe Queenan wrote an entire book about trying to best Rodriguez and make a feature for $6,999.00. Paying his actors nothing, he spent ten times that sum and still came up with an unreleasable picture.

What specifically is the difference between the dream budget and the bad-dream budget? Obviously, the more money you have, the more room you have to play. The producer, the director, and the actors make more. The crew rates are higher. You can afford to hire union crews, who are more experienced and generally more competent, and to build more of your sets instead of depending on locations. The number of shooting days goes up. Once you drop to the lower budget you lose those days, the union crew, lots of people in the art and construction departments, and much of what you'd spend on costumes. In the face of these dwindling resources, some producers budget only the bare essentials for postproduction, in the hope that at the end of the shoot they'll still have some of their contingency left over, which can then be sunk into the sound mix or a Dolby license or another week in the editing room.

None of this makes much difference to your financing entities. They'll leave it to you to do the impossible. "We won't make the movie for four million," they'll tell you. "We'll make it for two-and-a-half." In most cases, they don't really understand the difference. They think you can just take a budget and make all the numbers go down. They don't realize that the budgetary sacrifices will show up, sometimes dramatically, on screen.

Velvet Goldmine looks as if it cost three times what it did. We

put as much on the screen as possible, meaning the money didn't go into things like a trailer for Todd Haynes and me. We had an astonishingly inventive production designer in Christopher Hobbs. This is what I mean by inventive: For another movie, *Cold Lazarus,* he used a miniature for an important exterior, and he needed to come up with a way to make smoke come out of the chimney without looking stupid. (Dinky wisps of chimney smoke is one way you can recognize a miniature.) He ended up immersing the whole thing in a water tank and squirting a mixture of milk and ink through the chimney. It looked sensational. For *Velvet Goldmine* he built a grand ballroom with a series of flats. He said, "Don't worry. The way I'll arrange them, they won't look like flats."

They look like the walls of a—slightly surreal—grand ballroom.

RATES OF PASSAGE

One way to deal with a low budget is to have parity across the board. All the heads of the departments should get the same thing, no matter what the budget. Which means the costume designer is equal to the director of photography is equal to the production designer. On *Velvet Goldmine,* Peter King, the hair and makeup designer, also received a credit in the main titles. If they're central— as the designers were on *Velvet Goldmine*—I'll often give them back-end participation, which isn't noted in the budget itself. On a union shoot, the rates for the next level—the key grip, the electrician, and so on—are set. If it's nonunion, I like to go with parity again: The gaffer makes as much as the locations manager, and so on, level by level, down to the humblest PA.

Heads of departments don't come to me with budget proposals, I go to them. To each I say, "You have x amount." That x is a lowball figure, based on the assumption that they're going to go over budget no matter how much I give them and that it's better to keep something in reserve. Often they come back and announce, "It's too little, I can't do it," whereupon we sit down with their estimates and figure out what we can give up to make it all fit. We did that all the time on *Velvet Goldmine,* with its incredibly extravagant sets and incredibly shrinking budget. We had to go back a hundred times and say, "What else can we squeeze out of this?"

Scheduling should be done before you finish your budget. It's

tricky, because at that stage you have no idea about the availability of either actors or locations. So you concoct a best-case scenario, combining scenes that make sense—beginning, obviously, with the ones at the same location. You should always start with exteriors, because if the weather isn't to your liking, you'll have room in the schedule to push those days somewhere else.

I believe firmly in the five-day work week. That gives you and everyone else a full day in bed to recover. Then you have another day to address the most urgent problems of the last week before new ones arise to compete for your attention. If you decide to shoot for six days, be prepared to accomplish only five and a half days' worth of work. Be prepared to have crew members who come to resemble the supporting cast of *Night of the Living Dead,* only nastier. And what happens in an emergency, when you're over schedule and need to add a day? Go to a seventh? Even God needed a day off.

Six-day weeks can be a good idea on location, though, especially in small towns where there's nothing else for people to do except get drunk or get into trouble. There's another consideration: A four-week shoot—meaning four six-day weeks—makes a nice round number, and one which sounds appealing to busy actors and cinematographers. "Four weeks, I can knock that off," they'll say to themselves, whereas six or seven starts to sound like a commitment.

When you're scheduling, how do you determine how long it will take to get a sequence in the can? It's a hard call, even if you've scheduled fifty films. Some directors are faster than others (although what makes them faster is a little intangible). Sometimes a complicated dramatic scene will be simple to shoot because it needs only two or three camera set-ups. On the other hand, the more dialogue and the more emotionally demanding the material, the greater the odds that the actors will need a lot of takes to get it right. You also have to ask: How long will it take to get your equipment to a location? How long to light it? How many shots will cover the action? Can you shoot facing one side of the room first, so that you don't need to spend as much time moving lights around?

You're always adjusting on the fly, which is one reason producing can drive you insane. Budgeting isn't accounting; it's too elastic. One of your most vexing dilemmas will be where to stay firm and where to be flexible. You're not dealing with data processors but with artists, the best of whom are frequently (and inherently) unstable. Then

there are the vagaries of weather, location, and technology. If x and y are both variables, then z sure as hell won't be a constant. On *Happiness,* we scheduled two or three scenes per day, each consisting of seven or eight shots. The director averaged ten shots a day. Do the math: It wasn't working, and we were falling further and further behind. Either we had to schedule more days, compress the remaining scenes into fewer shots, or find a way to light the shots more quickly and do fewer takes. Informing a director that he or she has to make those kinds of choices is no one's idea of a good time.

It's awful to tell directors that they can't have what they want. Ideally, directors should be complicit in the budgeting, so that you don't have to intone from on high: "YOU CAN HAVE A CRANE. YOU CAN'T HAVE AN EXTRA DAY." Try to make the director understand what all those numbers mean. Some will get it faster than others. Some won't *want* to get it. When we had to cut the budget on Todd Solondz's film, we examined the sequence set in Florida, searched our souls, and said to Todd: "We can go to Florida or we can shoot for thirty-five days. Which would you rather do?" He said, "Both." I said, "I know. But you can't do both at this lower budget." Todd began to make peculiar noises of indecision: "Nnnn, nnnn, nhhh . . . " Finally he said, "Well, I guess I'd rather shoot for thirty-five days."

Actually, we ended up going to Florida anyway. So much for complicity.

The tension between Todd Solondz and me was not unhealthy: It's natural for a director to put his or her vision first. I've never had a truly adversarial relationship with a director, *and I encourage you to avoid one.* Directors I work with know—or I hope they know—that my sole purpose in life is not to keep costs down. My sole purpose in life is to get them what they want with the resources we have. Often that means helping them decide where they'd rather put the money: "What's more important," I'll ask. "More extras for this scene, a more elaborate set, or more shooting time?" Sometimes we'll have differences of opinion. But generally speaking, if it's a visual extravaganza like *Velvet Goldmine,* you pour your money into costumes, the art department, and hair and makeup. On an intricate drama like Todd Solondz's, you put it into extra shooting time for long, intense dialogue scenes. Low-budget horror films sink most of what they have into creatures, special effects, and splatter.

If the director says, "I need twelve mermaids with chainsaws dancing in a fountain," what I usually say is, "Let me see what I can do." Then I go to the line producer, who's in charge of the daily administration of the budget, and we look at the numbers to see if the request is feasible. One of the most difficult professional relationships I've had was with a line producer whose chief loyalty was to the bond company and the financiers, rather than to me and the movie. I would say, "We're going to need a hundred more extras than we thought," and the line producer would say, "*Really!* And *how* do you propose to *pay* for them?" A more helpful response would be: "Gee, that's tough. Let's have a look at the budget and see if we can figure something out." Then I could go back to the director and say, "Okay, we've come up with enough for fifty more extras. Can we spread them out so that they look like a hundred?" Or: "We can get you a hundred if you don't mind losing fifty off this other location." No cut is painless; the trick is to avoid slicing into a major artery.

UNION DUES

One of the central questions you have to ask when you sit down to construct a budget is whether you're going to use a union cast and crew. In the chapter on actors I'll discuss the Screen Actors Guild (SAG): Whether or not to use SAG talent is the first big budgeting decision you'll make. As for the crew, the difference in union and nonunion wages isn't huge. The real expense is Health, Pension and Welfare (HP&W), which *is* huge, at this writing around sixty dollars per day per union crew member. The upside is access to more experienced and professional technicians. If you can afford it, the advantages of a union crew far outweigh the monetary and bureaucratic headaches.

In New York, the union has been extremely successful at organizing, and it gets harder and harder to put together a decent nonunion crew. Some producers try to sneak a few union people into their movies—but remember, film shoots are not exactly inconspicuous. If you try that, be prepared for a union member to drive by your trucks one day and phone headquarters. Be prepared for a phone call, a visit, and a lot of bad blood.

When we made *Kids*, my coproducer, Lauren Zalaznick, and I sat

down with the union to explain that we were making a very risky movie and didn't have the budget to use them. It didn't go well, and we parted on ominous terms. Fortunately, we left the script behind, which proved to be a genius move, because it came back with a note that said it was so gross and vile that they didn't want their name on it. You can only go to the well so many times, however. The New York union is cracking down on movies that cost more than two million. Todd Solondz's film just squeaked under, and I doubt I'll do too many more nonunion shoots, at least in New York.

Teamsters, the guys who drive your equipment trucks, earn a lot of money—four or five times the rate you'd pay someone else, and they get *very* big fringes. Not all states have them, and producers often travel to so-called "right-to-work" states like North Carolina to be able to hire anyone they please. But if there are Teamsters in your neck of the woods, you should use them, unless your budget is really, really tiny—and even then you should call and tell them what you're doing. Otherwise, a driver could go by, see your truck, and before you know it there'll be three big guys on your set saying, "So: What's going on?" If you've got even a little money, they're going to insist that you hire a couple of their members. There's no rule of thumb about how many Teamsters for how many millions of dollars. On a small film, you usually have two to four. If it's peak season (in New York, summer and fall) and most of the Teamsters are working, you can get away with fewer.

Early in my career, I worked for a producer who tried to break the Teamsters. This is not a strategy for the faint of heart. Or even the strong of heart. Because in the old days, the Teamsters would fuck you *joyfully*. On that producer's film, in the middle of every take, firecrackers would explode, horns blast, and lights go on and off in surrounding buildings. When I say that he was run out of town, it's no hyperbole. He now makes films in Russia.

I'm interested in making a lot of movies, so I don't want to piss anybody off. The reward for my cooperation is that the Teamsters are usually quite reasonable. Better than that, they're good. It's scary to have nineteen- and twenty-year-old kids driving grip trucks. You see the little head above the steering wheel and it's like Michael Dukakis in a tank—surreal. You can't help but cringe. Accidents are a fact of life on a film set. Everyone's tired, they're driving mammoth vehicles they're not used to, and they crash them. The presence of

Teamsters saves you a lot of angst. They're responsible, and driving big stuff is what they do.

I think a new breed of Teamsters has emerged over the years. Many Teamsters are interested in filmmaking and they want to be a part of the family. We had a Teamster on one film that actually acted as a mediator between the grip and the electric departments (they were not getting along and hated sharing the truck). Often sharing the experience and wisdom of your Teamster can help your shoot in ways you would never expect.

FACTS—AND MYTHS—AND FIGURES

When I sat down to make a budget for my first feature, *Poison*, I'd produced eight short films and done a lot of assistant directing. I had a sense of how it would work, although in places—such as anything to do with costumes—my underbudgeting was almost comical. The heads of departments were paid a ludicrously low sum, maybe three hundred dollars a week. We shot the film in 16 millimeter, later blown up to 35mm after the movie found a distributor. The cinematographer, Maryse Alberti, who would go on to shoot *Velvet Goldmine* and Todd Solondz's film, owned a 16mm camera package, for which we paid her a nominal fee. Then we rented tiny grip and electric packages, all of which fit into one truck driven by an eighteen-year-old making a hundred bucks a week. We were all virgins. Maryse had never shot a feature. The gaffer had never gaffed a feature. The grip had never gripped a feature. But everyone was wild to take the plunge.

Although we ended up with a good-looking film for about $350,000 (including postproduction and blowup to 35mm), I don't think I'll share with you the *Poison* numbers—they're too fly-by-night to use as a model.

But it would be useful to go item by item through a medium-low—two million dollar—budget, and then two smaller, alternative budgets. Let's call our hypothetical feature *Jacked*. The producers are Steve Holworthy and Tony Bastamento, and the director is Jason Spielwitz.

Steve and Jason meet on an indie shoot in Greenwich Village, a "quirky" thriller-comedy called *Dead Tired*. Steve, who went to Yale, is the craft service PA (although he really wants to produce) and

Jason, who went to NYU Film School, is the parking PA (although he really wants to direct). The two become drinking buddies, agree during one late-night bacchanal that NEIL YOUNG RULES, MAN, HE ROCKS! and decide to form "TWO STRAIGHT WHITE GUYS PRODUCTIONS" with a little seed money from Steve's dad and the interest on an inheritance from Jason's grandmother.

Jason has four scripts that he's juggling, any one of which he knows will get optioned in a second if the right people read it. So Steve gets busy calling his contacts: Eddie from Yale is now an assistant to the script collator at New Line, and Yasmine from Choate is a clerk in the office of "Weird Al" Yankovic's lawyer. Steve pitches while Jason hones his vision.

The pair plop down $700 plus $1000 in promotional expenses to take their most polished script, *College is Over: Now What?*, to the Independent Feature Film Market. It doesn't get picked up, but Steve and Jason make lots of contacts, all of them young, would-be filmmakers like themselves. They go drinking with Tony, who's at the IFFM to pass out leaflets for a movie he worked on called *Queens DOA*. Tony comes from Howard Beach, Queens, and has, he informs his new buddies, "a past." Impressed, Steve and Jason decide that Tony would give their company an "edge" that it lacks, and invite him to be a partner in what will now be known as "THREE STRAIGHT WHITE GUYS PRODUCTIONS."

Tony encourages Jason to put *College is Over: Now What?* aside— at least until he has a couple of hits under his belt—and write something that will sell. And so Jason writes *Jacked* while Steve and Tony prepare a budget to go with the package.

Briefly, *Jacked* is a romantic comedy with thriller elements about a poetic, working-class Queens guy named Vinnie who longs to be a dancer but must work all day as a clown at children's birthday parties in the suburbs. The neighborhood kids make fun of him, his parents think he's "odd" and possibly light in the loafers, and his working-class buddies (Tommy, Jose, and Nick) just "don't understand." Vinnie falls hard for a woman in his dance class, Lucy, who turns out to be a lesbian with a butch lover, Micki. When Vinnie learns that the lesbians want to have a baby and have contracted with a sperm bank, he and his pals break into the facility and swap Vinnie's sperm with sperm marked for Lucy. (NB: Very funny scene with Vinnie desperately trying to ejaculate into a test tube as the cops are closing in.) In the end, Micki gets killed in a drive-by

shooting (the bullet was meant for Tommy); Lucy decides she loves Vinnie after all, which is a good thing since she is having his baby; and Micki's life insurance policy allows Vinnie to stop clowning around and pursue his dream of being a dancer. He and Lucy marry; name their son "Mickey"; and in the heartwarming last shot, pose with their baby's beaming godfathers: Tommy, Jose, and Nick.

The budget is attached as part of a package for potential investors, who like its combination of urban edginess and feel-good romance. That, plus the casting of a major cop-show star and a leading soap ingenue, is enough to give THREE STRAIGHT WHITE GUYS PRODUCTIONS its big shot.

BUDGET
JACKED/$2.5 Million

Producer: Stephen Hollworthy, Tony Bastamento	35 Days/ (5) day-weeks	
Director: Jason Spielwitz	Shoot September 25, 1997	
Location: NY	AVID edit/10 weeks pic	
	4 weeks sound	
	SAG/ IBT Local 4613	
	Non Union Crew	

Acct #	Category Title	Page	Original	Current	Variance
1000	STORY & RIGHTS	48	0	0	0
1100	DEV., CONT. & TREATMENT	48	0	63,245	63,245
1200	PRODUCER	48	0	65,000	65,000
1300	DIRECTOR	49	0	20,250	20,250
1400	CAST	49	0	160,850	160,850
1500	ATL TRAVEL & LIVING	52	0	23,823	23,823
	Total Fringes		**0**	**43,372**	**43,372**
	Total Above-The-Line		**0**	**376,540**	**376,540**
2000	PRODUCTION STAFF	53	0	190,482	190,482
2100	EXTRAS	54	0	38,585	38,585
2200	SET DESIGN	55	0	45,565	45,565
2300	SET CONSTRUCTION/ SCENIC LABOR	55	0	4,160	4,160
2400	SET CONSTRUCTION EXPENSE	56	0	5,450	5,450
2500	SET OPERATIONS	56	0	61,918	61,918
2700	SET DRESSING STAFF	57	0	36,735	36,735
2700	SET DRESSING EXPENSES	58	0	20,000	20,000
2800	PROPERTY STAFF	58	0	17,685	17,685
2800	PROPERTY EXPENSE	58	0	10,350	10,350

Acct #	Category Title	Page	Original	Current	Variance
2900	WARDROBE DEPT. STAFF	59	0	30,676	30,676
2900	WARDROBE EXPENSES	59	0	13,220	13,220
3000	SPECIAL EFFECTS	60	0	1,270	1,270
3100	MAKE-UP & HAIRDRESSING STAFF	60	0	22,940	22,940
3100	MAKE-UP & HAIR EXPENSE	60	0	1,700	1,700
3200	ELECTRICAL DEPT. STAFF	60	0	33,233	33,233
3200	ELECTRICAL DEPT. EXPENSE	61	0	59,009	59,009
3300	CAMERA DEPT. STAFF	61	0	50,989	50,989
3300	CAMERA SET OPERATIONS	62	0	55,905	55,905
3400	SOUND DEPT. STAFF	63	0	15,896	15,896
3400	SOUND DEPT. EXPENSE	63	0	14,280	14,280
3500	TRANSPORTATION LABOR	64	0	68,555	68,555
3500	VEHICLE RENTAL AND COSTS	64	0	98,813	98,813
3600	LOCATION EXPENSES	68	0	165,085	165,085
3700	SPECIAL EQUIPMENT	69	0	2,000	2,000
3800	FILM & LAB	69	0	147,973	147,973
3900	TESTS	70	0	800	800
4100	UPSTATE UNIT TRAVEL & LIVING	70	0	55,796	55,796
	Total Fringes		**0**	**120,539**	**120,539**
	Total Production		**0**	**1,389,609**	**1,389,609**
5000	EDITORIAL LABOR	70	0	75,925	75,925
5100	EDITING EQUIPMENT	71	0	32,953	32,953
5200	POST PRODUCTION SOUND	72	0	125,061	125,061
5300	POST PRODUCTION LAB	73	0	25,738	25,738
5400	MUSIC	73	0	50,000	50,000
6000	DELIVERABLES	74	0	38,316	38,316
6100	SALES & PUBLICITY	74	0	300	300
6200	MISCELLANEOUS	74	0	3,250	3,250
6300	INSURANCE & TAXES	74	0	33,072	33,072
6400	GENERAL EXPENSE	74	0	93,850	93,850
	Total Fringes		**0**	**9,777**	**9,777**
	Total Post Production		**0**	**488,242**	**488,242**
	Total Below-The-Line		**0**	**1,877,851**	**1,877,851**
	Total Above and Below-The-Line		**0**	**2,254,391**	**2,254,391**
	Contingency 10%		**0**	**225,439**	**225,439**
	Completion Bond	2.5%	**0**	**55,255**	**55,255**
	Grand Total		**0**	**2,535,085**	**2,535,085**

JACKED

Producer: Stephen Holworthy, Tony Bastamento
Director: Jason Spielwitz
Location: NY

35 Days/ (5) day-weeks
Shoot September 25, 1997
AVID edit/10 weeks pic
4 weeks sound
SAG/ IBT Local 4613
Non Union Crew

Acct #	Description	Amount	Units	X	Rate	Subtotal	Total
1000	STORY & RIGHTS						
1000-10	SCRIPT PURCHASE						0
					Total For 1000		**0**
1100	DEV., CONT. & TREATMENT						
1100-1	WRITER'S FEES	1	Fee		60,750	60,750	60,750
1100-3	PHOTOCOPIES SCRIPT COPIES	110	p	150	0.03	495	495
1100-20	RESEARCHERS: CLEARANCE REPORT		allow		2,000	2,000	2,000
1100-30	DEVELOPMENT COSTS						0
	ENTERTAINMENT		allow				
	ADMINISTRATIVE		allow				
	OFFICE EXPENSE		allow				
	BUDGET & BOARD		allow				0
					Total for 1100		**63,345**
1200	PRODUCER						
1200-10	PRODUCER #1 STEPHEN HOLWORTHY		Allow	0.01	2,500,000	25,000	
	ADDITIONAL 1% DEFERRED						25,000
1200-20	PRODUCER #2 TONY BASTAMENTO		allow	0.01	2,500,000	25,000	
	DEFERRED ADDITIONAL 1%						25,000
1200-30	ASSISTANT TO PRODUCER #1						
	PREP	6	Weeks		500	3,000	
	SHOOT	7	Weeks		500	3,500	
	WRAP	2	Weeks		500	1,000	7,500

Acct #	Description	Amount	Units	X	Rate	Subtotal	Total
1200-31	ASSISTANT TO PRODUCER #2						
	PREP	6	Weeks		500	3,000	
	SHOOT	7	Weeks		500	3,500	
	WRAP	2	Weeks		500	1,000	7,500
					Total for 1200		**65,000**
1300	DIRECTOR						
1300-01	DIRECTOR	1			20,250	20,250	20,250
1300-30	ASSISTANT TO DIRECTOR						0
					Total For 1300		**20,250**
1400	CAST						
1400-0.1	LUCY						
	REHEARSAL	1	Week		1,972	1,972	
	SHOOT	4	Weeks	1.35	1,972	10,649	
	HOLD		Weeks		1,972		12,621
1400-0.2	PTOLOMY (Co-worker)						
	SHOOT	2	Days	1.50	559	1,677	1,677
1400-0.3	TOMMY						
	REHEARSAL	1	Week		1,972	1,972	
	SHOOT	3	Weeks	1.35	1,972	7,987	
	HOLD - NO OT	1	Week		1,972	1,972	11,931
1400-0.4	MICKI						
	REHEARSAL	1	Week		1,972	1,972	
	SHOOT	2	Weeks	1.35	1,972	5,324	7,296
1400-0.5	VINNIE						
	REHEARSAL	1	Week		1,972	1,972	
	SHOOT	6	Weeks	1.35	1,972	15,973	17,945
1400-0.6	DINO (Vinnie's brother)						
	REHEARSAL	1	Week		1,972	1,972	
	SHOOT	3	Weeks	1.35	1,972	7,987	
	HOLD - NO OT		Weeks		1,972		9,959
1400-0.7	JUNE (Vinnie's sister)						
	SAG EXTRA	3	Weeks		1,000	3,000	
	NO OT						3,000
1400-0.8	HORTENSE (Vinnie's cousin)						
	SHOOT	3	Weeks		1,972	5,916	
	NO OT/CHILD LABOR LAWS						
	HOLD - NO OT		Weeks		1,972		5,916
1400-0.9	BIRTHDAY BOY'S MOM						
	SHOOT	1	Day	1.50	559	839	839

Acct #	Description	Amount	Units	X	Rate	Subtotal	Total
1400-1.0	PETEY Q						
	REHEARSAL	3	Days		559	1,677	
	SHOOT	15	Days		559	8,385	
	NO OT/CHILD LABOR LAWS						
	HOLD		Weeks		1,972		10,062
1400-1.1	CONNIE (dance teacher)						
	SHOOT	1	Week	1.35	1,972	2,662	2,662
1400-1.2	JOSE						
	REHEARSAL	3	Days		559	1,677	
	SHOOT	5	Days	2	559	5,590	7,267
1400-1.3	NICK						
	REHEARSAL	3	Days		559	1,677	
	SHOOT	5	Days	2	559	5,590	7,267
1400-1.4	CHUBBY MOE						
	SHOOT	1	Day	1.50	559	839	839
1400-1.5	RAFFELLI						
	SHOOT	1	Day	1.50	559	839	839
1400-1.6	IRATE DRIVER						
	SHOOT	1	Day	1.50	559	839	839
1400-1.7	DEBBIE						
	SHOOT	1	Day	1.50	559	839	839
1400-1.8	RAMONA						
	SHOOT	1	Day	1.50	559	839	839
1400-1.9	BIRTHDAY BOY						
	SHOOT	1	Day		559	559	
	NO OT/CHILD LABOR LAWS						559
1400-2.0	TINY TIM						
	REHEARSAL	2	Days		559	1,118	
	SHOOT	1	Week		1,972	1,972	
	NO OT/CHILD LABOR LAWS						3,090
1400-2.1	LISPING GANGSTER						
	SHOOT	1	Day	1.50	559	839	839
1400-2.2	STUTTERING GANGSTER						
	SHOOT	1	Day	1.50	559	839	839
1400-2.3	OFFICER PADDY O'SULLIVAN						
	SHOOT	1	Day	1.50	559	839	839
1400-2.4	RABBI SHLOMO BERNSTEIN						
	SHOOT	1	Day	1.50	559	839	839

Acct #	Description	Amount	Units	X	Rate	Subtotal	Total
1400-2.5	MOHAMMED						
	SHOOT	1	Day	1.50	559	839	839
1400-2.6	TALL						
	PROSTITUTE						
	SHOOT	1	Day	1.50	559	839	839
1400-2.7	WILMA						
	SHOOT	1	Day	1.50	559	839	839
1400-2.8	ENTHUSIASTIC SPERM						
	DONOR						
	SHOOT	1	Day	1.50	559	839	839
1400-2.9	ALFREDO (Vinnie's						
	Dad)						
	REHEARSAL	2	Days		559	1,118	
	SHOOT	2	Weeks	1.35	1,972	5,324	6,442
1400-3.0	SPERM BANK						
	DOCTOR						
	SHOOT	2	Days	1.50	559	1,677	1,677
1400-3.1	SPERM BANK						
	NURSE						
	SHOOT	2	Days	1.50	559	1,677	1,677
1400-3.2	VAL (Dancer)						
	SHOOT	1	Day	1.50	559	839	839
1400-3.3	HOIEZ						
	SHOOT	1	Day	1.50	559	839	839
1400-3.5	MADGE (Vinnie's						
	Mom)						
	SHOOT	2	Days	1.50	559	1,677	1,677
1400-3.6	FRIENDLY						
	PROCTOLOGIST						
	SHOOT	1	Day	1.50	559	839	839
1400-3.7	SURLY PROCTOLOGIST						
	SHOOT	1	Day	1.50	559	839	839
1400-3.8	AL THE BARTENDER						
	SHOOT	1	Day	1.50	559	839	839
1400-3.9	FLORIST						
	SHOOT	1	Day	1.50	559	839	839
1400-4.0	LABOR DAY						0
	HOLIDAY PAY						
1400-4.1	SAG TRAVEL						0
	DAYS						
1420	AGENT'S FEES		allow	0.10	130,000	13,000	13,000
1421	TURNAROUND						0
	PENALTIES						
1460	HOLDOVERS						0
1423	ADR	5	Days		559	2,795	2,795
	ALLOWANCE						

Acct #	Description	Amount	Units	X	Rate	Subtotal	Total
1430	INSURANCE EXAMS	5	exams		75	375	375
1450	CASTING DIRECTOR FRINGED		Allow		10,000	10,000	10,000
1452	CASTING ASSISTANT	7	Weeks		400	2,800	2,800
1452	MISC. CASTING EXPENSES						
1453	PHONES, SUP-PLIES, ETC.		allow		475	475	475
1453	CASTING OFFICE						0
1454	CASTING OFFICE TELEPHONE	3	mnths		300	900	900
1455	AUDITION SPACE						0
1456	REHEARSAL SPACE	2	Weeks		250	500	500
1460	LA CASTING ASSISTANT		allow		500	500	500
					Total For 1400		**160,850**
1500	ATL TRAVEL & LIVING						
1505	CASTING (Producer/Director)						
	HOTEL/CAR RENTAL	1	trips	4	150	600	
	HOTEL OCCUPANCY TAX		Allow	0.193	2,400	463	
	PER DIEM	1	pd	4	75	300	
	AIR FARE	1	trips		1,000	1,000	2,363
1510	REHEARSAL & PREP-CAST 1 WEEK REHEARSAL FOR VINNIE/LUCY						
	HOTEL	2	princ.	7	225	3,150	
	HOTEL TAX		allow	0.193	3,150	608	
	PER DIEM/WEEK	2	pd		375	750	
	AIRFARE LA-NY-LA	2	princ.		2,500	5,000	9,508
1520	SHOOT & WRAP-CAST						
	APARTMENT	2	apt	1.50	2,500	7,500	
	PER DIEM	2	princ	42	53	4,452	11,952
					Total For 1500		**23,823**
1999	**Total Fringes**						**43,372**

Acct #	Description	Amount	Units	X	Rate	Subtotal	Total
	Total Above-The-Line						**376,540**
2000	PRODUCTION STAFF						
2000-1	LINE PRODUCER/UPM						
	PREP	8	Weeks		1,400	11,200	
	SHOOT	7	Weeks		1,400	9,800	
	WRAP	2	Weeks		1,400	2,800	23,800
2000-2	UNIT MANAGER						
	PREP	6	weeks		875	5,250	
	SHOOT	35	Days		175	6,125	
	WRAP	1	Week		875	875	12,250
2000-4	LOCATION MANAGER						
	PREP	8	Weeks		1,200	9,600	
	SHOOT	35	Days		240	8,400	
	WRAP						18,000
2000-5	ASSIST. LOCATION MANAGER						
	PREP	5.20	Weeks		875	4,550	
	SHOOT	35	Days		175	6,125	
	WRAP	3	Days		175	525	11,200
2000-6	1ST AD						
	PREP	4	Weeks		1,125	4,500	
	SHOOT	35	Days		225	7,875	12,375
2000-7	2ND AD						
	PREP	2	Weeks		875	1,750	
	SHOOT	35	Days		175	6,125	7,875
2000-8	2ND 2ND AD						
	PREP	0.40	Weeks		625	250	
	SHOOT	35	Days		125	4,375	4,625
2000-9	POC						
	PREP	6	Weeks		875	5,250	
	SHOOT	35	Days		175	6,125	
	WRAP	2	Weeks		875	1,750	13,125
2000-10	PRODUCTION SECRETARY/APOC						
	PREP	4	Weeks		400	1,600	
	SHOOT	35	Days		80	2,800	
	WRAP	2	Weeks		400	800	5,200
2000-11	SCRIPT SUPER-VISOR						
	PREP	0.50	Weeks		1,125	563	
	SHOOT	35	Days		225	7,875	
	WRAP		Weeks				
	OT	1		0.10	8,438	844	9,282
2000-13	PRODUCTION ACCOUNTANT						
	PREP	6	Weeks		1,125	6,750	

Acct #	Description	Amount	Units	X	Rate	Subtotal	Total
	SHOOT	7	Weeks		1,125	7,875	
	WRAP	2	Weeks		1,125	2,250	16,875
2000-14	ASSISTANT ACCOUNTANT						
	PREP	3	Weeks		750	2,250	
	SHOOT	7	Weeks		750	5,250	
	WRAP	2	Weeks		750	1,500	9,000
2000-15	POST ACCOUNTANT	16	Weeks		300	4,800	4,800
2000-20	OFFICE PA						
	PREP	5	Weeks		375	1,875	
	SHOOT	35	Days		75	2,625	
	WRAP	2	Weeks		375	750	5,250
2000-21	KEY PA						
	PREP	1	Day		75	75	
	SHOOT	35	Days		75	2,625	2,700
2000-22	SET PAS						
	PREP	1	Day	4	75	300	
	SHOOT	35	Days	4	75	10,500	
	WRAP	1	Day	4	75	300	11,100
2000-23	LOCATIONS PA						
	PREP	1	Week		375	375	
	SHOOT	35	Days		75	2,625	3,000
2000-24	PARKING PAS	3	men	43	75	9,675	9,675
2000-25	EXTRA PAS	10	Days		80	800	800
2000-26	PARKING COORDINATOR	30	Days		150	4,500	4,500
2000-27	SCOUTS						
	SCOUT #1	6	Weeks		625	3,750	3,750
2000-99	HP&W						0
	SCRIPT SUPERVISOR	40	Days		0	0	
	POC	15	Weeks	5	0	0	0
					Total For 2000		**190,482**
2100	EXTRAS						
2150	EXTRAS						
		175	mndays	1.50	99	25,988	
	COSTUME ADJUSTMENT		allow		500	500	26,488
2160	NON-SAG EXTRAS	50	mndays		50	2,500	2,500
2165	STAND-INS						0
2170	STUNT COORDINATOR						0
2175	TUTOR	1	tutor	10	150	1,500	1,500

Acct #	Description	Amount	Units	X	Rate	Subtotal	Total
2176	EXTRAS CASTING PERCENTAGE FEE		Allow	0.10	54,465	5,447	5,447
2180	ANIMALS						
	POOPSIE	3	Days		150	450	
	DOG HANDLER	3	Days		150	450	900
2182	ATMOSPHERE CARS		allow		750	750	750
2184	ADJUSTMENT FOR EXTRAS		allow	0.05	20,000	1,000	1,000
					Total for 2100		**38,585**
2200	SET DESIGN						
2200-01	PRODUCTION DESIGNER						
	PREP	7	Weeks		1,600	11,200	
	SHOOT	35	Days		360	12,600	
	OT		allow	0.10	23,800	2,380	26,180
2200-02	ART DIRECTOR/ COORDINATOR						
	PREP	6	Weeks		750	4,500	
	SHOOT	35	Days		150	5,250	
	WRAP	4	Days		150	600	
	OT		allow	0.10	10,350	1,035	
	KIT RENTAL	7	Weeks		100	700	12,085
2200-03	ART PA						
	PREP	5	Weeks		400	2,000	
	SHOOT	35	Days		80	2,800	4,800
2200-06	MATERIALS/ SUPPLIES/ GRAPHICS		allow		2,500	2,500	2,500
2200-99	HP&W						0
	PROD. DESIGNER	65	Days		0	0	
	ART DIRECTOR	65	Days		0	0	0
					Total For 2200		**45,565**
2300	SET CONSTRUCTION/SCENIC LABOR						
2300-30	SCENICS						
	SHOOT		allow		560	560	560
2300-31	CONSTRUCTION	9	mndays		200	1,800	1,800
2300-33	ADDITIONAL LABOR	9	mndays		200	1,800	1,800
2300-99	HP&W						0

Acct #	Description	Amount	Units	X	Rate	Subtotal	Total
	CONSTRUC-TION COORDINATOR	5	Days		0	0	
	SCENIC ARTIST	20	Days		0	0	
	SCENIC DAY LABOR	7	Days		0	0	0
					Total For 2300		**4,160**
2400	SET CONSTRUCTION EXPENSE						
2400-01	SCENIC/ CONTRUCTION MATERIALS		allow		1,000	1,000	1,000
2400-02	RESTORATION		allow		3,750	3,750	3,750
2400-03	CARTAGE		allow		700	700	700
					Total For 2400		**5,450**
2500	SET OPERATIONS						
2500-01	KEY GRIP						
	PREP	4	Days		225	900	
	SHOOT	35	Days		225	7,875	
	WRAP	1	Day		225	225	
	OT		allow	0.10	9,000	900	
	KIT RENTAL	7	Weeks		100	700	10,600
2500-02	DOLLY GRIP						
	PREP	1	Day		175	175	
	SHOOT	35	Days		175	6125	
	WRAP	1	Day		175	175	
	OT		allow	0.10	6,475	648	7,123
2500-03	BEST BOY GRIP						
	PREP	2	Days		175	350	
	SHOOT	35	Days		175	6,125	
	WRAP	1	Day		175	175	
	OT		allow	0.10	6,650	665	7,315
2500-04	SET OP GRIP						
	PREP	2	Days		150	300	
	SHOOT	35	Days		150	5,250	
	WRAP	1	Day		150	150	
	OT		allow	0.10	5,700	570	6,270
2500-05	EXTRA LABOR						
		10	Days		150	1,500	
	OT		allow	0.10	1,500	150	1,650
2500-06	CRANE OPERATORS						0
2500-11	GRIP EQUIPMENT						
	GRIP EQUIP INCL. TRUCK	7	Weeks		2,000	14,000	

Acct #	Description	Amount	Units	X	Rate	Subtotal	Total
	CAR RIG RENTAL	3	Days		400	1,200	
	CONDOR		Days				
	SCAFFOLDING	1	Month		1,000	1,000	
	GRIP EQUIPMENT PURCHASE	35	Days		50	1,750	
	EXPENDABLES	35	Days		50	1,750	
	M&D (From Contingency)						19,700
2500-21	CRAFT SERVICE SUPPLIES	35	Days		30	1,050	1,050
2500-22	CRAFT SERVICE KIT		allow		500	500	500
2500-25	UNIT SUPPLIES						
	TABLES AND CHAIRS INCL. IN CATERING DEAL		Allow		1,500	1,500	
							1,500
2500-35	FIRST AID PURCHASE		allow		500	500	500
2500-50	MISC. LABOR						0
2500-55	CRAFT SERVICE						
	PREP	1	Day		80	80	
	SHOOT	35	Days		80	2,800	
	WRAP	1	Day		80	80	2,960
2500-60	WATCHMEN	20	mndays		125	2,500	2,500
2500-70	NURSE	2	Days		125	250	250
2500-99	HP&W						0
	KEY GRIP	40	Days		0	0	
	DOLLY GRIP	37	Days		0	0	
	BEST BOY GRIP	38	Days		0	0	
	SET OP GRIP	37	Days		0	0	
	EXTRA LABOR	15	Days		0	0	
	CRANE OPERATORS	2	Days		0	0	0
					Total For 2500		**61,918**
2700	SET DRESSING STAFF						
2700-01	SET DIRECTOR						
	PREP	4	Weeks		1,100	4,400	
	SHOOT	35	Days		220	7,700	
	WRAP	4	Days		220	880	
	OT		allow	0.10	12,980	1,298	14,278
2700-02	LEAD PERSON						
	PREP	4	Weeks		750	3,000	
	SHOOT	35	Days		150	5,250	

Acct #	Description	Amount	Units	X	Rate	Subtotal	Total
	WRAP	4	Days		150	600	
	OT		allow	0.10	8,850	885	
	KIT RENTAL	11.80	weeks		50	590	10,325
2700-03	SET DRESSER #1						
	PREP	3	Weeks		600	1,800	
	SHOOT	35	Days		120	4,200	
	WRAP	3	Days		120	360	
	OT		allow	0.20	6,360	1,272	7,632
2700-04	SET DRESSER #2						
	PREP	2	Weeks		500	1,000	
	SHOOT	35	Days		100	3,500	4,500
2700-99	HP&W						0
	SET DECORATOR	60	Days		0	0	
	LEAD PERSON	50	Days		0	0	
	SET DRESSERS	42	Days	2	0	0	0
					Total For 2700		**36,735**
2700	SET DRESSING EXPENSES						
2700-50	SET DRESSING EXPENSES		allow		16,500	16,500	16,500
2700-51	ADDITIONAL RENTALS		allow		3,500	3,500	3,500
2700-84	M&D						0
					Total For 2700		**20,000**
2800	PROPERTY STAFF						
2800-01	HEAD PROPS						
	PREP	3	Weeks		900	2,700	
	SHOOT	35	Days		225	7,875	
	WRAP	3	Days		175	525	
	OT		Allow	0.10	11,100	1,110	
	KIT RENTAL	7	Weeks		75	525	12,735
2800-02	2ND PROPS						
	PREP	2	Weeks		500	1,000	
	SHOOT	35	Days		100	3,500	
	OT		allow	0.10	4,500	450	4,950
2800-03	ADDITIONAL LABOR		Days				0
2800-99	HP&W						0
	HEAD PROPS	45	Days		0	0	
	2ND PROPS	55	Days		0	0	0
					Total For 2800		**17,685**
2800	PROPERTY EXPENSE						
2800-50	PROP EXPENSES		allow		4,000	4,000	4000
2800-55	VIDEO PLAYBACK	1	Day		1,000	1,000	1,000

Acct #	Description	Amount	Units	X	Rate	Subtotal	Total
2800-60	PICTURE VEHICLES		allow		5,000	5,000	5,000
2800-85	EXPENDABLES	35	Days		10	350	350
					Total For 2800		**10,350**
2900	WARDROBE DEPT. STAFF						
2900-01	COSTUME DESIGNER						
	PREP	4	Weeks		1,125	4,500	
	SHOOT	35	Days		225	7,875	
	OT		allow	0.10	12,375	1,238	
	KIT RENTAL	7	Weeks		100	700	14,313
2900-02	ASSISTANT DESIGNER						
	PREP	2	Weeks		700	1,400	
	SHOOT	35	Days		140	4,900	
	WRAP	1	Week		700	700	
	OT		allow	0.10	7,000	700	7,700
2900-03	WARDROBE SUPERVISOR						
	PREP	1	Week		875	875	
	SHOOT	35	Days		175	6,125	
	WRAP	1	Week		875	875	
	OT		allow	0.10	7,875	788	8,663
2900-05	ADDITIONAL LABOR	5	Days		0	0	0
2900-99	HP&W						0
	COSTUME DESIGNER	12	Weeks			0	0
	WARDROBE SUPERVISOR	45	Days		0	0	
	COSTUMER	45	Days		0	0	0
					Total For 2900		**30,676**
2900	WARDROBE EXPENSES						
2900-20	WARDROBE PURCHASES	90	costume		92	8,280	8,280
2900-30	WARDROBE RENTALS	90	Costume		30	2,700	2,700
2900-40	WARDROBE MAINTENANCE	35	Days		20	700	700
2900-45	WARDROBE ALTERATION	20	costume		25	500	500
2900-46	WARDROBE CLEANING	130	costume		8	1,040	1,040
2900-50	MISSING & DAMAGED		allow				0
					Total for 2900		**13,220**

Acct #	Description	Amount	Units	X	Rate	Subtotal	Total
3000	SPECIAL EFFECTS						
3000-01	HEAD SPFX						
		2	Days		350	700	
	OT		allow	0.10	700	70	770
3000-20	SFX PURCHASE		allow		500	500	500
					Total For 3000		**1,270**
3100	MAKE-UP & HAIRDRESSING STAFF						
3100-01	HEAD MU						
	PREP	1	Day		225	225	
	SHOOT	35	Days		225	7,875	
	OT		allow	0.20	8,100	1,620	
	KIT RENTAL	7	Weeks		100	700	10,420
3100-02	HAIR STYLIST						
	PREP	1	Day		225	225	
	SHOOT	35	Days		225	7,875	
	OT		allow	0.20	8,100	1,620	
	KIT RENTAL	7	Weeks		100	700	10,420
3100-03	ASSIST. MAKE-UP						
		10	Days		175	1750	
	OT		allow	0.20	1,750	350	2,100
3100-99	HP&W						0
	KEY HAIR	31	Days		0	0	
	KEY MAKE UP	31	Days		0	0	
	ASSIST MU	10	Days		0	0	0
					Total For 3100		**22,940**
3100	MAKE-UP & HAIR EXPENSE						
3100-20	MAKE-UP PURCHASE		allow		700	700	700
3100-30	HAIR/WIG PURCHASE		allow		1,000	1,000	1,000
					Total For 3100		**1,700**
3200	ELECTRICAL DEPT. STAFF						
3200-01	GAFFER						
	PREP	4	Days		225	900	
	SHOOT	35	Days		225	7,875	
	WRAP	1	Day		225	225	
	OT		allow	0.10	9,000	900	
	KIT RENTAL	7	Weeks		100	700	10,600
3200-02	BEST BOY						
	PREP	2	Days		175	350	
	SHOOT	35	Days		175	6,125	
	WRAP	1	Day		175	175	
	OT		allow	0.10	6,650	665	7,315
3200-03	3RD ELECTRIC						
	PREP	2	Days		150	300	

Acct #	Description	Amount	Units	X	Rate	Subtotal	Total
	SHOOT	35	Days		150	5,250	
	WRAP	1	Day		150	150	
	OT		allow	0.10	5,700	570	6,270
3200-04	GENNY OPERATOR						
	PREP	1	Day		175	175	
	SHOOT	35	Days		175	6,125	
	WRAP	1	Day		175	175	
	OT		allow	0.10	6,475	648	7,123
3200-05	ADDTL LABOR						
		10	Days		175	1,750	
	OT		allow	0.10	1,750	175	1,925
3200-99	HP&W						0
	GAFFER	40	Days		0	0	
	BEST BOY	37	Days		0	0	
	THIRD ELECTRIC	38	Days		0	0	
	GENNY OP	37	Days		0	0	
	EXTRA LABOR	10	Days		0	0	0
3200	ELECTRICAL DEPT. EXPENSE						
3200-20	ELECTRIC PACKAGE (INCL. TRUCK)	7	Weeks		5,000	35,000	35,000
3200-30	ELECTRICAL EQUIPMENT PURCHASE		allow		4,000	4,000	4,000
3200-35	BULB PURCHASE		allow		750	750	750
3200-55	GENERATOR RENTAL (INCL. TRUCK)	7	Weeks		1,750	12,250	12,250
3200-60	GENERATOR GAS & OIL	35	Days		50	1,750	1,750
3200-65	GEL PURCHASE	35	Days		125	4,375	4,375
3200-70	EXPENDABLES	35	Days		25.25	884	884
3200-80	M&D						0
	Total For 3200						**59,009**
3300	CAMERA DEPT. STAFF						
3300-01	DIRECTOR OF PHOTOGRAPHY						
	PREP	4	Weeks		1,600	6,400	
	SHOOT	35	Days		360	12,600	
	OT		allow	0.10	19,000	1,900	20,900
3300-02	CAMERA OPERATOR						0
3300-03	STEADICAM OPERATOR						

Acct #	Description	Amount	Units	X	Rate	Subtotal	Total
		1	Day		280	280	
	OT		allow	0.10	280	28	308
3300-04	1ST ASSISTANT						
	PREP	4	Days		225	900	
	SHOOT	35	Days		225	7,875	
	WRAP	1	Day		225	225	
	OT		allow	0.10	9,000	900	
	KIT RENTAL	7	Weeks		100	700	10,600
3300-05	2ND ASSISTANT						
	PREP	4	Days		175	700	
	SHOOT	35	Days		175	6,125	
	WRAP	1	Day		175	175	
	OT		allow	0.10	7,000	700	7,700
3300-06	1ST AC/ STEADICAM						
		1	Day		175	175	
	OT		allow	0.10	175	18	193
3300-07	CAMERA PA	35	Days		75	2,625	2,625
3300-08	STILLS PHOTOGRAPHER						
		35	Days		225	7,875	
	OT		allow	0.10	7,875	788	8,663
3300-99	HP&W						0
	DP	55	Days		0	0	
	OPERATOR	35	Days		0	0	
	STEADICAM	2	Days		0	0	
	1ST AC	40	Days		0	0	
	2ND AC	40	Days		0	0	
	1ST AC STEADICAM	2	Days		0	0	
	CAM PA	35	Days		0	0	
	STILL PHOT.	35	Days		0	0	0
					Total For 3300		**50,989**
3300	CAMERA SET OPERATIONS						
3300-20	CAMERA EQUIP- MENT RENTAL	7	weeks		5,000	35,000	35,000
3300-25	ADDITIONAL CAMERA RENTAL	35	Days		100	3,500	3,500
3300-26	CAMERA DOLLY RENTAL	35	Days		150	5,250	5,250
3300-27	DOLLY TRACK RENTAL	35	Days		100	3,500	3,500
3300-28	STEADICAM RENTAL	1	Day		1,000	1,000	1,000
3300-29	CAMERA CAR RENTAL	3	Days		1,000	3,000	3,000

Acct #	Description	Amount	Units	X	Rate	Subtotal	Total
3300-30	CAMERA CAR DRIVER (TEAMSTER)						
		3	Days		386	1,158	
	OT		allow	0.30	1,158	347	1,505
3300-31	CAMERA CRANE RENTAL		allow		1,750	1,750	1,750
3300-40	CAMERA EQUIP-MENT PURCHASE	35	Days		20	700	700
3300-45	CAMERA EXPENDABLE PURCHASE	35	Days		20	700	700
3300-50	STILL EQUIP. PURCHASE						0
3300-60	VIDEO INTERLOCK						0
3300-71	M&D DEDUCTIBLE						0
					Total For 3300		**55,905**
3400	SOUND DEPT. STAFF						
3400-01	MIXER						
	PREP	2	Days		225	450	
	SHOOT	35	Days		225	7,875	
	OT		allow	0.10	8,325	833	9,158
3400-02	BOOM OPERATOR						
	PREP		Days		175		
	SHOOT	35	Days		175	6,125	
	OT		allow	0.10	6,125	613	6,738
3400-99	HP&W						0
	MIXER	39	Days		0	0	
	BOOM	37	Days		0	0	0
					Total For 3400		**15,896**
3400	SOUND DEPT. EXPENSE						
3400-20	SOUND RECORDER RENTAL	35	Days		200	7,000	7,000
3400-25	ADDITIONAL SOUND RENTAL	35	Days		25	875	875
3400-26	PLAYBACK EQUIPMENT						0
3400-30	SOUND EQUIP-MENT PURCHASE	35	Days		10	350	350

Acct #	Description	Amount	Units	X	Rate	Subtotal	Total
3400-40	WALKIE TALKIE RENTAL	35	Days	25	5	4,375	4,375
3400-55	BATTERIES/ STOCK	35	Days		33	1,155	1,155
3400-60	EXPENDABLES	35	Days		15	525	525
					Total For 3400		**14,280**
3500	TRANSPORTATION LABOR						
3500-01	TEAMSTER DRIVERS TEAMSTER CAPTAIN						
3500-01	PREP	4	Days		532	2,128	
	SHOOT	35	Days		532	18,620	
	WRAP	1	Day		532	532	
	OT		Allow	0.15	21,280	3,192	24,472
3500-02	GRIP TRUCK						
	PREP	2	Days		386	772	
	SHOOT	35	Days		386	13,510	
	WRAP	2	Days		386	772	
	OT		Allow	0.20	15,504	3,011	18,065
3500-03	ELECTRIC TRUCK						
	PREP	2	Days		386	772	
	SHOOT	35	Days		386	13,510	
	WRAP	1	Day		386	386	
	OT		allow	0.20	14,668	2,934	17,602
3500-04	ADDITIONAL TEAMSTER DRIVERS	5	Days		386	1,930	
	OT		allow	0.20	1,930	386	2,316
	TEAMSTER MEAL MONEY	120	Days		20	2,400	64,855
3500-02	NON TEAMSTER DRIVERS WARDROBE/ PROP						
	PREP	0.20	Weeks		500	100	
	SHOOT	35	Weeks		100	3,500	
	WRAP	0.20	Weeks		500	100	3,700
					Total For 3500		**68,555**
3500	VEHICLE RENTAL AND COSTS						
3500-10	VEHICLE RENTALS						
3500-01	AD CAR	7	Weeks		211	1,477	
3500-02	PRODUCER CAR	7	Weeks		211	1,477	

Acct #	Description	Amount	Units	X	Rate	Subtotal	Total
3500-03	DIRECTOR CAR	7	Weeks		211	1,477	
3500-04	UPM CAR	7	Weeks		211	1,477	
3500-05	PRODUCTION OFFICE CAR	14	Weeks		211	2,954	
3500-06	LOCATIONS CAR						
	PREP	7.20	Weeks		211	1,519	
	SHOOT	7	Weeks		211	1,477	2,996
3500-07	ASSIST. LOCATIONS CAR						
	PREP	5	weeks		211	1,055	
	SHOOT	7	weeks		211	1,477	2,532
3500-08	SCOUT CAR	6	Weeks		211	1,266	
3500-09	PRODUCTION MINI VAN	7	Weeks		308	2,156	
3500-10	ART DEPT. VAN						
	PREP	2.50	Weeks		308	770	
	SHOOT	7	Weeks		308	2,156	
	WRAP	0.50	Weeks		308	154	3080
3500-11	PROD. DESIGNER CAR	5	Weeks		211	1,055	
3500-12	SET DRESSING CUBE	5	Weeks		500	2,500	
3500-13	PROP CUBE	7.40	Weeks		500	3,700	
3500-14	COSTUME CUBE	7.40	Weeks		500	3,700	
3500-15	COSTUME DESIGNER CAR						
	PREP	1	Week		211	211	
	SHOOT	7	Weeks		211	1,477	
	WRAP	1	Week		211	211	1,899
3500-16	15 PASS VAN #1	7	Weeks		432	3,024	
3500-17, 18	15 PASS VAN #2 AND #3	3	Weeks	2	432	2,592	
3500-19	UNIT LOCATIONS VAN						
	PREP	1	Week		308	308	
	SHOOT	7	Weeks		308	2,156	
	WRAP	1	Week		308	308	2,772
3500-20	CRAFT SERVICE VAN	7.40	Weeks		308	2,279	44,413
3500-20	TRUCK RENTALS						
3500-01	CAMERA TRUCK	7.40	Weeks		1,000	7,400	
3500-02	SET DRESSING TRUCK	7.40	Weeks		700	5,180	12,580

Acct #	Description	Amount	Units	X	Rate	Subtotal	Total
3500-27	WINNEBAGO RENTAL						0
3500-30	CAR ALLOWANCE	7	Weeks		200	1,400	1,400
3500-32	TAXIS/PRE-PRODUCTION	7	Weeks		750	5,250	5,250
3500-33	TAXIS/PRODUCTION		allow		4,250	4,250	4,250
3500-34	CAR SERVICE/AIRPORT	10	trips		60	600	600
3500-35	SUBWAYS/PREP	6	Weeks	5	15	450	450
3500-36	SUBWAYS/PROD.	7	Weeks	10	15	1,050	1,050
3500-40	PARKING/PROD	6	trucks	42	35	8,820	8,820
3500-42	PARKING TICKETS		allow		1,000	1,000	1,000
3500-45	REPAIRS AND MAINTENANCE		allow		1,000	1,000	1,000
3500-46	TRUCK OUTFIT		allow		500	500	500
3500-50	TOLLS		allow		2,100	2,100	2,100
3500-60	VEHICLE GAS AND OIL						
	TRUCK AND CARS		allow		15,000	15,000	15,000
3500-70	MISCELLANEOUS		allow		400	400	400
					Total For 3500		**98,913**
3600	LOCATION EXPENSES						
3600-01	LOCATION MEALS	60	heads	35	14	29,400	29,400
3600-02	OFFSET/OFFICE MEALS	15	heads	35	7	3,675	3,675
3600-03	SECOND MEALS	10	Days		300	3,000	3,000
3600-04	CRAFT SERVICE	65	heads	35	3	6,825	6,825
3600-05	EXTRAS MEALS	175	mndays		13	2,275	2,275
3600-10	SITE RENTALS						
	DOM'S RESTAURANT	2	Days		1,500	3,000	
	EXT. ROADS STREETS	1	Day		1,500	1,500	
	VINNIE'S PLACE	5	Days		750	3,750	
	BIRTHDAY HOUSE	1	Day		500	500	
	DANCE TEACHER'S OFFICE	1	Day		500	500	

Acct #	Description	Amount	Units	X	Rate	Subtotal	Total
	GYMNASIUM	3	Days		700	2,100	
	DANCE STUDIO	4	Days		500	2,000	
	ALFREDO & MADGE'S HOUSE	8	Days		1,500	12,000	
	EXT. BASKEBALL COURT	2	Days		750	1,500	
	SPERM OFFICE	1	Day		500	500	
	VINNIE'S CAR EXT.	1	Day		275	275	
	2ND BIRTHDAY HOUSE	1	Day		350	350	
	BROTHEL	1	Day		750	750	
	LUCY AND MICKI'S HOUSE	5	Days		500	2,500	
	BALLET CRITIC'S HOUSE	1	Day		500	500	
	AL'S BAR	1	Day		500	500	
	SPERM CLINIC	2	Days		1,000	2,000	
	CLOWN SCHOOL	7	Days		1,500	10,500	
	RESTAURANT	1	Day		1,000	1,000	
	COMEDY CLUB	2	Days		750	1,500	
	LIQUOR STORE	1	Day		500	500	
	LONG ISLAND ESTATE	1	Day		500	500	
	DELIVERY ROOM	1	Day		500	500	
	DANCE CONSERVATORY	1	Day		1,000	1,000	
	HOSPITAL	1	Day		1,000	1,000	
	PRISON	1	Day		500	500	
	EXT. CEMETERY	1	Day		750	750	
	BAR/RESTAURANT	1	Day		500	500	
	BOWLING ALLEY	2	Days		500	1,000	
	BRONX ZOO	1	Day		1,500	1,500	
	DOCTOR'S OFFICE	1	Day		500	500	
	SAPPHO SOCIETY	2	Days		500	1,000	
	SUBWAY TRAIN	1	Day		1,500	1,500	
	BENSONHURST SUBWAY STOP	1	Day		350	350	
	BENSONHURST STREETS	1	Day		250	250	
	JOSE'S SEEDY BUILDING	2	Days		350	700	

Acct #	Description	Amount	Units	X	Rate	Subtotal	Total
	INT. SUBWAY STATION	1	Day		500	500	59,775
3600-40	HOLDING AREAS	35	Days		250	8,750	8,750
3600-44	OFFICE ELECTRIC						
	NY OFFICE	5	mnths		400	2,000	
	UPSTATE OFFICE		allow		400	400	2,400
3600-45	LOCATION OFFICE RENT						
	NY OFFICE	4	months		1,675	6,700	6,700
3600-51	ART DEPT. STORAGE/ OFFICE	3.50	months		1,000	3,500	3,500
3600-52	WARDROBE SPACE	6	weeks		225	1,350	1,350
3600-53	PHOTOCOPIES						
	COPY MACHINE	5	months		800	4,000	
	ON-SET COPIES	1	month		500	500	4,500
3600-54	FURNITURE	5	months		0	0	0
3600-55	COMPUTERS						
	COMPUTERS	3	months	2	200	1,200	
	LASER PRINTERS	3	months		150	450	1,650
3600-56	TYPEWRITERS	4	months		40	160	160
3600-57	FAX MACHINE		allow		400	400	400
3600-58	TELEPHONE						
	PREP	2	months		1,500	3,000	
	SHOOT	3	months		1,500	4,500	
	TELEPHONE UNIT RENTALS	5	months	15	50	3,750	11,250
3600-59	OFFICE SUPPLIES	3	months		1,000	3,000	3,000
3600-60	SHIPPING & POSTAGE						
	OFFICE/FILM/ EQUIPMENT		allow		3,000	3,000	
	FLORIDA SHIPPING		allow		2,000	2,000	5,000
3600-61	AIR CONDITIONING						
	OFFICE		allow		2,000	2,000	
	SET		allow		3,000	3,000	5,000

Acct #	Description	Amount	Units	X	Rate	Subtotal	Total
3600-62	LOCATION PHOTOS	180	rolls		25	4,500	4,500
3600-67	GRATUITIES/ SCOUTING EXPENSES	35	Days		25	875	875
3600-68	BEEPERS	10	beepers	5	22	1,100	1,100
					Total For 3600		**165,085**
3700	SPECIAL EQUIPMENT						
3700-02	RAIN MACHINE	1	Day		2,000	2,000	2,000
					Total For 3700		**2,000**
3800	FILM & LAB						
3800-01	NEGATIVE ACTION RAWSTOCK 4,200 FEET PER DAY	4,200	feet	35	0.54	79,380	79,380
3800-05	SOUND STOCK DAT STOCK	35	Days		25	875	875
3800-10	DEVELOP FILM NEGATIVE	150,000	feet	0.95	0.15	21,375	21,375
3800-11	PRINT FILM NEGATIVE	150,000	feet	0.10	0.25	3,750	3,750
3800-30	VIDEO TRANS- FER WITH TC & BURN-IN VIDEO DAILIES FROM WORKPRINT TIME CODE, FLEXFILE AND SYNCING 4:1 RATIO SYNC FROM LOCATION DAT 4200 FEET PER DAY 45 MINUTES PER DAY	35	Days	3.50	275	33,688	33,688
3800-34	TRANSFER ¾" VIDEO STOCK	70	tapes		15	1,050	1,050
3800-45	DAT BACKUP STOCK	40	tapes		12	480	480
3800-46	DAT BACKUP TRANSFER	40	hours		50	2,000	2,000

Acct #	Description	Amount	Units	X	Rate	Subtotal	Total
3800-50	STILL FILM PROCESS	35	Days	5	25	4,375	4,375
3800-60	POLAROID		allow		1,000	1,000	1,000
3800-70	PREP NEGATIVE FOR MATCHBACK						0
					Total For 3800		**147,973**
3900	TESTS						
3900	TESTS						
3901	CAMERA TEST		allow		400	400	
3902	MAKE-UP TEST		allow		400	400	800
					Total For 3900		**800**
4100	UPSTATE UNIT TRAVEL & LIVING						
4100-01	UPSTATE LOCA-TION SCOUT						
	HOTEL	4	people	3	65	780	
	HOTEL TAX		allow	0.193	780	151	
	PER DIEM	4	pd	4	53	848	
	MINIVAN	4	Days		100	400	2,179
4100-10	CAST/ PRODUCER/ DIRECTOR TRAVEL						
	CAST	9	princ.	9	100	8,100	
	DIRECTOR	1	person	9	75	675	
	PRODUCER	1	person	9	75	675	
	HOTEL TAX		allow	0.193	9,450	1,824	
	PER DIEM	11	pd	10	53	5,830	17,104
4100-30	CREW HOTEL						
	HOTEL	40	crew	7	65	18,200	
	HOTEL TAX		allow	0.193	18,200	3,513	21,713
4100-32	CREW PER DIEM	40	crew	8	40	12,800	12,800
4100-33	MISCELLANEOUS		allow		2,000	2,000	2,000
					Total For 4100		**55,796**
	Total Fringes						**120,539**
	Total Production						**1,389,609**
5000	EDITORIAL LABOR						
5000-01	EDITOR						
	EDITOR ON THROUGH PIC-TURE CUT	90	Days		240	31,600	
	OT		allow	0.10	21,600	0	21,600
5000-02	ASSISTANT EDITOR						
		90	Days		175	15,750	
	OT		allow	0.10	15,750	0	15,750

Acct #	Description	Amount	Units	X	Rate	Subtotal	Total
5000-03	APPRENTICE EDITOR						0
5000-06	MUSIC EDITOR	20	Days		250	5,000	5,000
5000-07	MUSIC WORKSTATION	4	Weeks		1,250	5,000	5,000
5000-08	FILM CONFORM EDITOR						0
		4	Weeks		0	0	
	OT		allow	0.10	0	0	0
5000-10	POST SUPERVISOR						
	PICTURE CUT	10	Weeks		875	8,750	
	SOUND EDIT	4	Weeks		875	3,500	
	MIX	2	Weeks		875	1,750	
	DELIVERY	5	Weeks		875	4,375	18,375
5000-21	FINAL CUT NEG-ATIVE MATCHING	12	reels		850	10,200	10,200
5000-99	HP&W	60	hrs	7.75	0	0	0
					Total For 5000		**75,925**
5100	EDITING EQUIPMENT						
5100-10	AVID RENTAL	18	Weeks		925	16,650	16,650
5100-11	AVID MEMORY	21	Weeks		190	3,990	3,990
5100-20	EDIT ROOM SUPPLIES		allow		1,200	1,200	1,200
5100-21	AVID ROOM RENTAL	20	Weeks		250	5,000	5,000
5100-22	EDIT ROOM ELECTRIC	17	Weeks		50	850	850
5100-23	EDIT ROOM PHONE	17	Weeks		50	850	850
5100-34	FLOPPY DISCS		allow		300	300	300
5100-40	SCREENINGS	3	scrns	2	200	1,200	1,200
5100-44	FILM SET UP						0
5100-45	FLATBED						0
5100-46	FILM ROOM						0
5100-47	BINS REWINDS, ETC.						0
5100-48	EDGE CODING MACHINE						0
5100-49	CORES, REELS, CARRYING CASES	3	mnths		150	450	450
5100-50	POST SHIPPING	4	mnths		350	1,400	1,400
5100-60	MEALS						0

Acct #	Description	Amount	Units	X	Rate	Subtotal	Total
5100-65	OTHER CHARGES	4.25	mnths		100	425	425
5100-67	POST XEROX	4.25	mnths		150	638	638
					Total For 5100		**32,953**
5200	POST PRODUCTION SOUND						
5200-01	SOUND PACKAGE EQUIP/LABOR		allow		50,000	50,000	50,000
5200-02	ADR						
	ADR FACILITY	36	hrs		250	9,000	
	DAT STOCK	36	DATS		20	720	9,720
5200-03	FOLEY						
	FOLEY FACILITY/ ARTISTS	36	hrs		250	9,000	
	FOLEY ARTIST	36	hrs		60	2,160	11,160
5200-09	TRANSFERS		allow		1,000	1,000	1,000
5200-10	TASCAM RENTAL/ LAYBACK	2	tascam	10	100	2,000	2,000
5200-11	1 LITE TRANSFER FOR MIX	8,910	feet		0.10	891	891
5200-12	MIX						
	MIX	90	hrs		250	22,500	
	DIGITAL MIX SURCHARGE	90	hrs		25	2,250	
	TASCAM STOCK	30	pieces		20	600	25,350
5200-13	FOREIGN MIX						
		8	hrs		250	2,000	
	DIGITAL MIX SURCHARGE	8	hrs		25	200	2,200
5200-14	ME MIX MATERI- ALS/XFERS						0
	SEE 5115						0
5200-15	DOLBY LICENSE		allow		8,100	8,100	8,100
5200-16	ADDITIONAL SOUND EQUIPMENT		allow		2,500	2,500	2,500
5200-20	OPTICAL TRK NEG	10	reels		375	3,750	3,750
5200-30	DIGITAL STOCK						
	STEMS	10	reels		250	2,500	
	PRINTMASTER	10	reels		250	2,500	
	M/E (on printmaster)	10	reels		250	2,500	7,500

Acct #	Description	Amount	Units	X	Rate	Subtotal	Total
5200-35	DAT STOCK/ PRINTMASTER	2	mixes	2	35	140	140
5200-37	STRIPE MAG FOR CONFORM	8,910	feet	2	0	0	0
5200-60	TRANSFER TIME	3	hrs	6	0	0	0
5200-70	STOCK SOUND LIBRARY						0
5200-90	MISC. EXPENSE		allow		750	750	750
					Total For 5200		**125,061**
5300	POST PRODUCTION LAB						
5300-02	LEADER, FILL						0
5300-03	REPRINTS	5,625	feet		0	0	0
5300-10	ANSWER PRINT	8,910	feet		0.72	6,415	6,415
5300-11	CORRECTED ANSWER PRINT	8,910	feet		0.30	2,673	2,673
5300-25	RELEASE PRINTS						0
5300-29	REELS, CASES, MOUNTINGS, ETC.	3	prints		150	450	450
5300-30	TITLES & OPTICALS						
	CREDITS/HEAD DESIGN		allow		3,000	3,000	
	HEAD CREDITS/ OPTICALS		allow		4,000	4,000	
	END CREDIT CRAWL		allow		2,000	2,000	
	OPTICALS	12	reels		400	4,800	13,800
5300-50	1 LITE VIDEO TRANSFERS	2	hrs		350	700	700
5300-54	¾" STOCK NTSC	2	cass.		40	80	80
5300-55	¾" STOCK PAL						0
5300-56	¾" DUBS	2	copies	2	30	120	120
5300-57	VHS DUBS	200	copies		2.50	500	500
5300-90	MISC. DUBS		allow		1,000	1,000	1,000
					Total For 5300		**25,738**
5400	MUSIC						
5400-01	MUSIC SUPERVISOR		allow		5,000	5,000	5,000
5400-03	COMPOSER		allow		15,000	15,000	15,000
5400-08	SYNCHRONIZA- TION LICENSES		allow		15,000	15,000	15,000

Acct #	Description	Amount	Units	X	Rate	Subtotal	Total
5400-10	MASTER USE LICENSES		allow		15,000	15,000	15,000
					Total For 5400		**50,000**
6000	DELIVERABLES						
6000-01	INTERPOSITIVE	8,910	feet		1.10	9,801	9,801
6000-10	INTERNEGATIVE	8,910	feet		1	8,910	8,910
6000-20	CHECK PRINT	8,910	feet		0.30	2,673	2,673
6000-22	MIX DUBS						
	MAG STOCK	8,910	feet	2	0.10	1,782	
	TRANSFER TIME	3	hours	2	225	1,350	3,132
6000-50	D2 PAL/NTSC MASTER		allow		10,000	10,000	10,000
6000-51	TEXTLESS IP		allow		1,750	1,750	1,750
6000-90	SPOTTED SCRIPT	10	reels		205	2,050	2,050
					Total For 6000		**38,316**
6100	SALES & PUBLICITY						
6100-07	PUBLICITY STILL LAB CHARGES						
	COLOR DUPES OF SLIDES	30	slides	2	2	120	
	B/W PRINTS	30	prints	2	3	180	300
					Total For 6100		**300**
6200	MISCELLANEOUS						
6200-05	BANK FEES		allow		500	500	500
6200-06	WRAP PARTY		allow		750	750	750
6200-08	CREW T SHIRT	200	shirts		10	2,000 0	2,000
					Total For 6200		**3,250**
6300	INSURANCE & TAXES						
6300-40	PAYROLL SERVICE FEE		allow		500	500	500
6300-50	INCORPORA-TION COSTS		allow		250	250	250
6300-70	PRODUCTION INSURANCE	1	fee		32,322	32,322	32,322
6300-72	E&O		allow				0
					Total For 6300		**33,072**
6400	GENERAL EXPENSE						
6400-06	FINAL AUDIT		allow		1,000	1,000	1,000
6400-07	ACCOUNTING SOFTWARE						0
6400-08	LEGAL FEES		allow	0.0075	2,500,000	18,750	18,750
6400-09	MUSIC LEGAL FEES		allow		7,500	7,500	

Acct #	Description	Amount	Units	X	Rate	Subtotal	Total
	DISBURSEMENTS		allow		500	500	8,000
6400-11	PRODUCERS OVERHEAD		allow	0.025	2,500,000	62,500	62,500
6400-13	POST OFFICE SUPPLIES		allow		600	600	600
6400-14	POST POSTAGE	4	months		100	400	400
6400-15	POST TELEPHONE						0
6400-16	POST SHIPPING		allow		1,000	1,000	1,000
6400-17	STORAGE	32	weeks		50	1,600	1,600
					Total For 6400		**93,850**
5999	**Total Fringes**						**9,777**
	Total Post Production						**488,242**
	Total Below-The-Line						**1,877,851**
	Total Above and Below-The-Line						**2,254,391**
6801	**Contingency 10%**						**225,439**
6901	**Completion Bond 2.5%**						**55,255**
	Grand Total						**2,535,085**

1000. Story and rights. This is Jason's original screenplay, which means zero for "rights" and zero for "story." Everything gets lumped into the next item, the writer's fee. They'd be separate sums, however, if Jason had based the script on a novel or an incident as chronicled in a non-fiction book, or if someone had assisted him in concocting a storyline.

1100-1. Writer's fees. The money for the script. The figure is low for a two-million dollar film, but since Jason is also the director, he splits his salary between the functions. The writer would usually get $60,000–125,000. Jason took less up front because he wanted more shooting days. He gets net points, though, which means that if the picture shows a profit, he'll get a (tiny) percentage of it.

1100-3. Script copies. People often ignore this expense, but unless you sneak into your day-job office after midnight and burn out the copy machine, it's considerable. Every actor needs a script, not to mention all your creative personnel. Not to mention the actors you're pursuing, the actors pursuing you, the agents and their agencies, the lawyers and the accountants. And, of course, those scripts often change, which means more copies and different colored pages to mark the revisions to each successive draft. You're always running

out of scripts and rushing off to the nearest copy shop—enough to make a copy-machine rental at least worth considering. By the way, we try to keep track of our scripts. But once something's out of your hands, you don't know who can get ahold of it or how widely it will be circulated. Stanley Kubrick, I've heard, sends pages of his scripts in sealed pouches to whoever needs to see them, then takes them back once they've been read.

1100-20. Clearance report. This is where a law firm goes through a script and red-flags items. "Don't say 'Budweiser' here," they'll tell you. "Say 'beer' or 'brewski,' or else make up a name." Or, if your script has a child murderer named Fenster who's a cake baker in Mamaroneck, they'll make sure that there isn't a cake baker named Fenster in Mamaroneck or anywhere near Mamaroneck, because that could get you sued. You often need clearance for insurance purposes. We write "allow" because we're not sure what the exact figure will be, but we don't want to spend more than two thousand.

1100-30. Development Costs. Nothing is allowed for development because the production company didn't have to option any material. Some producers will use this item to cover their costs if they've worked on a script for a long time, organized readings, taken people out to dinner, sent researchers to do interviews, or made a lot of long-distance phone calls.

1200. Producer fees. On a two million dollar budget a producer usually makes around $75,000–125,000, or a lot less if he or she wants to take a payment on the back end. As I've said, back-end agreements are never in the budget, so you couldn't look at the figures for *Star Wars* and tell that Alec Guinness made millions on his net points. It's just as well, because, Sir Alec excepted, net points rarely pay. It's in the distributor's interest *never* to show a profit— always to tack on its overhead or sundry prints and advertising costs. I've taken a lot of back-end points in lieu of a salary and tell myself over and over that I have to stop making a habit of it. Five hundred a week is a decent salary for the producers' assistants, and I make them work for it.

1300. Director. Directors' salaries can be all over the map, too, but will generally range from $50,000 to $100,000 for a budget at

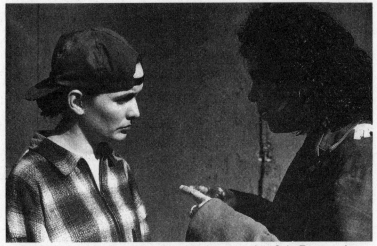

Rose took a chance with her friend and screenwriter Guin Turner, who was fabulous in the role of Max.

this level. Since Jason wrote the script, the overall payment is divided between writing and directing. They didn't budget for an assistant in the hopes that they could find an intern to do it for nothing. In Hollywood, needless to say, directors can have as many as three well-paid assistants and countless gofers.

1400. Cast. This section covers your actors. The fee they receive on a film of this size is scale plus ten—meaning SAG scale plus ten percent. That ten percent covers their agents' fees (for convenience, a separate item on the budget). As for rehearsal in the weeks before production, you pay for it just as you pay for shooting. Some directors don't like to rehearse (even on the set) because they think it detracts from the spontaneity of the performances. And if it's a particularly emotional or physically risky scene, you don't want to put the actor through it too many times. On a low-budget movie, however, where film stock is a big percentage of your budget, it makes sense to run a scene a few times and work out the kinks, rather than waste a lot of celluloid before it's set.

1400. Overtime. We budget a lot of overtime, thirty-five percent over the actual fees. You need it. When an actor works for more than eight hours, he or she gets time-and-a-half. After ten hours,

that jumps to double-time. The exceptions, as you can see, are children, who are protected by child labor laws and are not allowed to work overtime at all. If you call an actor less than twelve hours after he or she has finished work, it's called a "forced call," and you have to cough up a penalty in cash. It's also worth mentioning day rates versus weekly rates: If you bump actors up to a weekly rate, you can get more hours out of them per day—but, of course, you have to pay them for the week and they have to stay on a weekly rate for the rest of the shoot. What isn't specifically cited in the budget is the cost of **consecutive employment,** which means that if you hire somebody for the first week and want them to come back again for the last week, you have to pay them for the whole time in between. In the low-budget SAG agreement, consecutive employment is waived so that the actors can be added and dropped, which is a *huge* saving.

1423. ADR Allowance. This is when you have to bring actors back to do additional dialogue recording and looping. They get a full day's rate, even though they're just sitting in the studio reading their lines to their image. Needless to say, if they're out-of-town hires you have to be prepared to fly them in—first-class—and put them up.

1430. Insurance exams. Often you have your top leads insured, so if anything happens to them, you're covered. (Think of River Phoenix, whose death shut down a movie and cost the insurers millions.) Unless someone is deemed an "essential element"—whose departure would end production, and who is therefore subjected to much closer medical scrutiny—the exam costs around seventy-five dollars and tends to be perfunctory. An actor goes to one of several doctors. The doctor says, "You feel okay?" The actor says, "Yeah, okay, fine." And the doctor says, "Next." It's usually not a big deal, unless the actor has a bad reputation, is really old, or has pinpoint pupils and the shakes. For *Jacked*, exams are needed for the director, the male and female leads, and the lesbian lover (an actress who spent time at the Betty Ford Clinic after a drunk-driving arrest).

1450. Casting. For *Jacked*, there's no separate casting office—the casting director worked out of the producers' offices. To audition people, they were also able to use a nearby church basement, for which they tithed. The telephone figure covers calls to agents and

actors. If you're in New York and you're calling LA or vice versa, it can add up to a lot of money. How were these figures arrived at? They multiplied the number of roles times the number of agencies in other cities, divided by two, and added 143. Just kidding. They guessed. If you're in New York or LA and you want to use actors based elsewhere, a casting assistant for the other coast is a must. This is the person who'll put the actors you can't audition in the flesh on tape. If you like them, you can fly out to meet them or get them to fly to you. For *Jacked,* the producers sent the casting director to LA for a week to read actors for all the leads.

1500. ATL travel and living. This is where you put the money if you want the actors to come to you. On *Jacked,* the producers flew the leads (first class, per SAG directive) from LA to New York and rented them apartments. Even though several other actors flew from LA to be in the movie, the leads were deemed the only out-of-town hires. Everyone else agreed to be considered "local." The leads were given a fixed, SAG-mandated per diem.

1999. Fringes. This sum is hefty because you don't cover health and welfare for individual actors; instead, you pay SAG a high percentage—13.1—of their salaries, which the union puts into its general welfare fund. (This means that if an actor is paid $5,000.00 for the shoot, you pay SAG $665.00.) You also pay a standard 16.1 percent of their and everyone else's salaries to your **payroll service.** The payroll service is, on this film, the employer of record, in charge of issuing checks to all employees and paying taxes to the government. It's very complicated. On big budget movies, there's usually a full-time person handling payroll fringes.

2000-1. Line Producer. I'll discuss the line producer in the section on "Crewing Up," but it's worth saying here that he or she does a lot of the below-the-line hiring. "Below the line" is everything that isn't the cast, the director, the writer, or the producers—i.e., the crew, the equipment, the stock, etc. So if you don't take the job yourself, you need to have the person in place as early as possible. Prep is preproduction, which here is eight weeks. By the way, the actual seven-week schedule—35 days at five days a week—is relatively relaxed, although *Jacked* often went to six days and tacked a few more days on the end. Two weeks is standard for overseeing

the wrap—the return of equipment, restoration of locations, and lots of paperwork.

2000-2. Unit manager. Overseen by the line producer, the unit manager looks after the crew's needs on a day-to-day basis: "We need an extra Kino Flow for tomorrow!" "This dolly has to go back!" "We're running low on film stock!" "Truck number three has a flat tire!" The unit manager has six weeks of prep, usually doing the vehicle and equipment deals.

2000-4. Location manager. An important job, which I'll discuss at length in "Crewing Up." On a movie like this, eight weeks prep is short, because there are close to sixty locations. The location manager both finds the locations and manages them. Location managers often have their own cars. Killer Films allows them to claim gas and toll expenses. Some people pay them for mileage, but on a film at the level of *Jacked* that's unusual: Driving around is their job. We don't cover meals on the road, either, unless they have to spend the night somewhere.

2000-5. Assistant location manager. A location manager needs an assistant, frequently two. Assistants do preliminary scouting on their own, and also make appointments and do research while the location manager is out and about. Once production begins, the location manager manages the location while the assistant is off preparing the next location—which, of course, is not just where you shoot, but where you eat, park, and put the dressing rooms. (Often when we shoot in a small house, the actors' holding area is at a house next door or down the block. You pay for that, obviously.)

2000-6. First assistant director. The heartbeat—and, sometimes, the heartburn—of the set. See "Crewing Up" for the full description of the jobs of First and Second AD.

2000-9. POC. Production office coordinator. Manages the office. Never comes to the set. The APOC is his or her assistant.

2000-13. Production accountant. Your lifeline to the budget. See "Crewing Up."

2000-15. Post accountant. Someone needs to keep track of post-production expenses, but this isn't a full-time job. You can gather that from the figures: During the shoot, the production accountant is paid $1,125, while the post accountant makes a modest $300.

2000-20 to 2000-25. Production assistants. One in the office, four or five on the set, and more to handle days with lots of extras or a big exterior location. These kids often drive, too. Each is paid a little so that they take getting up in the morning seriously. An experienced PA can make a big difference, but on a budget like this you're not going to be able to afford too many.

2000-24, 2000-26. Parking PAs and parking coordinator. An utterly miserable job. This is the poor soul who has to guard parking spots the night before so that your trucks have someplace to sit. It helps to be fierce-looking and have nerves of steel because people in cities get upset when they can't park in their own neighborhoods. On *Jacked,* the parking coordinator was an unpaid intern, who occasionally got in shouting matches with the locals.

2000-99. HP&W. Health Pension and Welfare. You'll see this all over the budget with zeroes attached to it, because this is a non-union film.

2100. Extras. If you're SAG you have to use SAG extras and pay them a standard fee (at this writing a shade over one hundred dollars) per day, with overtime after eight hours. There are also additional fees for everything from night shots to working in (smoke-machine) smoke. And they eat a lot. The exception to the SAG rule on *Jacked* was for child extras, because it's hard to find a lot of kids in SAG. If you're a non-SAG film and have no money, it's possible to collar your friends, family, crew, and anyone who takes your fancy to occupy space at a party or restaurant or street scene. Sometimes SAG will waive a day on ultra-low-budget films, so that you can bring in anyone you want, but the rules really do change all the time. SAG meets and makes up new ones *constantly*.

2150. Costume adjustment. What you have to pay if an extra wears his or her own clothes. There's a whole list of things you have to pay extras for, all of which are mandated by SAG.

The prison gang from *Poison*: non-SAG extras all!

2160. Non-SAG Extras. As mentioned above, you might be allowed a few non-SAG extras, especially if they're kids.

2165. Stand-ins. You use them so that your actors don't have to stand around for hours while you adjust your lights. There are two on *Jacked*. SAG rules say you have to use them and to pay them a little more than extras. You're not allowed to use a PA as a stand-in, although lots of low-budget movies do. It's your call. But, remember, you can expect frequent, unannounced visits/inspections from local SAG representatives, and if they catch you using PAs as stand-ins they'll make you stop and they will fine you. If your budget is really low, you might prevail upon an actor to stand in for him/herself. That doesn't bother SAG. They only care if you're taking work away from actors.

2170. Stunt coordinator. They didn't use one on *Jacked,* but it's a significant cost on a film with more action. Typically, a stunt coordinator would be paid $500–600 a day (it's SAG-directed), but you can cut individual deals depending on the kinds of stunts. Actors often want to do their own stunts, but most of the time your insurance company will put the kibosh on that. In *Velvet Goldmine,* Ewan MacGregor's character leaps off the stage into the crowd, and Ewan

wanted to leap himself. Todd Haynes wanted Ewan to leap, too, so he could put the camera underneath him and shoot it in one continuous take. I was nervous. The solution was to have two stunt guys in the crowd to catch him when he jumped. It worked beautifully. On the other hand, in *Stonewall* we had some stunt guys in the crowd for the riot, one of them dressed as a drag queen. It looked so ludicrous that we changed the scene. Stuntmen are usually buff and don't look like anything except stuntmen.

2175. Tutor. Kids who miss school to appear in a film require on-set tutoring. You don't need to provide those little chair–desks, but it's a good idea to give them a quiet place to work.

2176. Extras casting. The chief casting director generally does not handle extras, who pose different kinds of challenges. Instead, you hire someone solely to cast them. The good extras casting people have thousands of headshots and in another century would have moved cattle from Texas to Montana.

2180. Poopsie, the dog, and his handler. The producers used Poopsie for three days. Oddly, he and his handler made exactly the same amount of money. I hope Poopsie didn't spend it all in one place. You need a handler because animals will soak up your shooting time without one. In the United States, you have to have an American Humane Society representative on the set if a creature will be involved in anything remotely dangerous or if, as in *Kids,* a character is called upon to give it a good swift kick.

2182. Atmosphere cars. Cars that you have parked in the shot, also called background cars. Yes, you pay for them, unless you want to leave it to the fates. That's a recipe for continuity disaster, because you can't control when someone will drive a car away, and that red Toyota you see through the restaurant window in one shot will in the next be a green Range Rover.

2184. Adjustment for extras. For when an extra drives by in his or her own car. Yes, they get paid for that, too, on a SAG shoot.

2200-01, 2200-02. Production designer, art director. The functions are discussed in "Crewing Up." Notice here that your production designer

starts quite early, a week before the art director, who's the second-in-command. That's because the production designer needs at least that long to get things ready, and there's nothing for the art director to do until there are locations. In key creative positions, you usually have the top person start earlier to lay the groundwork.

2200-02. Kit rental. A nebulous item, used to compensate people who bring their own tools to the job—their computers, their makeup kits, etc.. On union films, it's a lot higher.

2200-06. Materials/Supplies/ Graphics. This is for everything your designers use to generate their designs. It's also for graphics that have to be created, such as posters, fake newspapers, and menus for fictional restaurants.

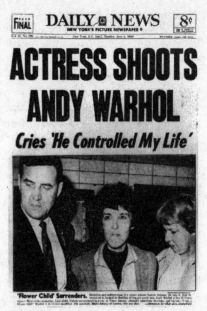

Therese DePrez, the production designer, used artifacts like this actual front page, to get a real texture of the time.

2300. Set construction, scenic labor. People who build and paint the sets. Construction means builders; scenics means painters. There wasn't a lot of construction on this movie, which was heavy on locations. Most of it was just paint and wallpaper for people's houses. Needless to say, you usually have to put it all back the way it was after you finish, even if what you did made it look better. "Scenic day labor" means people you bring in just for the day.

2400-01. Scenic/construction materials. Again, a low figure because they didn't need much scene work.

2400-03. Cartage. Taking away the garbage. You can't leave it behind.

N.B. Much of what follows is occupied with the salaries of the crew. The most important thing to look at isn't what everyone is paid,

but the number of people in each department. This is where the commitment is made to the scale of the production. If you have a lot of lights, you need people to move them around. If you have cranes, you need people to operate them. This budget is "four and four"—which means four grips, four electrics. I've done three and three. At the start of my career, I did a lot of movies two and two, with people bouncing from one department to the other.

2500. Grips. All-purpose handymen, they handle the dolly (a platform with wheels that lets you move the camera around) and also set the flags in front of lights (to cast shadows). Technically, the grips are responsible for safety on the set, but on a union shoot that's probably a bit more evident than it was on this one. The person who says "We need four grips, not three," is the cinematographer, who has the best sense of how much equipment it will take. If the cinematographer insists that he or she absolutely has to have four and four, I usually won't say no, because a genuine shortage of personnel translates into more time on each setup, which translates into not making your estimated shooting days. It isn't just a question of throwing another body into the department, though. You get more out of three grips who know what they're doing than five who don't. Sometimes the answer is to pay a little extra for a good one.

2500-11. Car rig rental. The things that attach to a car so you can shoot people while they're driving and conversing. These shots always take three times longer than most DPs will tell you. *Jacked* has a car-rig scheduled for three days. The item below it, the condor, is not a bird but a kind of crane, usually used for lights.

2500-21. Craft service supplies. We might as well talk about this here. Craft service means the table that sits off to the side of the set with coffee, soda, juice, and snacks. You might think it's no big deal, but it is. If the coffee isn't ready in the morning, it will have a grisly effect on people's mood. Conversely, if you bring something special to the table—guacamole, brownies, pie, ice cream when it's hot or soup when it's cold—it's a great morale booster. Liquids are essential in hot weather. Most of the time, no matter what you offer, people will complain about craft service. It's a great unifier. You'll see the crew gathered together and think they're discussing the next shot, but they're actually trading horror stories about craft service

on their last film. When people are frustrated, they like to go over to the craft service table and scream: "This food is shit! You people are amateurs!" That's a lot of pressure on the poor PA you put in charge, especially when it's his or her first job and there isn't a lot of money to take to the grocery store. On *Jacked,* the principal craft service expense is listed later in the budget, under Location Supplies. Seven thousand is allotted for the entire shoot. It would be more, but on this film there was also a catered breakfast truck, which meant that the craft service PA didn't have to worry about bagels. In London, where we shot *Velvet Goldmine,* production stops for afternoon tea with little watercress and egg-salad sandwiches and cakes.

2500-25. Unit supplies. This means things like tables and chairs for meals, as well as paper cups, Tampax, and aspirin. This budget notes that food-related items are included in the catering deal, which is helpful. But you'll still need supplies for the Second Meal (see p. 95).

2500-35, 2500-70. First-Aid purchase, nurse. You always need a first-aid kit because people trip over wires, get conked by lights, and throw themselves headlong into their performances—literally. Obviously, on days when stunts or special effects are executed, you *must* have a nurse around. On *Velvet Goldmine,* we had two full-time nurses, one just for the construction guys. On *Jacked,* there were only a few really physical scenes, so the producers got away with having a nurse for only two days.

2500-60. Watchmen. It's no fun to show up at your storage area at five in the morning and find the door jimmied and your equipment gone. If your stuff is in an area that's the slightest bit accessible, pay someone to watch it at night and on off-days.

2700. Set dressing staff. The size of the art department waxes and wanes in direct correlation to what you're doing on a given day. If you have a lot of separate locations—as they do here—there has to be simultaneously a team striking the place you've just finished shooting, a team working on the place you're about to shoot, and a team preparing the place that you'll be moving to next. It's a massive job. You'll have no idea how massive until you make up your schedule and give it to the production designer, who'll tell you how many

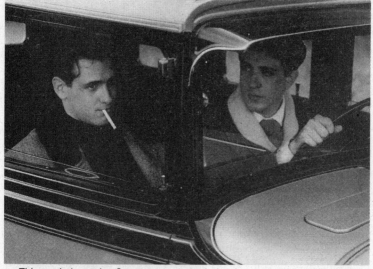

This period car in *Swoon* was one of the few props we spent real money on.

people he or she will need to get it done. The people you hire for a couple of days are known as "day players."

2800. Props. On a super-low-budget shoot, what usually happens is that the art department puts up a list of the things it needs for props, and if you have something yourself, you bring it in. Sometimes buying used props from thrift shops is cheaper than renting. This movie isn't so proppy. The trickiest props are always the custom-made ones—in *Velvet Goldmine*, it was the talismanic emerald pin affixed to the baby Oscar Wilde. That pin is the center of attention whenever it appears, and it has to be in four different states of distress. When a prop plays such an important part in the narrative, you have to get it right from the start, because once you've established it, you're stuck.

2800-55. Video playback. If your characters are watching television, don't expect the image on the TV screen to translate perfectly to film. It will be fuzzy and full of roll-bars unless you have special equipment to synchronize it with the camera. We usually hire someone to handle video playback.

2900. Wardrobe. Making your own costumes can get really expensive, but sometimes it's what you have to do. On *Velvet Goldmine*, it was a big percentage of the budget. Since wardrobe is front-and-center in a film about glam-rock, this wasn't the place to scrimp. SAG mandates that actors get paid for wearing their own clothes—still a big savings if they have something appropriate. In a period film, of course, this isn't an option. In a low-budget contemporary film, the costume designer will often go to the actor's house and take a look at what he or she owns. Sometimes an actor wants to

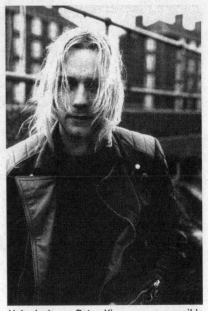

Hair designer Peter King was responsible for Ewan McGregor's realistic ragged tresses.

wear his or her Mizrahi suit because it looks terrific, even though it's wrong for the character. Since actors care *so* much about how they look, you have to be sensitive to their fears while quashing their suggestions. You can sometimes get designers to give you clothes, as long as those clothes will be showcased in a way that they like. Bigger actors have deals with designers and get their clothes for free. If you don't have an actor with that kind of relationship, you can always call a designer and plead your case, though it helps to have an angle. On *Kids*, we contacted a lot of those skateboarding designer types—the baggy-clothes places—and got free outfits, on the premise that we'd make them look cool. We did, and those companies were pleased. The time-honored (if otherwise dishonorable) low-budget way to get clothes for your actors is to buy them from a store, try not to mess them up, and return them when you're done. Movies do that all the time with props, too. The costume rentals that end up costing you a lot of money are uniforms for police and firemen. Many extras put on their resumes that they own a uniform. Hire them and you get the costume for a nominal (set)

fee. If it's a significant role, however, rent the costume separately because most extras can't act.

2900-40 to 2900-46. Maintenance, alterations, cleaning. If the actors wear their own clothes, be sure to keep them on the set for the duration of the shoot. Otherwise, the clothes will be forgotten at home or come back with coffee stains. It's a good idea for the wardrobe supervisor to have an iron on set, because actors' clothes are routinely messed up. Studios have their own launderers and dry cleaners, but you'll probably have to find a cleaner you trust and work out a deal. Needless to say, if you have a scene in which a character crawls through the mud or the costume gets distressed in any way, you need to have doubles or triples or quadruples of that costume. If the costume is a Versace suit, it could get really expensive. For such scenes I'd bend over backwards to put the character in a T-shirt and jeans, if possible.

3000. Special effects. You can't really mess around in this area: Even people who know what they're doing get maimed and killed. If you're dealing with firearms or explosions, you must have someone around who has done it before—a real professional. You don't want to risk your actors, let alone something irreplaceable like your camera. Contact a special effects coordinator, tell him (it's inevitably him) what you want to do and, most importantly, how you want the camera to see it, and he'll explain how it can be done, beginning with the most expensive method and ending with the Kmart version. For *Velvet Goldmine,* when Jonathan Rhys-Myers got shot on stage, Todd Haynes wanted something really violent. He wanted to see Johnny lifted off his feet so that it looked as if the bullet was blowing him up and back. There were two ways to do it. The complicated way involved attaching Johnny to a wire that would be yanked at the same instant that the blood-squib on his chest was detonated: *Boom!* He flies up and back and doesn't have to think about a thing. The cheap way was to put him on a kind of trampoline and have him throw himself backward—onto a glorified air-mattress—when the squib went off. It was an important enough effect that we'd have sprung for the expensive way, except the wire harness didn't fit under his skintight jumpsuit. We compromised because we wanted the costume. On another film, a character opens a package and gets blown up. We debated ways of doing it—from the moronically inexpensive (cut from the character opening the box to someone

The fake front door successfully blown off its hinges. At the end of the day it didn't make the final cut.

next door doing dishes and hearing a BOOM! while the camera shakes) to the Schwarzeneggerian (blow up a whole house). We also thought about blowing up a miniature. In the end, we built a fake front door on the house, blew it off its hinges, and pumped out a lot of black smoke. It cost about two thousand dollars. We worked with special gore makeup for *Office Killer*—the first time we've gone where zillions of low-budget producers have gone before. What we learned was that special makeup needs to be applied correctly—which takes a long time—if you don't want it to look silly. You must schedule accordingly, or you'll have a lot of bored crew members standing around and you'll lose a lot of time and money. This makeup also tends to be unpleasant for actors. It's nice, when possible, to have your make-up person design it with detachable pieces, so that actors can make themselves more comfortable on breaks and at lunch.

3100. Hair and makeup. Another scary special effect—although you wouldn't call it that in the budget—is an actress's hair. This can take as long to prepare as turning someone into a rotting ghoul. Actresses need to feel that they look *great* before they go in front of the camera. Many want to bring in their own hair and makeup people, but I don't love doing that. I could never put my finger on

why until I read Sidney Lumet's book *Making Movies,* in which the veteran director points out that the people stars bring in are often not working for the film, they're working for the star. On the other hand, I've said no to that request and the actress has been so unhappy that I've ended up having to hire her person after all. And at that point, once the shoot has started, I'm over a barrel.

3200. Electrical dept. staff and expense. The electrics deal with the lights, and there are four in this budget: the gaffer, who's the head of the lighting department; the best boy, the gaffer's assistant; the third electric, the assistant's assistant; and the genny operator, who, of course, operates the genny (the generator). The electrical package is a lot of money. That's the truck that has all the lights in it, which you carry around for the duration of the shoot. We usually get very basic packages and rent special add-ons as needed. Sometimes you can cut your best deals on grip, electric, and camera if you're not shooting during peak season, when there's less competition. The weather isn't as much of a factor in LA but then, the whole equation is different. LA equipment is cheaper because there's a lot more of it available. When New York gets busy, there often won't be a camera or a grip package left to rent. They're all out, working. It takes a lot of equipment to light a movie, and even though this is a relatively low-budget film, there's a lot to move. On the bigger-budget *Velvet Goldmine* our unit looked like an army. The generator by itself was colossal. When we started making low-budget movies, we almost always "tied in" to on-site electricity. In fact, before we hired the gaffer we asked: "Do you know how to tie in?" We learned differently when we shot *Safe* in LA, where the notion of tying into somebody's house was anathema. You can get electrocuted if you do it wrong.

3200-65. Gels. When you find out that another movie has wrapped, you can often get gels that they don't feel like storing. (You can get other stuff from them, too, like gaffer's tape and sash cord.) That can be a real savings, because gels don't come with the camera package, and the expense adds up. They're like cellophane—flimsy colored plastic lenses—and get damaged all the time in the course of shooting.

3300-01. Director of photography. The Master of Light. See "Crewing Up."

3300-02. Camera operator. On *Jacked,* there's no separate expense for the camera operator. The director of photography, Jerzy Ballsakowiczski, operated the camera himself, and was good at it. On a union shoot, you have to hire an operator. Actually, Jerzy photographed the big action film *Die in Excruciating Pain* and reported it was nice to be able to work on a shot with a director instead of constantly having to be behind the camera.

3300-01, 3300-05. Assistants. There are two here for the cinematographer, which is standard. The first is the "focus-puller," the second the "clapper loader." (You could spend a lot of time thinking up smutty movie-crew double entendres.) In addition you can use a free intern here—but not as the first or second assistant cinematographer.

3300-06. Steadicam. They are budgeted for a day of Steadicam in case the director wants it. You have to rent the camera and its operator, and it's expensive. (Then Jason decided that he didn't want to have that kind of slick, smooth, weightless feel, so he ended up staying with dollies and handheld—another case where the low budget worked for the aesthetic.)

3300-08. Stills photographer. Low-budget producers screw themselves by trying to save money on stills. It gets you in the end because stills from your shoot are some of the best PR tools at your disposal, and to blow up a frame from the actual film costs a fortune. (Stills are frequently "deliverables," too, which means a distributor won't accept your movie without them.) Sometimes you can save money by having the stills photographer in on limited days. The only drawback is that, in order for them to really be good at their job, everybody—especially the actors—has to get acclimated to them. The only way for that to happen is if they're around all the time. We had to change stills photographers on *Velvet Goldmine,* and even though the guy we got was terrific, nobody knew him. He never got in sync with the director of photography, so he didn't know how to charge right in before the shot, get what he wanted, and get out of the way.

3300-20. Camera package. Usually you end up going with the

camera that your director of photography wants. Even if Arriflex is cheaper, you use PanaVision if that's his or her preference. A lot of DPs have their own 16mm packages, so if you're making a low-low-budget movie in 16, you can often strike a deal to get the camera included as part of the rate. Do you want to be shooting in 16? If that's what you have access to, by all means. *Poison* and *Swoon* were both done in 16, although it seems to me that nowadays people shoot less and less of it. It does not always pay. If you have any commercial hopes for your film, you're going to have to convert it to 35 anyway. Incidentally, blowups look great these days, so the question is really: "Do you want to spend the money now or later?"

3300-26. Camera dolly rental. There are all different kinds of dollies. The one that you end up with will be dictated by your director of photography's needs. Some are designed to go up high; some down low; some to get through narrow doorways; some to do extremely elaborate moves. They used a dolly every day on this film. It's kind of hard not to—although you can always make a decision not to move your camera, like Jim Jarmusch did in *Stranger Than Paradise* and Whit Stillman in *Metropolitan*. There are other ways to move a camera, depending on your level of invention. You can pretty much put a camera on anything. When I was in school, we used to put the camera on a wheelchair, with which you could achieve a dolly-like fluidity. On *The Evil Dead,* they strapped the camera to a plank, put one person one each side, and had them run like hell. They called it a "shakicam."

3400. Sound. No matter how great a movie looks, if the audience can't understand what the actors are saying, they'll get frustrated and lose interest quickly. I know when I see a low-budget movie and the sound is crummy, I shut it off. The less money you have, the less you'll probably budget for postproduction sound, so what you get during the shoot becomes even more important. Don't scrimp here. If your production sound is good enough, you won't need a lot of ADR (additional dialogue recording), which most of the time you need because there's a flaw in the production sound, or an airplane was overhead and you couldn't get a clean take. Your sound person should scout your locations. If you're going to be shooting on a weekday and you visit on a weekend, make sure that there isn't a noisy garage next door that's only open Monday to

Friday. Sometimes you do ADR because you want to change the performance. That's fine, but I can usually tell when an actor has been looped, and I hate it, and so do many directors. Some actors are hopelessly bad at it—they're never able to dub themselves in a convincing way. The best reason to use ADR is when you want to fill in a scene where lots of people are talking at once.

3400-02. Boom operator. It's tough to find people who know enough about what they're doing to perform this task cheaply, because it largely consists of standing and holding a microphone in an incredibly uncomfortable position. What's in it for them?

3400-40. Walkie-talkies. Lord, we have a lot. Now, almost everyone has a walkie-talkie. Except me. That's when I knew I'd made it, when I didn't need a walkie-talkie to talk to people on the set. I'm the producer, so I have a cellular phone to talk to people *off* the set. You rent walkie-talkies—they're standard issue, and you can't shoot without them. It's how the gaffer talks to the best boy when the best boy is fifty feet in the air setting a light; how you tell people in holding areas to shut up when shooting is in progress; how you cue an extra down the block to drive by. They aren't expensive—maybe five dollars a day. People have suggested buying a load of them secondhand, but what would we do with them? The technology changes every day. I'd rather rent stuff like that than have it permanently in my life.

3500. Transportation labor. That is, the Teamsters. See the beginning of this chapter for all my warnings and recommendations. If you're shooting outside a major city, talk to someone who has produced there to determine the Teamster situation. It's possible that they don't function in some areas—but make sure that's the case before you make a different arrangement.

3500. Vehicle Rental. On my first, very-low-budget movies, I made the art and wardrobe departments share a truck. Now the scale is bigger, and the number of trucks has at least quadrupled. It's incredible how many trucks you need to carry equipment from set to set. On this movie, they budgeted for two fifteen-passenger vans a day, because everything's on location, and all the locations were a distance from where people lived. When you're shooting nearby—in

the Zone, as they say—it's a little easier, because you don't need cars for *every* person. But you have to pick up the lead actors, and your locations department will always need vehicles. And then there's the stuff that comes with transportation: taxis, car services, subway tokens, tolls, parking fees, and parking tickets—which are always a big deal, even when you have permits. When big cities are in trouble with *their* budget, they plunder everyone else's. We contest every ticket we get, but we allow for them because we don't always win. On Todd Solondz's film, for some reason, our cars and trucks were being towed or ticketed *constantly*.

3600. Location expenses. Here's where we put in the cost for location meals, which are catered. These can be expensive, from ten to sixteen dollars a head. Nothing will upset your cast and crew like a terrible caterer—I'm always getting petitioned to replace the ones I hire. If you're a small enough shoot, you might be able to find someone who does old-fashioned home cooking, but that can be a disaster if the person doing the cooking starts to freak out under pressure. Back at the production headquarters, the office staff gets its meals paid for during a shoot, too. And then there are "second meals." On a film set, union or nonunion, the rule of thumb is that you feed people every six hours; so if you haven't wrapped six hours after your last meal, you need to feed them again. So you send someone to a restaurant. Second meal is usually Boston Market, or pizza, or whatever's around your location. Always run your choice by the shop steward, because crews have strong opinions about food. "We hated the Chinese food last night," they'll say. "We want pizza." Or, "We're sick of pizza. We demand Chinese." Most of the time, it's nice to have a break from the catered food, no matter how good the caterer. On rare occasions, if you use a company's food in the movie, you can get a lot of it free for the crew. I once got a lot of cheese popcorn that way. We had our best luck with liquor and cigarettes on *Stonewall*. Those companies are very gay-friendly because so many gay people are addicts.

3600-10. Site rentals. Now begin the costs for specific locations. It's all guesswork, because when you're actually making the budget, you don't know where you're going to shoot, how many choices you'll have for each location, or how amenable people will be to your filming. A great, authentic location will add to your production value, but you

sometimes have to build sets instead because people don't want you messing up their offices, stores, or homes. It has become increasingly difficult to find locations for little money in and around New York because people are now film-savvy: they're not as fascinated by the glamour of it, so they don't flip because you want to shoot in their apartment or their store. (Personally, I would *never* let a film crew into my apartment. One filmmaker I know shot in her mother's house and her mother ended up suing her for damages.) If you find a restaurant where they'll let you shoot, you'll often have to do it between midnight and eight in the morning when it's closed, or else compensate the owner for a day or two of lost business. In terms of what you actually have to pay—well, some people are more sympathetic to your needs than others. Your director, as I mentioned in the chapter on development, might have a relationship with a potential location, which can be a tremendous asset. On *Jacked,* filmmakers wanted the locations to conjure up a certain working-class lifestyle. So even when the director's relatives said they could shoot in their houses for free, if the art department was going to have to spend ten grand to make them look right, it wasn't worth it.

3600-40. Holding areas. A separate—and major—expense are the areas for dressing rooms, wardrobe, hair and makeup, and catering. Sometimes a location will be spacious enough that you don't have to supplement it, but on *Jacked* they frequently filmed in one house and held actors in another down the block. A way to get around this is to give everyone trailers, but that can cost half your budget. Actually, we had trailers on the one-million-dollar *Safe* because we were shooting in LA and it *just wasn't done* to have holding areas. Trailers were cheaper there, too. We had star trailers on *Velvet Goldmine,* but usually there weren't more than a couple of stars working on a given day, so we only needed one or two.

3600-51. Storage. One of the things that's a drag when you're making a movie is figuring out where to put everything: Where to put the wardrobe as you're amassing it; where to put the props? You need a lot of storage space. If you don't have the money for it, the stuff usually goes into your production office. I've worked out of production offices that have been filled floor to ceiling with flats, props, lights, and costumes. After you wrap, you need to decide how long to keep it all around. You can get rid of it, but if you have to

go back and do inserts or reshoot a couple of scenes, you're going to wish you hadn't. Often films have sales after they're finished to get rid of as much stuff as possible. Cast and crew members tend to have their eyes on certain costumes and props from the beginning. Sometimes you just throw it all away, or donate it to a nonprofit organization such as New York's Materials for the Arts.

3600-53. Copy machine. We rent a small copier to take on location so we can copy our call-sheets. As the prices come down, it might make sense to buy one.

3600-58. Cellular phones. They're really killing film budgets because they're so expensive, everybody has them, and once you start using them, it's really hard to restrain yourself. I know I certainly can't.

3600-59. Office. They're pretty well-equipped already, and there are a lot of production offices where you can just waltz in and turn on the lights. But often when you start up a production office, you've got to get phones, fax lines, computers, modems, and so on. On *Kids,* where we worked out of a big, raw space, we had to start from scratch.

3600-62. Location photos. The photos you take on scout trips to show directors. We use a ton of them. We've tried video cameras to save money, and I found the tapes effective, but most directors can't concentrate on an image that's always shifting. They like photos because they can sit with their hands on their chins and stare at them. So videotape has gone by the wayside, although we sometimes use it to plot out complicated sequences. For *Velvet Goldmine,* Todd Haynes and Maryse Alberti went to a location and did a video mockup to use as a guide when they were shooting.

3600-67. Gratuities. Part of your scouting expenses. This is the $25 you have to give someone to turn off their stereo for three hours or the hundred to turn on their porch lights.

3700-02. Rain machine. They had one budgeted, but they decided they could do without it and just wet down the sidewalk instead.

3800. Film. *Jacked* budgeted to shoot 4200 feet per day, but ended up shooting about 5000. The rule of thumb on a low budget is that you shoot between 4000 and 6000 feet of film. What got them on *Jacked* were the long, long master shots, sometimes four or five pages of dialogue, and then coverage that wasn't terribly selective, each close-up as long as the master. It really added up. You just can't skimp on film stock, though. If you don't have what you need, you have to keep shooting—you can't just say, "Oh, well, we're out of money, so even though we don't have a complete take, we have to stop." One way to save money is to buy leftover film stock from other productions, which is considerably cheaper. The downside is that Kodak, for one, doesn't insure it if something's wrong. It's a gamble, but we've taken it and haven't (yet) had a disaster. A lot of DPs, understandably, hate the practice.

3800. Lab. We put our dailies on video and print only a small percentage of the film so that we can check our work. A lot of people do this and the savings are significant, but it can be frustrating, because a VHS tape doesn't tell you as much as celluloid does—it's a *lot* more forgiving about things like boom shadows.

3800-50. Still film process. For your photographer. We budget about five rolls a day.

3800-60. Polaroids. A huge expense, about a dollar and a half a picture. They're used by wardrobe, hair, makeup, and the script supervisor for continuity. They only allowed about a thousand dollars here but I'm sure they went over because people tend to go through film really quickly. I always get upset when I walk onto the set and see a Polaroid of, say, the crew. What a stupid waste! My partner, Pam Koffler, points out that movies existed before Polaroid was invented, but you wouldn't guess it nowadays.

3901. Camera test. An essential, and the best way to avoid unpleasant surprises in dailies with regards to your equipment and stock. On *Velvet Goldmine*, where color was especially crucial, we did several camera and lens tests and often combined them with tests of film stock, special effects, and makeup. Labs will often give you lower rates or even waive their fees on tests.

5000. Editorial. The editor starts the picture cut as we're shooting, which is a good idea because if something doesn't work, he or she lets us know as we're going along.

5100. Editing equipment, AVID rental, AVID room rental. All these expenses are discussed at length in the chapter on post-production.

N.B. What you have to think about is how far you'll budget *to*. I think it's not a bad idea to budget through delivery, on the upbeat assumption that you'll be handing it over to a distributor. Hoping that the distributor will pay those postproduction costs is a little naïve, although we did get the Samuel Goldwyn Company to pay for deliverables on *Go Fish*. That movie was so commercial that we were able to negotiate: We had the advance they paid us, and then a separate fee just for deliverables. It's not a common arrangement. In most cases, the more deliverables you have, the more attractive your package.

5200. Post-production sound. When you get into post-production sound and lab, what you start to see reflected is what you're contractually required to deliver to a distributor. If you don't have a contract, a lot of budgets project costs up to an answer print (the first print off the negative), but they won't have any of the things that a distributor usually requires, such as a music and effects mix; a final film-to-tape transfer or VHS dub; a Dolby license; an MPAA rating. This budget reflects a pretty comprehensive list of deliverables, which might or might not apply to your film. Nowadays, sound houses do sound for you, and a lot of it is done digitally or on DAT. Here we have budgeted for a foreign mix, or an M&E mix, which is a separate mix of the music and effects so that you can just drop in other (foreign) voices and not lose your effects. A Dolby license is the license to use the Dolby stereo, which is sometimes a delivery requirement. It costs about eight thousand dollars at this writing.

5300-30. Titles and opticals. Titles can be as simple as white on black (as in Woody Allen's films) or as complicated as the scratchy montage at the start of *Seven*. A great title sequence can set up your film beautifully. On a low budget, try to think of an inventive way to shoot your titles during principal photography. We did that on *Office Killer*, and it has one of the most spectacular title se-

quences we've ever done. The titles on *Kiss Me, Guido* were extremely inexpensive, but everyone remembers them because the camera sat inside a pizza oven looking out: every time the oven door closed there'd be credits, and when it opened again the dialogue would resume. Optical effects means multiple dissolves or anything from spinning headlines to split screens. Even though the technology to do these effects has improved, it still is quite expensive.

5400. Music. The "synchronization" license fee goes to the composer if you want to have a character sing a song; the "master use" license fee goes to the performer if you're using a track from an existing release. Music can murder you. *Kiss Me, Guido,* with all its disco, was a licensing nightmare. On *Velvet Goldmine,* the music budget just kept climbing, along with the finance company's anxiety. Some filmmakers get around the expense by using songs in the public domain. That can be pretty boring, or just odd. In *Safe,* the characters celebrate the protagonist's birthday with "For She's a Jolly Good Fellow" instead of "Happy Birthday to You"—the latter costs a fortune and the former is free. An old public-domain standard can be an indie producer's best friend, but unless you want a soundtrack that consists primarily of songs like "My Bonnie Lies Over the Ocean" and "She'll Be Comin' Round the Mountain," you'd better be prepared to drop some cash. Better yet, find a local band that wants the exposure, or hire a composer who's talented enough to evoke the emotions you need without resorting to the pop hits of yesterday and today.

6000. More deliverables. Deliverables include: the interpositive and internegative; the D2, which is a top-quality film-to-tape transfer; a textless IP, which allows you to put titles in a different language on the film; in post-production and a spotted script for subtitling. (All these expenses are discussed in post-production.)

6200. Miscellaneous. Everything from niceties to essentials. In the former camp, the wrap party or the crew T-shirt. In the latter insurance and taxes, payroll service fee, and corporation costs.

6300-72. E&O. Or Errors and Omissions insurance, in case someone sues you for libel or defamation of character, or claims that your story is actually theirs. Obviously, you have to provide your insurers with ample proof that you own all the rights to your material. You won't be able sell your film to a North American distributor without E&O.

THE COST REPORT

Your budget is an educated hypothesis, assembled well in advance of the shoot and with varying degrees of optimism and foreboding. Its sequels are the cost reports, which are generated more or less weekly from the start of production. The account numbers are the same as in the original budget, but the all-important column is the last: "Variance." This is how much you spent in relation to what you thought (or hoped) you'd spend. A zero in Variance means you estimated right, a positive number means you've underspent and have a surplus (which you can put somewhere else), and a number with a minus after it means you're over budget. The object of the game is to add those pluses and minuses, factor in the ten percent of the budget earmarked as contingency, and end up with a nice, round zero.

What follows is the Summary Page of Cost Report #16 of *Jacked*. (The actual breakdown runs to ten dense

pages.) This report comes halfway through postproduction, at the tail end of the picture edit and before the sound work.

THREE STRAIGHT WHITE GUYS INC.

MEMO
TO Peter Piper, November Films
FROM Steve Holworthy, Tony Bastamento, Sam Flamm, Boris Pratt
DATE January 10, 1998
CC Bingo Ripley, John Peckersmith—November Films
 Ming Mercilech—Movie Monies
SUBJECT "Jacked"—Cost Report #16, Period Ending 1/5/98

Enclosed please find the cost report #16, for the week ending January 5, 1998. The estimated final cost, direct is $2,465,953 summarized as follows:

PRODUCTION COST REPORT

Summary

Period Ending 01/09/98

Currency US Yr/Pd 1997/11/01 Page 0001

Production 01 Native/Budget
JACKED Displaying Sets

Account Number	Account Description	ACTUAL THIS PERIOD	ACTUAL TO DATE	PO COMMITS TO DATE	TOTAL COST PLUS COMMITS	ESTIMATE TO COMPLETE	CURRENT EFC AMOUNT	CURRENT BUDGET AMT	VARIANCE
ABOVE THE LINE									
1100	DEV., CONT. & TREATMENT	0	60,750	0	60,750	2,000	62,750	63,245	495
1200	PRODUCER	0	25,704	3,711	29,415	38,000	67,415	67,415	0
1300	DIRECTOR	0	0	0	0	20,250	20,250	20,250	0
1400	CAST	809	165,137	175	165,312	2,795	168,107	201,807	33,700
1500	ATL TRAVEL & LIVING	2,240	21,546	0	21,546	3,022	24,568	23,823	745-
ABOVE THE LINE TOTAL		3,049	273,137	3,886	277,023	66,067	343,090	376,540	33,450
BELOW THE LINE PRODUCTION									
2000	PRODUCTION STAFF	13,781	252,999	2,380	255,379	4,958	260,337	221,150	39,187-
2100	EXTRAS	516	57,700	0	57,700	0	57,700	47,069	10,631-
2200	SET DESIGN	0	48,333	0	48,333	0	48,333	52,498	4,165
2300	SET CONSTRUCTION	0	9,838	0	9,838	0	9,838	10,280	442
2500	SET OPERATION	3,416	86,236	290	86,526	0	86,526	68,144	18,382-
2700	SET DRESSING	188	72,646	0	72,646	0	72,646	62,649	9,997-

Account Number	Account Description	ACTUAL THIS PERIOD	ACTUAL TO DATE	PO COMMITS TO DATE	TOTAL COST PLUS COMMITS	ESTIMATE TO COMPLETE	CURRENT EFC AMOUNT	CURRENT BUDGET AMT	VARIANCE
2800	PROPERTY	31-	40,478	0	40,478	0	40,478	30,882	9,596-
2900	WARDROBE	504	46,409	0	46,409	0	46,409	48,835	2,426
3000	SPECIAL EFFECTS	0	3,250	0	3,250	0	3,250	1,394	1,856-
3100	MAKE-UP & HAIRDRESSING	0	26,380	0	26,380	0	26,380	28,333	1,953
3200	ELECTRICAL	2,912	105,989	0	105,989	0	105,989	97,593	8,396-
3300	CAMERA	3,768	110,154	0	110,154	0	110,154	115,767	5,613
3400	SOUND	1,941	29,324	4,550	33,874	0	33,874	32,735	1,139-
3500	TRANSPORTATION	14,443	193,484	1,753	195,237	2,351	197,588	195,506	2,082-
3600	LOCATION	6,529	211,817	2,806	214,623	2,541	217,164	165,085	52,079-
3700	SPECIAL EQUIPMENT	0	0	0	0	0	0	2,000	2,000
3800	FILM & LAB	35,703	200,887	8,298	209,185	0	209,185	147,973	61,212-
3900	TESTS	0	0	500	500	0	500	800	300
4100	ARKANSAS UNIT TRAVEL & LIVING	13,706	58,034	0	58,034	0	58,034	55,796	2,238-
BELOW THE LINE PRODUCTION TOTAL		97,376	1,553,958	20,577	1,574,535	9,850	1,584,385	1,384,489	199,896-
BELOW THE LINE POST PRODUCTION									
5000	EDITORIAL LABOR	8,801	30,267	0	30,267	63,629	93,896	85,702	8,194-
5100	EDITING EQUIPMENT	4,211	18,988	6,438	25,426	16,828	42,254	32,953	9,301-
5200	POST PROD SOUND	0	0	0	0	109,060	109,060	125,061	16,001
5300	POST PROD LAB	0	0	0	0	28,710	28,710	25,738	2,972-
5400	MUSIC	0	2,000	0	2,000	51,000	53,000	50,000	3,000-
BELOW THE LINE POST PRODUCTION TOTAL		13,012	51,255	6,438	57,693	269,227	326,920	319,454	7,466-
BELOW THE LINE OTHER CHARGES									
6000	DELIVERABLES	0	0	0	0	38,316	38,316	38,316	0
6100	SALES & PUBLICITY	0	0	0	0	300	300	300	0
6200	MISCELLANEOUS	1,495	5,680	0	5,680	364	6,044	3,250	2,794-
6300	INSURANCE & TAXES	564	36,377	0	36,377	2,101	38,478	38,192	286-
6400	GENERAL EXPENSE	28,374	75,037	1,500	76,537	19,313	95,850	93,850	2,000-
BELOW THE LINE OTHER CHARGES TOTAL		30,433	117,094	1,500	118,594	60,394	178,988	173,908	5,080-
TOTAL DIRECT COSTS		143,870	1,995,444	32,401	2,027,845	405,538	2,433,383	2,254,391	178,992-
BELOW THE LINE CONTINGENCIES									
6700	CONTINGENCY	0	0	0	0	44,831	43,190	225,439	182,249
BELOW THE LINE CONTINGENCIES TOTAL		0	0	0	0	44,831	43,190	225,439	182,249
COMPLETION COSTS									

Account Number	Account Description	ACTUAL THIS PERIOD	ACTUAL TO DATE	PO COMMITS TO DATE	TOTAL COST PLUS COMMITS	ESTIMATE TO COMPLETE	CURRENT EFC AMOUNT	CURRENT BUDGET AMT	VARIANCE
6800	COMPLETION BOND	0	55,230	0	55,230	0	55,230	55,255	25
COMPLETION COSTS TOTAL		0	55,230	0	55,230	0	55,230	55,255	25
PROD TOTAL		143,870	2,050,674	32,401	2,083,075	450,369	2,535,085	2,535,085	0

The first thing to notice is a huge surplus in the above-the-line total, with $33,700 saved on Cast (line 1400). What happened? Because some of the actors were regulars in an LA-based TV series, their time on set was fiercely limited. In the short term, that meant tense days. But the savings in overtime pay and other expenses was substantial.

The troubles start below the line. Production Staff (2000) is $39,187 over estimates, with Extras (2100) coming in at minus $10,631. These and other below-the-line variances have to do with shooting longer—and more—days than anticipated. Few of the overruns are enormous, but they add up. The biggest single overrun in the breakdown (not shown) is Scouts, which is $16,730 over budget. This was nobody's fault. Some crucial locations fell through at the last minute (as they are wont to do), and extra scouts had to be hired during the first and second week of shooting. (The location manager needed to be on set.) The overrun in Set Operation includes the employment of watchmen, after the producers decided that it would save time (and cost less) to have security people guarding locations and equipment so that the crew didn't have to pack and unpack the trucks every day. A lot of overages, you'll discover, are to save time.

Set Dressing (2700) and Property (Props, 2800) also run over by $10,000 apiece. In the first case, the producers realized that because the movie was threatening to go way over schedule, it would be cheaper to combine locations. Say you're shooting three days in an office building and plan to move to another building to film a different kind of office. If time is short, you can stay where you are and spend money to re-dress an office at the existing location. That can cost hundreds or thousands of dollars, but compared to packing up and moving the cast, crew, and equipment, it might still represent a savings.

The overrun for props is a bit more frustrating. In this case, the director, Jason, didn't communicate his vision clearly to the set decorators. He'd come on set and say, "I thought Vinnie was going to have a big stuffed giraffe," and they'd say, "Er, Jason, you didn't

ask for a big stuffed giraffe," and he'd say, "Oh. I thought I did." The only solution at that point is either to forgo the stuffed giraffe (which Jason was loath to do) or to throw money at the problem: send someone out to the nearest store to find a big stuffed giraffe. In those situations, you can't borrow or cost-compare; you dash out, see what you need, and grab it, whatever the price.

There's a fairly big overage in Electricals (3200), which once again had to do with saving time. The Director of Photography said, "If I light this exterior with my package it will take five hours. If you rent me two more big lights it will take two." The producers rented the lights. Overages in Transportation (3500) had to do with the extra cars rented for all those location scouts. It also included the three fender-benders that one PA had in two days.

The Location (3600) overrun is a hair-raising $52,079. That cost represents a lot of things, though. It includes unanticipated second meals (the result of so many late nights), as well as $7,739 spent on carpeted holding areas for the actress who showed up with her infant daughter. Nearly $10,000 was spent on cellular phone calls (ouch). Location Restoration is also in here, because one of the apartments got damaged. One of the gaffers pulled up some tape and ruined the hand-rubbed bleached and white-washed finish on someone's pickled floor. Stripping and refinishing came to $950.

Most bloodcurdling of all is the $61,212 overage on film stock and lab work. Budgeted at $147,973, the actual cost is estimated at $209,185, more than 40 percent higher. Jason did more and longer takes than anyone had estimated, and his partners didn't realize what was happening until it was too late.

Postproduction (which is still in flux) has some whopping overruns but also some whopping savings. Editorial Labor (5000) and Editing Equipment (5100) are over budget by $17,495. This is because *Jacked* didn't turn out quite the way anyone expected. Rough Cut #1 was viewed by a test audience with shock and disgust, and a heavily revised #2 with disdain bordering on tolerance. By the time of Cut #4, however, segments of the audience were starting to like the film a lot. But that extra time in the editing room took a toll on the postproduction budget.

The big savings is in the next line, Post Production Sound (5200). Roughly $125,000 was budgeted, but an up-and-coming sound house decided it really wanted this project and offered an attractive rate. The $16,001 savings nearly offsets the additional picture-editing

costs. Flush with this savings, the producers decided to give Jason $2972 more for titles and opticals (5300), including jazzier credits and a split-screen effect. They also gave $3000 more to their music supervisor (5400). It's important to remember that sometimes you spend more because *you make the decision to.* It's not always a runaway train.

So where are we, as of Cost Report #16? Not so bad. True, the sound edit and the mix haven't started yet, but *Jacked* is in surprisingly good shape. The total overrun is $178,992, but the contingency (6700) is $225,439. Assuming that the sound edit stays pretty much on track, this allows a bit of a cushion—an extra mix day, or maybe a case of decent champagne.

TWO SUPER-LOW
BUDGETS WITH NOTES

	$765,000 Budget BUDGET B	$218,000 Budget BUDGET C
Stock	35mm	16mm
Location	NYC Shoot	NYC Shoot
Schedule	5 five-day weeks	3 six-day weeks
Crew	Non Union Crew	Non Union Crew
Deliverables	Some deliverables	No deliverables - film finished with one print
Edit	Avid edit	Avid Edit
Screen Actors Guild	SAG-Low Budget Agreement	SAG-Limited Exhibition Agreement (film can play in festivals and art houses only)

Rates	Key-$100/day	all rates deferred
	Best-$75/day	
	Third-$50/day	
Shoot Days	25 (4.5 pages per day)	18 (6 pages per day)

SAMPLE BUDGET B: $765,000
Director: Jason Spielwitz

Producers: Steven Holworthy, Tony Bastamento **Shoot:** NYC
5 Five-day Weeks/25 days Non-union / SAG / Teamster
35mm
AVID edit w/ some DELIVERABLES

Acct #	Category Title	Page	Total
803-00	STORY AND SCRIPT	1	13,054
805-00	PRODUCERS AND STAFF	1	36,000
807-00	DIRECTOR	1	12,000
809-00	TALENT	1	76,421
	Total Fringes		**36,650**
	TOTAL ABOVE-THE-LINE		**174,125**
811-00	PRODUCTION STAFF	2	46,210
813-00	CAMERA	3	30,975
814-00	ART DEPARTMENT	4	21,430
817-00	GRIP	5	8,580
819-00	ELECTRICAL	5	30,580
829-00	EXTRA TALENT	6	8,925
831-00	WARDROBE	6	10,100
833-00	MAKEUP & HAIRDRESSING	6	4,300
835-00	SOUND (PRODUCTION)	7	9,550
837-00	LOCATIONS	7	52,735
839-00	TRANSPORTATION	9	31,099
841-00	FILM AND LAB	9	56,442
	Total Fringes		**26,338**
	TOTAL PRODUCTION		**337,264**
851-00	EDITING & PROJECTION	10	46,900
852-00	VIDEO TAPE AND DELIV.	10	13,000
853-00	MUSIC RIGHTS/VIDEO FOOTAGE	11	12,000
855-00	SOUND (POST PRODUCTION)	11	27,650
857-00	PRINTS POST	11	29,627
859-00	TITLES, OPTICALS	12	5,000
	Total Fringes		**2,005**
	TOTAL POST PRODUCTION		**136,182**

Acct #	Category Title	Page	Total
861-00	INSURANCE	12	23,500
865-00	GENERAL EXPENSES	12	24,200
	Total Fringes		0
	TOTAL OTHER		47,700
	Total Below-The-Line		521,146
	Total Above and Below-The-Line		695,270
	Contingency		69,527
	Grand Total		764,797

BUDGET NOTES $765,000 BUDGET B

The days must average 4.5 pages of script. The schedule also allows for more paid prep time. The crew will get their salary when the shooting is over, rather than have to defer part of it until the film sells, as in Budget C.

805-00	Producers and staff: Allows a nominal fee for the producers.
807-00	Director: Pays the director a living wage, just.
809-00	Talent: Based on a low-budget agreement with the Screen Actors Guild ($466.00 per day, $1620 per week). Many characters will have to become extras in this budget, and even more will in Budget C. This also allows for a stunt—a car screeching to a halt, a modest fight.
811-00	In Budget B, the heads of the departments may be new to "keying," but they will be likely to have been on a set before. With Budget C everyone will be new to filmmaking—i.e., the location manager will be right for the job because he or she has a car.
813-00	Camera: Allows a 35mm rental with a few toys.
814-00	Art Department: A larger art department allows more flexibility in terms of prep time. In the Wardrobe and Prop departments, you'll have to use what you have, though you can buy one crucial outfit or make a few specialized props.
819-00	Electrical: A generator rental for a few days allows more flexibility with locations and makes night shooting more possible.

829-00 Extra talent: Must use all SAG extras.

837-00 Locations: This is enough money to convince people to allow a shooting crew into their store.

839-00 Transportation: Budgeted for one Teamster. Depending on the film, two Teamsters are very possible. Two trucks for Props and Wardrobe allow more flexibility in prepping sets.

851-00 Editing and projection: Allows a longer picture cut, sound cut, and a little more per hour for the sound mix.

853-00 Music rights and video footage: You can afford to license some music in addition to the original score.

JACKED: SAMPLE BUDGET C: $218,000
Director: Jason Spielwitz

Producers: Steven Holworthy, Tony Bastamento	Shoot: NYC
3 Six-day Weeks/18 days	Non-union / SAG / NO Teamster
16mm	
AVID edit	NO BLOW UP

Acct #	Category Title	Page	Total
803-00	STORY AND SCRIPT	1	2,600
805-00	PRODUCERS AND STAFF	1	0
807-00	DIRECTOR	1	4,000
809-00	TALENT	1	17,113
	Total Fringes		**6,003**
	TOTAL ABOVE-THE-LINE		**29,716**
811-00	PRODUCTION STAFF	2	5,850
813-00	CAMERA	3	5,860
814-00	ART DEPARTMENT	3	7,130
817-00	GRIP	4	2,165
819-00	ELECTRICAL	5	11,165
829-00	EXTRA TALENT	5	1,850
831-00	WARDROBE	5	3,360
833-00	MAKEUP & HAIRDRESSING	6	950
835-00	SOUND (PRODUCTION)	6	3,590
837-00	LOCATIONS	6	32,210
839-00	TRANSPORTATION	8	8,825
841-00	FILM AND LAB	9	16,739
	Total Fringes		**2,813**
	TOTAL PRODUCTION		**102,507**
851-00	EDITING & PROJECTION	9	28,600

Acct #	Category Title	Page	Total
852-00	VIDEO TAPE AND DELIV.	10	0
853-00	MUSIC RIGHTS/VIDEO FOOTAGE	10	2.500
855-00	SOUND (POST PRODUCTION)	10	16,400
857-00	PRINTS POST	10	5,900
859-00	TITLES, OPTICALS	10	5,000
	Total Fringes		**1,027**
	TOTAL POST PRODUCTION		**59,427**
861-00	INSURANCE	10	4,000
865-00	GENERAL EXPENSES	11	3,300
	Total Fringes		**0**
	TOTAL OTHER		**7,300**
	Total Below-The-Line		**169,234**
	Total Above and Below-The-Line		**198,950**
	Contingency		**19,895**
	Grand Total		**218,845**

BUDGET NOTES $218,000 BUDGET C

The idea when preparing this bare-bones budget for *Jacked* was to stay around $100,000. That lasted about ten minutes. The next plan was to stay below $200,000. That actually seemed plausible. But the figures kept creeping up, which seemed a true illustration of the whole budgeting process. So we let it find its own ceiling: $218,000.

Even so, this budget depends on a couple of great deals: a free camera package and walkie-talkies, discounted film stock, a negative-cutting bargain, or all of the above. Don't be afraid to ask for favors and always sell the script and the importance of the film!! Prayer won't hurt, either.

The schedule here is drastically shorter than in the $2.5 million budget, and the shooting approach is "run-'n'-gun"—for a 110-page script you need to average six pages a day. This means less coverage.

807-00	Director earns what is basically pocket money.
809-00	Cast: The budget size falls into the Limited Exhibition category with the Screen Actors Guild. If you want to use professional actors you can become "signatory," but you will be required to pay the Limited Exhibition Rates ($100 per day if an actor works less than three days and $75 per day if the actor works three days or more).
811-00	Production staff: Rates are very low, but all the crew

will get some money deferred. This means that when the film sells, the crew gets salary due.

813-00 Camera: Assumes that the DP will own his or her own camera package and will let you use it.

814-00 Art Dept.: Assumes that most set dressing and props will be part of the locations, or will be provided by friends of the production. Cars used and parked in the shots will be the crew's. (This generally means no luxury cars. Forget about period automobiles, too.)

819-00 Electrical: Lighting package will be small. No generator means an electrical tie-in at every location.

829-00 Extra talent: Under the Limited Exhibition Agreement with the Screen Actors Guild, all extras can be nonunion. Many nonunion extras are *extremely* unreliable, so you need to overbook to ensure that there are enough bodies.

831-00 Costumes: Assumes a lot of closet-raiding, and that most of the actors will be wearing their own clothes. Forget about period unless a local high school lets you raid its wardrobe room. Clothes you must purchase should be returned if possible.

833-00 Makeup and hair: One person will do both. Beware!! The schedule will have to allow time to get everyone through "the works."

835-00 Sound package: Very basic. You'll need to rent DAT or Nagra from the sound mixer or land a favor. Ten walkie-talkies is the absolute minimum you can get away with.

837-00 Locations: Site fees and rentals will be nominal; you'll have to rely on friends and family for locations (e.g. producer's apartment, director's mother's travel agency, uncle's hamburger stand). You will also need to hold parking if you are shooting in a big city. Do not skimp too much on catering—bad food will make the crew walk faster than long days or invading turnaround. As for holding area costs, you'll need some favors to keep the costs down. If you shoot in the summertime, people can eat lunch outside. Your office space will be a hole-in-the-wall.

839-00 Transportation: Taxis are only allowed if it is the middle of the night or if what you are carrying is bigger than your body. Messenger services are out of the question.

Props and Wardrobe will also have to share a truck. This requires lots of cooperation on the part of the keys.

841-00 Film and lab: Get a deal somewhere on film stock—Eastman Kodak offers a discount through the Independent Feature Project. Also look for places that sell leftover footage and contact local shoots to see if you can buy what remains when they're done. The film will also have to be cut entirely on video. You will never see the film itself until the first answer print. You'll also need to try to make departments share Polaroid cameras and stock. Maybe the script supervisor can refer to Wardrobe's Polaroid or vice versa. On a $200,000 shoot, every little penny matters. You have to nickel and dime.

851-00 Editing and projection: The sound edit is shortened. Luckily, Avid rentals are constantly going down. If you have connections, you may be able to get it down even more.

853-00 Music rights: Find some kid fresh out of music school who wants to do the score for very little money.

855-00 Post-production sound: Assumes one week to mix at a very low rate. This means your film is on standby—you mix when it is convenient for the studio—weekends, nights. ADR and Foley are projected at a bare minimum.

859-00 Titles and opticals: Main and end titles will be very basic. No slow motion, a few fades.

861-00 Production Insurance: This is necessary. Almost no one will rent you equipment or permit you on a location without it.

865-00 Legal: Just enough to help out with the basic issues.

Contingency: While it is tempting to reduce the contingency, *resist*. You will need it.

Deliverables: When you sell a movie there are a number of elements required by the distributor to release the film, from Errors and Omissions insurance to protect the distributor legally, to the Music and Effects mix to allow the distributor to lay in a dubbed track (in order to show the film in other languages).

DIARY INTERLUDE
#1

ANATOMY OF A DEAL GONE AWRY

May, 1996: The Cannes Film Festival

Todd Haynes delivers a second draft of *Velvet Goldmine* to Scott Meek, the executive producer, and me. We decide to test the waters here at Cannes, giving out a few copies and trying to maintain a smug air of: "We know we have a hot property."

Scott is a gregarious Scotsman in his mid-forties. It's a tremendous amount of fun to have a drink or two or three with him. Several production executives sit with us happily for a good half hour before they realize that they're being pitched. My style, on the other hand, is far more studied: I have an earnest look on my face and bandy about words like "mise-en-scène" and "auteur." All in all, Scott and I make the perfect team. He pitches

for the sheer fun and exuberance of the movie while I speak up for its artistic integrity.

We concentrate on a handful of independent or independent-friendly studios: Miramax, October, New Line, Orion, Trimark, and Fox Searchlight. Our meetings all go pretty well but no one exec says "YES! WE MUST MAKE THIS MOVIE!" Instead there is guarded interest. The underlying message seems to be: "Make the package stronger."

How do you make a package stronger? Mostly by attaching cast—namely middle- to big-name stars. It's a little tricky at this point. I have to be able to telephone an agent with enough confidence in my voice about the movie ("We are one step away from being green lit!") so that he'll get his client to read the script. *But* I can't quite say that this movie is financed—I have to imply it without actually articulating it. It is a scary line to walk and requires a strong stomach.

May: New York

Scott goes back to England and I go back to New York. Two days after my return, Mark Tusk of New Line telephones me. Mark worked in acquisitions for many years at Miramax. He looks far younger then his thirty-four years and exudes hipsterness. He dresses in a kind of elegant grunge style and affects a hip-hop slang. Still, he always seems to have his fingers at least partly on the pulse; right after *Poison*'s release he tracked Todd and me down to our dingy office and knocked on our door to tell us how much he loved the movie. Even though he had definitely brought Miramax some of its cooler movies over the years, he was starting to get a bit restless. When New Line offered him a production job, he jumped. He has been there all of two months.

I pick up the phone and Mark says the magic words: "YES! WE WANT TO MAKE THIS MOVIE!"

Wow. Now what? I know that Mark doesn't really have the power to green-light a movie, but his boss, Mike De Luca, does. The next step will be a meeting with him.

June

Todd goes back to London while we try to insert ourselves into Mr. De Luca's busy schedule. Todd hires Sandy Powell (*Interview with a Vampire, Orlando*) to design the costumes, Christopher

Hobbs (*The Long Day Closes, Edward II*) as production designer, and Susie Figgis (*The Crying Game*) as casting director. The package is definitely getting stronger. He calls me excitedly one night. "I just saw *Trainspotting!*" he says—the movie hadn't yet opened in the United States—"We've got to get Ewan McGregor for Curt Wild!"

And get him we do. Now we had a bona-fide Hot Young Star, a strong creative team, and intense interest from a North American distributor. We're walking on air.

July

Still trying to nail down that meeting with De Luca. Meanwhile Mark says, "Hey relax, dude! De Luca is, like, so into this project. It's gonna be jammin'!" So I try to relax. I check up on Mike De Luca and find that he can in fact green-light a movie—or, as one person puts it: "He is one of the few people in Hollywood who can actually do what he says he can do."

Todd and I struck up a friendship with Michael Stipe of R.E.M. last year, initially based on Stipe's passion for Todd's *Safe*. Michael has expressed a great deal of interest in working with Todd on a movie, hoping to function as a producer and to contribute to the score. His production company, Single Cell, has a deal with New Line. So it seems like fate: Single Cell will be the executive producers, Michael Stipe will supervise the music, and New Line will advance fifty percent of the budget against North America.

And where will the rest come from? Using New Line's interest, Scott Meek has gone to CiBy Sales, a foreign company that specializes in auteur directors. Some of their films include *The Piano* and *Secrets and Lies*. They're eager to put up the remaining fifty percent. Now if we can just get that meeting with De Luca . . .

August

Finally, I get the call from Mark Tusk. "Yo, De Luca's coming to town and is, like, totally into meeting. So, like, when's good?" We set up a meeting for the next day at Pravda, an impossibly cool bar in Soho. I am worried it will be too crowded, but Mark assures me, "I got the juice to get a reservation."

Todd and I meet up beforehand. We decide we should be seven minutes late—we don't want to be too eager, but we don't want to seem too nonchalant, either. "What exactly is going to happen at this meeting?" Todd asks. "I'm not completely sure," I say, "but I

think it's kind of a formality. I mean, Mark has assured me that
Mike is completely into the movie, but he does have to meet us
before we go forward."

We take a deep breath and walk into Pravda. It is filled with
smoke and sultry models. I spot Mark and De Luca in a booth, well
into their first cocktails. Mike is short and compact with jet-black
hair. He leaps to his feet as we approach, yelling, "Hey howaya!" in
a thick Queens brogue. We order drinks. Mark is drinking something
pink in a martini glass. De Luca is drinking vodka tonics. Todd and
I order the same.

Mike speaks rapid-fire, his eyes bright. He tells us he loves the
project. A bit pompously, I say something like, "I assume that you
want to work with us because you too can see that Todd is a True
Visionary—" and he cuts me off with, "Yeah yeah, I mean I do, but
I want to make this movie because I think it'll make a fucking
fortune." He orders another cocktail. We work our way through
the issues:

Cast: "I don't give a shit. It ain't a cast-driven movie."

Budget: "Ten million bucks, huh? So whaddaya need from us?
Fifty percent? Shouldn't be a problem."

He orders yet another cocktail, but it doesn't seem to be affecting
him at all. "I gotta run some numbers with the video guys and talk
to publicity to get you an exact offer. But we're in the fucking
ballpark. LET'S MAKE THIS MOVIE!!"

Wow. Business over, Todd compliments Mike on *Seven*, one of
Mike's pet projects. Mike preens. More cocktails. Mark has re-
mained silent during most of this, but now opens up and we all
chatter excitedly about the music Michael Stipe will bring, etc. One
more cocktail and Todd and I stagger out the door. We hit the
street and throw our arms around each other. Our movie is practi-
cally financed!

The next day I call Scott with the good news: "We shook hands,
he didn't flinch at fifty percent!" I tell him we'll probably get the
offer in the next week and he should alert CiBy Sales. I call Mark
Tusk, who confirms that the meeting went great and an offer will
be forthcoming.

September
The offer still hasn't come in. Mark assures me that the delay is
simply due to everyone being in different places, what with all the

film markets. Okay. We continue making the package stronger. Jonathan Rhys-Myers is cast as Brian. He is the Next Hot Thing—a mere nineteen years old with a handful of good roles in movies that haven't hit the screens yet, but the Buzz around him is as loud as it can be.

Then we get a call from Nicole Kidman's manager. He has somehow obtained a copy of the script and says Nicole would love to meet with Todd. We arrange a meeting in Los Angeles, and I dutifully call Mark and tell him the good news.

Other companies have got wind of our casting—and Ms. Kidman's interest—and want to know what's going on. Has New Line got this movie sewn up? I call Mark yet again and say, "What's up with the offer? I'm getting calls."

He reprimands me. "Show a little good faith! The offer is on its way!"

He calls the next day to say that one of New Line's presidents, Michael Lynn, had a few questions about the script. "Not that, like, it's a big deal or anything. But, like, could we get together and go over them?"

We meet at a neighborhood bar. Mark has a typed list of questions, mostly having to do with the homosexuality in the film and its depiction. I am wondering what this is really all about. Is New Line having second thoughts? Is the gay stuff scaring them? Todd is his usual articulate self and Mark scribbles furiously on a legal pad, muttering, "This is great stuff! Great!"

Todd has a wonderful meeting with Nicole Kidman. But the following week her manager calls to say that her schedule might not work. She is doing the Stanley Kubrick film with Tom (Cruise) and Kubrick is notorious for going way over schedule. We decide to keep our fingers crossed and wait and see.

October

Still no word from New Line. A little desperately, I call Michael Stipe's partner at Single Cell, Sandy Stern. Since he's in Los Angeles, maybe he can find out what's really going on and if there's cause for alarm. The fact is, even with our potentially stellar casting, no other company has come after *Velvet Goldmine* aggressively. Maybe that's because everyone thinks New Line is signed, sealed, and delivered.

I make an experimental call to Lindsay Law, head of Fox Search-

light, and tell him about Ewan, Jonathan and Nicole Kidman. I hint at how much we'd prefer to work with Fox rather then New Line. I go so far as to say that New Line has not got its shit together and we'd jump ship in a minute. He does not respond with much enthusiasm. My feeling from most other companies is that they need to see a completed film before deciding if it's their cup of tea—casting or no casting.

Sandy calls back. He and Stipe have finally tracked De Luca down. De Luca assures them that an offer will be in on Wednesday. *But . . .* it won't be for fifty percent. Maybe closer to thirty. I am stunned. Three months ago we had hardly any cast and De Luca offered fifty—now we have great cast and he's offering less! Sandy says at least an offer will be on the table and then we can negotiate from there.

Wednesday comes and goes. No offer.

November: London

I am in England, where Scott and I have a great meeting with Channel 4. The amount of money they are willing to put up might take the pressure off North America. Maybe thirty-five percent. An argument could be made that the film is more valuable in Europe than it is in the States. However, we still don't have a North American offer of any kind. I call Mark yet again. He says, "Things are a bit tough here because *The Long Kiss Goodnight* didn't open so well, but chill out, it is still totally alive, De Luca is still totally into it."

Meanwhile, Nicole Kidman has been on the Kubrick film for one week and it is already three weeks behind schedule. So it looks like that won't work out.

I get ready to leave England just as the London Film Festival is beginning. Mark Tusk calls to say that Jonathan Weisgal of New Line will be there. He will meet with Scott and the offer will be made after that. Okay. I call Sandy Stern. He gets Michael Stipe to call De Luca directly and demand that something be resolved.

November: New York

Scott calls to say that the meeting with Jonathan went very well. Jonathan apologized profusely for how unprofessional New Line has been up until this point. He was flying back to New York the following day and promised that an offer would be sorted out immediately.

As Scott tells me this, I start to wonder if I am insanely gullible or insanely optimistic. The sheer effort of having to appear *up! confident!,* so that none of our attached talent absconds, is exhausting. Already I have had Ewan and Jonathan's agents on the phone: "We hear your deal at New Line is shaky—is this a go picture or what???" I take a deep breath. "Who told you that? We're in great shape!"

Todd is starting to sense my concern. I tell him I am worried New Line will fall through. He is incredulous: "But he sat across from us and told us New Line was making this movie!" he says. I share his complete astonishment that people would not do what they said they would.

Once again, I call Sandy Stern. He says that Jonathan Weisgal just called to ask if Michael Stipe is planning to write any music for *Velvet Goldmine.* Sandy told him it hadn't been discussed but certainly wasn't out of the question. Jonathan said, "Can you guarantee me that he will write at least one song?" Sandy said, "Sure, yes!" "Great!" said Jonathan. "You'll get our offer tomorrow!"

Then Sandy says to me, "The only thing is, Christine, I think the offer may be less then thirty percent."

LESS???

"Uh . . . How much less?"

"Maybe closer to a million. But look, at least it's an offer. It's a place to start!"

Tomorrow comes and goes. No offer.

December

Wendy Palmer from CiBy Sales calls. Miramax has just made an offer of one million dollars. It's low, but at least an offer—*any* offer!—is finally on the table from North America. I call New Line and tell Mark that a competitor has made an offer. I won't tell him who or how much. He still seems sanguine about *Velvet Goldmine*'s life at New Line, although he does not use phrases like "good faith" anymore. I ask him what the hell is going on and he stammers and finally comes up with: "Well, you know, when you lost Nicole Kidman it was, like, really tough."

WAIT A MINUTE! "We never *had* Nicole Kidman!" I tell him, livid. "And besides, De Luca said cast didn't matter!"

Mark counters, "Look, I'm just as upset as you!"

I seriously doubt that and slam down the phone.

Three days later, Sandy Stern calls. "Did you get the offer?"

"What are you talking about?" I say.

"New Line is making an offer today!" Sandy is so excited he can hardly get the words out. I hang up and call Scott. "Did New Line make an offer??"

Scott says yes, they did. He is strangely subdued.

"Well???"

"It was for $750,000," says Scott. "I said, 'No thank you.'"

The hard part, looking back, is that I don't know what I should have done differently. I took meetings with the people supposedly in a position to make the movie happen and I believed what they told me.

Mark Tusk can only shake his head and suggest that his attempt to get *Velvet Goldmine* financed during his first few months at New Line was akin to Bill Clinton trying to get gays accepted in the military during his first few months as president.

CHAPTER 4

FINANCING: SHAKING THE MONEY TREE

The one reason you probably bought this book was to learn was where you can find money to make your movie, and that's the one thing I can't teach you. There are so many ways to get financing and none of them are wrong, except maybe robbing a 7-Eleven. Here, briefly, are your options:

- You can use your own money, which is really the *only* way you won't have anyone looking over your shoulder and trying—literally—to call the shots.

- You can use your family and friends' money, which can add a load of guilt to the disappointment if your film goes nowhere.

- You can create a limited partnership for all those legendary Guys with Money in search of the motherlode that is the Independent Cinema.

- You can get a grant, except you probably won't, because grants are drying up, especially government grants—at least in the United States.

- You can take the script and troll for a distributor or production company that believes in your film both commercially and artistically and is willing to translate that belief into a budget.

- You can sell the rights to Luxembourg, New Guinea, or any other foreign territory, and use those contracts to acquire loans or to lure domestic investors or distributors.

- You can shoot a small piece of your film, and then use it to dazzle potential investors.

Some producers like to use combinations of all of the above, and to draw their financing from two or three different sources. They think this gives them more control. After all, it's hard to argue with a studio when it's all their money. It's true that if you use a mix of, say, private investors, foreign distributors, and a finance company, you can sometimes divide and conquer.

On the other hand, that combination has a house-of-cards quality: If one entity pulls out, the whole thing can collapse. *Safe*, for example, had four sources of funding: a limited partnership; the now-defunct American Playhouse; Great Britain's Channel 4; and a German distributor. The film was shot in Southern California, and as I arrived in Los Angeles—literally, as I walked through the door of our new production office—a fax was coming in from the Germans announcing that they were pulling out.

The Germans' share amounted to twenty percent of the budget, which might not sound like a fatal loss, but none of the other investors were going to cash-flow a movie that couldn't be finished. I needed to prove that the film could be made for considerably less than I had told them it could, or else find the money somewhere else—and all of this eight weeks before production and with a payroll going. I called David Aukin at Channel 4 and, without telling him the problem, tried to squeeze more funds out of the station. He smelled what was happening immediately, which was probably a good thing. "You know," he said, "I just met some very successful theatrical producers who want to get into movies." That's how I

hooked up with John Hart, a producer of such smash revivals as *Guys and Dolls* and *Tommy*, who put in what we needed on *Safe* and who has gone on to work with us on *Office Killer* and *Dark Harbor*. At this writing, we even share office space.

The moral of this story is that while you might lessen your risk if you diversify your financing, you'll also have a harder time going to a source—as I can go to, say, October Films, which bankrolled *Happiness*—and convince them to enhance your budget. When the costs are spread out among several different parties, it's more difficult to reach them psychologically. Think of it this way: If you owned twenty-five percent of an apartment and three other guys owned it, too, how would you feel about springing for a new oven all by yourself?

DAVID LINDE
President of International Sales, Good Machine, Inc.

What has happened in the marketplace today is that distributors are more in the prebuying business than they used to be.

Why? They want to secure their release schedules and create assets; when you prebuy a movie you tend to get it for a long time, which creates an asset base. And it's hugely competitive out there. So how do you get the movies? You get them either by a) overpaying, or b) getting them *first*. Companies such as Miramax and Polygram and even Fox try to get them first.

Let's use Todd Solondz's movie to talk about international financing. There were two different ways we tried to finance it, and the way we did was ultimately an amalgamation of the two. Scenario A was to sell North America for about fifty percent of the budget, then go out and sell two major territories (say, Japan and Germany), and then get a bank to "gap" the rest, which means making up the difference in return for interest payments and some back-end participation. Scenario B was to get four major territories—Japan, Italy, Germany, and either France or the UK—to put up forty percent of the budget and then get each of those countries to put up an additional 2.5% as equity in the picture after the talent is hired. That way we'd have fifty percent of the budget, North America open, and a bank willing to give us a good rate on the other fifty percent.

What we eventually did was get several territories to commit to buying the picture, which we then used to convince a North American distribu-

tor, October Films, to fully finance it. So October gets a big piece of the foreign presales, though that's not so great, to have the world rights cross-collaterized like that. But the advantage is that we avoided all bank costs, which could have been as high as $350,000. The reason you want to sell such high percentages before going to banks is that the rates are unbelievably better if you can cover seventy or seventy-five percent of the budget yourself. Otherwise, interest and fees can rack up to as much as twenty-five percent more.

Internationally, the market is really changing. It has become very theatrical-driven because the home video marketplace is declining at a rapid rate—in certain territories, revenue from home video has dropped as much as fifty percent just in the last two years. And the value of television for any motion picture is defined by how it does theatrically, or by what the perceived theatrical potential is. So the way you presell a Todd Solondz movie is based upon two perceptions: first, that Todd is one of the most interesting young filmmakers working today, which gives distributors a certain amount of security bacause they know it will be original and it will have a theatrical life; and second, that the producers, Christine Vachon and Good Machine's Ted Hope, are not in the business of making anything other than original theatrical motion pictures, and ones that important critics will pay attention to.

The surest way to have complete autonomy over what you shoot is to use your own cash, which is more common than you'd think in these days of government arts phobia. Around the Independent Feature Project, you'll find a lot of moneyed people, the sort of entrepreneurs who used to invest in computer businesses, hot dog franchises, and other get-rich-quick schemes. Now they're making independent movies because they think they'll get the brass ring.

MOVIES FROM NOWHERE?

You ask: What about those mythical Films that Come from Nowhere, the ones made by little geniuses working in a vacuum? Alas, that's not usually how it works. First, there is no vacuum. Every company has trackers who keep tabs on every piece of production, so most of the time those people have sniffed around, read the script, and already formed an opinion on the project. Then there are the films like *Go Fish*, which do originate in the Land of Nowhere, but by

the time you see them in theaters they have been guided into port by experienced hands. Edward Burns' first feature, *The Brothers McMullen,* arrived from Nowhere as a shapeless mess in which the head of Twentieth Century Fox, Tom Rothman, somehow glimpsed a movie and asked Ted Hope and James Schamus of Good Machine to step in and unearth it. The film released to theaters did not emerge, fully formed, from the mind of Edward Burns. There were real pros laboring to make it a hit.

Many of the independent films that get plucked out of obscurity at the Sundance independent film festival are made with money from people's credit cards, or with bank loans or college loans or bingo games or garage sales or bake sales. Or else they're financed by people who all have the same last name as the director. They often take a long time to shoot—months or even years, in spurts. (*The Brothers McMullen* was shot on weekends over eight months.) No book can really tell you how to finance a movie like *Go Fish* or *Clerks* or *She's Gotta Have It.* They just kind of happen. They tend to grow organically out of something in the filmmaker's life and are dependent on odd circumstances:

> *"Hey, I'm working in a film equipment rental house and I got all this film from a movie that just wrapped!"*

> *"My father says we can use his restaurant at night. Let's make a movie about a restaurant!"*

They usually don't have any actors to speak of, so they don't have to deal with the Screen Actors Guild. And they don't play by the rules that say: Never put your own money into a movie; never mortgage your house to make a movie; never think you can make a movie with nonactors. All those things go out the window, and when they work it's because of some weird, magical zymurgy of charm and ignorance, and a freshness that makes them seem totally new (even when their stories are old-fashioned). Of course, the media doesn't write up the thousands of people who *do* go into bankruptcy, lose their houses, etc. For every *Go Fish,* there's a hundred *Go Brokes, Go Crazys* and even *Go to Jails*.

SHAKING THE TREE

If the money doesn't come from your own pocket, make sure that you understand the implications of convincing people to invest what they can't afford to lose in a venture that will almost certainly lose it. (I know that you, personally, are the Great Exception, but I'm addressing the Statistical You.)

Occasionally, you can also find people who are passionately interested in the subject of your film. *Postcards from America* was partially financed by a rock musician, Jimmy Somerville, who was a big fan of the stories on which the movie was based. As I wrote in the first chapter, my partner and I were contacted by a wealthy ex-Nebraskan when he heard we were developing a film based on a murder that happened near where he grew up. And when Bill Sherwood made *Parting Glances,* he raised money in dribs and drabs from gay men who wanted a movie about their actual lives instead of the fist-fucking serial killers of pictures like *Cruising* (although I loved *Cruising*).

A limited partnership, in which you have many investors, is a huge undertaking; an agreement can run to hundreds of pages and drawing it up can cost tens of thousands in legal fees. Ten or twenty years ago there were tax incentives for that kind of investment, and all those plastic surgeons and orthodontists didn't mind as much if the money went down the drain. The tax laws have changed, however, and people who lose it really lose it. You must (for reasons both *moral* and *legal*) let them know that an investment in a film is incredibly risky. That doesn't mean, however, that you can't pitch them hard about how talented you are, how glamorous the movie business is, and how exhilarating it is to see their names in print in the end credits.

It used to be that you could get federal or state money to make independent movies, but government grants have mostly dried up, and the National Endowment for the Arts—the folks who helped bring you that infamous piece of homosexual backwash, *Poison*—continues to get hacked at and pilloried. There's no point in moaning about not having access to that money anymore because you don't and that's that. Anyway, does the world owe every Generation X twenty-five-year-old $500,000 to make his or her first film? In Canada and Britain they seem to think so. I can argue both sides of the fence quite easily. Yes, I've benefited from government grants and

probably wouldn't have made some of my movies without them. Filmmakers such as Atom Egoyan wouldn't be as accomplished as they are now without the opportunity to sharpen their craft on small, uncommercial, well-subsidized art movies. On the other hand, I once met a non-U.S. filmmaker who'd received from his government a considerable sum (more than I'd ever had at that point) to make what I thought (although I didn't say) was a lousy movie, and I was genuinely offended by his indifference to the prospective audience. "I don't give a damn who sees my movies," he said. "That's not why I make them. I make them to express myself, and if nobody sees them, so what?" I responded that I don't think a film is really alive until people *see* it. If there's no audience, all you have is a celluloid trophy.

PACKAGING ON A SHOESTRING

What should you show a potential financier? A script and a budget, certainly, and perhaps a cinematographer and designer, which will always make the package stronger. Some people think it's wisest not to send out a script until elements are attached, since you don't get too many shots to pitch your sale. But no distributor will give you the green light simply on the basis of a cinematographer. For a film we're developing now, the writer-director Josh Goldin has a good shot at getting Philip Glass to do the music. "Isn't that good?" he asked Pam, hopefully. Yes, of course, it's good—it's great—but in terms of financing, it's absolutely meaningless. In the end, what matters most is who's in front of the camera. Casting has come to play an increasingly large role in preselling a film both to foreign markets and distributors.

When should you go out? How wide? I suggest you do it systematically, that you choose two or three companies you think will understand what the project's about, and if all of them pass, go wider, to more long-shot companies. A script is only new once, so you shouldn't go out too often. All those junior executives at all those companies go to the same free parties. Junior Exec A says, "Did you read that pedophile script? It's entertaining, but my boss won't touch a film about a pedophile with a ten-foot pole." So Junior Exec B goes back to his or her office and says, "You know, Junior Exec A's company passed on that script." Of course, people pass on things

all the time, so it doesn't always mean the project's doomed. But after a while your currency gets devalued.

The hardest thing can be getting people to say no. No one quite wants to. They want to leave that door open just a little bit. So they say, "*Welllll,* if you do a *tiiiny* bit more work on the script . . ."— when usually, with those kinds of projects, it doesn't matter how much work you do on the script, it's not going to change what they don't like. But that door is open in case . . . in case . . . You're dealing with a world of professional bet-hedgers.

Remember, though, they're all hungry, all looking to get a bead on the zeitgeist. That knowledge comes in handy when it's time to do the Pitch.

A FIT OF PITCHING

In a sense, pitching should begin from the first moment the director communicates with the producer. When Todd Haynes says to me, "I have this idea about a woman whose environment starts actually to kill her," I'm instantly mulling over its life in the market-place: "Environmental poison . . . untraceable . . . all these support groups for people with undefined maladies like chronic fatigue syndrome . . . the horror of modern society . . ." I have to get distributors and finance people to see its potential. And it's important that the directors you work with are capable of articulating their visions, too: If they can't do it with a financier, they probably won't be able to do it on the set.

Even at this stage, financing entities are scrutinizing your project for marketable elements that will distinguish it from the morass of independent films. They want a director about whom good copy can be written: A black teenager like Matty Rich, who made *Straight Out of Brooklyn* on a shoestring. Someone who acquired fifty credit cards and ran each of them to the limit. Someone who used film they stole while being a production assistant at the *Today Show.* It helps if they're attractive. And it helps if they're male. I'm usually reluctant to spout stuff like: "If you're a female it's so much harder; if you're a male it's so much easier"—I hope it's a *little* more compli-cated than that. But I do think that the machine works better with boys. People are more familiar with the whole idea of a male direc-tor, especially when he's a maverick who's bucking the system. We

did, however, get lots of ink for Rose and Guin from *Go Fish* because they were extremely presentable and very articulate.

As I wrote in the second chapter, one thing I don't like is when people describe a project as, say, "It's a cross between *Go Fish* and *Pulp Fiction* with a touch of *The Full Monty*." I don't want to do that arithmetic. When I said as much on a Sundance panel about "pitching" recently, the other speakers—studio executives, producers, and distributors—laughed in agreement, but went on to direct the audience of aspiring filmmakers to cite as many successful movies in their pitches as they could. It's a way of life in Hollywood—a bum's shorthand. The films I produce tend to be, for better or worse, *sui generis*. Comparisons are rarely tempting. Trying to raise money for *Safe*, Todd Haynes and I enthused to prospective financiers that he wanted the movie to evoke the same kind of claustrophobic dread as Chantal Akerman's *Jeanne Dielman*. This sounded bad if they hadn't seen that film—three and a half hours of a housewife's lonely domestic rituals—and even worse if they had. *Jeanne Dielman* is a masterpiece, but it's difficult to imagine someone giving you three million dollars to make a picture just like it.

Besides, there are much more compelling techniques for putting across the originality of your vision. For *Velvet Goldmine*, Todd assembled a book of images from the glam-rock era: David Bowie, Bryan Ferry, T. Rex. The pictures were outrageous and enticing; they conjured up the wild energy and wayward allure of that period in a way that no glib comparisons ("It's sort of *Citizen Kane* meets *The Man Who Fell to Earth!*") ever could.

While we're on the subject of pitching, I feel compelled to caution you about pushing a script on producers or distributors at festivals or conferences or anywhere else you find them suddenly accessible. I never accept a script that way, which might be my loss. But I have good reasons: first, I'm usually busy and distracted; second, they're heavy, and no one wants to lug extra weight on a plane; third, I might lose one, and I don't want to have to feel guilty about it; and fourth, there are people in my office who'll give them a much less impatient first read. As a rule, I think it's smarter to cultivate a relationship with someone on the bottom of the totem pole—someone who'll pay more attention to you and perhaps become an energetic advocate.

Sometimes you can convince an established filmmaker to serve as "executive producer," an elastic function that is often ceremonial.

People like Oliver Stone and Sydney Pollack often take this role. David Cronenberg is helping to get *I'm Losing You,* Bruce Wagner's tumultuous Hollywood tragicomedy, financed, and it needs him. The project came about because I wrote a review of Bruce's novel in the magazine *The Advocate.* (I'd never done a book review, so I was flattered when they asked me.) The review was a rave, and the fact that it came from a producer must have been, for Bruce, a sign from on high. He called and asked if I'd produce the movie, and I said no, I'm too busy. But Bruce can be persistent. The script was incredibly dark and difficult to finance, like everything else I seem to have my name on these days; so I said, "What the hell," and Pam and I took it on. When David Cronenberg, who's friends with Bruce, agreed to serve as executive producer, his relationship with a couple of Canadian companies meant that financing in the two-to-three million-dollar range was suddenly possible. I can call him up and say, "David, will you make this call on our behalf?" and he will. He's being a good godfather.

On *Velvet Goldmine,* one of our executive producers was Michael Stipe of R.E.M., and he did a bit more. Michael was on set about half the time. If we were shooting a difficult scene and Todd Haynes was preoccupied and some bigwigs decided to pay us a visit, I could say, "Michael, these people are coming to set. I want to keep them away from Todd, but I also want them to feel looked after." He was surprisingly comfortable with my exploiting his celebrity for the film's benefit, and sensitive about helping to protect Todd.

INDIE DEPENDENTS

In a conversation with me that was hosted by and written up in the *New York Times,* the big-deal Hollywood producer Lawrence Gordon (*48 HRS, Waterworld*) defined an independent film as purely and simply a film that's for sale, financed in such a way that it doesn't have any distribution deals attached, so you make it the way you want and then take it to the market. I haven't worked that way in a while, although I had some exciting times in that position. There's nothing better than taking a movie to a market and having it become the object of a bidding war. But there's nothing worse than taking a movie to a market and not having someone want to buy it.

What does it mean when a company puts money into a movie? What kind of creative control do they have? How do you protect yourself? If you're a neophyte with a long-shot film, you're pretty much at their mercy. I have a track record, but the thing I argue most about with the companies bankrolling my movies—distributors, investors, studios, whatever—is approvals. I have the right as a producer to approve all creative choices: the actors, the cinematographer, the production designer. And they, of course, have the right as financiers to approve them, too, right? Sure. But what happens if we disagree? Who breaks the tie? It gets sticky.

I don't want to overemphasize the importance of autonomy. The other day I was shanghaied by a European filmmaker who went on and on about how he was finishing his movie with his own resources because he didn't want any dumb investors or distributors telling him what to do. Now, maybe he's sitting on a masterpiece. *But he should be so lucky* if some dumb distributor wants to buy his film and give him advice on how to edit it. One reason Kevin Smith was delighted when Miramax bought *Clerks* was that he had the chance to make it better, to fine-tune it on the company's dollar.

One of the biggest problems with being accountable to one entity is that most people, even in the business, don't know how to look at dailies, rough cuts, or assemblies and make any kind of real assessment. I've seen financiers become concerned about actors' performances based on dailies, not realizing that if you look at seven takes of any actor doing a scene, he or she will be trying different things, and the director will be asking for different things. Maybe only one of those takes is good, but *one is all you need.* I'm always nervous about financiers seeing dailies. But it is *absolutely their right,* and all you can do is let them see the footage and have their say and try to talk them out of any wrongheaded ideas.

JOHN SLOSS
Entertainment Lawyer

People who are lawyers in the studio world have a much narrower set of issues to address each day than lawyers who work for independent filmmakers. It's still all about contracts, but for independent film lawyers the issues that come up within the context of getting films financed from around the world, and obtaining the kind of control that indies seem to prize more than people who work in the studio system, bring additional complexities.

You'd think that independent distributors who finance independent movies would be more sensitive to the desire of filmmakers to control their projects, but the paradox is that they can often be less sensitive and more obtrusive; they have more at stake in any given film than, say, a large studio that is financing a film at a low budget. Some of the best experiences I've had with independent-type films have been at studios where the budget is sufficiently below the radar that they trust the directors and producers enough to let them go off and make their movie. To Fox or Warner, $2.5 million—that's interest on interest. That's *tips*. But at, say, October Films, that's their bottom line, so they're going to make sure the project comes out right—often by trying to retain more control than someone else might.

If you do have a situation like that, a fairly common legal strategy would be to make your filmmaker "pay and play" for a couple of weeks of photography. Let's say that he or she has written the script and wants to direct for the first time. There's motivation on the part of financiers and distrubutors to say, "We already have the script, so let's get someone who really knows how to direct, who has experience." For the writer, that's one of the worst things in the world: here's something that has sprung from your head, that you've developed, that you've fashioned into a script worthy of being green-lit, all so you'd be able to direct it—and you're fired. The compromise that the lawyer can now propose is that the writer be "pay and play," meaning they *can't* get fired during the first two weeks of photography—which gives them a fair opportunity to show they're either competent or incompetent. What you're saying is, "You can't treat me like a hired hack."

Another thing that independent film lawyers oversee is optioning properties, especially books. The challenge there is that the producers don't have much money, so they can't pay a lot up front. Whereas if someone who works for a studio buys a book, you know they're paying retail. What you have to do is convince the people whose properties you want to option that they're not going to get rich from *granting* the option, but they have a chance to get rich from what's made. Since there's a wildly varying potential range of budgets on independent films, the best way to approach those options is to pay low up front for the option, and then an option-exercise price that is tied to a percentage of the budget, so that it can slide up and down.

The earlier the money comes in, the more you have to compromise down the line. I dedicate a lot of my career to keeping people from selling a disproportionate amount of what they have for relatively little

in times of need at the beginning of a project. I know that sometimes that need is great, and that there are a lot of struggling would-be film-makers who can't pay their rent or buy groceries. So I find myself saying, "Look, I'm not in a position to pass judgment on how much you need this money. I'm a lawyer. If you need this money, I'll take you at your word. But this is what you're giving up. . . ."

You sometimes make wrenching sacrifices for the kind of cash a company will give you. On one of my films, for which the financing was in a state of near-collapse, the principal backer decided that a condition for giving money was to make the director and the star "essential elements." That means that if something happened to them—if, say, in the second week of shooting, one of them got hit by a truck and died—the film would cease production, and they'd get all their money back.

The problem was the insurance exam, which is more complex for those deemed essential elements. The company wants to know: "Will this person live for the next ten weeks?" It wants X-rays, an EKG—and something else, which we didn't know about in advance. I got the news from one of those essential elements, who called me from the hospital in a panic: "They're making me take a drug test! And I'm not going to pass."

The person smokes pot. Little alcohol, no hard drugs, but more than an occasional toke—although never while working: only at home, before bed. "Are you sure it shows up in your blood?" I asked, innocently.

Ha. I'm an authority now. It stays in your bloodstream for *six weeks*.

I called the executive producer, who said: "That can't be what they're testing for. It must be hard drugs." Ironically, though, if you're a cokehead or a heroin addict, relax: Those things go right out of you, a few days and they're gone. And you can also be the biggest alcoholic on the planet, but they won't test for that.

The insurance company called the executive producer and said, "One of your essential elements failed the drug test. We'll only insure the movie if a drug test is administered every two weeks." The executive producer informed me in no uncertain terms that the person would have to stop smoking pot. "It's four weeks before the start of a major film," I said, "and you're telling me you want to eliminate this person's one source of relaxation?" The executive pro-

ducer—a chain smoker who can drink to a state of near-blackout—
tsk-tsked: "Well, you know, Christine, it's not legal."

So I went and found a Dutch underwriter. In the Netherlands,
marijuana is legal.

The insurers blew a gasket when they thought they'd lose all our
money over what was clearly a trivial issue. "Hold on, hold on, hold
on," they said, suddenly ready to bargain. "Okay, the essential ele-
ment doesn't have to take any tests. But we'll need a deductible
against drugs." A lot of this person's salary ended up being withheld
until the picture was completed, although everyone—eventually—
got paid. I know, marijuana is illegal, and I'm not advocating its
regular use. But hassles like that are the reason filmmakers swear
off making big-budget movies.

FOREIGN AFFAIRS

Another way to go is to do a couple of foreign sales, and then get
a bank to finance you based on the strength of those sales. You can
worry about an American distributor later—if you can prove you'll
make your budget back on the foreign sales, then North America's
gravy. Or you can attract foreign distributors on the strength of one
investor. On *Kiss Me Guido,* which had a budget of around $800,000,
we found a guy who was willing to give us some money against the
North American rights, and then we managed to convince a foreign
sales company—partly on the strength of my and Ira Deutchman's
reputation—that putting up fifty percent wasn't going to bust them.

Who buys foreign sales? For the most part, you can name the
two or three people in each country who will be interested in an
American independent movie. For each country, a sales agent makes
an estimate of what the film will be worth, then shows the estimate
to the company you hope will finance the picture, saying: "See, this
is how you'll make your money." Actors are a key factor in predicting
foreign sales. You always hear people saying, "That actor means
nothing foreign." Or: "That actor's not so big here, but he's really
big foreign." Because *Velvet Goldmine* has a bona fide international
star in Ewan McGregor, the prices it has fetched in foreign markets
have been higher than anything we've gotten before.

You can cobble together your production costs out of foreign
presales, but you need to know what you're doing. You can't walk

into a foreign sales office and say, "I want to make this movie, this is who's going to be in it. Can I have $50,000, please?" You usually don't get the money until you give them the film. So how are you going to handle your cash-flow in the meantime? You get a bank to do it. Or you get an investor who charges you a financing fee in order to "cash-flow" your contracts.

A few years ago, a lot of film distributors in various countries relied on television financing. The German and the English stations in particular were responsible for many American independent films being made. The process worked like this: In England, Metro Pictures negotiated to buy your movie. Meanwhile, they made sure that they could turn around and sell it to Channel 4, which offered them the equivalent of $60,000. So Metro offered you $40,000 for the U.K. theatrical and television rights. Their assumption was that even if the release was a total disaster, they'd still have their back end covered.

In that situation, you could always say, "Screw you! I'm going to sell it to TV myself." But then you'd never see the film in theaters because it's more difficult—especially with "challenging" indie movies—to sell theatrical rights if TV rights aren't available.

The situation changes by the day, however. A lot of the stations that bought independent movies were government subsidized. They're on their way out because of Skychannel and all the alternative cable channels. Channel 4—which now distributes theatrically—is thriving, but that's because they've made some smart choices. A lot of the others are sinking fast.

PIECES OF THE ACTION

Should you shoot a film in pieces? *Living in Oblivion* was made in two chunks. So were *Go Fish* and *Swoon* and a lot of independent features you know and love. But I'm not sure I want to *advocate* this practice. It's one of those things where if it works it's a good idea, and if it doesn't it's a bad one (like putting your own money into movies). You don't see the hundreds of films that were started that way, didn't get finished, and never will. The scenario goes something like this: You run out of money; you lug what you have around to show people; you wait; you lose all your momentum; and the film becomes old news while people are looking to get excited about the

next new thing. Plus, you can have serious continuity problems, the way we did when an actor in *Swoon* showed up after a hiatus twenty-five pounds heavier.

Let's say then, here you are, trying to finish up your movie. You hit the What Do We Do Now? stage, in which the film is half-cut, but you don't have the chunk of change you need to get it to that 16mm release print—anywhere from $10,000–20,000, depending on how much sound work needs to be done. That's when you either hold another bake sale (or any other kind of fundraiser), go back to your parents for more money, or sometimes, start showing what you have to distributors. That's when it gets tricky, because if you're showing something to a distributor in that state, you're a fire sale, and they know it. You pretty much have to accept what they offer.

The makers of *Go Fish* did one shoot on their own for maybe seven or eight thousand—no one knows for sure, because no one kept a careful accounting. Rose Troche, the cowriter, coproducer, and director was working at a school, which is where she got her equipment, and her cast was largely friends and neighbors, so her expenses were mainly 16mm film and processing. When she came to me with what she had, I put in about five thousand of my own money to keep it alive and meanwhile shopped the half hour or so to distributors. No one got it. One executive was so bored he started talking to me halfway through about the restaurant where he'd gone the night before.

I had told these girls that I was going to get the money for them, and I really believed I could. Much later, when I started to meet more monied lesbians, they'd say, "Oh, if you'd just come to us." Yes, I could have tried to find those mythical lesbian accountants and lawyers and doctors, but at the time I didn't know anyone. So I finally went to John Pierson, a successful producer's rep who had a company of his own and a good-sized finishing fund. He was also skeptical, but to his credit, finally said, "It's not that much money: Let's just do it." He bankrolled us $50,000 at that point to finish shooting, do the post, do the sound mix, and get the film to a release print. It wasn't long before he knew he'd hit pay dirt.

What happens if you can't raise the kind of money you need even to start your feature film? Make a short so you'll have something to show. You can save up four or five thousand, borrow equipment, or find a "young filmmakers" organization (most cities have one) where you can rent it cheaply. If you shoot day exteriors only, you won't

need lights. You can buy short ends, leftover stock from other movies. It's a good idea to have several shorts on your resume. Ted Hope of Good Machine won't even consider doing a feature with a first-timer who hasn't made a short film. I will, but I understand Ted's point.

So start saving up. Hit on your parents. Cultivate rich friends. Find a big pool of investors who'll each invest a little money. Convince some bankable star to be in your movie. Or come up with an idea that's really commercial—and don't say "Commercial? *Moi?*" because this is a commercial art form, even for people who fancy themselves the Last of the Independents. Most important, think about who your audience is and pitch your film accordingly. If that audience is Buddhist cello players, great, but maybe that's a movie that shouldn't be made for five million dollars.

DIARY INTERLUDE
#2

I SHOT ANDY WARHOL

Production

- **DAY 1**

We are in Newark, New Jersey, in a welfare hotel.
Stephen Dorff takes three hours to be made up as Candy
Darling and we all get nervous. Does he really want to
play this part? Finally he emerges and gives a wonder-
ful performance.

- **DAY 2**

First day in the Hotel Kellor—very depressing. We are
ready to shoot at exactly 8:30 A.M., but the camera is
broken. No problem. We have a backup. No, we don't.
The camera department is vague about why it's not there.

We call every equipment house in New York, but all the cameras appear to be rented. We finally find one in Queens. Someone is dispatched, but it will take three hours roundtrip. Meanwhile, everyone is sitting around. The AD keeps muttering that if production had been more on top of things . . . until I snap and tell him we've done every fucking thing we can. By 1 P.M. we finally start shooting and somehow, miraculously, make the day.

- **DAY 3**

We are in Nedick's. I hope that Stephen can pull off the comedy. Jaime Harold is astonishing as Jackie Curtis and keeps wrestling the scene away from Stephen. Mary Harron, our director, wants to add him into the next scene. But she is getting nervous about Yo La Tengo. She has suddenly decided they are all wrong as the Velvet Underground. Ultimately, she changes her mind. Martha Plimpton's dog walker did not show up, so a production assistant has to drive up to her house and get the dog.

- **DAY 4**

Outside in Washington Square. A pretty day and crowds of people around. The actors are upset with their cubicle dressing rooms in Washington Square Church—I can't wait until we're at the Warhol factory set and they all have to use Porto-sans. Stephen is very worried that onlookers will take pictures of him in drag. Although he's playing a quasitranssexual in the film, he does not want pictures of himself in a dress getting around. Tom Kalin, my coproducer, beeps me 911. He has just spoken to Stephen's agent at ICM who chewed him out for allowing any stills to be taken—which according to him is BREAKING OUR VERBAL CONTRACT, which according to him is BINDING IN THE STATE OF LOS ANGELES. We might have to track down and destroy all the negatives, or the state of Los Angeles will come after us.

- **DAY 10**

Street theater on the Lower East Side. BEDLAM. Mary is yanking art department personnel and making them featured extras. That's against union rules. By the time the AD informs me what is going on we are on our third rehearsal. What to do? If we yank the

Tahnee Welch in all her fabulousness

illegal extras, it could take at least an hour to reset—bad, especially given Mary's trapped-animal state of mind. And the skies look like they are about to open up. We go for it. I know an extra is going to rat on us.

• DAY 11

First day in the Factory!

Tahnee Welch hates her hair. Jared Harris is astonishingly like Warhol. He says that Tom Kalin told him that we were getting him colored contact lenses. We're not. He reacts to this news with great distress. We finally secure very expensive alternative dressing rooms for Lili, Jared, and Stephen, but they look at them and decide they'd rather stay in the stinky ones they already have.

I've asked Chris Makos, the photographer and former Warhol sidekick, to take some photos on set. Kind of a publicity stunt. Billy Name, Chris' predecessor at the Factory, is here, too. He is walking around and exclaiming how extraordinary this all is, how it brings him back. Just the couch is not quite right he says—and the columns were round instead of square. But otherwise it is perfect. And the energy is the same. Chris and Billy discuss the Andys they knew. Billy says the post-shooting Andy was the cardboard Andy; he says Andy never knew if he died then or not.

Lothaire Bluteau's producer from the movie *The Confessional* calls to see if we could please please let the actor go to Cannes since the film is scheduled for the opening night of the Director's Fortnight. It is ironic since I am trying to get Julianne Moore released from *her* movie to go to Cannes for *Safe*. I'm mean at first, but then I calm down and try to figure out a way to make it work.

• DAY 14

Cindy Sherman visits the Factory. *Office Killer,* the horror movie script she's working on for us, is coming along very, very well. She asks if her step-daughter can PA for us on *Warhol*. I say sure—then I realize it's Viva's daughter, and she'll get to watch Tahnee Welch playing her Mom. Weird.

Crisis. The Maria Callas aria that was sent over for Jim Lyons (as Billy Name) to lip-sync to is the famous one from *La Wally* that's played over and over in *Diva*. Mary insists we can't use it, so we have to go with an aria that we haven't cleared; I tell Jim to steer clear of consonants in case we have to replace it. Mary asks me, "Am I being silly?" and I say, "I don't know." Part of my role is to support a director's sometimes obtuse way of getting what he or she needs. Mary could be right.

• **DAY 15**

Mary decides that Billy Name should shoot the screen tests within the film, as he did twenty-five years ago. Tom and I are a tad skeptical (the originals were said to be rather dark), but Mary thinks that for the Sake of Authenticity it's essential.

• **DAY 16**

I am in the office. Hysterical call from set. Billy Name's screen tests are unusable; they're practically black. The whole morning is spent reshooting them. We do not start shooting what we're supposed to shoot until 5 P.M. MUCH finger pointing, blame-laying . . .

But our dailies look wonderful. All the actors seem to be becoming their parts: There is a constant sense of delight as the cast re-creates these people, those times.

• **DAY 17**

The *Voice* prints what I think is a decent article about the movie BUT much unhappiness ensues. Jared is furious that his photo was printed. He thinks it's important to keep a lid on his Warhol "look"—and I think he is right. He tears up the paper in front of Tom. Stephen is upset because the article says he is "temperamental." He and Jared confer, and then Stephen accuses Tom of being friends with the writer and therefore responsible for the dig. Who knows? I think the writer just overheard something on set.

Today we are shooting Andy Warhol. Massimo (playing Warhol's assistant, who was shot in the butt) called last night in a panic that his butt would really get shot. He wanted to know if he could get a bullet-proof butt cover. Katie assured him he would definitely not be really shot in the butt.

The day is unbelievably long. I'm stuck in the office on a horrific

conference call with Miramax about *Kids*. When I get to the set, everyone seems calm albeit tired.

One of the electricians has started an irritating habit of drinking a cocktail *just* before wrap. It is a clear "fuck you" and it is driving me crazy. Tom spoke to him this A.M. and he seemed to agree to knock it off, but then he went ahead and did it again today.

• **DAY 22**

Jared is nervous that he cannot play Warhol at Studio 54 without a major makeover. He thinks that he doesn't look enough like Warhol at that point in his life. "Why don't you just get another actor?" he says. I bite my tongue and try to placate him.

One of the actresses wants an advance on her salary and keeps walking up to people and asking them if they are Christine. I am laying low.

• **DAY 30**

We start Week 6. Everyone seems a little worn out. Ellen Kuras, the DP, takes me aside and says that the crew has been grumbling. I feel weary: The weekend before I had taken them all out for drinks at my own expense. The day gets very late and very very tense. I retreat to my office.

• **DAY 34**

Chelsea Hotel. Very miserable owner, hates the way we moved the art around, *demands* we put it back the way it was, won't have good name of the Chelsea sullied, etc. The denizens are irritated and scary. Someone keeps pulling the fire alarm.

• **DAY 38**

The end is near. We're at Studio 54, and Jared, despite his anxieties, looks astonishingly like the older Warhol. The place is cavernous. Richard Harris, Jared's dad, comes to the set and hangs out. I imagine him saying to his son: "This is how you let them treat you?? Where's your trailer?? If you want to *be* a star you have to *behave* like one!"

ACTORS: HANDLE WITH CARE

Producing *Safe,* I had an opportunity to watch Julianne Moore at work. In the role of a woman who felt as if her environment was attacking her, she lost twenty pounds, and she was thin to begin with. She walked around weak from hunger, and she began to acquire an almost luminous fragility. Seeing up close what truly great actors do to their bodies—and their minds—brings it home: *Actors are not like other people*. If they were, you wouldn't want to sit and stare at them for hours—to read their inflections, ogle their bodies, or project yourself into their heads.

The camerawork might be shaky, the plot might have holes, the audience might not even know what the film is about, but if your actors are compelling you can still keep people in their seats. On the other hand, if a movie looks great but the acting stinks, that's all that anyone's

going to notice. The unavoidable conclusion is that actors are the single most important element in a film. It's certainly the conclusion that actors and their agents tend to draw.

Attracting, auditioning, and casting actors is not a science but an art, and keeping them happy is a black art. Still, it's not hard to master, as long as you understand the fragility and the preciousness of the elements that you're handling.

THE RULES OF THE GAME

First, though, you need to know the rules. The Screen Actors Guild exists in part because actors are so desperate to work that they could otherwise be easily exploited. As a consequence, SAG completely regulates what you can do with members of the union. If they're not members of the union, you can do whatever you want (and pay them about a fourth of what they'd otherwise get), except you need a special agreement to mix SAG and non-SAG actors, and you won't find many decent actors who aren't in the guild. On films like *Go Fish,* in which Rose Troche used people from her neighborhood, or *Kids,* in which Larry Clark wanted teenagers who hung out in that grungy milieu, we didn't need a SAG contract. And plenty of successful low-low-budget movies—*Slackers, Clerks, The Brothers McMullen*—are cast with the director's friends (and often with the director): A tinge of amateurishness gives those films their realism and their distinctive tang. If you don't have much money and you want to take the elements of your life and riff on them, then you probably know who you want for which parts anyway. (I recommend you audition everyone, though, even if you call the process something else, so that you know what you're getting. Otherwise, you might have a nasty surprise when the equipment is rented and crew members are standing around, glaring.)

However exhilarating it is to discover and mold great natural actors, doing a non-SAG film and doing it well takes a tremendous amount of effort. Luckily, SAG has different contracts for different kinds of budgets. It also has an experimental or limited exhibition contract, which allows you to pay your actors substantially less than the basic, low-budget agreement—with the proviso that the film can only be shown in a handful of theaters or film festivals, and that the second it exceeds that number you have to renegotiate and come

up with a lot more money. I had to do that on *Poison* and *Swoon* because the films got bigger distribution than we had contracted for.

That sounds like a no-lose situation: Pay as little as you can up front, and if the film hits big, you have more money from the distributor to upgrade. Except that sometimes, with your movie ready to open, an actor will hold you up by saying, "I'm not going to accept scale. I want triple scale." Some distributors will actually be scared off if you owe your actors too much—they think they're going to get stuck paying the upgrades. You're expected to deliver a movie that can play anywhere. And if your film doesn't prove successful in the wider marketplace, those upgrades could eat up all the money the distributor gives *you*. On *Poison*, I didn't renegotiate until the movie was playing in theaters, after the distributor asked (following the NEA commotion) if it could put the movie into wider release. On the next film, *Swoon*, I renegotiated the second I had an inkling that a distributor was about to bite.

Shorts are a no-brainer; they're unlikely to have a vast commercial life no matter how good they are. Otherwise, my feeling is that unless you really believe your movie will be shown in only a few venues, go with the basic low-budget SAG agreement and don't mess around with limited exhibition. If you have commercial aspirations and are trying to pull a fast one (which many producers do), SAG will sniff you out right away. *Poison* and *Swoon* genuinely were made with limited exhibition in mind; they ended up hitting in a way we didn't anticipate.

You can always call SAG to get their rule book, which is as thick as a Bible and much more zealously enforced. It's a difficult read, but if you're planning to produce films you should familiarize yourself with it. I've seen even the most experienced assistant directors clutching their rule books and ruminating aloud: "If we give them breakfast now, are we allowed to . . ."

The standard salary for SAG actors on low-budget films is scale plus ten percent. At the time of this writing that's approximately $1800 a week. It makes things very simple; if an agent asks for more I say, "You know what? It's a prestige movie and it's scale plus ten for everybody. If your client won't work for that, I understand, but it's all we can pay on this film." Often, if a name actor accepts that salary, his or her agent will ask me to make it confidential. I respect that. The agent doesn't want it getting out, or else *everyone* will want to pay scale. (In a way, I'm lucky because my reputation is

such that I rarely get into salary disputes.) Of course, sometimes I do pay more than scale—it depends on the actor and the film.

Some producers negotiate deferments if they don't have the money going in, but I'm more likely to sweeten the deal with back-end participation—say, a percentage of the net profits for actors who are carrying the film (as Julianne Moore did in *Safe*). That says: "I know you're working for less than you're worth, but you're part of the team and if the movie does well, we all do well. We're all in it together." It's not always an option, though. Sometimes your financiers don't allow it, or the points you have to play with are too small.

SAG also tells you how you get your out-of-town actors to the set—with a first-class plane ticket. That's prohibitive on some films. You can make it clear to the actors going in that if they live out of town and want to be in the movie, they have to be "local hires." This isn't always the fairest way to do business, but if the role is juicy enough, an actor will decide to put him/herself up in another city to be in your movie.

The key thing on a low-budget, independent film is parity: You don't treat one actor better than another. Well, okay, you do treat certain actors better than others, but in groups: You say, "These four are the genuine leads and will be treated the same. These two come next and they'll be treated the same. Then these two . . ." Stick to that, because if you don't, one actor might visit another's apartment and find out it's twice as big, and the next day you have a petulant actor and a screaming agent. Your actor can't say, "My trailer isn't as big as hers" if it's exactly the same size (or if no one has a trailer to begin with).

Agents will push for as many perks as they can get, but it's not always easy to discern if the actor actually gives a damn. On *Velvet Goldmine,* I approached Christian Bale, who plays the sad-sack reporter, Arthur, to ask if I could get a ride in his car to my apartment. He had only been on set for a couple of days, so I didn't really know him, but he seemed nice enough. He didn't take kindly to my request, though. "My contract," he said curtly, "says I get an exclusive ride to and from the set." It did, so that was that. When I started to turn away, he said, "Christine." Big grin. "I'm kidding." The thing is, you never know. Plenty of actors value their privacy when they come to the set in the morning and leave at night.

You always hear stories of, say, Bruce Willis having his gym flown to Vienna, or of stars insisting that you fly their hair and makeup

Steve Buscemi was an unknown when he auditioned for *Parting Glances*, which was his first movie role.

people to far-flung locations. Sometimes you have showdowns over issues like that, and you just need to take a deep breath and stick to your convictions. On one of our movies, an actress had to fly halfway around the world. A first-class ticket was $7000.00, which we couldn't afford, but business class—at half that—was doable. Actually, it was still a lot of money, but I'm not that hard-hearted: twenty hours in coach is a nightmare. So we got her a business-class ticket, and her agent called me the day before she was supposed to come and said, "We want you to know if she doesn't have a first-class ticket, she's not getting on the plane."

I called the director and explained the situation, adding, "It would be a bad idea to allow this before she's even here. We're not that kind of movie; we don't have that kind of money. I don't think she'll walk, but there's always a chance that if I call her bluff, she will." The director said, "If that's how she is, I don't want her." So I called the agent back and said, "She's not getting the first-class ticket. If she chooses not to get on the plane, please let me know so I can recast."

She got on the plane. And she could not have been a nicer or

more reasonable actress. My hunch is that her agent said to her—as agents are wont to do—"What?! They want you to fly business class?! Don't they know who you are?!"—and worked her into a froth. "If you don't take a stand on this, they'll think they can walk all over you!" Hell, if you had the chance to fly first class, wouldn't you push for it? But ultimately, I knew how badly she wanted the part. I would have been very surprised if she hadn't showed.

CASTING PEARLS BEFORE SWINE

When we began making short films for my first production company, Apparatus, neither my colleagues nor I had any experience with actors. It never occurred to us to hire a casting director. We said, "We'll do it ourselves!" So we called hundreds of people and told them each to prepare a monologue. That's how they do it in acting schools, but for a film it was the dumbest idea in the world. Actors would come in and announce that they were about to do a scene from *The Glass Menagerie,* then spend the next ten minutes emoting like crazy. It went on and on; we wanted to slit our wrists. After that I learned to stick to the movie. Give them a scene to read and work with them on it.

Whenever possible, hire a casting director. A top-flight one will have an encyclopedic knowledge of talent and an inside track to the most important agents. The likelihood that such a person will take on your unfinanced, $250,000 film is slim, but it happens. One prominent firm I know reads about ten independent scripts a month and chooses maybe one to represent. Their fee is on a sliding scale, and they might take a point on the back end. If they choose to handle your script, they can make all the difference in your film being made: One well-known actor is enough to inspire some finance companies or distributors to take the plunge.

If you're just starting out and your budget is minuscule, your casting director doesn't have to be very experienced. At that level, you don't necessarily need relationships with agents. On *Kids,* we wanted someone who could figure out a way to penetrate the New York street scene and get us pedigreed street teens. The casting director hired an assistant, Katie Roumel, who was young enough to be a part of that world—who could go into clubs with flyers and approach kids without scaring them off. We did the same thing on

Velvet Goldmine for real English club-kids. If the film is set in a specific milieu, you need someone who isn't afraid and who will be accepted. I try to send women out whenever possible because they're less threatening—we've all heard stories about guys who use the old "I'd like to put you in my movie" line to get cozy with starstruck young things.

A great casting director not only helps a filmmaker get to an established actor, but also has a good eye for someone up and coming, as well as an instinct for putting together a performer and a role in a way that would never have occurred to you. I work with several; some work better with certain directors than others. The best, for my money, are the ones who have strong opinions of their own. You can always disregard their advice, but unless your director is easily threatened and simply wants a rubber stamp, it's useful to have another firm point of view. Different casting directors have different styles. Susie Figgis in England likes to discover unknowns, such as Jaye Davison of *The Crying Game*. Others pride themselves on cultivating relationships with all the top agents, so that they have access to a vast pool of name actors.

No matter who's casting, the first thing to do is put out a breakdown—an announcement that says what the film is and what kind of actors you need. There's a breakdown service that's called, appropriately enough, Breakdown Services, which is paid for by actors' agents. You tell them what you want—say, a twelve-year-old blond girl, a sixty-year-old man, and a chorus of bald Japanese monks—and it goes out to agents on both coasts. Usually, each agency assigns one person to your film, and that agent matches the available parts against their list of clients. If your lead is an actor with, say, the William Morris Agency, that agency might be more inclined to get your script to its other clients. Agencies love it when they can point to a film and say, "That's our package." Call it family values.

You might also want to do an open call, which you can advertise in places such as *Backstage,* or your local paper, or with posters in areas you hope that natural (and inexpensive) actors will congregate. In *Happiness* we needed Russians, so we put up lots of flyers in Brighton Beach and took out ads in Russian papers. Whatever you do, make your open calls specific. For example, that you want to see Russian men and women in their thirties *and that's all*.

All kinds of issues come up in casting, some of which border on exploitation. On *Kids,* Larry Clark wanted "local color." He'd heard

about a man with no legs who'd go from subway car to subway car on a skateboard, asking for money. To find the man, Larry dispatched Katie, who rode the IRT up and down Manhattan, stopping at every station, talking to other beggars, transit police, and people in token booths. Finally, she found a token-booth clerk who remembered the man and said she'd pass him a note.

The next day the man called; elated, Katie set up an appointment to have him read. This proved more arduous for him than was at first apparent. He had to take the F train to one of the deepest stations in the city—three long flights to the street. Then he had to heave himself up another three floors to our office. And after all that, Larry wasn't thrilled with what he saw. He motioned Katie into the back and mouthed the words, "His nubs are too long." The man's legs, you see, extended almost to the knee. So Katie sent the poor man back down all those stairs and home.

The audition process, ideally, helps a director find out about his or her characters, just by virtue of seeing so many different people's interpretations. You can hear the same scene read by seventy different actors and find seventy new things in it; you can also learn what comes through regardless of the actor. Even when an actor's too "out there," the director might say, "Wow, that's a slant I hadn't even thought of." On Todd Solondz's film, we auditioned an actress with a background in comedy and a somewhat tremulous persona. Todd was quite taken with her and brought her back two more times to see how she took direction. The rest of us were crossing our fingers that she'd turn out to be a passing fancy. We understood her appeal, but we also feared that, because she had so little real acting experience, she'd soak up too much of Todd's time and energy on the set. Ultimately, he did choose someone else. But as a result of her audition, he saw something new in a character that he had written, a character that he thought he knew thoroughly.

I'm always amazed when a director doesn't take advantage of the audition process and actually experiment with giving direction. First-time directors are the worst. The actor comes in, reads the scene, the director says, "Okay, thank you," and the actor shuffles out. "What'd you think?" I ask. "Oh, he didn't get it," says the director, and I explode: "You didn't direct him!" An actor's not a mind-reader—you can't always expect him or her to know just what you want and deliver it in one try. Some directors have an attitude that

translates as: "Come in and do the job the way I want it, and if you can't, leave." A bad sign.

Actors like to be directed in auditions, especially if it's a risky movie, where they know they'll have to trust their director to lead them down the right path, to steer them clear of land mines. Since most of the films I produce are risky in one way or another, that's a major consideration. Not every actor who ventures off the beaten track emerges unscathed. An actor playing gay—even if he or she is gay in life—might be profoundly uncomfortable and need a great deal of handling. It can't be said too many times: Actors who feel protected will give you everything they have, often more than they think they have in them.

In auditions, some actors tense up. They're reading something they're not very familiar with for highly judgmental strangers. It's hard to determine whether you're seeing them at their best. Other actors will be sensational in the audition, you'll hire them, and they'll never be as good again. Part of a casting director's job is to sense which actors are capable of giving you more, and which are likely to give you nothing but what you see. My favorite casting directors are the ones who'll make a pitch for an actor who might need work, but who has some quality that—if you can get it onto the screen— will be unexpected and fresh.

It's hard now to get big-name actors to read for you. Even not-so-big-name actors. Their agents want you to know that they're above that sort of thing. "He'll meet with the director, but he won't read," the agent will say, and you'll say to yourself, "Who the hell is he?" Some directors cannot fathom casting actors without hearing them read. More and more you're supposed to just offer a part to somebody. Or to arrange an "offer-pending" meeting, so that both the actor and the director can get out of the deal if they end up detesting each other.

An agent might also say, "He'll read, but you can't tape him," which is really a drag for two reasons. Sometimes a quality will show up on screen that you don't perceive in the room. The other reason is that if the director has seen fifteen actors that day, he or she will be burnt out, trying to pay attention but sick of hearing the same scene again and again. In those cases, it isn't until later that he or she can look objectively at the tape of actor number fifteen and say, "Wow!"

Producers don't have to be present for every audition, especially

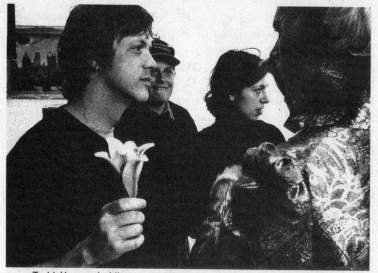

Todd Haynes holding a crucial prop on the set of *Velvet Goldmine*

if they're all being put on video. In fact, in some ways it's better for a director to show me a tape and ask what I think because I'll have a fresh perspective—I wasn't stuck in the room for eight hours. I was present for the final auditions on *Velvet Goldmine* with Toni Collette and Christian Bale because Todd Haynes needed somebody to turn to afterwards and say, "Well, what do you think?" That was a happy case, because we both said, "Let's cast them" as soon as they walked out the door.

Some directors like to have coffee with an actor, to keep things as casual as possible until the last moment. They'll do everything they can to make an actor feel comfortable. And then there are the ones who try to create an atmosphere of anxiety. The poor actor enters the room and the director just sits there, staring at the résumé in silence. The actor doesn't know what to say, what to do. The seconds crawl. I think this is incredibly counterproductive, not to mention inhuman. It's a power play, and you have so much power when you're auditioning actors anyway—you don't need to torture them. Going to auditions must be the worst thing in the world for an actor. They're coming from temp work or a job waiting tables; they give it their all before an unsmiling tribunal; and, as they leave, they can almost hear, "Nnnnah."

It does get heartbreaking in casting, when you know how desperately an actor wants to do a part. Actors lobby hard for good roles. Or sometimes you think somebody's cast and then, at the last minute, lightning strikes. When Todd Haynes was writing *Safe* and thinking about the protagonist, Carol, he had in mind an actress who had done a terrific job in *Poison*. We weren't even auditioning anyone else. But we were having a hard time getting financed, and we knew that a bigger name would help, so we agreed to meet some other actresses. ("All right," groused Todd, "I'll see a couple of people. But I know who's playing Carol.")

Julianne Moore wasn't exactly big-time then. She'd been Annabella Sciorra's best friend in *The Hand That Rocks the Cradle* and the victim of the film's most spectacular set-piece—she got cut to ribbons by a rain of greenhouse glass. *Vanya on 42nd Street* hadn't opened yet. Julianne's agent had said, "You absolutely, positively can't tape her, and you can't read her." That made her prospects even dimmer. So she came in, we chatted for a few minutes, and that might have been that if Todd hadn't said, "Can we read you?" and I hadn't said, "Can we tape you?" She said, "Sure!" She didn't mind being taped. She *wanted* to read.

And she gave the most astonishing reading. Time froze; the air in the room stopped circulating. Todd and I were both on the floor. What do you say? "Great! Thanks!" She left and we looked at each other and—"She's cast! We've got to get her!" Julianne told me later that she wanted the part so badly that out in the hall she burst into tears.

Ironically, we took the tape to LA to show the coproducer and executive producer, and it was a total blur. I had some intern doing the taping and he couldn't figure out the camera and was probably too scared to let me know. Sitting in LA, staring at the fuzz on the monitor, we could sort of hear Julianne and sort of see her shape. So it remains a mythical reading. She got the part, though. And, yes, it was hard on the other actress. But in the end, Todd will always, always do what's best for the movie.

Every year, the financing even of small, independent films becomes more cast-driven. I wonder if we could get away with doing *Kids* without stars now. As it was, we had problems convincing the money people (not to mention one another) that we could pull the

The magnificent Julianne Moore

movie off with such inexperienced performers. The temptation to gussy it up was close to overwhelming.

In fact, Larry Clark almost didn't use Chloe Sevigny, who ended up giving a wonderful performance as Jennie, the girl whose discovery that she has AIDS jumpstarts the plot. Out of fear that we didn't have any real actors, the casting director was pushing another girl— someone on the rise, who looked more like a conventional ingenue. We gave that actress the part, even though we didn't know how she'd fit in with the other kids. Meanwhile, Chloe was one of their posse—she had spent the last two summers hanging out with them in Washington Square Park.

We brought the actress to New York, and while Larry was working with her, her lawyer started acting like a jerk and holding up her contract. So Larry, who had a healthy respect for contracts, called me on the Sunday before the shoot and said, "I don't want to cast her." "Too late," I said. "You did." "She hasn't signed the contract," he said. "And now I want Chloe. She's perfect. I don't know why I didn't see that before."

Lauren Zalaznick (my coproducer) and I made him call the actress and give her the bad news himself, half-thinking that she'd talk him into using her, but five minutes later her lawyer was on the phone with me screaming: "You have *no idea* what you're doing! She is represented by some very important people and this is going to have

tremendous repercussions! What are you going to say when Mike Ovitz calls?" Well, Mike Ovitz never called, but I still felt bad about how it all went down. Nevertheless, Chloe was the right decision for the film. The other actress would have stuck out. Casting her was an attempt to play it safe, and it would have been a disaster.

It's not an uncommon dilemma. Directors on these sorts of films usually feel they're on the verge of having the bottom drop out of their budget, so when a financier says "You can't have that actress, you have to have one of these," they say, "Okay." And once you open up that door, forget it. I don't mean to sound unsympathetic to financiers. They have good reason to want recognizable actors. And if a star is right for the role—hey, it's just as easy to love a rich man as it is a poor one. The problem is that so often these stars are so obviously wrong. Directors have to sit back and remember what got them to where they are and what really matters. If they can't stand by their vision, they can't expect anyone else to—including, ultimately, the audience.

As for getting bona fide stars, well—they can help get you financed, but they bring a lot of baggage with them. In the first place, your intimate ensemble piece is going to look lopsided with an actor who has a neon sign over his head saying, "Hi, I'm Dustin Hoffman." Sometimes you see an indie film that's filled with name actors doing cameos—saying two or three lines and leaving—and it feels inappropriate. The little movie can't be seen for all the starshine. And I've heard about small films nearly wrecked by big-deal actors who think they're doing the filmmaker a favor just by showing up.

The other concern, which is more practical, is that it's unlikely that actors of stature are going to accept small-movie conditions. They might work for scale. They might say, "Sure, I just did a blockbuster, I'll do your picture for twenty thousand." Financially, they're able to afford it. Psychologically, they might not be. It's hard to give up the trappings of stardom. They'll want an air-conditioned trailer, their parents flown in, an exercise bicycle on the set, a nanny for their kids, and housing for their multiple assistants. In the budget, you call these things "star costs." They always mushroom, and they can throw your little movie into chaos. I'm not suggesting that if Sigourney Weaver wants to do your picture you should necessarily blow her off. But understand, you'll be entering a different realm of moviemaking, and you'd better be prepared

You also have to be careful about raised expectations, which can

injure more than your ego. When Nicole Kidman read *Velvet Gold-mine* and expressed interest in working with Todd Haynes, everyone was ecstatic: Someone with her name would make a huge difference in financing, not to mention how the picture would be handled. So Todd met with her and had a very good meeting. It looked like it could happen. But then the movie Kidman was set to make with Tom Cruise and Stanley Kubrick went into production, and—with Kubrick's reputation for going over schedule by, like, years—there was obviously no way she could take the part. (As of this writing, more than eight months after *Velvet Goldmine* has *wrapped*, the Kubrick film is still shooting.)

The problem was that her inability to do the movie created a *lack,* where before a lack hadn't been perceived. Now it was the film that Nicole Kidman had dropped out of, and the financiers' enthusiasm flagged. The same thing happened with Patricia Arquette on Todd Solondz's movie. The distributor said the budget wasn't cast-contingent, but when Arquette pulled out because of an illness in her family, the risk seemed suddenly higher, and the budget got slashed by a third.

It worries me, the way the money people meddle more and more with the casting of independent films. Distributors and financiers have forbidden me, in the last year, from hiring one very eager, very well-known actress because a few of her recent movies have tanked. True, her performances were not spectacular, but where were the directors? The fact is, she's brilliant, and sooner or later she's going to get a role that she hits out of the park. And then she'll be back on top. Meanwhile, I don't get to work with her and give her that opportunity. It will be someone else's fortune.

Getting your script to Name Actor if you don't have a well-connected casting director is tricky. Legends abound of screenplays thrown over fences or slipped under stalls in bathrooms. The latter, it is said, was used by the recipient in lieu of toilet paper. Better to find a connection, any connection. A hairdresser. A gardener. A housekeeper. A cousin of a friend of an assistant. Then you have to hope that the actor actually *reads,* which is not a given. But take heart: Unless they're only in it for the money, you have something they want, which is a role that will stretch them, remind them why they became actors in the first place. Make it easy for them to say yes. They might not give you twelve weeks in Somalia, but ten days in New York or LA is pretty painless, even for a prima donna.

POP QUIZ: How do you sit across from a financier and say, "Name Actor is in my movie" when you haven't got the money to make the movie yet?

(Remember: you must have Name Actor to get the money, but you don't *get* Name Actor *until* you get the money.)

ANSWER: You lie.

There are so many nebulous areas in casting, so many white lies you have to tell. Agents, meanwhile, are trained to sniff them out, because they don't want to waste their client's time—they don't want to be attaching their actors to your project if you're not financed. So you tap dance: You tell Name Actor that you have the money and the money people that you have Name Actor and if one party doesn't talk to the other it can all work out and you'll get the movie made.

Hey, agents lie like mad themselves. Some will stop at nothing to get their clients cast. If they get wind you're close to signing another actor, they'll call you up and say, "You know, he's a real pain in the ass on a set," or "Have you seen all the weight she gained?" or "I hear he has a substance problem." On one of my films, the choice for the lead came down to two actresses—it was very close—and both agents, on the same day, called the casting director to bad-mouth the other's client. And they both said virtually the same things: She's really demanding, no one likes to work with her, etc. An agent wants to be able to turn to his or her client and say, "It was a long battle, but I was finally able to get you the part!"

Of course, sometimes those agents are telling the truth, which is why I make calls to other producers, directors, and casting agents to get the inside story on actors I'm thinking of hiring. It's reckless not to. If someone has the potential to wreak havoc on your set, you should be aware of that going in. But that doesn't mean I wouldn't hire an actor if he or she were otherwise ideal.

Sometimes your information isn't accurate. Other times the actor in question just grows up. Before we cast *Velvet Goldmine*, I asked around about Toni Collette and heard that she was "a tad difficult." I mention that now because she turned out to be one of the easiest, most selfless performers I've ever worked with. There were people in the movie who didn't have her experience, and she guided them— sometimes literally. Once, when an untrained actor proved unable

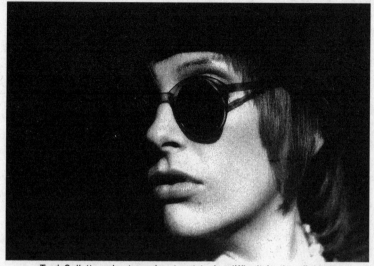

Toni Collette, who turned out not to be difficult in the slightest

to hit his mark and blew take after take, she took his arm and gently, discreetly, and totally in character, planted him on the spot where he was supposed to be. She made nothing of it, but it was pure class.

Calling around will help you know what to expect, so you can take precautions. You can learn what kinds of things tend to set an actor off—but also what will make him or her a happy camper. As I've suggested, you can make allowances for bad behavior, as long as the actor is giving a good performance and shows up on time with his or her lines memorized. The fact is, there are Difficult Actors and Problem Actors. Almost all actors are Difficult Actors. If they have a legitimate reason to get mad, they'll get *really* mad. If they're upset about something, they'll refuse to come to the set, forcing you to go to them. Their agents are all over you for small infractions. Live with it. Be happy that they're not Problem Actors. The Problem Actor is the guy who's genuinely disruptive on a daily basis—who doesn't show up for work, or who shows up drunk or stoned.

Let's be frank: people in the arts, especially performers, are prone to abusing chemicals. They tend to be anxious and vulnerable, given to "medicating" their moods; and they have irregular schedules, with periods of intense labor alternating with periods of complete idleness. Some manage not to let it affect their work. Even Robert Downey, Jr., with his much-publicized arrests for drunk driving and

drug possession, could be relied upon to give brilliant performances. One well-known older actor is famous for coming to the set drunk and stoned, leaving drunk and stoned, and being drunk and stoned (and a pain in the ass) in between. But his acting remains amazing, so he still gets hired. I'm pretty nonjudgmental about these things. As long as actors get themselves to work, what they do when they leave is their own business. And people do clean up their acts. They go into rehab, join AA, and come out relatively okay—apart from the fact that they go around bending your ear about their sobriety.

On the set, however . . .

Kids posed the biggest challenge. What was hard about it—and what's hard on any low-budget film that uses a vérité style—is maintaining a sort of controlled chaos. Lots of people think that the young actors in that movie were really drinking beer and smoking dope. I couldn't control what they did when they left the set, but once they came onto it, my answer was and is: No drugs—legal or illegal. I can accept actors who have a drink or two before shooting a love scene to relax; as long as you monitor their intake, it's probably okay. (Lots of people need a few drinks before having sex in real life—imagine the pressure with thirty people standing around.) Otherwise, drugs will mess your actor up, serve as a contagion for other actors and creative personnel, and give you a dangerous reputation for tolerance.

On one film I produced, an actor had a scene in which he was supposed to snort cocaine, which is usually glucose. He approached me and announced that he was allergic to glucose, so he had decided to snort the real thing on camera. I told him he could snort baking powder, because there was no way I'd let real cocaine on my set. He got so angry that I had to ask the director to take him aside. The director handled it well. "I don't want you fucked up for real," he said. "You have to act." And the actor said, "Oh. Right. *Act.*"

Unfortunately, in minutes the rumor that he was really going to do coke was all over the set. Which made me furious, because that's the kind of thing that follows a producer around. I'm still trying to shake off the scuttlebutt over *Kids*. Our last office was across from what turned out to be NAMBLA—the Man-Boy Love Association. I thought, all I need is a journalist to visit and write, "Christine Vachon, whose films feature kids having sex and whose actors are reputed to use drugs on her sets, has an office right across the hall from . . ."

WALKING ON EGGS (OR EGOS)

In real life, actors tend to be thinner-skinned than other human beings—which is part of the reason that on screen they're so transparent. An actress with a reputation for being a horror once pointed out that if she's working to make herself raw and exposed so that the camera can read her every twitch, and a light drops from the ceiling and nearly crushes her skull, she won't respond with patience and forbearance. She'll scream like a banshee.

Which isn't to say that actors are always within reason. They will get fits of pique about things—the food, their trailers, personnel they don't feel are treating them well. They make all kinds of crazy demands. And I don't mean seemingly crazy or crazy-until-you-get-to-know-them. I mean *nuts*. But I get angry when I see interns or production assistants roll their eyes when an actor has sent back the tea because the water is tepid or the lemon has seeds. Because *if that's what they need to give a performance,* then get them the damn hot tea with the damn seedless lemon slice. Get them *whatever* they need, as long as it's legal. And if what they need is just to send you back and forth twenty times, then that's what you have to do.

That said, I don't like working with actors who are nasty to the "small" people on the set. Partly I don't like it because they're picking on someone whose fault it really isn't. It's not the mistake of some hapless passing production assistant that they don't have any water in their trailer. It's my fault, as producer. And it's my job to soothe their injured egos and minister to their needs. Often, what's most important to them is that the person at the top has bothered to come in and discuss the difficulty, even if the second- or third-in-command could handle it just as easily. In those cases, taking them aside and saying, "I understand you're unhappy. Tell me what's the matter" is all it takes: they haven't just been handed off to anyone; attention by someone who matters has been paid.

On bigger films, a producer might be contractually obligated to provide an actor with an assistant. This will cost you money, but will make your job easier. Jonathan Rhys-Myers, the star of *Velvet Goldmine,* always needed to feel he was in a safe environment. He's a terrific actor, and I'd work with him again in a second. But he was nineteen years old, playing a role that required him to leap onto chandeliers and kiss a man. It would have been rough going for a seasoned pro, and Jonny was a *boy*. He'd get upset with himself if

he thought he'd done something wrong, even when the error was all in his head. His assistant made sure he was at the set on time and that he had what he required to relax and give a performance. Great actors are worth the extra effort. The one day Jonny thought he was a bit of a brat—it was no big deal, actually—he bought roses for the entire crew. He understood it was important to show respect for the people you work with. Not all actors do. He's a really nice young man—I hope he stays that way.

On one of my movies, the donnybrook with actors was costumes. We had agreed to hire a costumer who was a friend of the director's but who'd had little experience managing stars. On his own terms he was fine, but his own terms were the wrong terms. He couldn't handle the fact that the actors were—are—terrified of the way they think they look: that they're fat, that they're old, that they're wrinkly. It's not so hard to understand. Actors make their fortunes on how they look. Often when I'm out to dinner with actresses, wolfing down my pasta and knocking back two or three glasses of wine, I'll have a close-up view of what they go through: "Do you want some of that?" "Oh, I shouldn't." "Oh, I shouldn't, either. Here, just a little." "Oh, I'm so fat." "No, you're not fat." "Oh, I so am! Oh, this diet . . ." We who aren't performers can laugh about it, but we don't have to do what they do—and be eternally judged.

If we'd gone with a costume designer who had known how to make them feel good about themselves, who had said, "Trust me. You look gorgeous," then things would have probably turned out fine. What happened, though, was that one of the actresses insisted on picking her own outfits, and they weren't very flattering. She felt she had no choice: she didn't trust the costumer. These are the lessons you learn after it's too late.

Men, of course, have their own issues. Stephen Dorff was nineteen when he put on lipstick and makeup and high heels to play the drag-queen Candy Darling in *I Shot Andy Warhol*. He was marvelous in the film, but he needed a lot of reassurance that the part was not going to have a disastrous impact on his future as a swaggering leading man. This is not an uncommon concern, especially in the kind of movies I make. In the same film, Jared Harris had to transform himself from a rugged English rugby-playing type into the slim, effeminate Warhol. I remember hearing stories about *Longtime Companion,* in which most of the actors playing gays were heterosexual. After "cut" was called, a lot of them immediately meta-

morphosed into ball-scratching, football-loving, woman-fondling *guys*. I'm sure it was a pain to be around that kind of behavior, but I don't think less of them: They had agreed, after all, to play those parts. It's hard for men to act effeminate on film sets, which tend to be testosterone-driven places.

Nine times out of ten, a crisis with an actor is vanity based. I've been on panels with a Hollywood producer who likes to pose the following problem. You're making a movie with a big star. The director isn't a first-timer but he doesn't have any clout. After the first week of shooting, the star sees a cut of two scenes, calls you up, and announces, "I'm extremely unhappy with this director. Either he goes or I go." The producer asks, "What do you do?"

In an audience of would-be producers, everybody says: Stand by your director. But it's more complicated than that. Unless you agree that the director is doing a bad job, you have to be skillful enough to find out the real source of the grievance. Frequently, when actors are upset like that it's because they've gone to dailies and they think that they look fat or old, or that they're just not coming through on screen. You can't expect them to be objective about their own images unless they're very, very seasoned, and sometimes not even then. There's even a case to be made for keeping your actors out of dailies at all costs. The punch line to the story above—which is true—is that the producer eased the star's mind, the director was not fired, and the star went on to give a spellbinding performance, for which he won an Academy Award.

If you can't keep actors out of dailies, for God's sake don't invite them back to watch a rough cut and solicit their opinions. They'll say, "Don't you think you should hold on me a little longer in that scene?" or "Where's that thing I did that was really great? You know, that little bit of business. Oh, you have to put it back in!"

Tell them you'll see them at the premiere.

DIARY INTERLUDE
#3

THE LINE PRODUCER

December 8, 1996: London

I am in England to interview line producers for *Velvet Goldmine*. The position is especially important on this film: In New York, I can look at a budget and promptly gauge its weaknesses and strengths; the British budgets might as well be written in Urdu.

We don't have a lot of choices. Christmas is coming and no one wants to think about a difficult job that's going to start right after the holidays. Also, people in England are not as familiar with me and my work and aren't exactly turning cartwheels at the idea of doing a Vachon Production. (The only part of my reputation that has preceded me is that I am cheap.) The other problem

is that England is a relatively small country with a limited number of people who can do this job.

I have two meetings scheduled. The first is with a guy named Nick, who's young and hip and for whom I have high hopes. I meet him at the Groucho Club, buy him a beer, and look at him expectantly. But Nick keeps his eyes on his drink. "Um," he says hesitantly, "I don't think I'm right for this. I mean, I didn't really *get* the script. And I don't think I want to work in January." I am stunned. I can't believe he's drinking a beer that I've paid for. I say, "Fine," put a couple of pounds on the table, and leave.

One down, one to go. An hour later, I meet Guinevere, a thin, elegant woman in her early fifties who smokes constantly. Her résumé is impeccable, she says all the right things, and she's available. But I have a knot in my stomach. Maybe it's because she's totally unfamiliar with the music of the early seventies. Maybe, it's her habit of calling everyone, "Sweetie, Darling." Todd comes to meet us and we chat. She is properly reverential to him, but still . . .

December 13, 1996: New York
Back in Manhattan, I call the executive producer, Scott, who says he has checked up on Guinevere and has heard great things. We could keep looking, but a bird in the hand . . . We take the plunge.

December 21, 1996: New York
Guinevere has gone to Vienna for Christmas and has our budget and board with her, promising to return with her version of the best way to spend our five million pounds. I breathe easier now that someone is in place and, convinced that I have, in fact, made the right decision, tie things up in New York.

January 3, 1997: London
I spend the morning apartment hunting and then go meet Guinevere for lunch. "Sweetie, Darling!" I am enveloped in a cloud of cigarette smoke. "Sweetie, I've done the budget, but Darling it may scare you a wee bit Sweetie."

"Oh yeah? Why's that?"

"Well Darling, it's at seven million pounds right now."

I stare at her kind of stupidly. "Uh . . . but we only have five million to make the movie."

"Yes Sweetie I know but I thought it was better to make a budget

for what I really thought it would cost rather then just a five-million-pound budget. This way we can figure out how to take it down. Do you see, Darling?"

I don't, really. Maybe this is some English method of budgeting. "Well . . . how are we going to bring it down?"

"Sweetie, we'll ask all the departments to give us budgets for what they think they absolutely need and then we'll start carving away."

Now, I would normally never *ever* let department heads tell me what they want their budget to be. But I think to myself: "Maybe producers do things differently in the U.K." I scrutinize her seven-million-pound budget and my jaw drops: it has almost half a million in truck rentals alone. "Isn't that a little high for a movie like this?" I ask.

"No, Darling, that's what it costs here."

That phrase becomes her mantra. Every time I query an enormous figure, she says either, "No, Darling, that's what it costs here," or "No, Sweetie, that's what it costs here."

All low-budget producers know certain "tricks" to keep costs in check—annoyingly inconvenient but money-saving maneuvers like returning trucks when you're shooting in a studio and getting them back when you move to a location. Department heads *hate* that, because it means they have to unpack everything and then pack it up again, but it saves money. Other tricks include scheduling scenes with lots of extras in them for *after* lunch so that you don't have to feed them. But Guinevere acts as if such techniques are unheard of in London. I am starting to panic. Maybe we *can't* make this movie for the money.

January 9, 1997: London

The first week of prep slips by, leaving eleven. Each department head has dutifully given Guinevere a budget for what he or she absolutely needs. And of course, since no limits have been set, these budgets are *astronomical,* surpassing even what Guinevere has figured in her seven-million-pound first stab. "Well, Darling," she says, "Todd will have to do a re-think, a total reconceive. We'll have to do the Derek Jarman version of *Velvet Goldmine*."

Now, Derek Jarman was a wonderful filmmaker but he made most of his movies for well under two million pounds and shot them on essentially one or two sets. We have five million—eight million U.S. dollars! How is it possible that we are so constricted?

January 16, 1996: London

We are ten weeks away, no production staff has been hired, and the costume and art departments are telling me that they can't possibly cut their budgets. There is a general sense of chaos, a lack of leadership. I am already in danger of breaking the cardinal rule of producing: *Never let the movie get away from you.*

The second rule of producing is: *Everyone is expendable.* I learned this the hard way on several films—on *Safe,* I fired a spiraling-out-of-control art department midway through the shoot and spent a scary three hours huddled with my cell-phone in a corner of the set interviewing replacements.

So I fire Guinevere.

I begin, "Guinevere, I think this is not working out . . ."

"Oh, I see." Her voice is steely. "You want me to go." No more "Sweetie, Darlings" for me. It takes her three hours to pack up her computer, smoke a pack of cigarettes, and flounce out.

CREWING UP: GET A GRIP

Long before we get the green light on a film, my colleagues and I discuss the size and the makeup of the crew: who we can afford, who would be a good match for the script and the director, and who we could stand to look at for four months. It's a bit like assembling a *Mission: Impossible* team: You're not only shopping for artistry and competence, but for individuals who can coalesce into a crack unit, and who won't come apart when the clock is ticking down.

You put out feelers. You read résumés, make calls to other producers, and send out scripts. The cinematographers, editors, and designers you are seeking have agents, too, and at their various companies, the word will spread. You can also put ads in alternative newspapers or independent film magazines, most of which are eagerly perused by techies with time on their hands. Once the principals have been engaged, they in turn can do much of the tributary hiring. Your assistant director can hire

the second assistant director who will doubtless have suggestions for the second second assistant director. Your director of photography will know camera operators and grips and best boys, and will probably have a regular posse.

There are few things as frustrating as choosing your people, then having to wait until the project is a definite go before you can send out contracts—knowing, all the while, that some other production team might swoop down and snatch them away like hawks carrying off small children.

ME: Hang on just a *little* longer. We'll be starting prep at the end of August *for sure*.

CANDIDATE: Yeah, but I have an offer from this other movie—I mean, I like yours better—

ME: Our movie *is* better! It's *such* a better movie!

CANDIDATE: But they have a definite start date, and you might have to wait until November and I'll have missed out on a job . . .

ME: We are *so* on the verge.

CANDIDATE: They need an answer by three this afternoon.

(Pause)

ME: And to think I was the first person to give you a shot in this business, to take a chance when others . . . [Guilt-trip monologue continues ad nauseam]

It breaks my heart to see people slip away like that. Actually, it makes me livid. Most producers, even we're-all-in-this-together independent producers, are fiercely competitive, and at these prices there's always a limited pool of experienced talent.

Before you start hiring, it's important to know not only what the key jobs consist of, but the various personality types that make people good—or awful—at them. And then there's chemistry. The trinity at the center of the set—the director, the cinematographer, and the assistant director—needs to lock into a rhythm if the shoot is going to go smoothly. If not, it becomes your very own Bermuda Triangle, swallowing up whole days and leaving behind only crew invoices for tens of thousands of dollars. I've produced movies in which the director got along okay with the cinematographer, the cinematographer got along okay with the assistant director, and the assistant director got along okay with the director, but the three

worked together with the ease of junkies in a revolving door. Rhythm and balance can make all the difference between a dream shoot and a campfire-ready tale of terror.

DIRECTOR

On independent movies, the director generally comes with the package, but it doesn't hurt to consider the aspects of the job that they don't teach you about in film school.

The single most important quality in a director is the ability to communicate a vision in a clear and succinct manner. If, in addition, he or she can get people *excited* about that vision, better yet.

That said, I've worked on films where everyone loathed the director, and on films where everyone loved the director, and it doesn't have nearly the impact on the final result that you'd think. Crews clearly prefer directors who "settle," like the guy who says: "Oh, well, we've done three takes and it's maybe not a hundred percent, but it's late and everyone wants to go home . . . I guess we've got it." No Kubrick, he. Directors who create the best on-set atmosphere do *not* always make the best movies.

The other day I was telling Todd Haynes a story about the sadistic director of a movie that a friend of mine produced—a filmmaker who made an actress do take after take of an emotional scene for what appeared to be the sheer pleasure of breaking her down—and Todd wondered aloud if he wouldn't be a better director if he had a touch of sadism. He doesn't—he's blessedly compassionate. He might be a control freak—which is why every frame of his movies is so resonant—but he doesn't get a charge out of controlling *people*. Sometimes those sadistic directors are the ones who'll push themselves (and others) that extra, punishing mile. On occasion, I've had to help directors *not* settle, even if that meant provoking the wrath of cast and crew.

Plenty of times, however, a ghastly on-set atmosphere will manifest itself on screen—especially if the actors are so miserable and lacking in trust that they can't (or won't) reach down inside themselves for whatever they need to let go and give a performance. Despotic directors often end up with closed-down performers.

The worst thing is when the crew comes to perceive that the director doesn't know his or her job or isn't prepared for the shoot. It's a recipe

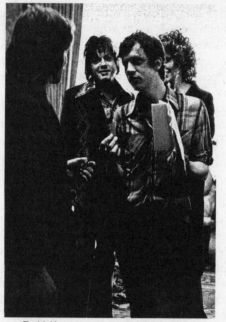

Todd Haynes surrounded by his cast

for insurrection and turmoil. It's also when the producer's choices become the most agonizing: Do you adopt a laissez-faire approach? Do you step in to keep the shoot on track at the risk of fatally undermining your director's authority? I've found that it's best to work behind the scenes, to beat up the director if you have to, but never let the crew or the cast witness the fisticuffs. Keep up a united front!

Great directors know exactly what they want and are able to articulate it—but can still surrender to serendipity and find something even better than what they thought they wanted. They don't get swayed by the peanut gallery, but they do listen, and they trust their collaborators. Even the mulish ones, if they're smart, will listen. When Joel and Ethan Coen were starting out, their then-cinematographer Barry Sonnenfeld told a writer that, contrary to popular belief, he *could* change their minds about things: "I find it's best to make my point, drop it, then wait a couple of days," he explained.

It's great when directors know enough about what everyone else does—designers, actors, techies—to give them pats on the back. People like to feel that their work is appreciated. Sometimes a director is so

stressed-out that the producer has to step in and exclaim, "Wow, that set looks beautiful!" or whatever. Actors in particular will languish without a director's attention. For example almost every film set these days has a monitor. And even though they're extremely important—they can save you an incredible amount of time when it comes to setting a background or getting a clear sense of the frame—it's awful to watch an actor do an intense scene while everyone on the set, including the director, is staring into the monitor. The actor feels as if no one is there. I like Todd Haynes's approach, which is to watch a rehearsal on the monitor but watch the actor during the shoot.

ASSISTANT DIRECTOR

Don't let the term "assistant" make you think the job of assistant director is subservient. A good AD can salvage a shoot, while a bad one can multiply the misery exponentially.

The AD is the general of the set. The AD *runs* the set. If you wander unbidden onto a set, you'll always know the AD because he or she is the one who'll probably throw you off. That's the AD yelling, "Places!" "Quiet on the set!" "Lunch—one-half hour!" and "That's a wrap, people!" It's all very ritualistic, like reveille and taps on a military base, at once grating and oddly comforting.

Practically speaking, the AD does everything from scene breakdowns—identifying the elements for each scene and listing them by category—to working with the line producer on the schedule, to creating lists of shots for the crew, to keeping tabs on the actors' whereabouts, to making sure that all union requirements have been met and the necessary releases and clearances are signed. The AD hires, trains, and supervises the production assistants; maintains safety standards; and oversees set security.

The AD answers these questions and a hundred more:

- What are the shots?

- Where can I set up the equipment so it's not in the shot?

- When does the actor need to be ready?

- What time is sunset? When will we lose the light?

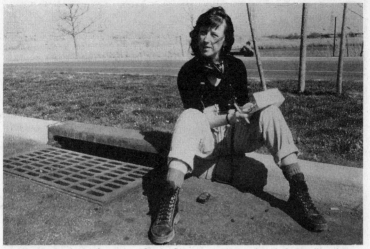

World class photographer Cindy Sherman takes a break from directing her first moving picture, *Office Killer.*

- Can we send the extras home?

- Can we park the trucks here?

Imagine forty-five people showing up with a vague sense of an agenda but no idea how they'll accomplish it. Someone needs to pull the strings that make the puppets move. The best way to understand what the AD does is to be on the set when he or she is gone.

ADs come in many different flavors. Some are martinets who scream all the time and rule the set with an iron fist. Some are cheerleaders who rally the crew back from the brink of exhaustion. Some are relatively ineffectual and bark orders that no one pays attention to. One quiet, careful AD I know runs a methodical set with a nice atmosphere, but it's not a set where everybody knows what's going on every second—and there's something to be said for that, even if it means a lot of screaming: "Camera on the dolly for scene one-oh-three!" "This side of the set is hot!" and so on. At least the energy level is kept higher. *There has to be something driving the set,* and often it's the assistant director or it's no one.

A great AD acts as a selective information screen for the director—letting only the vital stuff through—and creates an atmosphere that's conducive to his or her particular needs. One very famous

A beautifully lit scene from *Safe*

(and famously aloof) director is notorious for having sets like prison camps and exceedingly cruel ADs. Other directors thrive in a carnival atmosphere. In terms of loyalties, you'll find there are Director's ADs and Crew's ADs. Predictably, directors hate Crew's ADs and crews hate Director's ADs.

I like ADs to be part general and part cheerleader. They should also have the capacity to police their own emotions, because their moods will invariably have an impact on the mood of the set. If he or she is in a foul temper, the whole crew will tense up; whereas a well-placed joke at a difficult moment can offer a huge release.

ADs absorb most of the tension on the set: "Will we make the day?" "Will the actor come out of his trailer?" "Will we still have sunlight by the time we move to the next scene?" The best can absorb all that tension without putting it back out. They're the unsung superheroes of the movie business.

DIRECTOR OF PHOTOGRAPHY

Your director of photography often controls the tempo of the shoot, contributes his or her own vision (or provides a vision when the director has none), and makes the actors feel cared for, even worshipped. All decisions about lighting are made by the DP, who can make a $200,000 film look as if it cost five million, and a five-million-dollar film look as if it cost two hundred thousand. During production, the DP is privy to virtually every major creative decision, from the number of extras to the color of the costumes to the actors' movements to whether or not to call it a day. Along with your actors, this is your major hire.

Many low-budget producers look for Directors of Photography (DPs) who own their own 16mm camera package—which, all else being equal, will save you money (that is, if you're shooting in sixteen).* In any case, you'll want to see a sample reel. That's not a hundred percent reliable, however. With a good DP, every movie should look different—unless his or her aesthetic is consistently overwhelming the director's, which isn't necessarily a good thing. When inexperienced directors look at reels—for either a DP or a production designer—they're apt to declare things such as, "Oh, this is too stylized," when usually the amount of stylization has been dictated by the director.

Getting a great cinematographer won't make a studio say, "Oh, now we can finance that film!" What a great cinematographer can do, apart from making the movie look good on a low budget, is bring in people who want to work with him or her, who maybe wouldn't want to otherwise. They have a cachet. But make sure the high-powered DP understands the "size" of the film. If they're already rich, they might not care about the money they're making, but when they realize that on a low-budget film they're only going to have, say, two 6Ks and a 9 light, they may bolt. Also, even if they work cheap, their usual crew probably won't want to: What's in it for them?

Many cinematographers have justifiably high opinions of their own

*No one owns 35mm camera packages. The leading manufacturers—Panavision and Arriflex—only rent their cameras, and keep strict tabs on inventory.

abilities, and some go on to direct their own (frequently terrible) features. It's important that the DP's ego and the director's ego complement each other, because a set on which the two are locked in combat is a guaranteed six weeks of hell. On *Office Killer*, we needed a cinematographer to work with director Cindy Sherman, a brilliant and renowned still photographer with no conception of how to stage a scene on a set or move a camera. We chose Russell Fine because he could do his own thing but also enjoy the challenge of trying to tap into Cindy's unique sensibility—to use her gifts in the areas of lighting, color, and composition.

Make sure your DP commits to working on a schedule with you— to doing things in the specified amount of time, however insanely limited it might be. Be wary of a DP who refuses to take responsibility for the length of the days or to prioritize. This is what I mean by prioritize: "Uh-oh, we have a big scene to do after this and time is running out, so I'll light this little scene in half an hour so that we can have the rest of the day for the important one." A selfish DP will take his or her sweet time without looking at the big picture. One DP I know spent an age lighting every scene, and when the crew complained about the length of the days and threatened to walk, he said he'd go with them. He played both sides.

A cinematographer's ability to work quickly is a godsend on a low-budget shoot, where everything's compressed and there's little flexibility in the schedule. Some of the most elastic low-budget DP's have documentary experience. Eric Edwards was a superb choice for *Kids* because he'd done both features and documentaries. He knew you can shoot a scene with the existing light if it's right, but he could also work resourcefully to light a big effect if one was required.

LINE PRODUCER

The line producer hires all your key technical personnel, which is why he or she will generally be the first or second member of your team. Beyond that, his or her chief function is to monitor the minutiae of the budget.

Some producers can act as their own line producers, but not me. My eyes are fixed, for better or worse, on the big picture. I've been told that I'm too much of an optimist, too quick to exclaim, "We

can do it! We'll figure it all out!" It's probably good for me to have someone more cautious around as a reality check, to say, for instance: "Look, if we keep overshooting film stock, then by week six, we'll be over by thirty percent, and I don't know where we're going to get the money to cover it." Then I do my big picture thing: "We'll take ten percent of our contingency for film stock, and get the rest by eliminating a day of Steadicam and shaving twenty extras." Or, "Perhaps I should have a word with our director about not shooting so many takes." In general, it's best if those "words with the director" are initiated by me and not the line producer, who can easily be nudged into the role of the resident Scrooge.

It's good to have someone around to play devil's advocate and to anticipate worst case scenarios, but an Angel of Doom who's always spouting "We can't do this! We're not going to pull this off in time!" is bad for the crew's morale and can cause a high-strung director to throw more tantrums than are necessary. You should keep that kind of line producer far away from the director. My partner Pam, who occasionally serves as line producer on our films, would never say, "This is a disaster!" or "*How* do you propose to pay for this?" She'd say, "Well, Christine, really, given the fact that it takes us an hour to do each shot, is it realistic to think we can do six shots and shoot that location in two hours?" When it's put to me like that, I'll say "Maybe it isn't realistic" instead of getting defensive.

Good line producers are not simply fixed on the numbers. They know what the numbers mean: which ones are critical—and therefore inelastic—and which aren't. They know why it's important to have fifty extras in a particular scene and not thirty, and they won't spend time trying to convince you to do with thirty; they'll be busy searching for a scene where you can afford to lose twenty extras. They'll do everything they can to make the numbers fit without compromising the integrity of the director's vision.

PRODUCTION DESIGNER

Some directors have a clear image of every item of their characters' clothing and every tchotchke in their house, but most need inspiration from elsewhere, too. The best designers find ways to enhance what's in the script, and can make the narrative and the characters a hundred times richer.

Production designers determine the "look" of a film—and often, in the old days, they did the costumes, too. Along with the DP they control the way a movie feels. Therese DePrez, who designed *I Shot Andy Warhol* and *Happiness,* gives packages to the DP, the costume designer, and director: a little booklet containing a swatch of wallpaper from one set, the color of the paint from another, the upholstery on the couch in a third.

You don't always notice production design, especially when it's good, as in *Kids.* One of the illusions that Larry Clark loves to maintain about *Kids* is that we just went in and "did it." Not true. It was scheduled, it was scripted, it was location managed, and it was production designed. But you don't have a clue that somebody made a decision to put this bit of debris here and that chair there and paint that wall this color. Somebody did: Kevin Thompson, who also designed *Office Killer* and *Flirting With Disaster.* Kevin's work can be very stylized, but true style rarely calls attention to itself; it looks effortless—"found."

Designing a movie is one small part creative bliss and one huge part management. Production and costume designers—and, to a certain extent, DPs—need to be able to supervise their departments. On a teeny film those departments can be as small as two or three people, but on a bigger one they can be massive and require a juggler's dexterity. Production designers keep a lot of balls in the air. On a given day, they'll be striking yesterday's set while getting tomorrow's set ready and making sure that the director has everything he or she needs on today's set. Christopher Hobbs, the marvelous designer of *Velvet Goldmine,* is sometimes in his own world—say, out picking flowers—but part of his genius is hiring art directors who are masters of logistics.

The relationship between the production designer and location manager can be sibling-close and just as fraught. When our budget was slashed on *Velvet Goldmine,* many of the sets we'd planned to build were nixed and we had to move to locations, so the designer, Christopher, and the location manager, David Pinnington, often scouted together, and David worked diligently to meet Christopher's needs. Before they'll accept a job, many designers ask who the location manager is. Tom Whelan, a location manager I love to work with, sold himself to me by saying, "Production designers always like me."

When they don't get along, it isn't pretty:

This was the one set on *Poison* we went all out for—a Technicolor forest.

PRODUCTION DESIGNER: I'm going to paint this wall green.

LOCATION MANAGER: No you're not. I told the people who own this house we wouldn't paint.

PRODUCTION DESIGNER: Well, why didn't you tell me? Now the whole color scheme is thrown off

LOCATION MANAGER: Hey! Don't nail that in there! Get your hands off that!

PRODUCTION DESIGNER: Leave him alone. Keep nailing!

. . . and so on.

On *Happiness,* we needed a scene in a Florida real estate office but couldn't afford to spend another day in Florida. So we found a bare room in New Jersey and took designer Therese DePrez to see it. "But it's just a white box!" said Therese. "But after you're through with it," we said, helpfully, "it's going to look Condo Central in Boca Raton." And lo, Therese moved in with her sunny paints and furniture and tropical plants, worked her magic, and a day later you could practically smell the cocoa butter and hear the distant whack of golf balls. Unfortunately, that magic came at a price: nearly as much as an extra day in Boca.

LOCATION MANAGER

The location manager scouts locations and, once they're chosen, makes the deals for them, preps them, and then oversees your comings and goings. The job is not just logistical—it can actually be creative. Initially, the location manager sits down with the director and goes through the script and brainstorms:

LOCATION MANAGER: So . . . Patsy's office. It's sleek, modern, brand-new features, a little bit of Deco . . .

DIRECTOR: No no no. I want something . . . artsier.

LOCATION MANAGER: Like—a loft?

DIRECTOR: Not a Soho loft. Not cold.

LOCATION MANAGER: Artsy . . . and warm.

DIRECTOR: Artsy-craftsy.

LOCATION MANAGER: A warm, artsy, craftsy loft. A country loft?

DIRECTOR: Maybe . . . But Patsy lives in the city.

LOCATION MANAGER: You want a tension between artsy and homey, urban-chill and country-warmth . . .

DIRECTOR: Yeah. That's good.

LOCATION MANAGER: I saw this old carriage house in Brooklyn when I was scouting for *New York Undercover*. It has all the nine-teenth-century fixtures and moldings, but it's also someone's studio.

DIRECTOR: A carriage house. Cool! I could give Patsy, like, a horse fetish . . .

You could, of course, transform a conventional loft into that carriage house or build one afresh on a sound stage, but that would cost you a grotesque amount of money. On a low budget, you're better off finding something that approximates the real thing. For *Poison*, we needed a French prison of the 1940s. On a shoestring, of course. Our location manager had the idea of scouting army and navy bases around New York City. Many of those facilities were built in the 1800s out of stone. We found our Bastille—Castle Williams on Governors Island—in no time.

This is important: The location manager needs to be extremely presentable and well spoken. He or she is the rep from your movie with whom the community will have the most contact. A good location manager puts location owners at ease by appearing to be com-

pletely calm and responsible—but also not lying about the magnitude of what it means to have a film crew stomping around. The best are reassuring presences, even amid pandemonium.

Location managers usually precede you to the location by at least a few hours, if not a day or two, depending on how much work the art department has to do. Then their job is to protect the place from *you*. If there's an area that's going to be heavily trekked, they put down mats or brown paper, and they also safeguard the door jambs.

Inexperienced low-budget film crews tend to have a crash-and-burn mentality: "We're gonna blast in there and *shoot*, baby!" First, anyone who's dumb enough to let you come into their house and make a movie is worth treating with care, because they're few and far between. Second, you might have to go back, especially if you're using an inexperienced crew: Maybe you didn't get all the coverage you needed, or something went wrong with the film. But if you left crap all over the place or broke something special, the owners will often tell you to go to hell. That has happened to me. We've learned over the years to be very, very careful.

I've messed up locations, and it has had repercussions. For one of Apparatus' first short films, we convinced a guy to let us shoot at his country house in Woodstock, New York. We didn't have a location manager—and on a very low-budget movie where almost everything happens in one place you almost don't need one. But we should have had *somebody* in charge of the location. We went in and changed everything around, and when we finished and were cleaning up and preparing to return to the city, we realized that we hadn't documented the way it looked when we went in. We were saying things to each other like: "Er, do you remember whether this painting was here or there?" We put the place back together as best we could, but we weren't even sure what was his stuff and what was ours. Needless to say, the guy was furious. We barely managed to talk him out of suing. We could never talk him into letting us come back—which really screwed us up.

More on locations themselves in "The Shoot."

COSTUME DESIGNER

Think of clothes as an extension of personality: *This* is how a person chooses to present himself or herself to the world. A great costume

gives the actor an additional tool for characterization. And a great costume designer puts drama before fashion statement, and works closely with the director, the production designer, and the DP to achieve a unified look and feel.

On a low budget, you have few original designs, if any. Instead, you do lots of shopping and returning, and lots of closet-raiding. The designer has to put his or her ego aside and go with what works. On *I Shot Andy Warhol*, the costume designer, David Robinson, searched high and low for the right coat for Valerie

Toni Collette in one of Sandy Powell's creations

Solanas (Lili Taylor). Lili found one herself in a thrift store, and David was gracious enough not to let his pride get in the way of the right decision. That sort of behavior is not as common as you'd think.

Beyond the designs themselves, the most important skill a costume designer needs is the ability to put the "talent" at ease. Actors are usually hysterical about how they look in clothes—they're terrified of appearing fat or old. On one movie, an actress based in LA told our designer that she was a size six. When she arrived in New York only days before production she turned out to be a healthy size ten. A good designer has to handle problems like that with finesse, because you can bet that the actress was touchy about it. And if the film demands certain costume excesses (as in *Velvet Goldmine*), the actors' trust in the designer must be unwavering.

The hardest wardrobe day on a film is frequently the one in which a major costume gets established. That's what you're going to see the actor wearing for maybe half an hour on screen. Once you establish it, you can't change your mind. So right before you shoot that outfit for the first time, you inevitably hear: "The director

doesn't like the hat." Which means that that the costume designer had better be ready with seven alternative hats, or the shoot will stop dead. One job for the AD is making sure that the director goes to wardrobe before the actor arrives on the set—although even that's not foolproof, since directors often change their minds in the heat of the moment. Todd Haynes has said, "I don't like what that extra is wearing!" when the extra is one in a crowd of fifty. It might be a pain, but that kind of attentiveness is one of the reasons he's good at what he does. Your costume designer has to be prepared to dive in and make the necessary (instant) transformation—which means having racks of "stock" nearby with as many options as your budget will allow.

SECOND ASSISTANT DIRECTOR

The second assistant director is largely a people person, provided you think of actors as people. (They sometimes seem to be extraterrestrials.) He or she prepares the call-sheet—which lists call times along with location addresses and phone numbers—for the AD to approve, and then informs the actors when they have to be on set. Daily cars that pick up actors are also the bailiwick of the 2AD. Once they show up, the 2AD has to look after their needs (the temperature of their dressing rooms, their toilet and makeup facilities) and keep tabs on them—which means, for example, making sure the lead isn't down the block shooting hoops when he's supposed to be in costume and makeup and ready to go on.

If I have to rework the schedule, it's the 2AD I'll call. "Find out if Jane Adams is available on October ninth," I'll say. Or: "See if we can we switch Ben Gazzara from Friday to Tuesday." Discussing such changes with actors and their agents is the 2AD's headache. Another of their headaches is handling most of the SAG paperwork, along with the actors' time sheets. The 2AD verifies that the actors have scripts and revisions and that the extras are fed and watered. On top of all that, when the first AD screams into the walkie-talkie, the 2AD has to drop everything and Obey.

Because they're responsible for getting actors to and from the set, they have to know the van and limo drivers. In fact, they have to liaise with just about everyone. Consequently, 2 ADs are the people to go to if you want to know who's sleeping with whom, who's

Sandy Powell's costumes served to completely personify the sleazy rock 'n' roll manager Jerry Devine.

broken up, who's got a drug problem, and other good (or necessary) items of gossip.

PRODUCTION ACCOUNTANT

On a low-budget shoot, your line producer can follow the money, but it's good insurance to hire a production accountant, too—and, if you're using a bond company (which protects your financiers), you have to. He or she will be your lifeline to the budget, issuing a daily "hot-cost" report that tells you what you spent the day before versus what you were budgeted to spend, where you went over, and where you went under. I can phone the production accountant and ask: "If we add an extra day, what will it cost to pay the crew?" and he or she will run a few numbers and present me with the good or bad news.

Ideally, though, the production accountant should be more than a numbers cruncher. Along with the line producer, he or she needs to understand what the numbers *mean*, which is the only way you

can successfully extrapolate and forecast either gentle winds or ice-bergs ahead.

This is the chain of command: The production accountant goes to the line producer who goes to the producer.

The production accountant is an important hire to the people who finance your movie. They usually have to approve the person, and if you're working with a bond company, the bond company does, too. (I once had my first choice turned down because the financiers didn't think the candidate was experienced enough.) On studio films, it's clear who the production accountant is working for: the studio. On independent movies, they tend to be on Our Side. Our accountant would never put a cost report through to the financiers without checking with us first, although if they called to ask something, he or she would probably tell them.

A good production accountant will work with you to figure out ways not to alarm your financiers. For instance, you can decide not to show an overage until you have a savings that can cover it—which, in the short term, will make your life less harrowing

SCRIPT SUPERVISOR

The script supervisor is in charge of continuity, whether that means the length of actors' cigarettes from take to take or how much food is on their plate or at what point in the scene they shifted their bodies so that when you cut to the close-up they're in the same positions. They also pay attention to actors' eyelines from shot to shot and to that cinematic bugaboo known as "crossing the line," which means staying on roughly the same side of the action so that you don't perceptually jar your audience.

Now, the prop department could pay attention to the food on people's plates, and the costume department could worry about a collar that's up in one shot and down in the next. And some DPs have an innate sense of continuity and the location of "the line." But many don't, and a lot of directors need help with things like large dinner-party scenes. It's also good to have someone around to settle the inevitable debates.

The script supervisor keeps track of which takes the director se-lects and lines the script for the editor. He or she should also pay attention to the movie's pace and running time. If, for instance, the

director elects to shoot a scene from a single master—the pacing of which you can't change in the editing room, unless you want to go back and film close-ups, which no one will—it's the job of the Script Supervisor to approach the director and say, "This scene is playing five minutes and we really should try to make it play in three-and-a-half or four." Or, "The actor's walking really slowly up those stairs. Maybe he could take them at twice that speed?"

Is a good script supervisor anal retentive? Well, he or she should certainly be detail oriented. But some script supervisors get into a mindset where they decide that the only thing preventing the movie from descending into utter, uncuttable chaos is them. A good script supervisor has a sense of priorities. Whether the food on the plate is slightly more canted to the left or the right from take to take doesn't make a hell of a lot of difference most of the time. I recall a shot that took two and a half hours to set up and light, and then, finally, when the AD was about to yell "Action!" the script supervisor stepped in and queried whether the hall light should be on or off. What followed was a twenty-minute discussion during which I wanted to throttle someone. (Guess who.)

When we interview script supervisors, we care mostly about their personalities, because they're around all the time, and the overbearing ones can make you want to be sloppy just for the sake of driving them crazy.

PRODUCTION ASSISTANTS

My colleague Ted Hope calls production assistants "the circulatory system of the crew," because they come into contact with everyone, and they can spread their attitude like a virus. They're also the crew's eyes and ears, which means that they should police the set for intruders and always be prepared to troubleshoot. No matter what happens, they should be brave, cheerful, thrifty, and reverent, which is really, really hard because most of what they do is sit around waiting to be given orders. For hours they wait to "lock up" the street when it's time to shoot, or to drive people home, or park the vans. Meanwhile, they tend to absorb much of the crew's frustration. The difference between a PA and a dog is that people are afraid to kick dogs.

The best PAs are the ones who keep themselves as busy as possi-

ble. They can always be tending to the talent. One thing that irritates me is when I see an actor walking off the set in his or her pajamas (the costume) on a freezing night while a bunch of PAs are clustered together nearby not helping out. Actually, I loathe seeing PAs clustered together *period*. They should be doing something—trying to anticipate what will happen next—instead of sitting around blabbing. When I see PAs complaining to each other, I want to fire them on the spot. They should keep a "production face": My Movie Right or Wrong. They should not gripe about the food or the hours. For them, this is basic training, and you don't question orders in basic training. Look, everyone wants those pathetic $300- or $400-a-week PA jobs. We have many, many more applications than we can use. (We still end up hiring some idiots.) If you're lucky enough to get such a job, you should throw yourself into it body and soul, absorb as much about the process as you can, and impress the people who matter (like me) with your incredible initiative.

When I hire a production assistant (and I don't much anymore, since it's the AD and the unit production manager's job), the first question is: "Can you drive?" Because a lot of what PAs have to do is get in a car and go pick something up or drive someone someplace. When they're just starting out—before they graduate to being set PAs—they spend most of their time nowhere near the set.

Because I don't know how to drive, when I was a PA I was on the set all the time, right away. I think I was hired by accident. Nobody thought to ask if I could drive, and then, when they turned around and said, "Christine, we need you to jump into the van and drive over to Camera Service Center because we need a replacement lens," I just said, "You've got the wrong girl." I bet they were really pissed off because they had to hire someone else, but I was delighted. It meant that I was on the set from the start and could never be sent away.

Sometimes you work on movies where it's obvious that the director only wants gorgeous girl or buff boy PAs. There's nothing wrong with a little set decoration, but if they aren't any good, they should be dumped as quickly as possible, because that's too high a price to pay for beauty.

One PA's recent mishap made all the papers and has passed into legend. It was on a mega-budget film that was shooting in New York. Some poor fellow had the job of transporting the negatives from the day's shoot to the lab. *He left them in a taxi.* The producers

called all the cab companies, but never came up with that precious day's filming. The PA was merely fired; in a different time and place, he would have been shot. My colleagues and I (all former PAs) talked about what we'd have done if we had been in his shoes. Pam would have gotten on an airplane, flown to another city, and changed her name. Another producer I work with said she'd have pretended she was mugged and would have even filed a police report. One person said if he'd been the producer he wouldn't have fired the PA, because what are the odds of the guy screwing up again after a disaster like that? Ha! On a movie I produced, a PA wrecked a car. The policy was that if you have an accident, you're fired, except my partner was a bleeding heart and said, "He'll never do it again." The next day: BOOM!, another car accident. He was out of there *so* fast.

EDITOR

Even though the editor does most of his or her job in postproduction, you should hire one early so that the assembly of footage can begin when you start shooting. Your financiers, if you have them, will want to see scenes. More to the point, *you'll* want to see scenes to make sure that you have enough coverage, and to get a better sense of the pacing, the performances—everything.

The position varies in importance from director to director. Some directors prefer to cut their own movies, and some get an editor to implement their desires without being especially interested in what he or she might bring to it. Some directors edit in their heads. When I talk to Todd Haynes about changing a shot, I can see the wheels turning in back of his eyes: "Hmmm . . . I was going to use the master, then I was going to cut to *that,* then cut to *this,* then cut to *that,* but instead of cutting to *that* I can cut to *this* . . . Okay, we can change that shot."

A great editor can bring something to the process that wouldn't otherwise have been there. The late Ralph Rosenblum's great book, *When the Shooting Stops,* gives you a sense of how an editor can save a scene and how that scene can save a movie. It also gives you a sense of how little recognition editors get for their work.

It's important that editors are familiar with the changing technology. Films just aren't cut on film anymore. On an Avid, using video

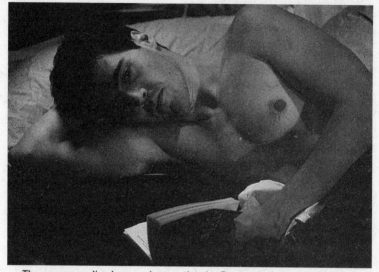

The gorgeous Jim Lyons—here acting in *Postcards from America*—but also the editor for *Poison*, *Safe*, and *Velvet Goldmine*

and computers, you can make fine cuts that were much, much harder to do on celluloid. And as the technology has changed, the language and syntax of the cinema has changed with it. I was on a panel recently with a producer who pointed out that the average length of a shot has dropped by thirty to forty percent. Today, radical jump cuts are nothing. Leaping back and forth between black-and-white and color, or grainy stock and silken stock, is nothing. The editing room is where the revolution in film language really begins.

STILLS PHOTOGRAPHER

When you're shooting, stills seem like the least important thing in the world, but you'll kick yourself afterward if you don't have them.

It's best to have the stills photographer on set from the beginning; that way the crew will get used to him or her. Some actors prefer that stills be taken before a take, some after; a good stills photographer is flexible and sensitive, and after a week or so will lock into a rhythm with the actors, the DP, and the AD. Actors have peculiar sensitivities in this area: I once overheard two of them commiserat-

ing about how awful it was to have two lenses pointed at them at the same time.

If you don't have the stills you need for publicity, or if you need another kind of image for the poster, you'll have to get the actors back, get their hair back to the color it was, put them back in their costumes, and hope that they haven't gained or lost too much weight. But don't beat yourself up too much: A lot of posters are done after the fact, usually at the discretion of the distributor.

DIARY INTERLUDE
#4

VELVET GOLDMINE: THE DAYS AND NIGHTS

This is is a record of the most difficult—and exhilarating—shoot I've ever worked on. What made it especially arduous was that we lost a million dollars in backing just weeks before production began. This meant: asking department heads to cut their budgets (and their salaries), dropping scenes, and scrambling to find locations to substitute for lavish sets that we couldn't afford to build. All of this with zero time to work it out. When Todd Haynes, at the end of his tether, says, "I can't work this way," he's referring to our circumstances and not to moviemaking in general.

My descriptions of the trials the line producer, production executive and executive producer put me through

Jonny and Eddie get acquainted on the first day of shooting.

should be taken with this grain of salt: I'm sure they could all tell equally gruesome tales about me.

Day 1: Sunday, March 23, 1997

It's always hard to know what to shoot on the first day: something not too challenging and very achievable, but also something that makes you feel like you've really *begun.*

We choose the exterior of the Bijou offices. It's a lot of people getting into cars, getting out of cars, rushing up the stairs, down the stairs, etc. Also, Curt (Ewan McGregor) and Mandy (Toni Collette) staring meaningfully up at the Window where Brian (Jonathan Rhys-Myers) is staring down at them.

I cannot believe that we are finally shooting the film after so many trials. I find myself near tears.

At the end of the day, Todd and the DP go off with Ewan and Jonathan to do a super 8 shot of Brian and Curt relaxing affectionately in a garden and then noticing (our) camera stalking them. It is a little tough because they have to muster a comfortable physical ease with each other and we have literally just begun. But they

manage. In the last take, Jonathan trips, falls backwards, breaks a plant, and cuts and twists his ankle. I hope this isn't an omen.

Day 2: Monday, March 24

We are shooting Curt and Arthur (Christian Bale) in the midtown bar. It's a little difficult—this is a big emotional scene that comes at the end of the film, and it's hard to shoot it so soon. But Ewan McGregor's schedule is forcing us to shoot him out in the first four weeks, so we'll face this situation a lot. Also, it's the first time we're seeing how the New York 1984 look is working. The seventies stuff is authentic period, whereas this is a might-have-been Orwellian world, and has to be invented. Todd is concerned about the extras' clothing. We change stuff around and finally get started: Our first interior. We're shooting half the bar in an upstairs room and cheating the other half downstairs. I hoped we'd move downstairs today, but we don't and I'm worried. But Waldo, the AD, says he knew we wouldn't and not to give it much thought.

Day 3: Tuesday, March 25

A tremendous amount to do today: the last part of yesterday's scene and a big fat new one. Very complex, with lots of coverage. And the worst kind of location: tiny, hot and crowded. I know we have to finish today and am nervous. I sit outside the set, in a bar called the Railway Social Club. Even though we're shooting on half his premises, the owner is open for business and there are lots of working-class patrons chatting over their ales. Whenever the AD shouts "Stand by!" the seconds shriek "Quiet!" and the patrons shut up. The AD shouts "Turn over!" to indicate that film and sound are now running (in the U.S. we say "Rolling!"). I'm hearing "Turn over!" a lot, which is good. I decide to stay off set; it is so hot and crowded and I know Todd knows where I am. Finally I hear a wrap called. Just a shade under twelve hours, which is when we'd hit overtime. Todd is jubilant: 27 setups today, and we didn't have to cut one shot!

Day 4: Wednesday, March 26

THE RECORDING STUDIO

Another big emotional scene: the disintegration of Brian and Curt's relationship. Eddie Izzard, Toni Collette, extras. Curt has a

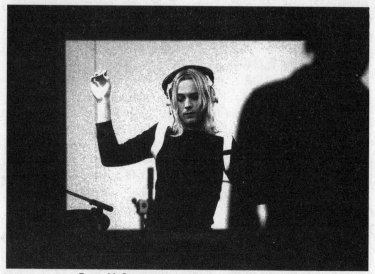

Ewan McGregor singing in the recording studio

tantrum and smashes a pane in the recording booth. The art department only has enough sugar glass to do it twice, and there's a twenty-minute install.

These workdays in London—twelve hours including an hour for lunch—are making me anxious. In the States we work twelve *in addition to* lunch. That extra hour can make all the difference. We spend a long time doing a complicated reflection shot in the glass. Ewan and Jonathan have to hit their marks superhumanly perfectly to make it work. Exactly the kind of shot I'm worried will be in jeopardy with this insanely short day. Once again, we finish under the wire.

I go home tired and frazzled. Still, we are making our days and my confidence in our AD is growing. It seems like he really knows how to keep us moving. *And* we have two big scenes in the can *and* we're on schedule *and* it is only one more day to the weekend.

But of course . . . the phone rings. The AD's mother has died. I find myself torn between sympathy for this very nice man and frustration at the inconvenience. The line producer and I decide that the second will first tonight, and then we'll have two days off to figure out what happens next.

Morning arrives and again the phone rings. Waldo's mother is not

dead but has only a five percent chance of survival—"which, when you think about it," says the line producer gloomily, "is even worse."

Day 5: Thursday, March 27

A very, very late night. We are shooting a near impossible day with four company moves. The third is the Movie Palace: not enough extras. Todd is very unhappy. We start yanking people from the sizable crowd that had gathered outside and throwing '70s-style gear on them.

Jonathan Rhys-Myers looking miserable. On each rehearsal his bottom lip droops lower until finally we ask him what's wrong. "I hate my costume," he says. "I look like a prat." More delays while we find the designer, dig up an acceptable alternative, and get him into it. I see some eye-rolling beginning with the crew—but what can we do?

Finally, we get to the last location of the day: our "Kreuzeberg" set, a drab corner of London that we turned into Berlin. The problem is that it's a bit too much like Berlin: we're surrounded by people, mostly Indian and Turkish. They are curious and polite except for a bunch of extremely noisy kids on a nearby roof. Everyone is somewhat indulgent until they start throwing eggs—and then eggs are raining down on us from everywhere. We call the police ("Not much we can do, luv"), they show up for a minute, and things quiet down.

The temperature is dropping steadily. It is already 9 P.M. and we haven't done a shot. We are supposed to wrap at midnight, but it is looking less and less likely. The grips and electrics are starting to look at me balefully.

There is such a delicate balance in getting the shot. If too much discussion transpires around the lens, the crew starts to feel that the director doesn't know what he wants—almost the worst adjective you can apply to a director is "indecisive"—and that hours could be spent waiting around until while he figures it out. Those moments make my stomach sink—but, on the other hand, there is no point in shooting if the shot looks bad or it's not what the director wants.

At 1:20 A.M. we finally wrap.

Day 7: Monday, March 31

It is the first of three days that we are spending at Mentmore Academy, an enormous country manor in Leighton Buzzard, Bed-

fordshire. Mentmore has been taken over by the Transcendental Meditation people, but up until now has been very cooperative with film shoots. Apparently, though, there is a new TM president who thinks that the meditative premises should not be disrupted by shooting, so we are the last movie.

The manor is on a gentle hillside overlooking fields and farmhouses. I feel like I'm in *Sense and Sensibility*—and after the urban chaos of last night it's a relief.

Because we shot so late last night our crew call isn't until 1 P.M. This is so everyone gets ten hours off the clock. We can invade people's turnaround if we have to, but we'd pay dearly for it. Waldo (he's back, mother holding on by thread) and I decide to shoot a short day so we can get back onto 8 A.M. calls.

Day 8: Tuesday, April 1

Still at Mentmore. It takes an hour to get here and back; apparently the crew thinks travel time should be included in our shooting day(!). I feel a little despairing. It's not more money the crew is after—they just don't want to work the long hours. I am filled with such anxiety at the heavy days ahead of us that I just have to take a deep breath and take it one hour at a time.

We are shooting the orgy today. Todd is concerned that the cast (extras and principals) be relaxed enough so it doesn't feel horribly stagy. Strangers have to be kissing each other, caressing etc. Also, we are doing it in one long circular track. We pass out real champagne and after a few rounds everyone is definitely relaxing. We shoot some takes where a guy goes through the frame with his dick dangling and a few with pants on. The MPAA seems to have a number of double standards. Naked females get R ratings, but pickle shots tend to get NC-17s. Our Miramax contract obligates us to an R, so we have to make sure we are covered.

The day ends badly. The electricians do not want to work past 9 P.M. (we'd had a 9 A.M. call) and are threatening to pull the plug. At 8:55 we have one more shot to do and are racing to finish it by nine. It is a frustrating way to work. I am angry at the electricians (or "sparks" as they call them here)—I feel like we're either here to make the movie or we're not.

Todd is very downcast at the end of the day. My heart breaks— I feel I'm not protecting him enough.

Day 9: Wednesday, April 2

The last day at Mentmore! Last night Todd and I decided to stay at a local pub (they all have names like "The Buzzard's Loin") so we didn't have so much travel time. We got drunk and decided that we would do whatever it takes to get the time we need. In the light of day I'm not so sure how. . . .

First, I talk to Waldo. I tell him that this is just the kind of movie where every shot will take a tremendous amount of care. I do not want to operate in a state-of-siege atmosphere all the time. If the crew can't hack it, they should quit. Waldo agrees and says he will try not to put so much pressure on Todd.

Next problem: Tomorrow is our first day at Brixton Academy, where we are shooting all our concert stuff. We will be there for a week and change. But I just found out that the song we are supposed to shoot Maxwell Demon and the Venus in Furs playing tomorrow hasn't been recorded yet—at least, not a version that Todd likes. And he doesn't want to go with the version we do have because he is afraid the lip-sync will be off when we replace it. So what are we going to shoot? I propose the Tommy Stone scenes. Hair (Peter King) would have to stay up all night knotting his wig, but he'll do it. Costume insists the outfit simply isn't ready and won't be until next week. The line producer fumes: "Can't we just put him in *anything*?" I try to explain that it isn't that kind of movie. Then Waldo suggests we shoot Placebo, a real band that is playing a band called the Flaming Creatures in the movie. They have recorded a cover version of "20th Century Boy" and we are scheduled to shoot them performing it next week. I call their manager, who tells me that they are doing press all day tomorrow. What are we going to do? The line producer says, "Can't we *replace* them?" I try to explain that they are a major draw and it would probably piss off the record company. Finally, I take a deep breath and call the manager back. And beg. And plead. I tell her they can do press on our set, and the reporters will get to see them perform. She says it is a major reorganize for them, but if I am really really desperate she'll do it. I am, I say. Two hours later she calls back and says it's done. Alleluia. I send her flowers.

Day 10: Thursday, April 3

Our first day at Brixton Academy—a dank, cavernous concert hall that stinks of beer and cigarettes. After a few hours I can't smell it anymore.

This is not our greatest day. We are shooting bits and pieces: Arthur

Xaf, Brian Molko, and Antony Langdon really helped us out a lot.

watching Curt perform, Mandy watching Brian, etc. It's confusing be-
cause the actors have to look at nothing and work themselves up. And
for some reason we are moving very, very slowly. And of course this
is the day the bond company chooses to visit the set. I try to keep
Graham Easton (the bond company rep) away from the action: We
usually are moving in a much more purposeful manner and I don't
want him to see us limping along. But he's no fool and he pushes right
past me. Todd, Maryse, Joe (the camera operator), and June (the script
supervisor) are involved in an excruciating discussion of eyelines. The
crew is rolling its collective eyes. Oh, boy.

Flaming Creatures/Placebo will perform their cover of "20th Cen-
tury Boy." It is taking a long time to light and I am starting to feel
the familiar pressure—and then we start, and it is our first musical
performance, and everyone is completely enthralled. The band is
energetic and mesmerizing, our crew is practically dancing.

The end of Week Two.

Day 11: Sunday, April 6
A really good day—tons of period extras. Ewan and Jonathan
perform "Baby's on Fire" with Jonathan going down on Ewan's gui-

Ewan McGregor performing "Gimme Danger"

tar (à la David Bowie and Mick Ronson) and the crowd goes wild. Ewan is concerned that he won't have the guitar fingering down exactly. We made him a videotape of Bernard Butler playing the solo and he sits playing it over and over in his dressing room.

We have about 300 extras. Todd and I were nervous that Brixton Academy would just swallow them up because it's so huge, but Waldo knows how to place them so that it looks as if we have twice as many.

Waldo does not use a bullhorn. He shouts at the top of his lungs and is so loud that the extras do what he says. After lunch he is hoarse and he looks pale. I ask him if he's okay, and he says he's got a really bad toothache. These English people and their teeth! The on-set nurse gives him aspirin, but it is clearly not enough and his face is starting to contort. My assistant, Romany, is calling every dentist in London, but it's Sunday in a non-convenience-oriented country. Finally we find a place that is about to close—my assistant keeps them on the line and I throw Waldo into a taxi.

Our next few days are big extra days—we can't afford to lose our first AD.

Day 12: Monday, April 7

More performances today. Ewan does "Gimme Danger." He sings live and is the only performer to do so—everyone else sings to playback. Ewan throws himself into his performance. Todd decides not to rehearse him too much because he's afraid he'll be burnt out before we commit him to celluloid.

I am getting concerned about our electrical crew. Our gaffer is

really old-school. He is in his sixties and wears a tie. I can tell he
disapproves of the laid-back way in which Todd works. And I disap-
prove of the liquor on his breath after lunch everyday. He is a
ringleader of the pull-the-plug mentality that I'm trying to get rid of.

Day 13: Tuesday, April 8

Today is our first crane shot. We are shooting Jack Fairy singing
"2 HB." When David Bowie refused to license "All the Young
Dudes," we substituted "2 HB," which isn't as anthemic but still
gives us a sense of a journey somewhere and a journey back.

The shot is very complicated; glitter has to fall and giant slide
projections (of all the glam-stars in the movie) have to appear on
the stage. The camera has to glide on a crane from a close-up to a
very wide shot, and a very inexperienced actor has to lip sync.

We approached a number of "real" rock stars to play Jack Fairy,
but they all turned us down. I think they were afraid that if it didn't
strike exactly the right note, the rock star playing a rock star thing
could expose them to ridicule. We went with a guy named Micko
who looked great but had virtually no experience. This is his big
moment; Todd and I have our fingers crossed.

He does a rehearsal: The lip sync is a little off but it's not bad.
Meanwhile, it's taking longer then we thought to "find the shot."
We're almost ready to shoot, and then Todd and Maryse decide to
combine three shots into one. This is always tricky: It has the *illusion*
of saving time, but usually it just takes three times as long. For the
first time, we don't get a shot off before lunch. I am super nervous—
I keep feeling like I'm holding the movie in my hands, and it's like
mercury and keeps slithering out of my fingers just when I think
I've got it.

Finally we roll the camera at 3:30 P.M. (We started at 9 A.M.!)
Micko comes through. We have Ewan on standby to come in for a
very brief scene of Curt in his office in 1984 New York, but since
that office could be shot almost anywhere, we decide to push it to
another day. So for the first time we don't make our call-sheet.

Day 14: Wednesday, April 9

While we're setting up inside, we shoot a crowd of extras outside,
waiting to get into a Brian Slade concert. An actor playing a BBC
reporter gives a minute-long speech about the Brian Slade phenome-
non; it will play on a television in Brian's dressing room in a scene

we'll shoot tomorrow. The poor actor playing the reporter simply can't get through his speech without flubbing it. We do take after take. The actor looks like he is going to cry. The tension escalates. Finally, finally he gets through it. Cut and print and he's out of his misery.

Today Jonathan/Brian gets shot! We spend a long time trying to figure out the best way to pull this off. Todd wants to see Jonathan Rhys-Myers jerk into the air with the force of the impact. We originally thought we would use a wire with a harness, but when the costume designer saw the harness she went ballistic. It didn't work with her skin-tight jumpsuit concept. So we figured we would use a trampoline, although it would mean the floor of the stage couldn't be in the shot. The stuntman will put an electronic device on Jonathan's chest that he'll detonate, and then Jonathan will leap up and backwards and land on some crash pads. The only thing that concerns me is the fact that Jonathan is wearing gigantic silver platform shoes.

Jonathan practices the jump in bare feet and then flat shoes, then finally the mega-heels. We only have two costumes, which means we can only do it twice. So . . . we go for it. Jonathan is terribly nervous—more about screwing up the shot then about hurting himself—but it goes fine.

Day 15: Thursday, April 10

Our last day at Brixton Academy. I am glad, even though it has been a relief to be in one place for so long. But being in the dark space means whole days go by where I don't see the sun. Even though my nose has gotten pretty numb to the beer-cigarette-dirty feet smell, I feel like it clings to me.

We have to shoot the Rainbow Theatre reception, Max's Kansas City, the office scene we missed, *and* Brian Slade's dressing room. By the time we stagger to Max's it is pretty clear the latter two scenes might not happen today. Still, we optimistically prelight them.

Donna Matthews of Elastica is performing "Personality Crisis" (originally by the New York Dolls) at Max's. We break for lunch. After lunch she is nowhere to be found. I call her manager and work her into a frenzy, which doesn't help us locate Donna. I run around Brixton Academy, looking in all the bathrooms. Finally, we open her dressing room: There's a note!

"At the pub, call me on my mobile #"

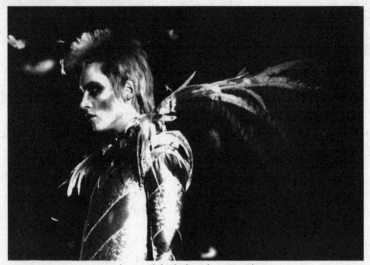

Jonny right before he gets shot

We call, she comes, we shoot.

The thirteenth hour is rapidly approaching and it's obvious that we won't get those two last scenes. Which means we brought Emily Woof in and didn't use her. She's a little upset but professional. So now we are about a half day behind schedule.

Day 16: Sunday, April 13

SEX ON THE ROOF

It is a mercifully clear night, but with a slight chill that intensifies as the hours pass.

Tonight we are shooting Ewan and Christian making love on the Rainbow rooftop. We start with the end—a big, splashy crane shot with snow and glitter. The crane is on a neighboring roof, but it all goes remarkably smoothly. Then we start doing the more intimate shots and time starts to drag. I have a bad cold and I don't feel like racing up the seven flights to the rooftop, so I sit and snuffle on the dining bus. The set falls into that weird terrible time warp where it keeps feeling as if you're about to start shooting *any second* and then two hours have slipped by and no film has been exposed. It is getting colder, everyone is tired and dopey. . . . I keep thinking that

if we're in trouble, the AD will summon me. When he finally does, he says those awful words: "We won't finish tonight."

However sick I was, I should have dashed up those seven flights the moment we started to drift into that two-hour abyss. It's always difficult to know whether it is making things better or worse by applying pressure. I don't want to breathe down Todd's neck because I know he is just as aware of the time constraints as I am. But tonight I think I gave him too much space and let him down.

At 5 A.M., Waldo points at the sky: It's still night but dawn has a way of just cracking over you—BANG!—and then there's no more night shooting. He also tells me that the actors seem tired and cold and too exhausted to go on. He thinks we should call it a wrap. Todd seems taken aback, but has no choice in the matter since the sun is coming up. We both go home exhausted, defeated. I tell him we'll figure something out in the morning—*our* morning.

I fall asleep for about two hours and am awakened at 9 A.M. by an actor's agent: His grandmother had died. Could we release him to go to the funeral? I say no and go back to sleep.

Day 17: Monday, April 14

Today we are shooting Ewan's big outdoor concert scene: three hundred "hippie" extras, who boo Curt Wild, who responds by mooning them and then setting the stage on fire *and* then leaping through the flames and into the crowd below. Whew. Ewan is in a much better mood than he was last night.

My cell-phone rings. It is Wendy from CiBy sales—she says Harvey Weinstein (Miramax) is landing in London in one hour and coming right to our set. They are all going to drive out as well. Okay. I decide not to make too big a deal out of it. An hour later CiBy calls again: It seems that Harvey never got on the airplane, so he probably won't make it to the set tonight. . . .

Waldo instructs the extras to jeer and hiss and go crazy when Curt hits the stage. First, we use two cameras to shoot the scene up until the flames should start. Once again, Ewan is throwing himself into it body and soul; two cameras help insure we'll get him on film before he burns himself out. In the second take, Ewan not only moons the audience but turns around, kicks off his pants, and treats the crowd to his member as well. (I'd heard that in *The Pillow Book*, Ewan was so well-endowed that his member deserved separate billing. I'm not disappointed—nor is the crowd, which goes wild.)

After lunch we start the flame shots. The FX guys put flame bars across the stage. They ignite them. Maryse thinks they look too straight and fake. They mix them up, adjust the flame heights—finally it starts to look like a genuine fire. The FX man can flip off the flames for the split second that Ewan jumps through them and then flip them back on. Ewan has no qualms about walking through the fire.

The stunt men dress in hippie garb and place themselves strategically in the crowd so they can catch Ewan when he jumps.

It all works perfectly. In fact, we finish three and a half hours early. I'm starting to realize that the big, seemingly complicated stuff isn't what takes a ton of time—it's the two-actors-in-room that takes us forever.

Day 18: Tuesday, April 15

We shoot Jonny singing in his hippie phase today. While we're doing that, the art department sets up another part of the area to look like an American trailer park. We bring in a silver Airstream and a Winnebago. The scene consists of a pack of wolves dropping a baby on the trailer's doorstep.

The wolf ladies arrive early so the "wolves" (they are really half dog, half wolf) can get acclimated to the location. They traipse down to the trailer park and come running back—there's no fence! The wolves have to be in an enclosed space! The art department says no one told them, the ADs say they did, blah blah blah. Finally, we find enough chicken wire and start enclosing.

When we finish Jonny's concert, we let all the extras go and most of the crew, since the wolf scene can be shot with a reduced unit. In the scramble, we screw up seriously: Somehow, the extra who was supposed to play Curt's father was told to go home. He is now irrevocably on a bus headed off with all the other background people. Oh, boy. The second AD is near tears. "No problem," says Waldo, the AD, "I'll play the dad!" And, in a tight white T-shirt, Waldo looks exactly like somebody's white-trash father. Crisis averted. I tell Waldo I can't fire him now since the dad shows up again later in the shoot.

We use a plastic doll for the baby. The wolves start fucking each other the second they are let off their leashes. They pay no attention to the baby, let alone the trailer. I can tell it is going to be a long night. Finally, we get the wolves to approximate picking up the doll and dropping it near the trailer—and we call it a day.

Day 19: Wednesday, April 16

The kind of day I hate—three smallish scenes in different locations and then an elaborate night scene: Jonny and Toni dancing under a tree, lit by a fake moon, with a real raven silhouetted against it, in a snowfall. The three smallish scenes of course take much longer than anticipated—it's all the moving around and setting up. By the time we get to the night scene it is close to ten o'clock. I am getting concerned that we will have to push tomorrow's call— and our whole day is daylight-dependent.

Jonny and Toni are singing and dancing to "Ladytron." It is one of those magical moments. The "snow" (biodegradable non-tree-toxic substance) looks great, the raven is amazing—even the incredibly loud noise of the snowblower doesn't make it any less moving.

But we go late and we have to push tomorrow's call.

Day 20: Thursday, April 17

A baaaad day. Crew call is not until 12:30, then we shoot the bus scene until 4 P.M.—this is a good example of a misconceived day. The bus scene is not as important location-wise and should have gone on the end of a day instead of the beginning. SHOOT THE MEAT FIRST. We should know this by now. By the time we get to the English Garden we only have about three and a half hours of daylight left. Todd starts to panic. So do I. I try to calm us both down by saying, "Let's just shoot what we can, if we have to come back we will"—although I don't know when we can!

I am trying to focus us on getting through the day. We shoot out the dialogue . . . now what? There is not enough time to do the whole garden scene, and it seems stupid to just do part of it. Finally we decide to just shoot Jack Fairy as a statue. Micko comes to set, *but* his makeup is wrong—there has been a miscommunication about the statue makeup. We wrap early.

Todd is distressed. He says, "I don't know how we're going to do this in nine weeks, I really don't."

I try to calm him down. I don't want him to start to think it's not possible or it won't be.

Day 21: Sunday, April 20

First day at Bray Studios, about an hour out of London on the banks of the Thames—very pretty.

Shooting in a studio is a little tough because it lends a false sense of security that there is plenty of time: There is no "concrete envelope"—no location owner screaming that you have to leave by a certain hour.

It takes a very long time to light. I'm not sure why. Part of the problem is that everyone just had two days off and most of them spent all forty-eight hours plastered. So they are nursing killer hangovers.

We get through only about two-thirds of what we wanted to shoot.

Christian Bale as Arthur in *Velvet Goldmine*

Day 22: Monday, April 21

Finally, we pick up the pace and bang through today's schedule and what we missed yesterday. It feels great to be back on track

The actors have a bit of a collective tantrum. The nature of the stuff we're shooting—the St. Francis Hotel—is a little frustrating for them. They're all in fabulous outfits and mostly they are being placed for camera: They deliver a line, get placed, deliver a line, and get placed again. In short, they are props. Some of them decide they've all been waiting around all day, this is crazy, they shouldn't be treated like this, YAK YAK YAK. It's one thing when this nonsense comes from a *star* but when it starts to infect the bit players . . . "Look," I say to them, "this is what actors do. They sit around. That's why you get paid more than anyone else."

They shut up.

Day 23: Tuesday, April 22

Another bits and pieces day: lots of small sets. First, we do Curt and Brian on the carnival rockets. This is a lot of fun. They are lip syncing to Lou Reed's "Satellite of Love" (one of my favorite songs)

and it's very buoyant and freeform. I know we haven't exactly cleared the song yet and I am worrying a little.

In the afternoon we do our first bluescreen shot. Ewan is dressed as a satyr and jumps down a chimney stack (very Mary Poppins). He is having a tough time because there is no chimney, no background—it all gets laid in later. But he needs to look like he knows what he's doing.

We put on today's call-sheet that we're going to shoot a sixth day on May 16 in order to get the English Garden. People are grumbling.

Day 24: Tuesday, April 23

THE GRAND BALLROOM

One of those odd conundrums. The set has been sitting here for days. Todd and Maryse looked at it the night before to prelight; Maryse said she needed two more hours in the morning. Since Jonathan Rhys-Myers required at least three hours in makeup (full green body paint), we planned accordingly. But now, per Todd's instructions, Maryse is re-gelling all the lights. Two hours come and go. Maryse swears that she needs just one more. BANG: The hour is gone. Jonathan is ready. "One more, one more," says Maryse. BANG: That hour is gone. Jonathan begins to flake. Waldo starts to seethe. We break for lunch without having shot anything. Makeup is sulking because Jonathan looked great two hours ago but is now starting to come apart. Maryse works through lunch. FINALLY, two hours *after* lunch, we shoot.

Day 25: Wednesday, April 24

We had a ton to shoot today so we put "extended day" on the call-sheet to warn people. *So of course* we end up not shooting late at all. . . .

The last scene of the day is Jonathan dressed as a mod in his bedroom. A schoolboy lies naked on the bed. We called Alaister (the schoolboy) to the set too early, and by the time we get to his scene he has worked himself up into a panic over the nudity. Jonathan takes him aside and is incredibly good with him, puts him completely at ease—by the time we shoot, he's relaxed. It gives me a new respect for Jonny. Not all actors are that generous.

Day 26: Friday, April 25

It is our first sixth day—the first six-day week as opposed to the usual five-day—and everyone moves like molasses. It is also Ewan's last day. We finally shoot the NYC office scene that we've been carrying around for weeks. Then we do the two shots from the rooftop that we didn't get on that horrible night. The art department built a brick roof corner. It's so easy that I think maybe we should have done the whole damn thing in a studio.

We wrap early. As a joke, the AD walkies the second AD ten minutes before wrap and says, "We're going late, we'll need a second meal." The second AD is not amused.

End of Week Five.

Day 27: Sunday, April 27

Our last day in the studio!

We are more than halfway through now, but I am really not seeing the light at the end of the tunnel. Todd and I had convinced ourselves that the first four weeks would be the toughest since we had to shoot all of Ewan's scenes. Now, looking at the weeks to come, I don't know what the hell we were thinking.

To top it all off, my relationship with a production executive is rapidly crumbling. He calls me this morning and says, "Everything is a complete disAHSter, the bond company is definitely going to step in." I try to calm him down—I remind him that we're pretty much on schedule, our over-spend into the contingency isn't that bad, and the film looks great and isn't that the most important thing?????!!!

Day 29: Tuesday, April 29

We are shooting all the school stuff in an empty school in South-hall. We start in the schoolyard with a crane shot of little Jack Fairy getting beaten up by a crowd of schoolboys. The little actor is understandably concerned. I watch the stunt coordinator work with the kids and the scene magically comes to life: They all look really fierce, their kicks and punches look real, but after "Cut!" little Jack Fairy stands up, grinning and unharmed.

The line producer calls and we have another argument. I had spoken to our executive producer (Scott Meek) the night before and said, "I know the schedule is tight and I'd be delighted to figure out ways to lighten it. I just don't think we're at panic level yet."

That other production executive—my bête noir—doesn't see it that way, and has come up with a list of scenes to cut.

I say, "I don't want to cut any scenes—"

"Well, you have to!"

I lose my cool and accuse him of sabotaging the movie rather then working for it. I yell something eloquent like, "You should be supporting *me* and it sucks that you don't!"

He hangs up on me.

Big crisis at the last scene of the Oscar Wilde schoolboys: Todd thinks their hair is all too short. Lengthy discussion of how long little boys' hair was in the 1850s. The casting person says no one told him they had to have long hair. Todd wonders if he has to think of everything.

I think, Yes, Todd, you do.

Day 30: Wednesday, April 30

Two crane shots today, one for the beginning of the movie, one for the end. The first is two dockers kissing and the second is the Oscar Wilde shot.

Todd does not like either of the extras who came in to be dockers—he doesn't think they're cute enough. The two most handsome men on our crew are Peter, the stills photographer, and Joe, the wardrobe supervisor. We ask them if they will kiss each other and surprisingly quickly they agree. The crane then breaks down and we spend two hours waiting for a new "pod"—whatever that is.

Off to Elder Street, to shoot the exterior Wilde house. This street happens to be the only one in London that can double as Dublin. The residents have imposed a lot of restrictions on us; the location manager tells me that another movie shot here last week and made a lot of noise, damaged the street, blah blah blah. So we have to leave by 11 P.M. and it's not dark enough to start to shoot until 9 P.M.

The art department has dressed the street, removing all modern elements, putting in gas lights, etc. It looks amazing. Our shot is a complicated crane swooping from the rooftops down to the baby on the doorstep. We finally get it and move in to closer coverage on the servants discovering the baby. Then Todd says he wants to cut to a side shot, looking down the street in the direction the art department *hasn't* dressed.

Christopher Hobbs is aghast. "But you CAHN't!"

Todd says "That's where the action *is*."

"Yes, but . . . but . . . Todd, it's all wrong! There's modern lamps! Buildings!"

Christopher looks like he's going to cry. He says, "I have to go home." And he does.

Day 31: Thursday, May 1

Election Day today.

We're back at the midtown bar location, this time shooting the Flaming Creatures at the Last Resort club. It seems like the last time we were here—week one—was a hundred years ago.

Scott and I met on the set last night and went over ways to lighten the schedule, mostly by moving things to second unit when possible. I keep redoing and redoing the days in my head and then running over to Waldo and Todd: "How about if we do the dressing room, the theater, and Jack Fairy's parents' bedroom all on the same day . . ." And then he'll point out a fatal flaw and I'll go back to square one.

The production executive (who is barely speaking to me) says, "You do know you will have to cut something don't you? So why not decide now?"

I DON'T WANT TO CUT ANYTHING.

The bond company pays a visit. I spend two hours with Graham Easton, the rep. He is a little nervous. "I know you only have three weeks left," he says, "but don't get complacent." HA. I go through the schedule and try to convince him that we can finish on time. That's what everyone is panicking about: If we go past May 24, it will cost big, big bucks.

Done at midnight.

End of Week 6.

Day 32: Sunday, May 4

Tony Blair won the election, which everyone seems pretty happy about. We're shooting in Croydon, a miserable suburb about forty-five minutes from London which doubles very well for 1984 New York. Dull day, not much to say.

Day 33: Monday, May 5

I am just walking out the door when the phone rings—it is Maryse. She can barely talk and she croaks out that she thinks she is

too sick to come to work. Oh, boy. Since it is all exteriors today, her operator can probably handle it, but what about tomorrow? And what if everyone gets what she has? I call the office and tell them to get a doctor there *now*.

We are shooting on Portobello Road right near my house. Today we have a lot of club-kid extras and they all showed up smashed (at 8 A.M.!). They are a little hard to control.

I call Maryse at the end of the day. She still sounds like shit. I book another cameraman for tomorrow. Todd says, "What happens if *I* get sick?"

"YOU WON'T," I say.

Day 34: Tuesday, May 6

New cameraman. We are shooting the newsroom stuff, and it goes very, very slowly. We don't make our day (sigh). I spend most of the time reconfiguring and reconfiguring the schedule, trying to put a ten-pound sausage in a five-pound bag. How can we finish in two and a half weeks? I can feel the sharks circling. . . .

Day 35: Wednesday, May 7

Maryse is back (a little worse for wear) and today we actually catch up a bit, which feels great. A glitch in the last scene: We're shooting Arthur running down his office's hallway to the elevator. The hallway is very long and Maryse lights it with fluorescents from the ceiling. It is a big lighting job and the "sparks" have been working on it for two days. But when it is time to shoot the scene, Todd says, "But Maryse, we have to see the ceiling. Those lights can't be there."

Down come all the lights.

Day 36: Thursday, May 8

Today we're shooting Jonathan and Toni making love. The set is closed, which means only essential crew is allowed. I don't really deem myself essential, so I keep my distance. Jonathan and Toni were both super-nervous, but by the time we break for lunch they seem relaxed and relieved.

Once again we have to push the Sombrero lavatory to another day. . . . I have a feeling we will be dragging that scene around for the rest of the shoot.

Day 37: Friday, May 9

Chaotic morning: I get a call on my way to the set that there has been a fire at the garage where we park the camera truck. The gear is okay, but it will probably be two or three hours before it can leave (!). I call the production office and tell them to see if Panavision can pull another package together. Then I remember that our backup (B) camera isn't on the truck—it's on its way to a magazine press in Worcester to do a second unit shoot of the Curt/Brian headline being printed. I call and reroute it to us. So now we potentially have *three* cameras making their way to set. We'll use whichever gets there first.

Our second AD is out sick. One of the PAs tells me he doesn't feel so good himself: Can he go home? I tell him we're really short handed and ask if he could please wait until reinforcements arrive. He sort of winges away and then comes dashing back: "Waldo said I could leave!" Great. When I was a PA you weren't allowed to get sick.

Todd is now panicking that he will get this virus. He is worried that a pain he feels in his neck is a symptom. Yeah, of this movie. Maryse does not help by nodding sagely and saying, "Yes, that was how *my* flu started!" As a strong believer in the power of suggestion, I flash her a dirty look, but she is totally impervious.

Finally a camera arrives and I redirect the other two. We are shooting a relatively simple scene, but as usual, it is taking us a very, very long time. It is also the sixth day of a tough week and everyone is burnt out.

Around 6 P.M. I get the "Waldo needs to see Christine right away" call to the set. Waldo is upset. "We have three more shots before we even get to the electroshock scene!" (The scene of young Curt being "treated" for wildness.) "We'll be here until midnight!"

Maryse is so afraid of giving us lighting estimates that are too short (after the green makeup debacle) that she tends to go overboard on how long she needs. I calm everyone down. We go over all the shots we need and it turns out there are a few in the electroshock scene that we can move to second unit. I calculate a half an hour per shot—very optimistic. "See?" I say to Waldo, "We'll be done tenish, not too bad." He is very dubious, but we are done in fact by 9 P.M. HA.

The end of week seven; only two more to go. Day off tomorrow, thank God.

Day 38: Sunday, May 11

We have a split day today, meaning we start around noon and go to 1 A.M. or thereabouts. I was looking forward to sleeping in, but Todd and I need to go watch Lindsay Kemp rehearse (she's on tomorrow) so off we go at 9 A.M.

As I watch Lindsay strut around singing "A Little of What You Fancy Does You Good" my phone rings—Waldo, too sick to come in . . . this fucking flu!! So here we are with a big extras night outdoor scene and Mark, the third AD, filling in.

I try to stay away from the set so Mark doesn't feel like I'm looking over his shoulder. Also, I don't want the crew to think I don't have faith in him, and they will if they see me hanging around. And then they will stop listening to him.

Waldo calls and croaks, "Maybe I can come in later . . ." and clearly waits for me to say, "Oh no, that won't be necessary." But I don't.

He doesn't come in. We make it through the day.

Day 39: Monday, May 12

Waldo *still* out sick. Today we are shooting Lindsay Kemp's big scene—and the little boy (young Brian) watching him. Callum is a trouper, but he is still only seven. We start with his scene in the hallway and then move to Lindsay's scene on the stage, giving the kid a chance to rest. He doesn't do a whole lot of resting and proceeds to consume vast quantities of candy. Just as we're about to bring him back on set, he starts to throw up. I call for the nurse and then sit down with him and his mom to get a sense of how ill he really is and how far his mother will let us push him. I go back to the set and tell Todd to consolidate as much as possible; this kid doesn't have a lot left. . . .

We finish Lindsay et al., but our additional scene—the "imaginary theatre"—gets scuttled. The production executive looks at me balefully. "SOOOO what do you propose to cut?"

Oh, God I am so tired. I summon up all the civility left in my bones and say, "Look, we've already scheduled an additional day, we can probably fit this in there. Let's not start carving yet . . ."

"But you realize we CAHN'T schedule any more days . . ."

I go home and spend the night moving scenes around.

I DON'T WANT TO CUT ANYTHING.

Toni Collette in the Sombrero Club

Day 40: Tuesday, May 13

Sombrero Club. Lots of extras, Waldo back, a little worse for wear. We have a daunting amount of material to cover in two days. We decide that we'll shoot out the scene where Cecil sees Brian for the first time and then do Brian meeting Mandy with the fake snow-fall. It's a long day, but it is exhilarating to get so much big stuff done. Waldo and I look at tomorrow's shot list and wince—it's going to be long long long.

Our stills photographer went to the Cannes Festival over the weekend for the opening of his pal Johnny Depp's movie. He was supposed to be back yesterday, but he's not back yet. On the set, I get a call from Depp's manager: Johnny would consider it a personal favor if I let the photographer stay until the end of the week in Cannes. I say he can stay as long as he likes and I fire him.

Day 41: Wednesday, May 14

We are shooting New Year's Eve 1969. *Big* shot of Jack Fairy. I am a little melancholy because my brother's girlfriend just went into labor. It's his first child and I feel like I should be there, not here. . . . Michael calls me on the cellular phone and I can tell that

he is a little angry that I'm not there for him. He says he will call when the baby is born.

I go back to set—there is a commotion. I run over to a very irate Todd. It seems that we've just shot three shots of Jack Fairy and no one noticed that he didn't have his birthmark on. It just fell through the cracks: The makeup people should have put it on; the script supervisor should have made sure; a more experienced actor would have reminded the makeup people . . . I calm everyone down and say, "Look, we'll reshoot the close-up at the end of the night, no one will notice in the wides." I tune out everyone's explanation about why it isn't *their fault* and make my way over to the devastated makeup man, Peter, who is taking full responsibility. He is near tears. He says, "This is a disaster." I say, "No way. A disaster is irrevocable. A disaster is not being able to shoot. This is nothing." It takes us about ten minutes to redo the close-up.

We go very, very late. The extras are cranky and tired of dancing to "Ballroom Blitz." Finally at about 2:30 we wrap and I'm in bed around 4 A.M. The phone rings at seven—my brother had a boy.

Day 42: Thursday, May 15

Arthur's house today. We are shooting in a house that hasn't changed in thirty or so years and is inhabited by an ancient couple. The location manager says we have to be out by midnight. I don't see how this is physically possible. At 11 P.M. I tell him that we won't be done before one at the absolute earliest. He sighs and goes in to the TV room with the house owners—I hear him drone on and on about his early years in Liverpool to keep them distracted. We wrap at 2:33.

Day 43: Friday, May 16

The last day of the second-to-last week. Why don't I feel more relieved? I guess it's because next week is a seven-day one and it's *huge*—all the Bijou office stuff.

We are negotiating with the crew about that seventh day. They have us over a barrel and they know it. We come up with some inane plan that forces us to finish by 10 P.M. Who knows if we will? If we can?

Short day today because the location says we have to leave by 10 P.M. and we didn't start until two. . . . The production executive is nowhere to be found and he is the one who negotiated this stupid

deal. After trying to reach him all day I finally send a crew member (a nice enough girl, but with a perennial air of "it's not my responsibility, is it?"—a drag in a production person) to see what we can do. No dice. Once again we drop Jack Fairy's parents' bedroom.

One more week to go. . . .

Day 44: Sunday, May 18

Today we're shooting the glitter kids running through the streets of London—an organizational nightmare, particularly on a tourist-ridden Sunday. On our way to the set, Todd asks me to call ahead so he can talk to Micko (Jack Fairy) about the scene. As I do this, I scan the call-sheet—Micko's not on it. Todd is furious, the ADs are flustered—I cut them off in midapology and say, "Just get him here!"

It's a good lesson. Todd should have checked the call-sheet and I should have checked it, too. We're all just getting so tired.

They reach Micko, he gets there, no real time is lost.

Days 45 & 46: Monday & Tuesday, May 19 & 20

We are in the same place for two days, which is a relief after all this hopping around. Big acting scenes for Mandy and Christian, but for camera and lighting it is all pretty simple (or simple for this movie, anyway). There are only a few more days, but I know the Bijou offices are going to be impossible. We are sending all the electrics there to prelight—the whole thing is being lit with 6Ks on towers that shine through the windows. And the office is wall-to-wall windows. We go over and over the placement of the towers, since moving them is a major, major pain in the ass.

Day 47: Wednesday, May 21

Of course we get to location and . . . the towers are in the wrong place. I can't even get it up to be pissed off. Maryse is white-faced and near tears. The gaffer makes a big show in front of me of how they were put exactly where she said, *but if* they have to be moved, of course he'll deal with it. . . . Later, I see him quietly reaming out his best boy: "Teddy man, what the fuck were you thinking? I told you where to put the goddamn towers—how could you screw up so bad?"

Maryse, to her credit, spends her time trying to solve the problem rather then explaining to me why it is not her fault. She has grown a lot on this movie.

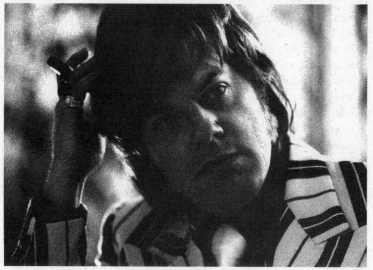

Eddie Izzard as Jerry Devine

Day 48: Thursday, May 22

Oh, we are down to the wire, yes, we are. . . .

Toni really wanted to get through the whole scene today so she wouldn't have to try to work herself up to the same pitch tomorrow. But Maryse is now saying that she is using daylight, so when it fades she can't shoot. This is news to me and Waldo—we would have planned these days differently if we'd known they were daylight-dependent. So we stop early, halfway through the scene, with promises to start shooting straightaway in the morning.

Day 49: Friday, May 23

Today is going to be miserable. . . . We have to shoot the rest of yesterday's scene, *plus* Brian watching himself on the TV, *plus* Tommy Stone's dressing room (which we have been carting around since Week 2), *plus* exterior news office, *plus* the Sombrero lavatory.

I sit with Todd and Waldo: We have two hours for this scene, an hour and a half for this one . . . Todd nods glumly and say, "I hate working this way." God, so do I. But what can we do? Waldo keeps saying, "Don't worry, we'll make it!"

We are grinding through the last part of yesterday's scene at about 11 A.M. when the phone rings. It's the executive producer, slightly

hysterical. "This call-sheet is impossible!" Oh, God. Tell me some-
thing I don't know. "What are you going to cut??!!" I tell him we
have a plan and not to worry. He says, "*We* can't shoot past tomor-
row—there's no more money!!!" I *know,* I say, we won't. He says,
"Well you will just have to cut the English garden tomorrow." I try
to explain that cutting tomorrow's scene won't lighten today's load,
but he doesn't get it.

"I'm coming down there!" he thunders. "I'll be there in an hour!"

Somehow, we actually stick to this crazy schedule and hurtle
through the day. Scott doesn't actually show up (after all that sturm
and drang) until late afternoon.

By the time we get to the lavatory, Todd is on the brink of
collapse. We have a difficult time mostly because of the actor and
finally stagger through, wrapping at midnight, a killer fifteen-hour
day. Todd is miserable on the ride home. He says that making
movies this way is awful and he doesn't want to do it. I don't know
what to say.

The Last Day: May 24

This is it. The last day, a beautiful sunny Saturday.

We shoot in an English garden, then two sets: Jack Fairy's parents'
bedroom and Arthur as a teenager in a movie theater. Stuff that
doesn't demand tremendous concentration in terms of acting—more
technical, which is a good thing, because I don't know what anyone
has left.

We wrap at ten o'clock, tears and champagne—it is over over
over!!!

THE SHOOT: KILL OR BE KILLED

Often I'm struck by the absurd discontinuity between a movie itself and the moviemaking process. There's a shot in *Velvet Goldmine* in which Brian Slade (Jonathan Rhys-Myers) sees his future wife, Mandy (Toni Collette), across a crowded dance floor and takes her hand: Roxy Music's "Ladytron" begins to play, everyone else fades away, snow starts to fall on the dance floor, suddenly the club itself dissolves into a beautiful forest, and the two are dancing under a storybook moon. It sounds clichéd, but the sheer lyricism transcends any schmaltz—it's a lovely and intimate and magical moment.

Of course, when we're shooting it, the snow machine is making a horrible racket, the AD is screaming "ROLL SNOW MACHINE!" "ROLL SMOKE MACHINE!" and we're trying to make the "Ladytron" playback loud enough so that the actor can hear it over the clamorous din and be able to lip synch; and we're trying to get the

extras out of the way so that they don't trip over the smoke machine
or get flattened by the zigzagging dolly . . .

It's all mechanics. And sometimes in the middle of the confusion
you realize that you're so far from the original impulse that you
forget what that original impulse was: why you wanted that scene,
where it fit into your overall design, what your overall design even
is.

That's why things like shot-listing and storyboarding are so impor-
tant. Early on, before you're beset by machinery and personnel and
cost allowances, the director, in consultation with the producer, the
director of photography, and the designers, thinks deeply about the
best way to tell this part of the story—so that, on the thirty-fifth
day of shooting, when you're so exhausted that you can barely re-
member what the movie is about, you have something to look back
at that you trust, something devised in tranquility, from a time when
the initial inspiration burned brightly.

I know that in this book I've been rattling on about money and
locations and equipment, but it's important to remember that they
all surround a thing so fragile, a thing that requires imaginative leaps
and an incredible emotional commitment. And yet, there's no other
way to approach it, is there? No matter how deep and poetic and
delicate an onscreen moment will be, you still need lights, a camera,
and a location in which to shoot. And in the middle of the most
intense, hushed scene, when your actors are plumbing their most
profound emotions, the AD will still turn to you—as an AD turned
to me, recently—and point to the clock that shows you're three
hours behind schedule, and whisper: *"We suck."*

Before You Shoot

Ultimately, a smooth production depends on the strength of the
preparation that came before it. In addition to assembling a reliable
crew, that means storyboards, shot lists, and a thorough tech scout.

Not every director does storyboards, but many do. On large-scale
Hollywood movies, storyboards are big productions in themselves,
and artists will spend days designing these beautiful little frames. In
this part of the world, Todd Haynes draws boxes with small pictures
in them, a few for each scene. He shows them to the DP and the
editor (who tends to be involved on his films before a frame has
been shot)—but mostly he draws them for himself.

I've heard people complain about too much storyboarding in mov-

Nothing puts more pressure on a schedule than a small child in every shot.

ies these days—how it makes a film feel canned, drained of spontaneity, like something on MTV. And I think that's largely nonsense. There will always be improvisation on a movie set, but, barring that rare miracle, it's better when improvisation comes within a set structure. Then it's much easier to insert a found object, a new line of dialogue, or even an extra shot. Miracles happen to filmmakers who create a framework for them.

Most productions can't handle surprises. That's when things get crazy. Some surprises you can't help. You're thrown off a location. The actors took longer than you thought they would. The weather changes violently, without warning. The bigger the production, the more difficult it is to handle the unexpected. A director who suddenly decides that instead of shooting in *this* room—which is all prepped—he or she wants to shoot in *that* room—which hasn't been dressed—will send the crew into a tizzy. So will shooting stuff that's not on the shot list. As far as crews are concerned, if it's not on the call-sheet, it's not happening that day.

There's nothing more sickening than watching directors try to work out their shots on set because they haven't done their homework. There's always a certain amount of working out to do, especially if you're there for the first time with the actors. But starting from scratch on the set—hammering out shots and setups with the crew standing around glaring—will wipe out morale in no time.

Everybody schedules by computers nowadays, most with a program called Movie Magic. The *program* might be magic, but making a schedule is anything but—it's grueling.

The first thing to do is schedule around what you know—an actor's calendar or a location with specific hours or days. Certain

actors and locations will probably be your greatest expense, so the
idea is to minimize time with both. You should plan to "shoot out"—
that is, complete photography on—each location and make an as-
sumption that, say, the parents' bedroom and the kids' bedroom will
be in the same house and not across town from each other. (This
isn't always the case, but it goes without saying that the more loca-
tions you can combine—and the more you can make one location
double for another—the easier a time you'll have.) Be careful, too,
not to spread actors out over the entire schedule, so you don't have
to pay them when they're not working.

Something will always trip you up, like an actor with a limited
amount of time. We had only four weeks with Ewan McGregor on
Velvet Goldmine, and ended up having to go back to some locations
twice. Ewan's schedule pretty much dictated ours. We did some
very intense scenes the first week, when people barely knew each
other. That isn't always a bad thing: James Schamus maintains that
you should film the big love scenes first, before the actors have a
chance to hate each other.

The Tech Scout

If, when you start a day, you know where your lights and camera
will sit, what your shots are, where you'll put the equipment, and
where the actors will be made up, you have a good chance of sticking
to your schedule. But like any unwieldy army, you need to send out
scouts first.

The *tech scout* should take place the week before the shoot so
that you have time to alter the schedule or locations. It's nightmar-
ishly dull, not to mention exhausting, but it's an utterly crucial expe-
dition. The director must attend, along with the line producer, the
AD, the 2AD, the location manager, the heads of the departments
(including sound), and however many note-taking assistants you can
cram into your stationwagon or van. In the course of one, two, or
three days, you should visit every one of your locations and get down
to the nitty-gritty.

It works something like this. You enter a house and smile pleas-
antly at the nice, gullible owner. ("My son is a senior in high school
and wants to work in the movies. Do you think he could help out?"
"Oh, *sure,* no problem. We'll definitely find something for him to
do.") The AD announces: "In this location, we're shooting Scene
Thirty-five, where Clive makes a sandwich for Biff. So Clive will

start out in the kitchen over here, and he'll walk from here to here." The DP confers with the grip and says, "I want to use a dolly, but this floor is a mess, so we're going to need a dance floor brought in." The production designer says, "I had planned to paint the wall green," and the DP says, "Don't paint it green, paint it yellow, because then we'll get more light." The location manager confirms that the wall may be painted, but emphasizes that it must be restored to its current color by week's end.

One of the characters needs to walk into a bathroom, but there's no bathroom in this hall. "Let's cheat the closet for the bathroom," says the director. The DP checks the angle and confirms that it can be done—that, on screen, you won't be able to tell that actor saying, "I gotta use the john," is actually hurrying into a coat closet. In the film, you can cut to the interior of a real bathroom if you want to show the character using the john.

Meanwhile, the 2AD and the location manager are figuring out what happens behind the scenes: where the actors will be made up and dressed so that they're out of the way but within easy reach; where the trucks will park (and if you'll have to put up "No Parking Thursday" signs, reroute traffic, or possibly tow away the cars of soon-to-be-irate motorists); where the caterer will set up; and where cast and crew will settle down for some of that four-star film-shoot cuisine.

When shooting in a public place—say, a restaurant—the DP, the director, and the AD go over the shot list and determine which way the camera will be facing and how many extras will be needed for how many tables. The DP takes readings and ascertains how many and what kind of lights will be required, makes a note of any bulbs to be replaced, and checks to see if major fixtures or doors will need to be removed. The director might pace out a complicated shot: "We'll start with the camera over here with the waiter in focus, then rack over to a passerby dumping his garbage here, and then tilt down onto Bill and Mary. That's a single shot." The location manager then reminds everyone that, on the day of the shoot, they'll have to be finished and out by six, when the restaurant opens for business.

Next, it's back into the van because there's going to be a driving shot in the same neighborhood. Here's a typical exchange:

AD: Okay, Scene Fifty-four. This is where Bill drives Mary home. Where are we rigging?

LOCATION MANAGER: At the holding area, which is four blocks away from the restaurant, in the parking lot of Rocco's Mattress Heaven.

DP: We're looking at one two-shot of Bill and Mary, and then two side-mounts.

AD: You want a hood mount?

DP: Yeah, a hood mount for the two-shot.

AD: This can be done in any weather, right?

DIRECTOR: Scene 54 doesn't have to be matched to anything, so it can be in any weather. But Scenes 17 and 99 are also driving scenes, and they have to be in good weather, so if we shoot all the driving stuff on the same day we need to do it in good weather.

2AD: Isn't this road kind of bumpy?

DP: Yeah. Shit. I think it will show up on film.

PRODUCER: Is it bumpy because it's bumpy, or because this van is so overloaded?

AD: That's a good question. We'll have to get a car out here and drive it.

DIRECTOR: I don't want to find out in dailies that it's not smooth. I'd rather pick another street than chance it.

LOCATION MANAGER: Well, this is the best street for miles in terms of the houses you want and the absence of intersections. We scouted four towns and you won't find a better street.

AD: Okay, let's make a note that we come back here in a process truck, and if it's still bumpy we'll use the backup location.

. . . I'm falling asleep just writing about it.

But what happens when you don't do that grueling tech scout? You leave yourself open to nasty surprises. It might be that a subway runs under a house and rattles everything and you had no idea it was there, or the location's on a major uphill bus line and every ten minutes you get a thirty-second roar from the street. It might be that there's an antiquated electrical system that you can't plug into and you didn't bring a generator; or that the elevator isn't big enough to accommodate a piece of equipment or furniture so you, one PA, and a ninety-pound 2AD have to haul it up twelve flights of stairs. *Do the tech scout.*

Location, Location, Location

As I've said before, on a low-budget shoot, where you can't afford to build a lot of sets from scratch, good, flexible locations—and a good, flexible location manager—are paramount.

We're at a point now where most major cities—certainly New York and LA, and maybe Vancouver, which doubles for every other city—are overshot. People have gotten savvy. They know that having a film crew in their store or building or apartment will be a huge pain. And they want a lot of money. The days when you can get someone in a city excited about the glamour of a movie shoot (in your very own home!) are gone. Outside a metropolis, you can still find places where people will cooperate with you. Filmmaking, even on a low budget, is great for a small town: A bunch of people come in, spend a lot of money, employ a few people, mingle with the locals, and leave. Fantastic. For a movie that we want to shoot in the Midwest, a producer whom I work with flew to Nebraska and was met at the airport by the state film office, escorted around for three days, and even given a reduced rate at a decent hotel.

Most big cities (and most states) have an Office of Film and Television that can provide you with lists of locations. When I was working as a production assistant in the early eighties, there was one New York police station that wasn't used anymore, but the city kept it up solely for film and TV shoots. I recognize it in movies—that same old precinct. The courthouse in *Swoon* is in Harlem. It's in session only once a week, as a small-claims court. The rest of the week, you can shoot in it, provided you bring your own electricity. Sometimes a city has a hospital that's no longer in use where they let people shoot. Or you can go to a working hospital, although it's unusual that they'll let you anywhere near real patients. If you can find a wing that's rarely in use, most hospitals are more than happy to take your cash. Just don't plug into the same power source as the life-support systems.

For *Safe*, we didn't have enough money to build the New Age-ish camp where Carol ends up for treatment of her environmental poisoning. We needed to find a facility that already existed and then modify it. The location manager heard about a Jewish retreat-cum-summer-camp in California's Simi Valley that wasn't used in February. It had something else you look for in a location: Other places to shoot. At the top of a hill there was a scary-looking modern center—part synagogue, part study area—to pro-

A victim of Environmental Illness wanders through Wrenwood in *Safe*.

mote Jewish theology. It was the kind of place that people leave their money to when they die. We used one of its rooms to shoot the large gatherings, when the resident guru is speaking to his patients. At the end of the film, Carol is living in a sort of igloo. Finding it was serendipity. While filming in LA, we read an article about prefab, igloolike houses that could be set up in a couple of hours, the invention of the LA Coalition for the Homeless. We contacted the coalition and asked if we could buy one, and it wasn't very expensive.

If you're going to try to shoot in a school during the year, you'll be limited to places that are no longer functioning, which gives you a lot less to choose from. Movie shoots are always being tossed off campuses for being too disruptive. If you agree to involve film students, though, the administration might be more accommodating. We built a reform school for *Poison* on a sound stage at SUNY-Purchase. In exchange for letting us shoot, the chairman of the film department asked that we use students as production assistants, and it worked out great. That sort of quid pro quo is not uncommon. When you get a movie financed by private investors, you're often pressured to give jobs to their sons, nieces, or nephews. We've never had a problem, though, because the bottom of the barrel on a film set is pretty far down. Somebody always has to be doing something so menial almost anyone can do it.

✿ ✿ ✿

Swoon successfully evoked the twenties on a threadbare budget.

Let's say the villain of your film is a big Wall Street baron who's supposed to have a Long Island mansion. You need something that looks like it costs ten million dollars, except your entire budget is under a hundred thousand.

There are a couple of things you can do. Number one, call your parents' friends. Is there somebody in your circle who knows somebody who knows somebody? (Six Degrees of Separation and all that.) Whit Stillman's *Metropolitan* was an extremely low-budget film about extremely high-budget people. However, the director was intimate with that super-rich milieu, so he was able to use his friends and his contacts to get into all those Upper East Side apartments.

If you exhaust your connections and still can't find your mansion, you can go to a place like Long Island, find a likely-looking home, and shoot the exterior. Are you allowed to? Well, ask your lawyer, because you might well be trespassing. However, you can often get permission to shoot an exterior only. At the very least, you could give the owner a couple of hundred dollars (not that he needs it) to have an actor walk up to the front door. Then, for the interior, you need only fill a big room with the ritziest looking props and furniture you can borrow, or find a private club or fancy university library that's willing to let you shoot at an off hour. Law firms will sometimes let you shoot in empty offices. (Empty offices in most cities are easy to find.)

When all else fails and you can't reconceive the character, try stylizing the scene: Put the Wall Street baron in a big, blank white

room behind a big, beautiful desk. That might be all you need to get the point across.

More and more often, you *do* need permission to shoot exteriors. When we were filming on Portobello Road in London, we learned that the exterior of one of the antique stores—a quaint, ye-olde-London façade—had been copyrighted by the owner. So you can't just shoot it. You have to pay. A distributor, if you have one, will often *make* you get permission in order to preempt a lawsuit down the road..

The Shoot Begins

Shoot the big scene of the day (the "meat") first, if you can. You'll be stunned by how quickly the time will disappear, and you don't want to spend five hours on an insert shot and then suddenly realize you have a whole, complicated scene to do before you lose the light. But on those occasions when you're shooting out one location before moving to the next, you have to do the small stuff first. That's when you have to set priorities *ruthlessly* to keep from devoting a disproportionate amount of time to relatively minor material.

Every so often an actor or director will make a request that brings the shoot to a halt. It happened on *Safe*, when we were just about to shoot a scene in the heroine's bedroom, with Carol (Julianne Moore) on one side and her husband on the other. Then Todd Haynes noticed the alarm clock. "I wanted an alarm clock with bigger numbers!" he said.

Now, Todd is a reasonable man; he isn't a prima donna who'll stop a shoot over trivia. But he felt he needed that big-number alarm clock. So we dispatched a PA and had to wait around for half an hour. The AD approached me and whispered: "Shouldn't we just tell him he can't have it?" But I respect Todd so much that if he tells me that a clock will make a difference in a scene, then I think it's worth holding things up. And, in the movie, the clock does register: It's one more oppressive modern appliance in a sea of oppressive Reagan-era appliances. Obviously, my relationship with Todd Haynes is close enough that I could wait that half-hour confidently, even if it meant that people would be standing around.

One thing I hate on a set—I can see it coming, like some awful black funnel cloud—is the discussion about a sightline or "crossing the line." God, does that suck up time—you can kiss half an hour good-bye. It looks like a demented Robert Wilson piece: For what

seems an eternity, the cinematographer peers one way, the camera operator paces the other, the director swivels his or her head, the script supervisor leans in and points to something in the script, and then they all turn to the actor: "Okay, Joe, look a little camera left." They whisper among themselves: *Bzzz bzzz bzzz.* "Joe, raise your eyes a tiny, tiny bit." *Bzzz bzzz bzzz.* "Here, Joe, look at my fist." *Bzzz bzzz bzzz.* "No, lower." *Bzzz bzzz bzzz.* The poor actor is trying to do a scene!

Some people have an innate sense of the line, some don't. I always have to think about what's right and what's left; others just know that there's a rightness to the world and a leftness to the world. And, be it the script supervisor, the cinematographer, or the director, *you should have one of those people on your set.*

The Production Report

Call-sheets, prepared by the AD, are what you have before your day starts. On the other side of the day is the production report, again prepared by the AD and signed off on by the line producer, which tells you how much film and how many setups and scenes you shot, and what you didn't get that's still on the call-sheet. The report tells you what time people got to the set, what time you broke for lunch, and it also documents your minor annoyances and major crises.

Here are the "Remarks" from an actual production report. It was the first day of the shoot for a film that will remain nameless.

1. Costume Designer's car hit hazardous boulder on edge of road into location, bent rim and flat tire—to be repaired today.

2. Key lost to back of Grip/Electric truck. After genny was placed, lock was cut at 7:20 A.M., resulting in ½ hour delay.

3. Due to lack of rain, scene 80 was shot first. TKs call pulled 1 hr. earlier.

4. Stand in for star got lost, arrived ½ hr. late.

5. Office PA's personal car got stuck on boulder at the edge of road into location, and needed to be pulled out.

6. Camera department had a broken lens—the aperture stuck on

KISS ME, GUIDO

Kiss Me Productions, Inc.
625 Broadway, Suite 7B
N.Y., N.Y. 10012
212.422.1000
212.432.1000

Director: Anthony Vitale
Producers: Ira Deutchman, Chistine Vachon
Line Producer: Katie Roumel
Prod Manager: Eva Kolodner

CREW CALL:
7:30A
ALL CREW RPT TO
80 SPRING ST.

Date: Friday June 7, 1996
Shoot Day 20 of 25
Sunrise: 5:25 A
Sunset: 8:25 P

1st AD: Kevin Moore
2nd AD: Susan Labunski-Saxe
718.399.2848
2nd 2nd AD: Steve Kandell
Set Pager: 917.794.9362

WEATHER: Partly sunny all AM
Possible T'storm in
afternoon. Lo:72 Hi: 83

Set Description	Scenes	Cast	D/N	Pgs	Location
EXT SOHO STORE T tries to pick up hunk	Sc 9	2,4,x	D3	1/8	ZaZaShoes & Clothing 150 Bloome St
EXT W'BWAY & PRINCE T & W walk n' talk	Sc 10	2,4	D3	4/8	West Broadway & Prince St
INT WARREN'S LOFT T answers ad	Sc 14	2,4	D2	3 5/8	**80 Spring St.**
F calls P to set him up	Sc 67	1,2	D6	2	CATERING/HOLDING on loc
				Total=7 3/8	

CAST	STATUS	# CHARACTER	P/U RPT	MU/HR	ON SET	COMMENTS
Nick Scotl	W	1. Frankie	3P	3P	3:30P	rpt to 80 Spring St.
Anthony Barrile	W	2. Warren	7A	7A	7:30A	rpt to 80 Spring St.
Craig Chester	W	4. Terry	7A	7A	7:30A	rpt to 80 Spring St.

BREAKFAST FOR 40	READY AT 7:15A	LUNCH FOR 38 READY AT IP serve @ 1:30P
EXTRAS/STAND-INS	PROPS/DRESSING	SPECIAL EQUIPMENT/INSTRUCTION
1 Hunk Sc9 1 Model Sc9 RPT @ 4B to 16 W. Broadway	PROPS Sc9 T's House keys bags o groceries Sc10 VV newspaper bag o groceries	PLEASE COME EARLY IF YOU WANT B'FAST.

ADVANCED SCHEDULE				TRANSPORTATION	
Saturday June 8, 1996				Grip/Electric rpt @	7:30A @ 80 Spring St.
INT WARREN'S LOFT	Sc 12,57,61	D	total=7 1/8	Camera/Sound rpt @	6:30A @ 80 Spring St.
TWO DAYS OFF				Art Cube rpt @	7:30A @ 80 Spring St.
Sunday & Monday				Wardrobe Cube rpt @	6:45A @ 80 Spring St.
Tuesday June 11, 1996				Unit Cube rpt @ 6:30A	6:30A @ 80 Spring St.
INT WARREN'S LOFT	Sc 25,27	D	total=6 2/8		
Wednesday June 12, 1996					
INT WARREN'S LOFT	Sc 22,31,66	D	total=7 6/8		
Thursday June 13, 1996					
INT WARREN'S LOFT	Sc 6opt,46,49,51	D	total=6 5/8		

NO FORCED CALLS WITHOUT PRIOR APPROVAL OF LINE PRODUCER

QUOTA DA DAY:

Line Producer: Katie Roumel Prod Mgr. Eva Kolodner 1ST AD: Kevin Moore

Call Sheet Date: Friday, June 7, 1996

Production	IN
Director:	7:30A
Producer:	o/c
Prod. Exec.:	
Line Producer:	
UPM:	7:30A
1st AD:	7:30A
2nd AD:	6:30A
2nd 2nd AD:	6:30A
Set PA:	6:30A
Set PA:	6:30A
Set PA:	6:30A
Set Intern:	
Set Intern:	
Addl PA:	
Script Super:	7:30A
Camera	
Dir of Photog:	7:30A
Cam. Oper.:	7:30A
1st Asst. Cam.:	7:30A
2nd Asst. Cam.:	7:30A
Camera Trainee:	7:30A
Stills:	
Steadicam Op.:	
Electric	
Gaffer:	7:30A
Best Boy:	7:30A
Electrician:	7:30A
Genny Operator:	
Addl Electrician:	7:30A
Grip	
Key Grip:	7:30A
Best Boy:	7:30A
Dolly:	
Grip:	7:30A
Grip:	7:30A
Addl. Grip:	

Wardrobe	IN
Designer:	6:45A
Asst. Cost. Des.:	
Ward. Suprv.:	6:45A
Wardrobe:	6:45A
Wardrobe PA:	6:45A
Make-Up/Hair	
Key MU:	6:45A
Key Hair:	6:45A
Addl:	
Addl:	
Art Department	
Prod. Designer:	7:30A
Art Director:	7:30A
Set Decorator:	7:30A
Art Dept Coord:	
Art Dept PA:	
Art Dept PA:	
Set Dressing	
Set Dresser:	o/c
On Set Dresser:	
Production Office	
Coordinator:	o/c
Asst. Coord.:	o/c
Asst. to Dir:	o/c
Office PA:	o/c
Office PA:	
Accounting	
Prod. Acct.:	o/c
Asst. Account:	o/c
Props	
Master:	7:30A
Asst. Props:	
Extras Casting	
Extras Casting:	
Extras Casting:	o/c
Stunts	
Stunt Coord:	
Special Effects	
Special Effects:	
Special Effects:	

Editors	IN
Editor:	
Asst Editor:	
Craft Service	
Craft Serv.:	6:30A
Ready @ 7:00A	
Catering	
Caterer: Fresh Dish	1P
Coffee Rdy @	for:
Lunch Rdy @	for:
Safety	
Police:	
Firemen:	
Watchmen:	
On Set Security:	
Medic	
On Set:	
Locations	
Loc Mgr:	6:30A
Loc Mgr:	
Loc Coord:	
Unit Mgr:	6:30A
Loc Asst:	
Parking:	
Transportation	
Transpo Capt.:	7:30A
Driver:	
Driver:	
Driver:	
Sound	
Mixer:	
Boom:	7:30A
Cable:	

ADVANCE SCHEDULE

KISS ME, GUIDO
DAILY PRODUCTION REPORT

625 Broadway, Suite 7B
NY, NY 10012
212.432.1000 212.344.1000

DIRECTOR:	Anthony Vitale	
PRODUCERS:	Ira Deutchman, Christine Vachon	
LINE PRODUCER:	Katie Roumel	

DAY OF WEEK: Friday
DATE: 6.7.96
DAY 20 of 25 PRODUCTION

WEATHER: Sunny 80's

	1st UNIT	2ND UNIT	REHEARSAL	TEST	TRAVEL	HOLIDAYS	TURN AROUND	RETAKES & Added SC.s	TOTAL	ON
NO. DAYS	25									SCHEDULE [XX]
										AHEAD ___ DAYS
ACTUAL DAYS	20									BEHIND ___ DAYS

SCENES SET DESCRIPTION / LOCATION(S):

9	EXT. SoHo Store	ZaZa Shoes, 80 Spring St.
10	EXT. SoHo Store	ZaZa Shoes, 80 Spring St.
14	INT. Warren's Loft	150 Broome St.
67	INT. Warren's Loft	150 Broome St.

Date	
STARTED	Mon. May 13, 1996
SCHEDULED	
FINISH	Fri. June 14, 1996
REVISED	
FINISH:	
Crew Call:	7:30a
Arrive Loc.:	6:30a
Shooting Call:	
First Shot:	9:00a
Meal Out:	1:30p
Meal In:	2:15p
First Shot:	2:40p
Meal In:	
Meal Out:	
First Shot:	
Cam. Wrap:	7:45p
Crew Wrap:	8:30p
Location:	
Actual Hrs.:	

SCRIPT SCENES & PAGES

	SCENES	PAGES	MINUTES	SET-UPS	ADDED/OMITTED SCENES	RETAKES PAGES	SC.S
SCRIPT	98	105 7/8					
PREVIOUS	72	64 7/8	58:27	256			
TODAY	4	5 5/8	2:36	10	+4		
TO DATE	76	70 4/8	1:01:03	266	+4		
REMAIN	22	35 3/8					

SPECIAL NOTES: WILD TRACKS 1073-1075

FILM INVENTORY STOCK: 5298

PICTURE NEGATIVE

	EXPOSED	PRINT	NO GOOD	WASTE	S.E.	TOTAL
PREVIOUS	26,060	0	0	750	1700	26810
TODAY	0	0	0	0	0	0
TO DATE	26,060	0	0	750	1700	26810

FILM INVENTORY

ON HAND	5,790
RECEIVED	0
USED TODAY	0
BALANCE ON HAND	5,790

SOUNDS ROLLS-DAT TAPE

PREVIOUS	26
TODAY	1

PICTURE NEGATIVE STOCK: 893

	EXPOSED	PRINT	NO GOOD	WASTE	S.E.	TOTAL
PREVIOUS	27,570	0	0	70	1,310	27,640
TODAY	1,930	0	0	40	770	1,970
TO DATE	29,500	0	0	110	1,080	29,610

FILM INVENTORY

ON HAND	16,760	TO DATE
RECEIVED	0	FILM ROLLS 35MM
USED	1,970	PREVIOUS
BALANCE ON HAND	14,790	162

PICTURE NEGATIVE STOCK: 5245

	EXPOSED	PRINT	NO GOOD	WASTE	S.E.	TOTAL
PREVIOUS	23,830	150	0	250	2920	24,080
TODAY	1,860	0	0	70	730	1,930
TO DATE	25,690	150	0	320	3650	26,010

FILM INVENTORY

ON HAND	2,520	TODAY 8
RECEIVED	0	
USED	1,930	TO DATE 170
BALANCE ON HAND	590	

CAST - WEEKLY & DAY PLAYERS

S-START W-WORK T-TEST R-REHEARSE
H-HOLD F-FINISH TR-TRAVEL

#	CAST	CHARACTER	S W R T TR	Meal M.U./WDRB	Pen./Stunt Adj	WORK TIME Report on Set	Dismiss on Set	MEALS 1st Meal Out	1st Meal In	2nd Meal Out	2nd Meal In	TRAVEL TIME Leave Loc.	Arrive at HDQ
1	Nick Scotti	Frankie	W	W 3:00p		6:20p	8:00p						
2	Anthony Barrile	Warren	W	W 7:00a		8:00a	8:00p	1:30p	2:30p				
4	Craig Chester	Terry	W	W 7:00a		8:00a	6:20p	1:30p	2:30p				

K=Minor, NP=Not Photographed, N=Night P=Prop, W=Wrobe, H/M=Hair & Makeup, MP-L=Meal Penalties incurred @ Lunch, MP-W=Meal Penalties incurred @ Wrap

ATMOSPHERE AND STAND INS

#	RATE	CALL/WRAP	HOURS	ADJ	MPV	#	RATE	Call/Wrap	HOURS	MPV	#	RATE Call/Wrap/Hours	ADJ	MVP
2	$99	8:00a/10:45a	8											

Prod Mgr: Eva Kolodner

1st AD: Kevin Mobre

Line Producer: Katie Roumel

"Kiss Me, Guido" SHOOT DAY: _____ of _____ DATE: June 7, 1996

PRODUCTION	IN	OUT		ART	IN	OUT
Director	7:30A	8:00P		Production Designer	o/c	
Producer	o/c			Art Director	o/c	
Associate Producer	o/c			Propmaster	7:30A	8:00P
Production Manager	6:30A	8:00P		Set Dresser PA	o/c	
Production Coordinator	o/c			SOUND		
APOC	o/c			Sound Mixer	7:30A	8:15P
Office PA	o/c			Boom Operator	7:30A	8:15P
1st AD	7:30A	8:00P		HAIR/MAKE-UP		
2nd AD	6:30A	8:00P		Key Hair/Makeup	7:30A	8:00P
2nd 2nd AD	6:30A	8:00P		Hair/MU Asst.	7:30A	8:00P
				COSTUME		
SCRIPT				Costume Designer	o/c	
Script Supervisor	7:30A	10:30P		Asst. Costume Designer	o/c	
LOCATIONS				Wardrobe PA	7:30A	8:00P
Location Manager	o/c			CRAFT SERVICE		
Location Scout	o/c			Craft Service	6:30A	8:15P
CAMERA				EDITORIAL		
Director of Photography	7:30A	8:15P		Editor	o/c	
1st Asst. Cameraperson	7:30A	8:15P		CASTING		
2nd Asst. Cameraperson	7:30A	8:15P		Casting Director	o/c	

ELECTRICAL			PRODUCTION ASSTS.	
Gaffer	7:30A	8:00P	Set P.A.	o/c
Best Boy Electric	7:30A	8:00P	Set P.A.	o/c
Third Electric	o/c		Set P.A.	
Fourth	o/c		Intern	
GRIP			Intern	
Key Grip	7:30A	10:15P	Intern	
Best Boy Grip	7:30A	9:30P		
Third Grip	7:30A	9:30P		
Fourth Grip	7:30A	9:30P		
SPECIAL EFFECTS			Lunch Ct. - Ordered:	Actual:
Special Effects	o/c			

COMMENTS–DELAYS (EXPLANATIONS) - CAST, STAFF & CREW ABSENCE

DELAYS

Grip/Electric truck 20 minutes late to set due to delay at parking lot.

the 24mm, resulting in a 15-minute delay. Another lens ordered did not arrive.

7. Main dressing room experienced power outage due to overloading breaker. Electric department provided tie-in.

8. Lunch delayed due to camera set-up on tripod in water. The lens kept fogging. Non-working crew were broken at 12:40 P.M., the rest of the crew at 12:45. The 1st AC was last man to lunch due to getting camera out of the water and showering and changing before eating.

9. Craft service gave notice at 9 A.M.

10. Scenes 82, 83 omitted, scenes 85, 86, 87, 88, 89 not shot due to time constraints.

11. Scene 80 owed one setup for first thing day 2.

12. Due to miscommunication of directions, most of the crew arrived on set 6 minutes late.

It would be hilarious if it weren't so sad. Actually, it's pretty frightening. Even a small thing—the craft-service person quitting at 9 A.M. on the first day of the shoot—suggests that all is not well.

TED HOPE
Co-Chair, Good Machine, Inc.

One of the greatest skills that a producer can develop is extreme paranoia. By concentrating on where things can fail, you build up protections, and that itself gives you a confidence that you can instill in others: A big part of producing is being a confidence man. Not a *con* man, but someone who makes sure that everyone around—fellow producers, actors, financiers—always sees how something *can* happen and *will* happen. The film *Walking and Talking* collapsed three times, and *The Ice Storm* didn't actually get a green light until the second week of postproduction! On almost every movie I've produced there have been moments when anybody could have thrown in the towel. So I've had to learn that even if everybody says "yes," and I've already spent hundreds of thousands of

dollars, I still better have a Plan B. And that's true of all stages of production, particularly in the kind of production where you can't afford to buy your way out of a problem. Even if you're shooting in a house, you'd better know what the backup houses are. Even if your key grip is fantastic, you'd better know who else is available.

Maybe I'm lucky in that ever since I was a kid—I was raised by a single parent in a house with a tiny black-and-white TV, no rugs, a beat-up car—I've had a serious chip on my shoulder. I've been told so many times that I couldn't do the things in life that I wanted to do, a tear-it-down attitude was a big part of what drove me. And that, actually, is a big part of what drives independent film. There's this method of business that a whole industry has followed for generations, and there are things that you're told that you May Not Do: "It's an insult to hire this kind of actor for scale." "You can't put your assistant director in the main titles!" "What do you mean, this is a period piece?" "No one's going to see a gay film!" "No one's going to see a gay film in Chinese!" If I had actually believed all the stuff that people told me, *I wouldn't have done anything.* I mean, it's gotten so I actually love it when someone says, "You can't do that." When I show a script around like Todd Solondz's and executives say: "Oh my God, how can you make this film?" that's, like, a rallying cry—I know then what I'm going to be doing for the next year.

Watching Dailies

Watching your scenes of the day is a different process now that all the footage gets put on video. It's not that you get your dailies any quicker—actually, it often takes longer because it gets processed first and then transferred to video. It's that people rarely watch them as a group anymore. The producer gets a tape, the director gets a tape, the DP gets a tape, and that's about it. There is something to be said for the sense of camaraderie that comes from watching dailies together, so sometimes I'll put a monitor on the set so people can watch them during lunch. The problem with that is they get treated a little cavalierly—and actors can get their hands on them, take them home, obsess over them, etc.

Because video is so much more forgiving than celluloid, dailies can obscure fundamental flaws on the negative. In one of the most elaborate shots in *Velvet Goldmine*—the one that opens the picture—a spaceship passes over Dublin rooftops, and the camera de-

scends to a nineteenth-century street to show a baby (Oscar Wilde) on the doorstep of an elegant townhouse. Todd Haynes and I watched the dailies on tape to pick the take we liked best. Later, the editor went to look at the footage on a projector and discovered it was out of focus. In fact, of the six takes, five were slightly blurred. It was a real lesson in the imprecision of video dailies.

The Producer During the Shoot

As with any position of leadership, a producer has to be a bit of a performer. You have to fake confidence a lot. You have to fake calm a lot. You learn early the consequences of showing doubt, of acting in the middle of a crisis as if you're in the middle of a crisis. Don't. You want the mood to be productive, which means not ridden with anxiety. You don't tell a director bad news when he or she is on the set, unless that news relates directly to the next shot. One thing that's hard with Todd Haynes is that he and I know each other so well that he can read me instantly. So if something's wrong, I can't go anywhere near the set: He only has to look at me, and even if I'm faking like mad he'll panic: "What's wrong? What happened?"

As a woman, I bump up against that well-known double standard: How do you command respect without being called a "bitch"? It's hard. Every time I go onto the set it means taking a deep breath and . . . *here we go*. I know that my reputation is more in the direction of being a bitch than a fount of niceness, but I don't really mind. Well, I mind, but I try not to think about it. When I started out, the people I worked for said to me what I now say to other young producers: "It's not a popularity contest. Don't worry about that."

I've decided that people need to earn my respect. It's not that I start from a point of *dis*respect, but I don't assume that they're terrific and competent at what they do until they show me.

Even on low-budget movies, you're still dealing with king-sized egos. I've worked with actors nobody's ever heard of whose egos are bigger than Tom Cruise's. The same goes for crew members.

Low-budget shoots, no matter how well planned, are always under the gun and producers always come up against crew members who grumble about the hours and the conditions. Every production manager has lists of additional crew members, and we bring them in frequently. I get disappointed when crews don't give a hundred percent. I try hard, especially on nonunion films, to make an assumption that people

are there because they want to be, and not to have an us-versus-them
mentality. But if you're a producer, however progressive you fancy
yourself, you can end up in situations where it's clear that you're man-
agement and they're labor. And you can negotiate and tell them your
sob stories, but ultimately, it's not their problem.

I don't know if it matters so much how the cameraman feels on
Terminator 6 because it's not that kind of movie. But on a lot of
films it does matter, and the lower your budget, the more it helps
to have a let's-pull-together attitude. Much of that will emanate from
the director, of course, because ultimately most people are there to
please the director.

Pam and I work a lot with first-time directors, and that's really
tricky, because you have to gauge, as a producer, when to supple-
ment your director's inexperience while at the same time making
sure that you don't undermine his or her authority. You're working
with crew members who are probably more experienced than the
person whose vision they're trying to put on celluloid, and it won't
take much for them to conclude that the director is hopelessly out
of his or her depth. My respect for first-time directors rarely wavers,
but my confidence in their ability to pull something off can get
shaky. I never, never show that to a crew, though.

With *Office Killer*, there were times when it was important to
make everyone understand how lucky they were to work with a
world-class photographer—Cindy Sherman—without expecting her
to transform overnight into a bona fide film director. Cindy was a
gracious student. Larry Clark, of *Kids*, was also an established artist,
but he had a more difficult time admitting that he didn't understand
every nuance of filmmaking. Invariably, on a low-budget film, the
crew is under thirty. Larry was fifty, and wasn't happy having chil-
dren tell him, "This is how you do it."

Is the producer on the set for most of shooting? It depends on
the director and the movie. On *Velvet Goldmine*, I was there every
minute, and closely involved in the minutiae of the schedule, helping
to jigger and re-jigger: We need more time for this, less for that;
can we move these actors to this day? I was in constant touch with
the AD, asking: Are we on track? How can we get through the day
without a disaster? Some ADs, at the beginning of the day, almost
to cover their butts, say, "We're never going to make it! This is
ridiculous!" So I'm the voice of reason (or optimism), saying, "Of
course we can!" And often, because the director and the crew are

so far *inside* the process, laboring to get the shot, thinking about a hundred different things, someone like a producer needs to step in and say: "You know what? This part of the scene we don't need to shoot here. Let's concentrate on *that* part, and then we'll shoot this one somewhere else." A producer can see solutions that no one else sees, because everyone else is too enmeshed—and too freaked-out.

Which doesn't mean that the on-set producer is busy constantly. Usually, I don't have much to do except wait for those one or two problems a day that only the producer can solve: "The AD needs to see Christine right away!" I sit around for a long, long time waiting for a call. Meanwhile, I run up cellular phone bills talking to the financiers and the office.

Do directors ever *not* want me around? I don't think so—at least, not that they've said to me. Todd Haynes wants me on set more than I am. Some directors work so hard to project confidence that they need to have at least one person on whom to lean—a person who they can show just how needy and put-upon they really are.

Crises, Annoyances, Disputes

A crisis is a) someone getting hurt and b) not being able to shoot. In that order. Anything else might be an annoyance, a headache, or a drag, but it's not a crisis.

The first rule is to make sure that everybody's safe, and if they're not, to get help as quickly as possible.

Then comes shooting. Say you're a PA, out on a run for sandwiches for the actors' lunch and a piece of equipment for the next scene. If the restaurant where the actors wanted you to go is closed do you: a) Drive around for half an hour looking for a comparable restaurant? or b) Get the piece of equipment and go back? If you said a), congratulations: You'll soon be eligible for unemployment compensation.

You hope there won't be too many disputes, although there are departments that are traditionally at odds. The 2AD's job is to get the actors through the works and in front of the camera by the time the AD calls for them. Friction tends to develop between the 2ADs and the costumers and makeup people, and it all comes down to estimates made the day before, when the first AD, who's preparing the call sheet, consults with costume and makeup about how long they'll need with each actor. ADs usually err on the side of caution, but even so, a director might not like a costume, or an actor might show up after a terrible night needing an extra half hour in makeup.

So the first AD is yelling at the 2AD, who's desperately trying to get the actor onto the set, and the costumers are screaming, "You're not making it go any faster by breathing down our necks!" It's all a lot of hot air, except you don't want that tension to get to the actor, who's often feeling nervous about going in front of the camera.

Other classic conflicts are between the location manager and the production designer (see "Crewing Up") and between the location manager and the sound person. On one of our films, the sound guy was always turning off the refrigerator to get rid of the hum and then forgetting to tell anyone that he had. So we kept having to pay for refrigerators filled with spoiled food.

I haven't had two actors who despise each other, but I'm certain it happens. What I have seen a lot is actors vying with one another for attention. It's important that the director and producer give everyone his or her fair share, that no one becomes the obvious favorite. You don't want a good performance only from your star, you want one from all your actors. It's a bit of a balancing act.

Sometimes an actor and a director don't get along, but provided they both do their jobs, this falls under the category of an "annoyance." Most actors can tell you a story about a movie they were on where they loathed the director, but it's rare—unless the person was horribly destructive—that you can see it in the work.

An overly perfectionist DP can often be a source of tension, especially if you're doing a scene that the director just wants to bang through, a scene that's just a matter of getting Person A to Place A. The cinematographer, of course, doesn't want the shot to look like crap, but how much time can you actually spend on a character crossing a street? I've had cinematographers tell me that the schedule wasn't their problem, and I know it's important for them to fight for their right to take the time they need. That kind of care shows on screen. But I've also seen directors driven crazy by the slow pace of a DP, and forced to reduce the number of shots. It's not fair to the director—if you have three hours in a location before you're thrown off, someone has to make a sacrifice.

Going Over Schedule

On a very low-budget film you don't go over schedule—you just cut scenes. If your schedule is really tight, you should have a sense going in of what you could stand to lose if push came to shove.

Shooting extra days is enormously expensive. You have two options

if it looks like that's inevitable and you can't lose those scenes or lose something else in order to shoot those scenes. First, try to schedule those days while you're still in production and you have all your equipment. The other, chancier option, is to finish shooting the days you have scheduled, do a rough assembly of the footage, and see if you really do need that scene or scenes. The problem with that is it's like you're starting up all over again if you have to shoot more footage.

If something is minor, a "pickup"—an insert, an establishing shot, even a close-up—you can always do it later with a skeleton crew.

Four Crises and a Headache

1. THE END OF *VELVET GOLDMINE*

As my production diary relays, the last two days on *Velvet Goldmine* were excruciating. I felt so helpless, because we were asking Todd to do the impossible, to barrel through so many important scenes. It was a nasty, impossible call list, and the executive producer had phoned me to express (hysterical) concern, maintaining yet again that Todd had no choice but to cut shots. I didn't want Todd to be exposed to that, but I knew than we were in trouble. So I went to Todd and said, "This is going to be a fourteen- or fifteen-hour day. This is how we're going to have to get through it. We need to get in and out of *this* scene in two hours, *this* scene in two and a half, this scene in one and a half. . . . I'm making the assumption that this scene is more important than this one, so we'll give it more time. Then we'll need to do this one in forty-five minutes . . ." and on and on and on through every scene. Todd nodded okay, looking dazed.

We executed that schedule. And it was an awful, awful way to work. The very last scene we did was the most difficult. It was when Todd sort of hit the wall. Until then, he'd been great about just gritting his teeth and doing it. But the last scene was something he cared about, and the actor just kept getting it wrong, and the clock was ticking . . . and he just *had it*. We finished, but he was as miserable as I've ever seen him. He said: "What's the point?" And what *is* the point if you have to settle for something you don't want?

The day after we wrapped, Todd and I went out for lunch. I said, "I just wish I could have helped you more." And he said, "You did. You helped. Because every time I looked at you, you just seemed

so calm. You'd stand where I could see you, but you didn't hover over us. And it made me feel so supported."

So sometimes *that's* what a producer does.

2. KIDS AND ANIMALS . . .

There weren't many actual minors on *Kids*, although it looked as if there were. People always ask: Were they really smoking pot in the movie? Were they really drinking beer? Not on my set. I'm not naïve; I'm sure they went off all the time and got smashed and came back. But most of them had spent every day of their lives drinking beer and smoking pot, and frankly it didn't worry me that much. The single biggest incident involving *Kids* had nothing to do with drugs or alcohol. It came after the shoot, and involved a scene in which one of the leads, Telly, kicks a cat.

It was our office cat. Big, lethargic. It had wandered in and we had adopted it: We took it to the vet and got rid of its fleas and whatever else it had. And it sat around and slept in people's In and Out boxes.

One day, Larry decided he wanted Telly to kick a cat. So we brought the animal to the set. What happened was this: The actor playing Telly nudged the cat with his foot and someone called it with food from behind the camera. (This was the kind of cat that you could nudge for hours and it would just look at you like: "Huh?") The cat wasn't hurt; it went back into the box and then back to the office. At the end of the shoot, one of the crew members decided to take it home with her. She moved to the Midwest and that was the last we saw of the cat.

But not the last we heard of it. Someone in the ASPCA read a review that said: ". . . and then Telly kicks a cat, so we *really* hate him." What followed was a barrage of letters, many from ASPCA headquarters in Washington, D.C. The gist was: "We think you abused an animal in the making of this film, and we're coming after you." I asked the distributor to deal with it, but they never did. To stave off an ugly incident—not to mention a lawsuit—I phoned the ASPCA and told them what had happened.

"We need to see the cat," they said.

I called the crew member in the Midwest and explained the situation to her. She declined to cooperate. She and Larry hadn't gotten along, and anything with the potential to make life miserable and

Julie Halston as Dottie—as you can see, she fit in the costumes.

embarrassing for him gave her great joy. She even phoned the vet in New York and forbade him to release the cat's records.

The ASPCA reluctantly backed down, but only on the condition that I sign an affidavit swearing that the animal had not been mistreated and was entirely unhurt. In retrospect, we should have delayed that scene until we could have hired someone from the Humane Society to come by and supervise. That's what you do if there's ever any doubt, because animal-rights activists are, no pun intended, dogged.

3. DOTTIE GETS SACKED

Just before we made *Safe,* Todd Haynes directed and I produced a short film called *Dottie Gets Spanked,* about a young boy who's obsessed with a Lucille Ball-type slapstick TV comedienne, and about how seeing her get spanked on her sitcom led to the birth of a radiant fetish. For Dottie, we approached an actress who at the time was the toast of Broadway, and it was a genuine show-biz coup to have her tell us—at supper, at Orso's, after a performance—that she thought the script was fabulous and she'd love to play the part.

Because the boy in the film had glossies of Dottie in various guises all over his bedroom, we needed to make a load of costumes for the actress and to take photos of her wearing them. The actress was fitted and then posed for the pictures without incident. We scheduled the shoot around her, so that we could do her major scenes on days when her show was dark. We shot our first two days (of eight), and then called her to say that a car would pick her up the following morning. "That's great," she said. "That's fabulous."

The next morning, with the car waiting outside her door, she called and said, "I'm too sick to come in." I laughed; I thought she must be joking. But she wasn't. "I'm so sorry, I don't do this," she continued. "I'll stay in bed all day and take care of myself, so that I'll be in good shape for tomorrow." What followed was insanity. We had to cobble together other scenes to shoot, on sets that the art department hadn't finished; for the entire day we were frantically trying to figure out how to shoot without her. I called her twice, just to stay in touch, and then she stopped answering her phone.

At seven, her agent called to say, "She's not coming in tomorrow. Can you reschedule everything for next week?" I couldn't believe what I was hearing. "It's not that kind of movie," I said. It was a $150,000, half-hour movie for television, and we didn't have cast insurance. And he said, "Well, she can't come in tomorrow. There's nothing I can do."

I don't remember how long I let it go—whether we actually thought she'd show up the day after or not. The bottom line: We had to recast. The title role. *While* we were shooting.

I sat the shocked Todd down and showed him tapes of other actresses. The costume shop was right below us, so if he said, "Oh, maybe she's okay," I'd run down and say, "36-28-35!" and they'd say, "Can't do it," and I'd run back up to Todd and say, "That actress won't fit in the costumes, we can't cast her."

Boy, did we get lucky. We ended up hiring Julie Halston, a great comic actress, and she was amazing. She literally came in, got fitted, got all her photographs taken to replace the ones of our first actress, and started working the next day. In the midst of this, John Anderson, the critic for *Newsday*, called to interview me for a story he was writing on whether *El Mariachi* could really have been made for seven thousand dollars. I told him it was a bad time to talk; he asked why; and, after a few more phone calls back and forth, a big item appeared about the actress and *Dottie Gets Spanked* on the gossip page of *Newsday*.

It was not smart of me to fan the flames. But oh, was it satisfying after how we had been jerked around. Her agent thought we were just a stupid little movie; it blew his mind that we actually had the pull to get something in the paper. He called and *screamed* at me: "HOW COULD YOU DO THAT TO HER? SHE'S AT HOME CRYING!!" And I said, "That's right, she's *at home* crying. She's not crying here on the set." He said, "You'll never work with any of my clients again." (I have, many times.)

I know that actors get sick. It happens. But if we had been a "real" movie, would the actress have dragged herself out of bed and gone through the motions? Whatever happened to "The show must go on!"?

4. Forgive Us Our Trespasses

Productions of mine have trespassed and paid the price. We were shooting in a place where we hadn't gotten permission to be. Well, we'd gotten permission, but not from the person who it turned out we needed to get it from. You don't always know. Sometimes tenants are allowed to give you permission to shoot in their building, sometimes they aren't. If you have to go in front of a co-op board, it's a whole song-and-dance, and it can take months. Usually, there's someone who (with good reason!) doesn't want some horrible film crew in their building. Also, so many movies shoot in New York apartments, that there's a chance Woody Allen went in and paid somebody ten thousand dollars a day, so if I walk in with maybe 500 they'll laugh in my face.

Anyway, it was one of those days. We were so close to getting the shot that I said, "Let's brave this out. We'll be done in a second." And as we were wrapping, the police came and took my location manager away. I said, "I'm the one you should be taking away. I'm

Peter Freedeman at the shaken location

the boss." But the location manager played chivalrous and said, "No, Christine, I'll go." Of course, I was the one who had to get him out. He was pretty shaken. He kept saying, "Now I'm going to be known as the location manager who got arrested."

5. THE SHAKES

It was the week of January 17, 1995, and I was in Los Angeles producing *Safe*, written and directed by Todd Haynes. We were three weeks into the shoot, and I had just taken my one weekend off, spending it in the Chateau Marmont with my girlfriend, Marlene. I got up a little after 4 A.M. to go to the bathroom and on my way back BAM! the floor was buckling and I leapt onto the bed, which started to skitter across the room. "GET IN THE DOORFRAME!" shouted Marlene and I thought, "What a dumb idea." But up we went and huddled in total darkness under what we hoped was the doorframe.

That day, a Monday, we were supposed to be shooting in Simi Valley, which, it turned out, was right next to the epicenter. I tried to call the apartment I shared with Todd and Lauren Zalaznick (the coproducer) but the lines were all dead. Our call time was supposed to be 11 A.M. Marlene and I finally drove over to the apartment. No streetlights were working. California drivers sat helplessly at the intersections ("After you." "No, after *you*."), too polite to move. It

seemed as if every closed or collapsed freeway reported on the radio was one we needed to use to get to our location. How were we going to stay on our already precariously low budget if we had to miss a day of shooting? What if our location had been destroyed? What if the trucks that held all our equipment had fallen over?

Lauren and I tried to reach the cast and crew, but so many phone lines were down that we decided we'd have to go to people's homes to make sure they weren't lying under piles of rubble. Later we learned that no one had been hurt, but a few people's houses were virtually leveled.

"DO NOT LEAVE YOUR HOMES," blared the radio, but we hopped in the car and set off to inspect the remaining locations for the film. I crossed myself every time we went under an overpass. The dry cleaners we were going to shoot in had lost all its windows. The owner was there, sweeping up glass. He said the last thing he needed at that point was a stupid film crew to mess up what was left of his business, so I called the location manager from the car phone and told him he had to find a new cleaners.

Too bad there wasn't an earthquake in the movie, since North Hollywood looked like the perfect set for one. There were fissures in the road.

We called the film laboratory to find out if our negative was the one being processed when the quake hit. They told us it was too dark in there to see anything, and to please call back.

The next day, Tuesday, an earthquake relief center was set up across from our house. A water truck was parked right in front, and people were lined up, filling bottles, pots and pans. I asked the man behind the wheel if he could move up a bit so we could get our car out of the driveway. He shook his head: "I park where the government tells me to park."

We waited on line at the supermarket under a sign that said "ESSENTIALS ONLY!!" and bought batteries, candles and canned tuna. We convinced the cashier that cigarettes and beer were essentials.

We were supposed to look at rushes, and our editor was furious because we hadn't heard from our dailies syncher. I reminded him gently that Mark lives (or lived!) in Northridge, on top of the epicenter. "We all have our problems," the editor muttered darkly.

Horror stories from other productions started to trickle down to us. The worst was the one about the movie that had a 6 A.M. call

time in Venice Beach so all the trucks were on the freeway on the way to location when the quake hit *and* the freeway collapsed in two spots *and* the trucks were trapped in between. All day.

The radio said to sleep with your shoes on in case there were big aftershocks in the middle of the night and you had to run outside before your house collapsed.

We decided we could start production the following day. Then came three strong aftershocks, which sent us under the doorframe again.

On Wednesday, our set looked a bit bruised but workable. Todd, the cinematographer, and I went into a building that we had already shot in, to do our one last scene in it. The insulation was hanging from the ceiling and the floor was cracked. No problem, we said: We'll just shoot it so we don't see the ceiling or the floor. One of the big windows was shattered. No problem, we said: We'll frame it out.

Then in walked a uniformed man who told us we had to leave the premises because he was condemning the building. "What do you mean *condemning*?" we cried. He said it could collapse at any minute. I said, "You don't understand! We've already *established* this building!" The three of us tried to negotiate (one actor and one light? two actors and no lights?) until his expression (faintly appalled) shut us up. We went outside, subdued, and decided that the scene could happen on the lawn.

The next day we were finally up and running again. Julianne Moore was cheery. Because of our earthquake-induced schedule change, she didn't have to attend the Golden Globe Awards that night and receive an ensemble acting prize with the rest of the cast of *Short Cuts*. She said she didn't mind a bit. It wasn't that she belittled the award or her fellow cast members; it was that she was in the middle of portraying an extremely disturbed woman, and didn't relish the idea of getting all dolled-up for some lavish ceremony.

Our New York-imported hair and makeup artist pulled me aside and said she was too upset, too nervous, and too distraught to continue. She was very sorry, but she had to leave Los Angeles right away. I spoke quickly and smoothly. I said I understood, of course, but surely she didn't want to leave us in the lurch? The earthquake was already over, things were calming down; why not take the weekend to think it over? Just as color started to come back into her

cheeks, just as she said, "Well, maybe I *could* stick it out a little longer . . ." there was a violent rumble. The trees shook. The horses in the neighboring fields whinnied and bolted. Later, we learned that it was the most severe aftershock to that point. I watched our hair and makeup artist dash into her trailer and knew we'd lost her.

We lost another person—this time an actress—to post-quake trauma, and sweated through a few more aftershocks. But our sets, cast, and crew survived. And maybe—who knows?—the off-camera jitters contributed to the endangered aura of *Safe*.

How to Talk Like You've Been On a Film Set Before:

Flying in	I'm bringing it as quickly as I can
I'm ten–one hundred	I'm in the bathroom
Copy that	I heard you
I'm riding the cans	I am listening to the headphones
We're on the Martini	This is the last shot
We're on the Abby Singer	This is the second-to-last shot
What's your twenty?	Where are you?
She's (He's) in the chair	She (He) is in hair and makeup
NDBG	Nondescript background extras
I greeked it	I changed the label so it is no longer a recognizable brand name
Walking	I am on my way to the set with the actors
Hero	A featured prop
Flashing!	The flash bulb on my Polaroid is about to go off
Crossing!	I am planning to walk past the lens
Chicken in the gate	There was a hair in the camera, we must retake
Stand by for room tone	We must roll 30 seconds of nothing, please do not talk or laugh

Lock it up!	Please prevent passers-by from walking through our shot
Fire in the hole!	A loud explosion is about to take place
Walking meal	When the second meal of the day is eaten while working
We're shooting this MOS	We will not roll sound on this take
Holding area	The "pen" where actors and extras have to stay until they're needed
We're going to cover	It's raining so let's shoot inside on the other set we prepared just in case this happened
We're rolling!	Film is going through the camera, please shut up

DIARY INTERLUDE #5

POST-PRODUCTION DIARY: NEGATIVITY

January 1998

It has been a long, long haul on *Velvet Goldmine* but finally it looks as if the end is in sight. We've just completed our sound mix, managing to work on both Christmas and New Year's Eves. (The technicians just love us.) The movie has now gone to our London-based negative cutter.

The negative cutter is the craftsman who logs and stores the negative; pulls selected takes to make work prints for editing and early screening purposes; and finally cuts the actual negative together so that it conforms to the finished cut. Words like "cautious" and "methodical" don't fully encompass the job's requirements; a good negative cutter must have a reverence for that precious negative that borders on the mystical.

Todd Haynes and Maryse Alberti, our cinematogra-

pher, leave for London for the final phase—the timing of the print. I follow later, planning to stay just two or three days to make sure that everything is proceeding apace. I'm also anxious, after all this killing labor, to see the print *finally* in all its glory.

Alas, the lab is backed up, and I only see one reel before I have to return to New York. Still, it is magical. We watch it through several times as Maryse and Todd sit with the timer making color adjustments from shot to shot. I leave on a high.

Back in New York, I get a stunned phone call from Todd. He was timing reel four and he noticed that the print was frequently jumping at the cuts. The timer noticed it, too. They called the negative cutter. He assured Todd that it could easily be fixed. Then some disturbing facts came to light: the source of the problem was a faulty splicer. This means that the perforations at every "join" are aligned on one side but not the other, which manifests itself as a visible jump every time there's an edit in the movie. It looks horrible. Beyond that, it signals potential catastrophe. Every time the lab uses the negative to make a print, we risk having the perforations catch in the processor—and rip frames.

They'll see reel four again on Friday, hopefully all fixed. We'll be back on track, on schedule.

On Friday, my phone rings at 6 A.M. I wake up and reach for it with a sinking heart; I know exactly what it is. And I'm right. Todd is shaking with anger: "I am so sorry, Christine, I just couldn't wait . . ." Reel four is still totally fucked up—along with reels three and five! Worse, it now bears the wear and tear of being over-handled: there are visible glue splotches all over, along with dirt and dust. Our beautiful movie!

I hang up and immediately—at 6:30 A.M.—call my staff and everyone else I know to solicit advice and opinions. The first response of the negative cutter we use in the U.S. is succinct: *"Oh my God,"* followed by a deathly silence. Others say things along the lines of: "This is the worst post-production problem I've ever heard of." Translation: "You're screwed," and "I'm *so* glad I'm not in your situation." Those nightmare stories that make the rounds and become legend: we're living one.

What are our options? We can:

a) Re-cut and lose a frame at each edit. Because *Velvet Goldmine* is such a music-driven film this would mean having to go back

in, re-edit and re-sync the sound, then re-mix. A nightmare. And mucho dinero—although we are clearly in the land of the Large Insurance Claim.

b) Make an inter-positive—a copy—of the cut negative as is and then strike our internegative optically, adjusting for the jumps. Again, incredibly costly because it is so labor-intensive, plus there's no guarantee of uniform quality for all the reels. But it would save wear and tear on our fragile negative.

c) Find another negative cutter who will carefully undo the damage frame by frame.

d) Let that stupid idiot jerk asshole go back in *again* and try to fix it.

So guess which option our insurers and the bond company insist we go with? D!!

Their reasoning is that no other negative cutter will want to be responsible for a mess like this and therefore will not accept any liability in case anything else goes wrong. Also, they say, it's in our negative cutter's interest to right the terrible tragedy he has caused. They seem to feel we owe him another chance! Needless to say, Todd and I are not convinced. The idea of putting our precious negative back in that bozo's hands seems insane. We finally reach a compromise: we make an inter-positive and start doing optical tests on it in case the negative cutter screws up yet again.

February

Which, of course, he does.

We had been assured that the faulty splicer had been replaced before the work on reels one and six had begun. But when Todd goes to look at those reels for timing they jump like crazy—and show even more dirt and dust. In addition, the negative cutter has miscut a "join" on the optical track, which means it has to be entirely re-struck. Another insurance claim! It's as if the guy has just completely given up. *Finally,* the bond company lets us move the film.

There is now no way that *Velvet Goldmine* will be ready for the U.K. spring release that Film 4 has planned. We move the date from April to September. Todd is beside himself. What if we can't fix this mistake? What if we have to re-edit and remix the entire movie? What if the negative rips? I try to act confident, telling him we will work this out. Meanwhile, I've stopped sleeping.

March

The new negative cutter is very, very good. With hair-raising precision, he manages to fix the torn frames without having to re-synch, but the movie still has jumps—imperceptible to everyone except us, but still, maddeningly, there.

I once had a cast on my knee. During that time, strangers would approach me and tell me stories about how they had hurt *their* knees. Well, the same thing has happened now: I've heard virtually every the-negative-cutter-fucked-up story in the world, including one about an Oscar-winning film where all the splices came apart when it was printed—ripping some sections of the negative into pieces! The end of every story is pretty much the same: "And they fixed it." That's the end of our story, too, except we never got to see that first perfect print off the clean shiny negative. And our negative will always bear the scars of its ordeal.

I worked for two years to get *Velvet Goldmine* financed, then struggled through the most arduous shoot I'd ever done, then toiled through a lengthy post-production with production and bond companies screaming about swelling schedules and escalating costs. In the end, it all came down to this: a skinny strip of celluloid that some pinhead almost destroyed with a "faulty splicer." It puts every other crisis in perspective. You can replace crew, equipment, set-dressing, even actors. You cannot replace damaged original negative. That's your *movie*.

CHAPTER 8

POST PRODUCTION: A BIG PRODUCTION

Many people think that "postproduction" begins a couple of days after the shoot ends, when your hangover from the wrap party has finally faded, and when you journey to the editing room to view—and be astonished by—the fruits of your last six or seven or eight weeks' labor. Except for the hangover, that couldn't be further from what happens. If a producer does his or her job properly, almost every element of so-called "post" has started mid- and even preproduction.

Not that you can ever eliminate surprises. If the editor has been working all along—and it's pretty standard to have your editor working during production so that he or she can monitor sound and picture and give general feedback—you'll already know how shots are cutting together. But you won't know how whole scenes are cutting together. You won't know how clearly the narrative is emerging, or how strongly the characters are coming through for an audience that hasn't lived with them for

months or years. The pacing might be slower or faster than you'd imagined, and elements of the plot that you thought were obvious might fly over people's heads. Real knowledge of what you've got won't come until you watch the first, rough assembly—or even the first test screening.

In some ways, a postproduction schedule is more iffy than a shooting schedule because, after eight weeks, if you're not done cutting, you're not done cutting. You can certainly set goals: x weeks for a rough cut, x for a fine cut, and so on. You should *try* to stick to your schedule. But if you screen your fine cut and the audience doesn't have a clue what's happening on screen, it's back to the editing room. Post is a maddeningly inexact science, a profusion of Catch-22s: A lot of things can't be decided until the movie is finished, but those things need to be decided in order to finish the movie.

Unexpected problems will arise: a scene doesn't work, a lousy effect needs an optical, the sound is screwy, you realize you're missing vital coverage, you get into a festival and suddenly have a new deadline for your mix and final print. Six weeks ago the special effects supervisor phoned the director at home in the middle of the night and got him to approve a new digital process that costs $20,000 and you're only finding out now because the invoice just arrived. . . . *Stay calm.* Study the cost reports and think of possible savings. Brainstorm: "If we schedule a screening and invite everyone we know, then the editors will have to be finished to avoid a career-staining embarrassment." "If five interns sell a pint of plasma each, we can afford an extra hour of mix time." Stay on top of all the disparate elements and move forward, forward, always forward to that magical delivery date—*which you will not make!*

THE DAZE AFTER

Let's catch our breath for a second and go back to the wrap. The day after production ends, you:

1. **Sell off what you can,** including the beer you didn't drink at the wrap party, plus leftover stock, gels, Polaroid film, etc.

2. **Return all equipment.**

3. Make sure that all locations are restored to the satisfaction of their owners.

4. Inventory costumes and props, and arrange to store key ones for a period of time in case you need them for reshoots.

5. Conclude your contracts. Deal with all the unhappy vendors, people who are missing paychecks, etc. Make sure all production paperwork is complete.

It's also time for the production accountant to tidy up the books and pass them on to the postproduction accountant, if you have one. On smaller films, which don't involve *that* much accounting, your postproduction supervisor can often handle the books. But as the movies get bigger, the variety of expenses gets mind-boggling. You'll have a payroll for sound and picture departments, optical vendors, labs, and sound houses, along with bills for shipping, vehicle rentals, and reshoots. Plus there're all the bills from production that, like ol' man river, just keep rolling along. If you can afford one, hire a separate postproduction accountant. If nothing else, he or she will act as a check against a profligate post supervisor, earning his or her salary back and then some.

A postproduction office is different from a production office: fewer people, a lot quieter. But it's hardly pressure-free. If your movie has been financed by someone else, then there's usually a delivery date in your contract. And, if you're smart, that date will allow for every possible disaster. On *Safe*, a couple of cans of negative were never developed, and when I called the lab they had no record. All the negative film for a crucial scene was in those cans, and our only recourse was to get the missing takes from a work print that had been pawed and scratched and mangled for twenty weeks. I debated calling Todd, but he was in the middle of the sound mix, and I feared he'd throw himself off the Williamsburg Bridge, so I went back to the schedule to see when the scene was shot: Ah ha! *Right* after the major earthquake that had shaken LA, when the lab had been in (understandable) disarray. Knowing that helped me get through the next excruciating twenty-four hours; I figured if ever there were a time for reels to be misplaced (as opposed to lost), it would be just after a six-point temblor.

After a day, the reels turned up, and Todd and I had a good laugh.

MAKING THE CUT

An editor from the first hundred years of moviemaking would not recognize the inside of an editing room as it has come to look in the last five. People still occasionally edit on film: They cut frames and tape (splice) them back together; to make changes they have to pull off old tape, and put on new tape; and they have to keep their bits and pieces ("trims") in order in case they need them. When I was an assistant editor I spent most of my time organizing trims and looking for missing ones.

What has changed the face of editing is the advent of the immense, nonlinear Macintosh-based system called Avid—a system that allows you to use "telecines" that are digitally transferred to a computer. (Another computerized system is called Lightworks.) This means no more film bins, editing tapes, or splicers.

The process is supposed to be faster on an Avid but, in my experience, that isn't the case. The fact that you have more options when you edit on video can slow you down. Making a change on film is a commitment: You pull things apart, cut off frames, resynchronize everything—your editor can spend at least fifteen or twenty minutes just moving shots around. On an Avid, you do all that with the push of a button. You don't have to commit so quickly: You can save the sequence the way you had it, try it a new way, try it a completely different way and save that, and then go back and watch all three ways. By the time you're done fussing around, you've put in the same number of hours as you did in the days of Steenbeck tables and yards of loose celluloid. (Writers I know say that the same thing is true for writing on a word processor versus a typewriter.)

Another Avid frustration: The computere opens the door to expensive possibilities that you probably can't afford. You can put in just about any fancy optical you want: cross-fades, superimpositions, wipes, split screens. The problem comes when you transfer them to film. A lab will do certain standard dissolves for free, because its machines are already calibrated, but for extras you'll pay dearly. So every time the director and editor add an optical effect on the Avid, your costs go up. Keep tabs on them, or they'll bankrupt you.

Actors invariably complain about scenes that have been left on the cutting-room floor, but most performances are improved, not weakened, by editing; I've heard of stars whose careers were saved because of what never saw daylight. On almost every one of the films I've produced, we've been concerned about an actor in dailies, but have been able to cut together a strong performance. This isn't theater acting. Many performances don't take hold until you see them cut together. Good directors will ask for different kinds of readings, so that they'll have more choices in the editing room; when you pair together master take three and close-up take two, something amazing can emerge. (One thing you'll hear directors and editors complain about is actors who "can only do it one way.") Editing can't make a bad performance (or a bad movie) great, but it can make it much more watchable.

JAMES LYONS, editor

My role as editor on *Velvet Goldmine* really began when Todd Haynes and I first conceived of the film. Knowing that the plot would cover many characters over a great period of time, that musical sequences would be at its heart, and that much of the story would be told in a series of flashbacks, forced us to make strong editing choices in order to write the script. With each draft we debated questions that can be seen as editing questions: How to reveal narrative information and when to withhold it? Which actions needed to take place over the course of a scene and which could be abbreviated in a montage? Where would musical performances increase the emotional intensity of the movie rather than stop it dead? Many decisions that on a film with more money would have been made in the editing room, had to be made ahead of time. I don't recommend this to most filmmakers. Todd Haynes has amazing skills of pre-visualization and can hold immense amounts of information in his head. He knows what he absolutely has to have to make a scene work, what's worth going the extra mile to get, and what can be omitted. Without these skills the film would never have come together. As it was, I think, everyone—Todd included—was crossing their fingers a bit.

My first official actions as editor were to attend Todd and director of photography Maryse Alberti's storyboard meetings. Having the editor at storyboarding is, I think, crucial, but is not done often enough. On *Velvet Goldmine* we needed to have a full assembly of the film three weeks

after principal photogrpahy was completed. This meant I would be cutting scenes while Todd was shooting them, with very little access to him. Without this time together before production began, it would have been impossible to know what he and Maryse had in mind.

Storyboarding is one of the nicest parts of the filmmaking process. Our work was simply to dream: What would be the most elegant, compelling, and beautiful images with which to render the ideas in the script? Todd would come in with sketches and notes and explain what he wanted and Maryse would say, "That's possible," or "We'd need other equipment; what about this?" The money at this point is all in your head.

It's the editor's job to think about coverage, and mistakes at this stage can have a very high price. Without that shot of the murderous feet walking slowly down the stairs, it's impossible to build suspense. Inexperienced directors are often drawn to shooting important dramatic scenes in a single continuous take—a "macho" style that leaves no way of changing pacing or helping unsteady performances.

During production, the editing room is the first line of defense. Mark (my British assistant) and I would look at everything as quickly as possible to make sure it was exposed and developed correctly. After that, you look at the performances: Are they working together? Actors can have very disparate styles. You have to cut scenes to know if they feel like they are in the same movie.

Working on performance is my favorite part of editing. The key to its looking hard at what the actor actually did in front of the camera and leaving aside what you hoped they'd do or expected them to do. Once you understand what they brought to that moment and how it makes you feel, you can use it in the larger structure of the film. Jonathan Rhys-Myers brought a warmer, youthful quality to the part of Brian that I never expected. This tempers Brian's cold, calculated side and makes him more human. Christian Bale has an uncanny ability to register subtle shifts of emotion without speaking a line. As Arthur he spends most of the film listening to Cecil and Mandy tell their stories while he remembers his youth. Without this faculty, his character would have been lost; with it, he takes his rightful place as the emotional center of the film. As we watch him listen, we see how much what he's hearing makes him feel. First, we are intrigued, then, as we learn more about him, moved.

In contrast, Toni Collette as Mandy carries off grand gestures and sudden changes of emotion with great accuracy and grace. *Velvet Goldmine* itself walks a tightrope between these two poles—the glory of the extravagant gesture and the deep intimate feelings that make such ges-

tures necessary. Toni and Christian played off each other wonderfully, so wonderfully in fact that our first cuts of their scenes together were much too long. We cut them back considerably.

You have to be rigorous and, sometimes, ruthless even with the stuff you love the most. The musical sequences were another case. At first we tried extending the songs to include all the great material we had shot. This proved deadly. Those sequences had to be fast and colorful and fleeting—like dreams you can't quite remember. They had to embody the exuberance of youth recalled from the compromises of adulthood.

Perhaps the hardest part of cutting a film is trying to imagine what it would be like to see it for the first time after seeing it yourself 500 times. Screening it for other people, especially those not in the film industry, is invaluable. *Velvet Goldmine* is so complicated that people often had a hard time explaining where they were confused or lost. Here again we had to leave aside our ideas about how the script was supposed to work and learn how it *did* work. Only then did we ahve a chance of making good on the dreams we dreamt in the very beginning.

THE FURY AND THE SOUND

Now it should all go like clockwork:
- From the Avid, the editor prints an Edit Decision List (EDL), which gives you the selected shots and their corresponding key codes on the negative.

- The negative cutter pulls relevant sections of the negative and sends them to the lab. (The negative cutter does not yet cut the negative, which is a Big Deal; he or she only finds the takes the director has chosen so that the lab can make a print.)

- The lab produces a "one-light print" of all the takes—the cheapest and fastest you can get, with no adjustment of light levels or color correction.

- The one-light is sent to a "conform" assistant, who splices it all together.

• A "work print conform" is struck, and everyone gathers to see how everything looks on celluloid. Although very low-budget movies skip this step (we didn't do it on *Kiss Me, Guido*), it's a good idea to check out what you have before you commit to cutting the negative. The Avid hides fine details, and shots that work on the video might look horrifying on film. Say hello to boom shadows, reflections of hapless crew members in mirrors, and focus problems that were minimal on the Avid. Sometimes the technology will allow you to reframe a shot or blow up a small detail, but a lot of times with a low budget you just have to go to another take or live with your gaffes and hope that no one will notice.

As you're putting together your picture, you're trying to find a sound team and arranging the dates for your mix.

If you haven't hired a composer, you're searching for one. Every day, more kids graduate from music school who'd kill to be the next Danny Elfman, Carter Burwell, or Michael Kamen, and you can get them cheaply. If you've got a really terrific movie, you might even get Carter Burwell or Michael Kamen, as we did on *Velvet Goldmine* and *Stonewall,* respectively.

Do you have a distributor? If not, now's the time to think about how and when to initiate a Close Encounter with an acquisitions person, a process discussed at length in Chapter 9. How soon you attempt this might depend on how desperate you are for money to finish postproduction.

Meanwhile, your music supervisor is trying to get songs that your director wants to cut in, and the cost of those songs will be a rude awakening. You're trying to decide if you can afford a particular number while the music supervisor hunts for cheaper alternatives— but quickly, because many directors in the post-MTV generation like to edit to the music. There are publishing (synchronization) fees and master fees. If someone in your film sings a copyrighted song, you have to pay a publishing fee, which goes to the composer. If you use an existing performance, you have to pay a synchronization fee *and* a master fee, which goes to the performer. A lot of directors edit to temporary music and get very attached to it, so the earlier they can start playing with the music they're going to use, the easier a time—creatively and emotionally—they're going to have.

You can't start your sound editors until you're pretty close to locking the picture, because if they edit to an unlocked picture,

they'll need to go back and redo it all. That's a common screwup in post. Your sound person finishes an intricate collage and then you suddenly realize that the scene needs to be two seconds longer or shorter—and everyone goes nuts. You take a lot of risks doing a digital mix to a videotape instead of a film; once you cut the negative, you might find yourself with unsalvageable sync problems. (On *Guido*, we never could figure out why ten frames were out of sync, but we had to remix to fix the mistake.)

Once the editor locks the picture, the director and the supervising sound editor sit down and watch the movie and make the big decisions about sound, music, and dialogue. Should the composer lay down some violins over the love scene, or will the couple's heavy breathing be enough? Do you want silence when the heroine opens the door to the attic, or doom-laden music, or just the echo of her footsteps and the *creeeak* of the door? The last you achieve with "Foley," which covers, say, footsteps or doors closing or the rustle of clothes. The effects are created in a Foley studio, which is filled with myriad surfaces for walking and running and door-slamming, and where Foley technicians watch the movie and stomp around in heavy boots or stab cabbages to simulate someone being knifed. Some directors hate Foley because every single movement has a *huuuge* effect. And it's true that once you've used it, you'll register the artificiality in every movie you see. But you often need Foleys to get a clean sound effect.

You'll also be creating an ADR (additional dialogue recording) track, which includes the "looping" of dialogue and the addition of voiceovers. ADR can cover for problems you had while shooting. If a car alarm was blasting nearby, and you couldn't wait for it to stop because you were in danger of losing the light, someone had to make the decision to go ahead and shoot and "ADR it" later. (The common expression is: "We'll fix it in the mix," and sound editors are always cursing you for passing the buck.)

Often directors use ADR as a last-ditch tool for improving (or saving) performances. You can correct a lapsed accent or a wrong inflection. The only problem is that some actors are terrible at it. Others have difficulty getting back in touch with their characters. Jared Harris underwent an astonishing transformation to play Andy Warhol, and he had a hard time reviving Warhol for ADR months later. To play Arthur in *Velvet Goldmine*, Christian Bale developed a "Mancunian" (Manchester) accent which he'd forgotten by the

time we did ADR. Brad Simpson, our postproduction supervisor, brought him a tape of himself a couple of days before the session so he could practice his Arthur again. Another factor in scheduling ADR is that your actors might have scattered to all parts of the globe. In the best of all worlds you want to have everyone together, but you often end up recording people in different places. When it came time to do ADR for *Velvet Goldmine*:

Toni Collette was in Australia.
Ewan McGregor was filming in a small town in the north of England.
Jonathan Rhys-Myers was in Dublin.
Christian Bale was in Los Angeles.
Eddie Izzard was on tour in Paris and New York.

Meanwhile, our contingency had dwindled to almost nothing. We had to delay some of the voiceover, squeeze in Ewan and Jonathan, drop Eddie Izzard from ADR (we made do with his existing production tracks), and wait a month to get Toni and Christian when they were both going to be in Los Angeles. We also had to pay for Todd Haynes' travel to three different ADR studios.

You add texture to a film with background voices, but you often don't know what you'll need in terms of crowd reactions until you've cut everything together. *Velvet Goldmine* posed a lot of problems in this regard. For one thing, it was shot in England and edited in the United States. The background voices—say, to fill up a pub—had to be English, and although a bunch of us Yanks could have stood in front of a microphone and bellowed things like, "Blimey! Give us another pint then!" we thought it more prudent to fly Todd Haynes and the ADR person back to England to record the real thing. (Todd did put on an English accent and record himself for a "scratch" track, which accompanied rough-cut screenings of the movie.) For a scene outside the Lyceum Theatre, where an actor playing a BBC reporter was doing a news story on Brian Slade, we wanted to hear the reporter without a lot of background yelling, so we had to go back to London to record the crowd later. Yes, we could have done it after we shot the scene (and we did record the concert audience going crazy for Ewan McGregor as Curt Wild after we'd dismissed Ewan for the day), but it's hard to get into a sound recording mindset when you're shooting. Who wants to spend three

hours recording additional dialogue for a scene that might not make it into the movie?

Once you've recorded and edited your sound, it's time for your premix and mix, which is always an expensive process. First you hire a sound house that provides the equipment and the personnel. Low-budget films will often go "standby," which means you'll wait until the people mixing the Bruce Willis movie are done for the night and then move in and work until morning. This saves a lot of money. Another cost-cutting technique is allowing the sound house to break in a new mixer on your film. *Go Fish* was one of mixer David Novak's first features, and now he's a big deal. (He just finished mixing *Velvet Goldmine*.)

At the mixing house, the mixer takes all your disparate, edited sound elements—ADR, Foley, voiceovers, crowd noises, music—and makes them work together. After a premix, at which temporary levels are set, the mixer goes through the movie reel by reel in excruciating detail. It's a surreal vision, an anarchic muddle of blinking lights, levers, and flashing buttons. The mixer sits in a rolling chair and glides left and right along the length of a master console that looks like something you'd find on George Lucas' Death Star, moving his or her hands across the board like a pianistic fighter pilot—listening, watching, adjusting levels. Lay folk who visit the mix think it's cool to see how the sound comes together—but by the second hour of hearing the same line of dialogue over and over and over again with subtle changes, they're pulling their hair out. The mix takes virtuosity *and* patience.

You'll have a lot of decisions to make. Do you want to use Dolby? (You'll need to pay a license fee.) Digital or analog? Foreign distributors generally insist on a separate Music and Effects (M&E) track, which allows a foreign distributor to drop in German or Italian or Japanese voices without losing any texture. Then your sound house films the optical track, which goes to the lab and gets laid down—it looks like scratches on the side of the film—on your final prints.

The final negative cutting takes a long time, sometimes a month or two. You insert all the opticals; watch an answer print, which is the first print off the negative and is scrutinized especially closely for light levels by the cinematographer; correct for color and sound; strike an "interpositive" and an "internegative"—the latter a sturdy negative that's used to make your scores (hundreds? thousands?)

of exhibition prints; and open a bottle of the best champagne you can afford.

When you deliver a movie to a distributor, you're expected to provide them with copies of the shooting script and all your contracts and music licenses. The latter might take years to finalize, though. I was in Ted Hope's office at Good Machine recently and in walked someone with a draft of the final soundtrack deal for *The Brothers McMullen*—a film that was released more than two years earlier.

A distributor will give you a long list of "deliverables"—and you'd better deliver them. (See the typical deliverable list below.) One missing element and you're technically in breach of contract, which means that the distributor can refuse to pay you. If they're not pleased with your movie, you've just given them an easy way out of the deal. So *deliver*.

JACKED
PHYSICAL DELIVERY
MATERIALS

		MAIS OUI SALES AGREEMENT	NOVEMBER FILMS AGREEMENT
	FILM MATERIALS		
1	35mm Combined Optical color print	1	1 Made from IN To go to November Distrib.
2	35mm master positive with main and end titles (replaces usual interpos)	1	1 Access letter
3	35mm internegative (IN) with mainand end titles	1	1 Access—to go to lab IN to contain November animated logo
4	35mm optical soundtrack neg conforming to the 35mm IN	1	1 Access—to go to lab Optical sound neg to contain sound of November animated logo
5a	35mm IN textless of main and end titles, inserts etc.	1	
5b	35mm master positive textless of main and end titles, inserts etc.	1	

		MAIS OUI SALES AGREEMENT	NOVEMBER PRODUCTION AGREEMENT
	35mm neg textless backgrounds of main/end titles where do not appear over black		1 Access letter
	35mm textless IN of any sub-titled/captioned scenes		1 Access letter
6	35mm magnetic master of M&E	1	1 Access letter 35mm 4-track or 6-track
7	35mm magnetic mono three-track (M/E/D)	1	1 Access letter
8	35mm fully mixed sound magnetic track or, if in stereo, 95mm SVA stereo variable area	1	1 Access letter 2-track stereo magnetic
9	DAT of music	1	1 Access letters
10	Access to 35mm original neg (for purpose of manufacturing new master positive only)	Yes	
11	Access to 35mm separate D/M/E stems	Yes	
12	Access to all unused takes/trims/all film material/soundtracks (neg, positive or magnetic), together with a summary of Producer's rights to which use of these materials are subject		
13	Proforma billing block for posters, video packaging, paid advertising, & trailers, approved by all parties, & camera-ready B & W artwork of all logos	Yes	
14	Camera ready artwork of the main title treatment	Yes	

WRITTEN MATERIAL

15	Spotted Post-production script see contract for full description	Yes	2
16	Final shooting script	Yes	

	MAIS OUI SALES AGREEMENT	NOVEMBER PRODUCTION AGREEMENT
17 Music cue sheets see contract for full description	Yes	2
18 Summary and full extracts of full contractual screen advertising credit obligations re those persons/entities entitled to receive credit in paid adverts. Separate list of credits for main/end titles, final billing blocks for posters, video packaging, paid adverts/trailers, all approved, & camera-ready stats of all necessary logos	Yes	Yes
19 Full cast and crew listing	Yes	
20 Originals of Certificate of Original notarized & fully executed	5	
21 Originals of Certificate of Authorship, notarized and fully executed	5	
22 Copies of all documents evidencing Producer's Chain of Title including copyright and title reports	Received by Mais Oui already	
23 Summary of dubbing and subtitling restrictions, specifying which languages are covered	Yes	
24 Contact list for principal players, director, producer & writer	Yes	
25 Copy of all recording licenses & composer agreements (including rights for videogram), inc. proof of payments, or reliance letters	Yes	Yes
26 Copy of copyright registration certificate for the Film, the title & the screenplay and the correct copyright line for the Film.	Yes	

		MAIS OUI SALES AGREEMENT	NOVEMBER PRODUCTION AGREEMENT
27	Copy of Dolby license (or other sound system	Yes	
28	Power of attorney to register and sue, notarized	Yes	
29	Certificate of E&O policy	Yes	
30	Cast/Personnel Agreements— see full contract for details	Yes	
31	Confirmations of residual payments	Yes	
32	Final audited cost statement no later than 3 months after delivery	Yes	Yes No date
	Access and loan of materials will be by way of a lab letter		
33	Full copies of all agreements from which extracts are taken pursuant to paras 18–33	Yes	
	Copies of all release forms, performer's consents, all licenses, agreements etc.		Yes
	Delivery date	15.12.97	

Testing One Two Three

Studios test movies early to get John Q. Public's feeling about, say, whether it's okay to kill off an actor or if an ending is too much of a bummer. Independent filmmakers, on the other hand, are supposed to operate differently—to stay true to the director's vision, to *lead* the audience instead of following its dictates. But that's no excuse for arrogance: You should always listen to what objective viewers have to say. We routinely screen our movies for people who haven't read the script or been involved in the process, especially when a film of ours consciously sets out to experiment with narrative language. In the case of *Velvet Goldmine,* we expected there to be moments when the audience was off balance, but we wanted to be *in control* of those moments. It's a tough call: When are you tantalizing your viewers and when are you pissing them off?

As soon as he finished a rough cut of *Velvet Goldmine,* Todd Haynes held a screening on high-definition video for close friends

and colleagues, and afterwards passed out a questionnaire that was as challenging as some of the final exams I took in college. People sat hunched with their pencils poised, struggling to answer probing questions about the plot, themes, and pacing—and it wasn't multiple choice! Ultimately, Todd and his editor, James Lyons, learned a lot about what was and wasn't coming through onscreen.

What Todd doesn't like about standard questionnaires (I've included an example in chapter 9) is what I like about them: They're not too leading. If you ask a question like, "What would you say, in terms of pacing, was the slowest part of the film for you?" you're planting the idea that parts of the film *are* slow. And so your viewers will write: "Well, actually, now that you mention it . . ."

It's a shock seeing your movie with people who haven't seen it before. You *know* when their attention is starting to wander. Things you think are totally obvious turn out to be incomprehensible. Major characters get mixed up in people's minds. We knew we were in trouble with *Swoon* when the audience couldn't tell the difference between Leopold and Loeb—we had to put in voiceovers to distinguish them. In *Velvet Goldmine,* the audience had no idea who Shannon, Brian Slade's increasingly formidable assistant, was—her style changed so radically from scene to scene that they didn't recognize her. We had to hold on her longer in certain shots, and to reshoot some footage to emphasize her more. Americans were also confused by Toni Collette's accent, which is English in the London scenes and American when the action shifts to New York, more than a decade later. The British got it instantly, because they see so many Americans who move to England and suddenly start vocalizing like Henry Higgins. But to clarify the character—and to protect Toni from unfair criticism—we had to insert a line explaining that she's an American living in Britain and affecting an accent.

You have to read between the lines, because people don't tend to be articulate, especially right after they've seen the movie. A scene that they think isn't working might have nothing wrong with it: It might not be working because the section before it didn't work, and so they didn't know what was going on. In that case, the solution might not be to get rid of the scene but to tighten up what's around it.

It's important not to be defensive, especially if you're making a film that takes risks. Not everyone is going to like it, nor should they be expected to. You can't expect to please all of the people all of the time, unless you're a mogul with a hundred million dollars on the line—which is the best reason of all to stay independent.

DIARY INTERLUDE
#6

THE FESTIVAL GAME

Sundance, 1995, with *Safe* and *Kids*

- **DAY 1**

Long flight. Todd Haynes is very tired. Picked up at
the airport by a cheerful Utahan and head for the Kim-
ball Art Center. Everyone wants to see *Safe*. I see James
Schamus at the Fox party. He is very flu-y and semihys-
terical. I let him use my cellular phone to find out
whether or not *Sense and Sensibility* has been green-
lighted. It has. I also let him call Ang Lee to tell him
the good news. I am happy for James and a little jealous.
We meet Todd and go to the Egyptian Theater—
crowded, and with many people looking for tickets. Todd
McCarthy, the *Variety* critic, asks if he can call me in

Julianne and James LeGros in *Safe*. Our reception at Sundance was a little unnerving.

the morning to get the technical credits for his review. I'm a little nervous because he wrote a stinging pan of *Postcards from America*.

During the movie I go across the street with James and Tom Bernard and Michael Barker. James is high about *Sense and Sensibility* and the three of them talk business. I feel a little ignored. I am very nervous about the screening,

The reception to *Safe* seems to have been good. We slip and slide down Main Street to the Depot and have dinner with about thirty guests, courtesy of Sony. Todd's parents are there, looking very very proud. A little before midnight there's a mass exodus to the screening of *Kids*. I decide it is *Safe's* night, so I stay at the Depot and have a last drink with Todd. When we leave, I walk up to the theater and poke my nose in—very quiet and packed. No sign of Cary Woods or Harmony Korine or Larry Clark. I am tired, and after twenty minutes or so I go home.

• Day 2

I ask around about the reception to *Kids*. James didn't go, but I know Ted Hope did, so I ask James what Ted said. James sucks in his breath. "Sorry, but Ted said it didn't go well *at all*," he says. I am dismayed and disappointed. But then, I showed Ted the script

last year and he told me it "lacked character development," so maybe it just isn't his cup of tea. Still, I brace myself for the worst.

At the Claim Jumper I am besieged with people declaring *Kids* a masterpiece. Many think it loathsome, many more tell me it "changes the face of cinema."

Safe is a little tougher sell. The *Variety* review, I'm told, will be bad. The rest of the critics seem to be coming out in favor. All day people come up to me and say, "It's *brilliant!*" but sometimes they mean *Kids*.

Dinner with Todd and his parents at the Depot

"A scene from *Postcards from America*"

again. We drop them off at the *Postcards* screening and then try to go to the *Party Girl* party. But we don't have the right invitations and they won't let us in, so we stand outside in zero degrees, smoking. One of the makers of *Hoop Dreams* tells Todd he loves *Safe*. A bit of warmth in the cold.

• **DAY 3**

Coffee with the French distributor of *Safe*, who hates the last twenty minutes. I try to placate him. Then I have lunch with Ronna Wallace of Goldwyn: I pitch *Savage Grace* and hog all the sushi. After lunch, we run into Lindsay Law. I try to talk about *I Shot Andy Warhol* with him, but he is in a big hurry. I am worried about its imminent start date.

At our publicist Jeff Hill's condo I read the *Variety* review. It couldn't be much worse. It says *Safe* is preachy and pretentious. I wish there was some way I could prevent Todd from reading it.

I go to the Brian Wilson party but leave before he plays. Outside,

I call Pam from my cell-phone. She confirms a midnight flight to London for a screening of *Stonewall* with a one-hour 5 A.M. stopover in Atlanta. I am out of here.

Cannes, 1995, with *Safe, Kids,* and *Stonewall*

- ### DAY 1

I have a little studio in the Residence du Grand Hotel, right in back of the Petit Majestic. Am nervous about everything. I join all the *Kids* people in the lobby of the Majestic half an hour before the screening. Bedlam: Too many people clamoring for tickets and the publicist looks as if she's going to throw up. Still, I get my ticket and join the official party and march up the red carpet.

Kids looks great. Mixed yays and boos. Afterwards we go to the Miramax yacht. Take off your shoes first. Veuve Cliquot only, pasty little hors d'oeuvres. I sit on the bow with the set designer, Kevin Thompson, and my lawyer, John Sloss, getting drunk, feeling content, gazing at the Riviera. Then Harvey Weinstein asks everyone to leave—he has to talk to Larry and Harmony, the screenwriter. We go to an awkward dinner. I sit next to Gus Van Sant, who is in an amiable mood. We chat until Larry and Harmony arrive. Harvey, they say, was lecturing them about their press conference. "He said we were punk rock and we should have been classical," says Harmony. What a great way to put it! I leave before dinner and walk to the Independent Feature Project party, then go home too early (for my taste) but still feel awful the next day.

- ### DAY 2

Stonewall was not chosen for the festival, but is being screened in the market. I am disappointed, but the sales company seems to feel it'll do fine anyway. Anthony, the BBC rep, keeps asking me what he's supposed to say to "salve the wounded hearts of Nigel's [the late director's] friends." Fuck if I know.

We gather for the *Safe* screening. Todd Haynes' whole family was supposed to be here but are nowhere to be found. We finally head for the theater and hope we'll run into them. Word from the lobby that a hysterical American family is insisting they be let in and security is being called. Alison from the Sales Company dashes off to rescue the Hayneses. We enter the theater through the parking lot and go into a room with a lot of champagne. Todd huddles with

We were all a little sad when *Stonewall* didn't get into Cannes.

Olivier to compose his speech. I hover and Todd tells me to get lost. I drink more champagne than I want and smoke and bounce around with James Schamus.

We are called onto the stage one by one—I'm a little slow. Full auditorium. Todd thanks everyone and then makes a speech saying *Safe* could not have been made without me. I'm moved and embarrassed. We dismount, Todd on one side of the theater, me on the other. The opening looks good, then we dash out, hugging each other and crying. We go to the Grand Hotel and drink through the screening.

Back in the theater the audience is still there. Slightly more than polite applause. Everyone keeps saying, "It went great—this is a great reaction!" What do I know? We go to the El Morocco for dinner, stiflingly hot, then to a succession of hotel bars until 3 A.M.

Sundance, 1996, with *I Shot Andy Warhol*

• DAY 1

Packed, sold-out Saturday-night screening. Brooke Shields is there, the cast of *Friends*. Hard to tell how it goes down. We go to the Riverhorse afterwards, where Michael Stremmel gives David Schwimmer a copy of Valerie Solanas's *S.C.U.M. Manifesto*.

- **DAY 3**

Monday, Sandra Schulberg—who has been attempting to run American Playhouse since Lindsay Law decamped for Fox Searchlight—summons Anthony Wall, the executive producer, and me to her hotel room. She tells us that Playhouse has just filed suit against Goldwyn, which was supposed to be distributing its movies. This means that I *Shot Andy Warhol* might no longer have a distributor; worse, it could fall into some kind of legal limbo. Sandra speaks in circles and I feel like I've been kicked in the stomach. I'm close to tears—so I leave, and walk down the hill to John Pierson's book signing. I'd asked Sandra if I could tell John Sloss, my lawyer, about the lawsuit, and she said, "NO. ABSOLUTELY NOT," but when I see him at the bookstore I tell him everything—I mean, I *have* to. He asks me a lot of questions I can't answer, then I go home and sit alone in the condo.

Mary calls and we meet for dinner at Grappa. She asks what the meeting with Sandra was about and I think for a second and say, "Video rights." I just can't tell her. She's in the midst of all these wonderful things—interviews, screenings, meetings with other filmmakers. She'd panic if she knew what was really going on, and it would be a crime to spoil her festival.

- **DAY 4**

I meet Tony Safford for breakfast. He says that Miramax can't buy *Warhol* because it would steal the thunder from *Basquiat,* which is *their* Warhol movie. I had figured as much, but when I call Sandra she responds as if it's a shock. Her voice is full of doom; she says things that drive me crazy like, "The applause at the screening was not *good* applause."

Sloss and I go over to Jon Taplin's condo to discuss an overall deal for him to represent our movies, but it's an exercise in futility— Taplin represents *Shine,* the screening was yesterday, and the phone won't stop ringing. Jon is very apologetic but . . . Suddenly there is a bang on the door: Ruth Vitale and Jonathan Weisgal from Fine Line. They say they won't leave until they get a deal for the picture. I do not want to discuss my movie or a deal in front of them and so I go and meet Lindsay Law at the Wasatch Pub. He tells me he's enjoying his new job. I'm torn between happiness for him and misery over the position that my movie is in now that American Playhouse is foundering. Lindsay is very sympathetic but . . . no

lifeboat here, either. Then I mention Dan Minahan's idea for a picture about Halston and Lindsay perks up. "I'm interested," he says. "So is everyone," I say. He asks if he can have until noon tomorrow to think it over and I say OK.

• **DAY 5**

A showing of Chris Munch's film *Color of a Brisk and Leaping Day,* which I like a lot although I think I'm in the minority. Michael Stipe, who's in the movie, is at the screening and gives me an invitation to a party at his condo at midnight.

A half hour before noon I call Lindsay. He says he's on the other line but: "Yes! Let's do it!" I say, "I'm shaking your hand over the phone."

The *Variety* review for *Warhol* comes out: incredible, a genuine rave. I start to feel a little better about the movie's chances.

At the Trimark dinner, Fiona Mitchell suggests that we don't send *Warhol* to Berlin but hold a few more months for Cannes. Given what's happening now between Playhouse and Goldwyn, that sounds like a good idea.

Midnight, and Mary, Gideon (*Warhol*'s set-dresser), Dan Minahan, and I go to Stipe's party. We're the first to arrive—in fact, Stipe isn't even there. We are too embarrassed to be in front of the door when he comes in, so we go sit by the jacuzzi downstairs and wait.

After what seems a sufficient amount of time, we creep back up, open the exit door, and—"Oh no," says Gideon, "they're coming in now!" So we duck back into the staircase and wait another five minutes. What a lot of trouble just so we won't look like losers.

• **DAY 6**

No headway with Goldwyn, so *Warhol*'s future seems uncertain. There's a chance it won't get out in time for spring. I feel as if I'm letting Mary down.

Breakfast at the Eating Establishment with Julie Golden of Lakeshore Entertainment. The place is teeming with Miramaxers. Harvey Weinstein walks in with Anne Thompson of *Entertainment Weekly.* I'm trying to get my energy up for Julie—but it's flagging.

I get up to leave and signal to Mark Tusk of Miramax. "I'm going to do Halston with Fox Searchlight unless you tell me there is a reason not to," I say. Looking pained, he says he tried to talk to

Harvey about it but Harvey didn't seem interested. I say "Fine" and walk outside, where who do I bump into but Harvey and Trea Hoving. She says, "You know Christine, don't you?" and Harvey says, "YOU, CHRISTINE?" I nod. "YOU ARE A MIRACLE WORKER! I AM YOUR BIGGEST FAN!"—on and on and on. I say, "Thank you. That means a lot." We shake hands and he asks me to call him. Trea says to me later: "Sometimes Harvey gets it right." I'm thinking: kudos from moguls; rave reviews; but *I Shot Andy Warhol* could still sink like a stone and there's nothing I can do.

Cannes, 1996 with *I Shot Andy Warhol*

• Day 1

Dan Minahan, *Warhol*'s co-writer, and I go to the airport together. There is a bevy of blondes on the flight that turn out to be the Hawaiian Tropics tanning team. My eye is infected and I am wearing glasses and feeling miserable. At least *Warhol* is being released— next week, courtesy the Samuel Goldwyn Company and its new owner, Orion Pictures.

We arrive and are taxied with Sandra Schulberg. No one is here from our team yet.

Mary and Lili arrive and are whisked off to do press. There *is* a fancy, fancy sitdown dinner scheduled for tonight. Tom Kalin and I give Dan and Diane our tickets. They are thrilled. It ends up going to about 3 A.M. and everyone gets to keep their plates.

I see Godfrey Cheshire at the Petite Majestic. I am polite but am upset at his review of *I Shot Andy Warhol*—unnecessarily snide and a tad malicious. I decide not to invite him to the party, thinking, "Humph. Bad review, no party." But Jeff Hill, our publicist, invites him anyway. Oh, well.

Dinner with Zenith executive Scott Meek and his friend Ash. Little tour of the Petite Majestic, then bed.

• Day 2

Screening at 2:30. We gather at Gray D'Albion all in nice duds. Our publicist, Ginger Corbett, is nowhere to be found. We leave

without her. It turns out later that she was dealing with a crisis: the director Lars von Trier had suffered extreme travel phobia and had turned back halfway to Cannes, so would not be there to present his film.

We go to the Palais and are shuffled around. Anthony, the BBC producer, wants to be presented on stage with us. The French ignore him. Three guys give speeches. The last is Gilles Jacob, who waxes eloquent about how fabulous Lili Taylor is. Lili stands

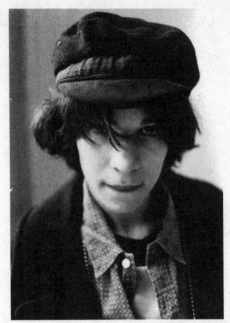

Lili Taylor was the toast of Cannes.

there smiling blankly. She clearly does not have a clue what is being said. I watch the movie—the subtitles are fun and reasonably accurate.

Flowers are presented to us ladies on stage. I hand mine to Jared Harris. He waves them away with a smile and says, "I don't want anyone to get the wrong impression."

Afterwards, press conference. Anthony, the BBC producer, wants to be up on stage with us. The French ignore him. No scintillating questions and it seems a bit anticlimactic.

Goldwyn dinner at 8:30 at the Majestic. Sort of dull and stodgy and I wish they'd picked somewhere livelier. Oh, well. We go across the street to our party at midnight. Now we get lively. What the hell is this? There is a guy lying on the stairs, facedown in a Warhol wig. Lili whispers, "Is he getting paid?" Yes, it turns out, five hundred dollars. There are go-go dancers covered with body paint and little else, a Candy Darling impersonator who smears glitter on your face as you walk in, a hippie sitting in the corner sorting M&Ms by color, and blasting seventies music. Could this be tackier? Mary looks aghast.

But everyone is having a good time! TV crews everywhere! Sofia Coppola, Kris Kristofferson, Leonardo DiCaprio . . .

I find refuge outside and sit with Tom, Scott, and the producer Ed Pressman. He is very soft spoken and I do not know what to say to him. At 2 A.M., I stumble home.

• **DAY 3**

In the *Hollywood Reporter*, our party is rated 3.5 martinis out of a possible five. I had planned to take our crew out tonight, but we've been invited to an official festival dinner, which seems to be an "honor." Oh, well. We take Anthony and Kim Evans for a drink at 8 P.M. at the Petite Majestic. I see an Israeli distributor march out of the Grand Hotel with two pillows.

I am so tired I can barely move. But off we go to dinner at the Carlton. I say hello to director Mike Leigh, whom I met in Australia six or seven years ago; he very graciously pretends that he remembers me. I introduce him to Jared, who is delighted.

After dinner, Jeff Hill wants to go to Zanzibar, a Cannes gay bar. I don't want to—it's filled with prostitutes and is vaguely tragic. Also, they practically throw you out if you're female. I mention this last salient fact to Jeff, and he says, "Yeah, well—they have tables outside!" I am too stunned to reply. Cannes is making me homophobic.

• **DAY 4**

Tom Kalin and I are invited by Tom Rosenberg of Lakeshore Entertainment to lunch at the Hotel Du Cap. I have been coming to Cannes for five years, and this is my first invitation to this legendary establishment. I try to make sure Tom realizes how fortunate he is, and borrow money from Scott for the cab fare. Poor Tom has been so drilled on how to behave with T.R. (don't talk too much, don't talk about the rewrite, etc.) that he can barely speak, and we journey to Antibes in silence.

Of course, we are too early. A forty-five minute ride we were told, and it took maybe fifteen. We walk along the grounds of the hotel and listen to the *thwaap* of tennis balls. We enter the restaurant on the dot of one and are promptly surrounded by waiters— "Yes?" "Yes?" "Yes?" We perch on chairs and wait for T.R. "Are you sure he's coming or should we call his room?" says Tom.

"He's coming!" I snap. We are both thoroughly intimidated. T.R. arrives with some hairy business partner I've never heard of. Tom

proves thoroughly charming. We sit by the sea on an impossibly beautiful terrace. Dustin Hoffman is behind us, George Clooney to our right. Chen Kaige. Atom Egoyan.

We open menus with entrees that cost 200, 300, 400 F. Oh, well—it's the Hotel Du Cap, let's live it up! I choose a bouillabaisse with saffron and fresh tiger shrimp, but T.R. orders first and asks for an omelet. An omelet! So I quickly shift gears and order a green salad and pasta.

Tom has risotto.

Tonight we plan to take everyone out to dinner. We select a cheap (for Cannes), cheerful place called Oscar's. Dinner takes about three and a half hours. I sit at the end of the table with Jeff Hill and John Sloss and talk business the whole time. Jared and his friend get drunk and merry, as do Mary and Diane. Lili is talking very somberly in the corner to Tom.

We finally get to the Petite Majestic, where I secure tickets to the *Van* party for Mary and Diane. Off they go. Dan and Tom decide they simply must go to the Zanzibar. I am happily abandoned. I find some old friends and—freedom finally!—relax.

Tom, Lili, Dan and Diane, and Jared are all leaving in the morning. Tom announces that he will of course stay up all night (his car leaves at the ungodly hour of 5 A.M.) which translates into *crash bang* at 3:30 or so, frantic wakeup call ("Your car is here, monsieur Kalin!"), Tom rummaging hysterically in the room, all the lights blazing. I pretend to be asleep. The door slams shut—*finally!* I get up, cautiously. Tom has left at least half his clothes in the wardrobe—including a very pricey Comme Des Garçons jacket. I contemplate leaving it here.

• DAY 5

The last day. Only Mary is left. A few meetings and dinner plans with Marcus Hu. We decide to meet at the Independent Feature Project party, which turns out to be a dull affair. Only wine is served, and I don't see anyone I know. Marcus and I sit in the corner and drink bad white wine. Finally, we take off for a British Film Institute rooftop party for the surviving members of Queen, under the mistaken impression that there'll be food there. No dice: just some dry, teeny weenie sandwiches. I fill up on beer and contemplate the glamorous, jet-setting life of an independent film producer.

DISTRIBUTION, MARKETING, AND RELEASE: OUT OF THE FRYING PAN . . .

Distribution

Unsuccessful independent producers say that looking for a distributor is when you finally pay the price for your independence. And it's true that an indie film that no one wants to distribute is not even an orphan in the storm, since storms pay enough attention to smack you around. Orphan indies waste away in a desert of neglect. On the other hand, if the fruit of your independence is a film that a distributor covets, you can write your own ticket and use it to ride into festivals, general release— and even a deal for your next movie.

What can possibly happen to your finished, unaffiliated film?

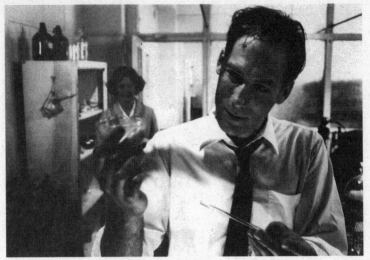

Poison went to Sundance with a small distributor and not a whole lot of buzz.

1. It's bought by a big or midsized distributor that gives you a national (often art-house) release and puts a lot of money behind you. This is the brass ring. Think of *The Brothers McMullen*; *sex, lies, and videotape*; *Clerks*; *El Mariachi*; *Sling Blade*; *Swingers*; and *All Over Me*

2. It's picked up for not much money by a small distributor, which works hard to get you media attention and a decent showing at festivals, art houses, and important cities. Think of *Poison, Stonewall*, Gus Van Sant's *Mala Noche,* or Atom Egoyan's early movies.

3. It has a life on the festival circuit, where it's seen by enthusiasts in key cities around the world, members of the media, and other filmmakers—ensuring that your next project will receive some attention. Think of—well, you probably won't think of Cheryl Dunyea's *The Watermelon Woman* or Chris Munch's *Color of a Brisk and Leaping Day,* because you've probably never seen them, but all were well reviewed with almost no commercial exposure.

4. It receives no domestic theatrical release, but has foreign sales and shows up on cable and cassette or laserdisc. Genre movies

routinely go this route and still turn a profit; other films—*Red Rock West*, *The Last Seduction*, *One False Move*, and *Freeway*—had premieres on cable followed by a limited theatrical release on the basis of considerable acclaim.

5. It's used as a doorstop.

• HOW DO YOU GET DISTRIBUTORS TO NOTICE YOU?

As I mentioned in the chapter on financing, at the point you're ready to show your film to distributors, they probably know all about it and have already formed an opinion. There are people who work at every company whose job it is to track small movies, and no underling wants to be responsible for missing the next *Welcome to the Dollhouse* or *Clerks*. They pore over the trades for announcements of projects, and sometimes they'll call you up and say: "Show us what you have when you're ready."

This is a good time (actually, it's always a good time) to cultivate relationships with the "smaller" people, the ones without the power to say yes or no but who can still function as your champion within the company. You might have met some of these people if you shopped your script around while financing. I'm always surprised by how many young producers make a beeline for the top of the organization, not realizing that for every Sammy Glick who favorably impresses a mogul with his chutzpah, there are a thousand who are brushed aside without a second thought. I think of myself as a pretty decent human being, but when young filmmakers buttonhole me for the purpose of selling themselves, I start to get that trapped-in-an-elevator feeling. Anyone in this business in a position of power has many people competing for his or her attention. You're more likely to make it to the top if you start with a lower rung.

Say you've made contact with the busy acquisitions person. He or she will inevitably ask if you have a videotape of your film. (Most of us would rather watch a tape than travel to a screening room or theater.) I strongly encourage you to stick to your guns and say: "Tape? We don't have any tapes." It's not just a cliché to say that movies look better on the big screen and with an audience present. If you're asked to send your film to be projected in the distributor's screening room, be aware that the acquisitions person might watch ten minutes of the first reel and ten minutes of the last reel and talk on the phone the whole time. *Try to control the circumstances*

under which the distributor sees your movie. If the film is especially quirky, or will work best for a niche audience, screen it at a festival where you think it will have a good reception, so that the acquisitions people can see it in context.

MARK TUSK
former VP of Acquisitions, MIRAMAX FILMS

When I was working at Miramax, the tone was extremely aggressive about acquisitions, so it wasn't a matter of just opening up a festival guide and saying, "What should we see today?" We would actively track movies—go balls-out to see if we could screen them in advance. That would clear the schedule so we could roam around festivals and look for more off-beat stuff.

Our knowledge stemmed from the trade papers. When there was an announcement of a film, we'd call the producer and find out when the first answer print would be ready; and then we'd call a few weeks before that and say, "We know you must be getting close! Just reiterating our interest!" We'd keep in touch with producers, sales reps, and the film-makers themselves. Of course, if someone found us, we'd take note of that project and put it into the system.

It wasn't always typical for acquisitions to take so aggressive a stance. There was a time, when *Farewell My Concubine* was screening, that the idea of executives flying to Hong Kong to look at a movie was extraordinary. Miramax raised the ante on both the aggressiveness of screening the movies and taking them off the table *before* they got to the festivals. And then they raised the advances on things that people wanted to be paid. People were *constantly* telling Harvey Weinstein, "You pay too much to acquire them! And spend too much to release them!" And he always laughed and said, "Oh yeah, that extra $100,000 for *Sex, Lies and Videotape* was *really* overspending." He often had the last laugh.

How rough could a film be and I'd still look at it? I saw foreign films with no subtitles, with the associate producer leaning in my ear and translating. I watched rough cuts of indie movies on Steenbecks or Avids, and promos or scenes shot in advance of the rest of photography. It's fairly common that someone struggled to get a film in the can but then was short on postproduction money. If you jive to what you've seen at whatever length, that might make you more inclined to ask to read the script.

If someone said, "It's on video and we want to get the money from

sant

you to blow it up," that wasn't a real incentive to look at it. The same with film-school shorts. If they sent me a tape I'd look at it, but I wasn't going to trek to midtown for a screening. It's less attractive to look at a film in pieces. Although if someone's looking for completion funds . . . Producers are at their most vulnerable when they're desperate to complete a movie. Not that we exploit them . . . but we do stand to get in for less money. It's mutually beneficial, though. You're cutting a good deal as the distributor, but you're sparing the producer the possibility that the moment for their film will pass.

Sure, in the worst case scenario, I'd look at only the first twenty minutes of a feature. But it's rare that you capture the audience's attention in the second or third reel of a movie if you haven't in the first or second. It sounds kind of callous, but when booking screening rooms, we'd often stack a second film. Sometimes we'd cut right to the last reel. Don't tell me you've never fast-forwarded through a tape and still felt confident about your judgment of the movie!

My powers were limited to recommending the film or passing on it; I couldn't say, "Yes! Let's do a deal!" I'd have to go back and make my case in-house, which would involve either showing the movie to the staff and trying to build a consensus before bringing it to the bosses, or going right to Harvey Weinstein and saying, "You really should spend an hour and forty minutes looking at this movie." Not that you want to lay your career on the line every time you recommend a movie. Sometimes you bring an audience to help bolster your opinion before you go too far up the chain of command.

I always thought that raising people's expectations only to blow them out of the water later was worse than being candid with them. You do want to generate enough excitement so they don't turn around and sell the movie to someone else, yet you don't want to mislead people. There are different types of blow-offs. One is, "Hey, recut your movie, play it at some festivals, and if the response is favorable we'll consider." That really does mean you're interested, just not enough to be overly involved at that stage. It's only when the movie is really awful or the producer's an annoyance that you let them go completely. If the producer is a pain, do you want him or her bugging you for the next sixty weeks?

The whole idea of acquisitions seems to be that a movie's mystique is highest until it has been screened. When you're at a festival, it doesn't take a genius to spot the hot film. Usually the dollar will dictate who gets the movie—and then the marketing people have their chance to fuck the whole thing up.

Miramax has caught flak for cutting movies, but there's another side to that. Filmmakers get so immersed or in love with their footage—sometimes they need an outsider to say, "This character doesn't come through," or "This scene doesn't work." Smart filmmakers work *with* you. On *Clerks,* I introduced Kevin Smith to Harvey Weinstein at Sundance, and he was, like: "It's an honor to meet you, Mr. Weinstein. I've seen my movie four times with an audience here, we've been taking notes, and I know the ten minutes I'd welcome the chance to remove." Of course, we pushed him to remove, like thirteen and a half minutes, but it was nothing that the movie suffered for. Sometimes it's a matter of: "Do we keep the scene because there's one joke that has a payoff?"

No one wants to pull the card of "We'll only release this movie in Topeka." You don't *want* to threaten that stuff. Unfortunately, it's the first-time filmmakers who have struggled the most who are the most stubborn. It's the professionals, the people who've done a bunch of movies, who seem to understand that it's a collaborative process. I've had a firm feeling that movies all find their proper place. Between the market forces, independent reps, and festivals, films do kind of find their audience. It's rare that stuff that deserves to be seen slips by.

To whip up excitement, some producers choose to hold two screenings only, one on each coast; invite the distributors; and then stand back as (this is the hope) they bid against one another like fiends. The producers of *Sling Blade* held two screenings and fielded only one offer. It came from Miramax, however, which threw its resources behind an unprecedented Academy Awards campaign that brought fame and fortune to all involved.

I know of another movie that fielded a bid from a small distributor of *three million dollars sight unseen,* simply on the basis of its script and cast. The producer turned it down (perhaps fantasizing that a bidding war was about to begin), held simultaneous East and West Coast screenings, and watched in horror as the picture was all but laughed off the screen. Amazingly, the first distributor still agreed to buy it, but for a fraction of its initial offer.

With *Swoon,* we had a modest offer before the Sundance Festival from Fine Line, and had to ask ourselves: Do we take the film to Sundance and hope that people start bidding against each other, or do we sell it now at lower-than-bidding-war prices? We chose the safer route because we wanted a distributor behind us at the festival, and because *Swoon* was such an unusual picture—there was no way

On *Swoon*, we took an offer before Sundance.

to predict how it would be received. Part of you always wants to go for broke. But there are so many stories of producers who decided to hold out and lost a sure deal, watching helplessly as their movies sank into obscurity. Sometimes, people *stop* being excited once they see the film in a public context.

That happened to the producers of a recent movie, who turned down an offer from a small distributor in hopes of dazzling the ski-bum executives at Sundance. None of those executives jumped, and the small distributor, feeling slighted, declined to renew its offer. What to conclude? That a distributor in the hand is worth ten on the slopes.

I don't malign the producers of that movie because I've been there myself. Selling *Stonewall* was an especially harrowing experience, and since the director had just succumbed to AIDS, it seemed especially vital to get the film out in his memory. We fielded a so-so offer from a big distributor, which said it would only be on the table for twenty-four hours. As no one else had seen the movie, we (nervously) turned it down.

Stonewall didn't get accepted into the Cannes Film Festival. In-

stead, it was shown at the Cannes market, which meant it wasn't screened for a festival audience but a tougher industry one. Those industry audiences aren't there to judge the merits of your *mise-en-scène*, only whether or not they think they can make money off it. So they're often dour. And as soon as they realize that your film's not for them, they walk.

Stonewall went over okay at the Cannes market. Some foreigners bought it right away, but no North American distributor was especially attentive. Executives at one company led me to believe that they were going to take it, but when I got back from Cannes and hadn't heard a word, I started to get that queasy feeling. Sure enough, they called to say, "We're passing." I slammed down the phone; thought, "Who the hell is going to buy this film?"; and promptly dialed the Patric Walker horoscope (just before he died of salmonella poisoning). My girlfriend came home and I shushed her, because you can keep pressing buttons and getting more and more and more information. Walker explained: "You're going to get bad news, but it will all work out." He was right. We ended up selling *Stonewall* to Strand, a small distributor that couldn't afford to pay much. But it got a decent release, and the film made more than many art-house pictures do. So it did all work out (for me if not for Patric Walker), and it gave a shot in the arm to a company that deserved it.

MARCUS HU
Strand Releasing

I guess it's fair to say that we distribute "niche" movies. Like a lot of distributors, we started out by taking what was left over from the festivals after the feeding frenzy. But we've been very fortunate in being able to get some great films that way—*Wild Reeds*, for example, and *Stonewall*, which other people bid on but which we *really* pursued. We also had the idea of re-releasing older movies that a new generation would want to experience in the theater, like Jean-Luc Godard's *Contempt* and *The Graduate*.

I saw *Stonewall* in Cannes in 1995, at a 10 P.M. screening. I think the screening time was one of the major reasons that reaction to the movie wasn't sensational. At late screenings people have just eaten dinner, and they're extremely tired from a full day of looking at stuff in the market

and/or the festival. People were exhausted. So we got *Stonewall*, and it was our widest release ever—46 prints, with a platform release beginning in San Francisco, New York, and Los Angeles. We marketed it principally to gay audiences—we tried to make an event picture. It was the closing-night presentation at the San Francisco Lesbian and Gay Film Festival, and we also timed it with the parade. The film did extremely well on the gay-festival circuit—although not commercially, since I think more and more gay people are gravitating to light-hearted films. Anyway, *Stonewall* was still extraordinarily profitable.

After the acquisitions, the next thing that companies like Strand have to focus on is building and maintaining relationships with exhibitors. We like to tell filmmakers that our motto is: "We suck so you don't have to." With exhibitors, you can make all kinds of deals: "If you play this picture next month, we promise that a few months down the line we'll award you these two other pictures." At the same time, you don't want to alienate the competing theaters, so you try to spread the wealth around.

Above all, theater owners want you to guarantee that you're going to spend a certain amount of money on advertising. One of the conditions for booking *Contempt* at the Castro in San Francisco, for example, was that we take out larger ads in the San Francisco *Chronicle* and that our publicist push a previously published essay from the *New York Times*. Cities like San Francisco—and New York—pay a lot of attention to critics. The one city where *Ulee's Gold* bombed was San Francisco, where the *Chronicle* critic said it was slow and horribly acted.

Postcards from America played the New York Film Festival, and the *Times* review was particularly terrible. So what do you do? First, let me say: I loved that movie. When I first saw it I was glowing. I know it has flaws, but it's *so* passionately made. My partner, Jon Gerrans, said: "There is no way we can take this picture without losing on it." But the rule at our company is that if one of us is adamant, we can have it. He said, "Okay, if you really take care of this picture, you can do it." That's how we got *Postcards*. We already knew that certain critics wouldn't like it. So we took countermeasures: We went to the gay press. We ran a provocative ad campaign featuring a bare-chested James Lyons—selling it at the most base level you can sell a picture. But I thought it was worth doing that, because I really cared about that movie. It was hit-or-miss. In San Francisco, we got good reviews and the film grossed nicely. And once the ancillary cable and video money came in, we managed to get into the black, so the story has a happy ending.

One last thing independent filmmakers need to think about—with re-

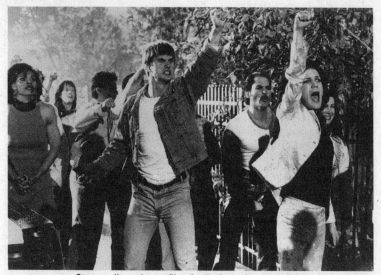

Stonewall used gay film festivals to its advantage.

gard to distributors—when they're shooting is stills. *Good stills.* They're
the main sales tool. And when we have to reassemble a cast for a photo
shoot it's a big pain, because by then the actors might be elsewhere and
they might all look different. So filmmakers need to think about that, or
they will really pay on the other end.

We had a more unusual experience with *Kiss Me, Guido*, which
had a solid screening at Sundance but was deemed "too mainstream"
by most of the independent distributors. The coproducer, Ira
Deutchman, and I were perplexed, but then we thought, "Let's see
if it *is* mainstream," and took it to the studios. Paramount picked
up our little million-dollar film and released it to decent business in
the months between *Face/Off* and *Titanic*.

Another possibility when hunting for a distributor is to work with
sales representatives, whose job it is to predict which distributors
will be interested in your type of movie. Different reps sell different
kinds of films. They work for a percentage of whatever the distribu-
tor pays, and their only drawback (if you choose to think of this as
a drawback) is that they can be quite money-oriented, and will some-
times push you to hold out for a bigger distributor when you have
a modest offer from a small, possibly more appropriate, one. Some-

times, if they have a film that a distributor wants badly, they put together a package deal: "We'll sell you Film A," they tell the distributor, "but only if you also buy Film B and Film C." If you're B or C, you get a free ride—although the distributor might not make you its highest priority.

If you're in a situation where only one distributor bites, when do you say yes? Not right away: Distributors can smell fear, and indie orphans with desperate producers clue them in to a fire sale. Learn what you can about the distributor, especially its record with films similar to yours.

Usually, the distributor offers you an advance against the movie's profits (assuming there are profits). Once you sign, you receive, say, $50,000, which means you won't see any more money until the distributor has recouped whatever it has spent plus your advance. Subsequent profits are divided by an agreed-upon percentage—sometimes fifty-fifty, sometimes less (for you). It's really in the distributor's interest never to show a profit—to say, "Well, we're still paying for the prints and advertising." Be prepared for cross-collateralization, which allows the distributor to use profits from TV, cable, and video sales to offset any losses on the theatrical release. The bottom line is that it's pretty hard to make serious money on the back end—even on movies that make hundreds of millions of dollars. Just ask the producers of *Forrest Gump*.

I Shot Andy Warhol had one of the more frustrating releases. American Playhouse, which produced it, was crumbling, and the Samuel Goldwyn Company, which was supposed to distribute it, was also falling apart. Goldwyn had sold the video rights to their films as part of a package deal to Hallmark, so they told us we could only sell the theatrical rights to *Warhol*. Well, it turns out that no one wants theatrical without video. While all this was happening, the film got a fantastic review in *Variety* and was a hit at Sundance, where it won an award. Everything was working out—and everything was falling apart. At the end of the day, Goldwyn was bought by Orion, which released the movie, and it did okay—it didn't lose money, though on the other hand, it didn't cost much—and it launched its director, Mary Harron. But it didn't have anything behind it. The studio didn't even mount an Oscar campaign for Lili Taylor, whose performance was remarkable.

Still, any release is better than none. There are two things on the agenda of an independent producer: pay back the investors, and get

the film into the hands of the best qualified people—who aren't always able to put up as much money, but will do a better job of marketing it to the right audience. Hire a lawyer to comb through your contract, and be prepared to cajole, bully, and persuade your distriibutor into the most passionate release possible.

This is the picture that inspired the poster.

If your film isn't feature-length, there are a limited number of entities that will distribute or exhibit it. One possibility is to package it with similar movies. Strand Releasing has put together extremely successful programs of gay short films called *Boys Life* and *Boys Life 2*. If your movie has something that ties it to a particular community—be it gay, black, Latino, etc.—it has a good chance of finding a place on a well-entrenched circuit, which might include festivals in smaller cities and towns.

If your goal is simply to sell your movie to television, the process is relatively straightforward. Depending on what it's about, a limited number of stations will be interested, and you can narrow that list down by finding out who's willing to see a tape. (In the case of TV, obviously, it behooves you to send a videotape.) It's a good idea to call and find out the procedure, because you're apt to hear something like: "We look at unsolicited stuff the first Thursday of the month," or "We've filled our schedule for the year; we take submissions again in August," or "We've spent all our money. Sorry." Find out—so your film doesn't just become part of a pile.

In rare cases, filmmakers decide to cut out the middleman and distribute their movies themselves. This is not a course to be embarked on nonchalantly, since it means starting from scratch with

scores of potential exhibitors (each of whom can demand a separate arrangement), and getting a crash course in a business that takes people years to learn. The upside is that you get to keep a hundred percent of what you make. The 1992 documentary *Brother's Keeper* is one of the more notable self-distribution success stories. It premiered at the Sundance Film Festival and generated some heat, but the sums offered were not what the producer-directors, Joe Berlinger and Bruce Sinofski, had in mind. Ultimately, *Brother's Keeper* did well for them, but for two years, distributing that movie was all those guys did.

Festivals and Markets

When I showed my diaries of film festival life to an associate, he complained, "All that happens in them is you go to parties and get drunk." I responded, "Don't you understand? That's what you *do* at festivals." That, and schmooze, and show your film to audiences that generally *want* to like it, and hold press conferences at which people ask questions like, "What was the budget?" The only time it's different is when you go into a festival without a distributor. In that case, your life revolves around the acquisitions people, who are now in their element.

JAMES SCHAMUS,
co-chair, GOOD MACHINE, INC.

Sundance is the most commercial film festival on earth. There is no discourse about film, even independent film, in a public fashion, in the halls of the festival, on panels, that is not about the following: "You made it for *this* little and you sold it for *that* much?" That's really what Sundance from its inception was about, although, obviously, there was once a kind of Ralph Laurenish Western individualist ruggedness about the Sundance image that was supposed to rub off on the filmmakers.

A film like *Poison* or *Swoon* could do well at Sundance in the late '80s and the early '90s because there was still a kind of apparatchik, NEA, public fundy, alternative discourse that was in its own way very careerist. It was tied into the Whitney program, where you could turn pieces of crap tissue paper into million-dollar art or, less lucratively, video art, which would at least get you teaching gigs. Within that context, there was some fantastic work being done, just as in the context of Soviet

realism there was great painting, and in the context of Hollywood filth, greed, and corruption there are great movies being made.

The other space that was competing for ascendancy at that time was created mainly by European television, which was itself a publicly-funded thing. American Playhouse combined those two cultures: It was a bridge between the international marketplace and NEA apparatchik culture. A good chunk of the first wave of Sundance winners were American Playhouse-inspired or partially funded. The ideology was replicating Canadian National Cinema, which was itself television and government financed, and was embodied by noble farmers struggling against both the elements and American imperialism. These were faintly anticapitalist-world-order gestures.

Now, with the loss of so much public funding, you have producers like Christine Vachon and me: post-late-capitalist entrepreneurs who aren't thrilled about capitalism and how wonderful it is but who are nonetheless taking tried and true small business practices and grafting them onto counterculture or subcultural modes of expression—puttinig those two things together and getting them into the "marketplace of ideas." The purchase price for speech different from mainstream speech is still handled in hard U.S. currency, and that's still the system that we're working in right now.

I think the work out there is as interesting and the audience for it is as big as ever. Look at Todd Solondz's movie. That script is unbelievable. It's one of those things that you read and think, "Holy shit, I can help make this!" At the same time, you're saying, "Five million world sales"— so it's business as usual. But this is business as usual? Even *The Ice Storm*, which opened the New York Film Festival and had a wide commercial release—I still think, "Goddamn! They let us make it!"

A film festival can lead to a sale, or it can discourage a sale. Examples of each outcome abound. But festivals generally help more than they hurt, and there's nothing quite like the thrill of being discovered by press and fans and other filmmakers at the same exhilarating moment.

That happened to Ted Hope and James Schamus in 1993, when their fledgling company, Good Machine, was desperately trying to sell Ang Lee's *The Wedding Banquet* (cowritten by James), a micro-budget American comedy with a gay theme in which most of the dialogue was in Chinese. "When we showed it to sales agents, they said it had no commercial potential," says Ted. "We became con-

vinced it was unsellable. We would have taken ten thousand dollars
for a U.S. release! We had two thousand in our bank account, and
we thought, 'We can either keep the company open for another
month and pay our two employees' salaries, or close the office and
use that money to fly to the Berlin Film Festival and try to sell it
ourselves.' So we went to Berlin and did *three million dollars worth
of sales* and it was, you know, *heaven.* I mean, we knew we'd have
a company for at least the next couple of years." (*The Wedding
Banquet* went on, according to *Variety*, to become, percentagewise,
the most profitable film of 1993, earning *four thousand percent* on
its investment.)

Festivals give you two potentially priceless tools for selling a film:
critics and audiences. The trick is to find out which critics are
thumbs-up so that you can report any positive reviews to potential
buyers. If the *New York Times* reviewer chases your director out of
the screening room—which is what happened with *I Shot Andy
Warhol*—you should make sure that the right people hear about it.
Many (not all) critics will tell your publicist, or you, if you're acting
as your own publicist, what they think—information that you can
selectively pass along. You should also pass along things like: "The
LA Times critic was doubled over with laughter at the screening!"
Or, "I'm surprised how many women are responding to this movie!"
Every film has its own angles, and you need to work each one
of them.

Don't turn your nose up at festival hucksterism—it's an art. If
you believe in your movie and want people to see it, you have to
be prepared to thump the tub. *Poison* was accepted at Sundance,
but it wasn't a film that many people knew about. No one knew
who we were. We didn't have money for a poster, and a lot of
movies arrived with custom-made T-shirts and caps. What to do? I
went to a pharmacy and bought a roll of orange stickers that said
"POISON" with a little skull and crossbones—a thousand for only ten
bucks. We took the stickers to Utah, and started putting them on
people's ID badges. Then it became cool to have a "POISON" sticker
on your badge. It was the perfect low-budget—but completely dis-
tinctive—marketing idea. So much so that the following year, *every-
one* had stickers.

In January 1988, when the festival was less than five years old, Sun-
dance put *Superstar* on the map. Todd Haynes' maiden featurette got
lots of attention from the press, and from directors such as John Wa-

Go Fish was a real hit at Sundance.

ters. Park City was relatively peaceful and uncrowded, so you could be there with a short film and still feel as if you were part of the festival. There wasn't as much weight put on the prizes. For a few years, serious movies like *Poison* and *Swoon* played as well or better than lighter fare. Now, I think comedies go over bigger. It's not that the Sundance aesthetic is changing; it's that the people who go there have changed. Sundance is in some ways the victim of its own success, and many independent filmmakers think the party's over, spoiled by the swarms of Hollywood types looking for the next *sex, lies, and videotape*. And it *has* become something of a cartoon: cell-phones ringing during screenings; predatory agents running up and down the hill; hundreds of executives and filmmakers on the make.

Has Sundance transformed the nature of independent filmmaking? Not single-handedly, although it has become a focus for marketing, and some people think that you're screwed if your movie doesn't make it in. It's true that you couldn't ask for a better leg up, especially if you don't have a distributor. But there are good films that don't get into Sundance and still do fine. *Daytrippers* didn't get in, and neither did *Swingers*.

Go Fish almost didn't get in—the selection committee dragged its feet for a few weeks before saying yes. But the film turned into one of the festival's big success stories. I didn't arrive until after the sale; I was in California producing *Safe* under arduous conditions (a

tiny budget, an inexperienced crew, a major earthquake). John Pierson, the producer's rep who provided the movie with its much-needed finishing funds, describes his "skillful orchestration of the *Go Fish* sale" in his book *Spike, Mike, Slackers & Dykes*. In the weeks before, he had written to distributors suggesting that *"Go Fish* just might become for the lesbian audience what *She's Gotta Have It* was for the black audience." (Pierson had also supplied finishing funds to Spike Lee's first feature.) Then he refused to show it to anyone before Sundance. Moments after its premiere, Pierson writes, he was negotiating with representatives from the Samuel Goldwyn Company at a pizza parlor next to the theater: "It was the first film ever sold during the festival," he crows. *Go Fish* went on to an ecstatic premiere at San Francisco's Gay and Lesbian Festival, before opening sensationally in major cities across the United States.

To which other festivals should you pay attention? The New York Film Festival, which is the showcase of the Film Society of Lincoln Center, is the most selective and the toniest, regarding each acceptance—perhaps justifiably—as a momentous event in the life of its makers. In recent years, it has become less stuffy, and it programs a gratifyingly broad range of works, including shorts, documentaries, and restored or rediscovered oldies. The only thing to consider with the NYFF is that it means an automatic review in the *New York Times*—which, if it's bad, can sour a film's prospects.

If your chief concern is finding a distributor, your festival options are limited. Certainly there are cities where your film will be greatly *appreciated*. Gay and lesbian festivals in places such as Rochester, New York, and Charlotte, North Carolina, are vital outlets for gay indie filmmakers. And small, regional festivals will afford the only opportunity for locals to see your movie on a big screen. Regional newspaper reviews can also attract attention, although San Francisco and Boston and Seattle are not where distributors reliably go to look for new product. Even if a critic writes, "This is the best thing in the festival!," Manhattan and LA-based distributors might never know. If a tree falls in the forest, and the *New York Times*, the *LA Times*, and *Daily Variety* don't report it . . .

FESTIVALS VERSUS MARKETS . . .

A distinction needs to be made between festivals and markets. The latter exist purely and simply for the buying and selling titles.

Many markets are attached to festivals but function independently. At Cannes, the market takes place in a huge bunker under the Palais du Cinema, where the festival is just a rumor. Sales agents run the booths, each with its own distinct wares. The guy selling Korean action pictures is not likely to feature American independents, or vice versa. Ninety percent of the titles are probably slasher or porn, and not all have finished films (or even scripts) attached. In the eighties, one ambitious exploitation company was known for marketing movies to distributors on the basis of jazzy titles and lurid posters. The problem was that then they had to make the films, most of which were godawful, and some of which they couldn't even afford to produce.

Where else do distributors go to buy? The big combination international festivals and markets are in Cannes (spring), Venice (summer), and Berlin (winter). Right after Cannes, the American Film Market (no festival) takes place in Los Angeles. Telluride (August) and Toronto (September) don't have formal markets, but people go to both to buy movies. (The latter, in particular, is a real schmooze-athon.) Distributors also show up at the Hamptons Film Festival, which is close to New York City and happens in the early autumn—a particularly lovely time to be at the beach.

The Independent Feature Project, which serves as a sort of clearinghouse for unaffiliated filmmakers, holds an Independent Feature Film Market in New York every year. The IFP is a wonderful resource: The magazines and booklets that it publishes with lists of festivals and deadlines and contact numbers are indispensable, and its Web site is extensive. But I'm uncomfortable with its market, at which anyone who can pay the fee can exhibit a film. It depresses me to see kids with inflated expectations spend everything they have to travel to New York with some tiny movie that no one will ever buy. The IFFM charges a hefty amount of money to submit a film, and once it starts there are so many people competing for attention and stuffing producers' and distributors' mailboxes with flyers and invitations that pretty soon no one goes near their mailboxes. It was at the IFFM that I first thought: "Maybe we've demystified this process too much."

One solution would be to structure the market so that it's more selective, so that there are one hundred movies instead of four hundred. It would also help if filmmakers had a more realistic attitude about what the market can and can't do for them. The whole allure of indie films right now has more to do with striking it rich than with making the best movie possible. For every film that some *Vil-*

The ads for *Stonewall* played up its appeal to a gay audience.

lage Voice writer deigns to say has promise, there are a hundred that no one shows up to watch.

Gearing Up for Release: Your Distributor and You

Christine Vachon: We don't use cards or questionnaires.
Lawrence Gordon: You don't use a testing service? Do
 you test awareness? Tracking?
Vachon: No.
Gordon: You really should stay out of the studio system.
 You won't like it at all.
Vachon: Well, they're not asking me.

—from a conversation between me and Lawrence Gordon, producer
of *Waterworld* and other hundred-plus-million-dollar movies, in the
New York Times

Once you have landed a distributor, you'll find you've barely re-
covered from the postcelebration hangover before new headaches

emerge. You and the distributor are now on the same team, which is when the fighting generally begins. The first question: Who has final cut?

If a distributor finances your film, you'll have worked out the issue of final cut way in advance. Remember, though, that even if a film-maker has final cut, distributors will still protect themselves from having to release a four-hour movie or one saddled with an NC-17 rating. An "R" rating is often contractual, as is length (usually 120 minutes or less). A distributor can therefore require a filmmaker who has "final cut" to cut for length or sexual content—they simply won't accept delivery if the movie is over, say, two hours. That doesn't mean that they won't ask for other changes, but they'll have to use a different kind of leverage. They might say, "If you don't make the cuts we want, we'll give your film a small and pitiful release." A director with a brain in his or her head should at least *listen* to the company that's going to be out there selling the movie.

In between a producer or director with final cut and a distributor that can dictate changes there are infinite shades of gray. In the event that all parties are at loggerheads, the distributor might agree to use a trusted third party as a tie-breaker. The tie-breaker on *Kids* was Gus Van Sant, the executive producer. Gus never had to dis-charge that particular function (tie-breakers rarely do), but the fi-nanciers felt better for his existence.

Test screenings, as discussed in the last chapter, can be extremely helpful after you finish your rough cut, especially if you organize and run them yourself. When the distributors move in with their testing services, however, the process is altogether more terrifying.

For *Office Killer*, Miramax held a test in its Tribeca screening room. When it began, my coproducers and I fled downstairs, to the bar of the Tribeca Grill, where we got anxiously drunk. Afterwards, the audience seemed upbeat. Some people opted to stick around and serve as a focus group, going over the film in detail with a professional focus-group manager. They liked the movie and seemed to agree on its weak points, most of which we were already dealing with. The co-executive producer, James Schamus, and I sat together, and as each complaint was aired we whispered to each other: "Yeah! We're covering that in the voiceover!" and so on. By the end, we were beaming.

But the Miramax executive wasn't. He had tabulated the scores on the questionnaires and wasn't happy: Below Average. We said,

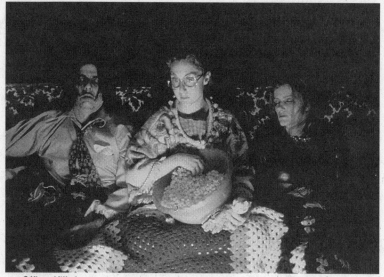

Office Killer's test screenings convinced us but not, unfortunately, the distributors.

"Yeah, *but*! We're fixing everything they complained about! They liked lots of things!" It didn't seem to matter. He called the next day and said that if the scores didn't go up, Miramax would release the film straight to video. I thought: "If we tested all my movies this way, they'd probably all go straight to video." Ultimately, Miramax kept the video rights and we gave the movie to Strand for a limited theatrical release.

Test screenings are also frequently done by distributors to get a sense of the best *way* in which to market a film. An audience might respond much more to one character than another. Or young women might love the movie and middle-aged men hate it. Test screenings help the distributor to *find* the audience.

The following is a standard questionnaire, which the distributor used for test screenings of Todd Solondz's film.

UNTITLED

1. How would you rate this movie overall?
 ___Excellent ___Very Good ___Good ___Fair ___Poor

2. Would you recommend this movie to your friends?
 ___Definitely ___Probably ___Probably Not ___Definitely Not

3. How would you describe this movie to your friends?

4. What did you like *most* about this mvie?

5. What did you like *least* about this movie?

6. What, if anything, did you find confusing about the movie?

7. How did you feel about the length of the movie?
 ___Too Long ___Just Right ___Too Short

7A. If you found the film too long or too short, please tell us where
 you found this to be the case:

8. What was your favorite scene?

9. What was your least favorite scene?

10. Were you satisfied by the ending?
 If not, why?

11. How did you feel about the pacing of the movie?
 ___Just Right ___Too Fast ___Too Slow ___Uneven

12. Do you think the film was funny?
 If so, what did you find funny?

13. Did you think the film was depressing?

14. How would you rate the following performances?

	EXCELLENT	VERY GOOD	GOOD	FAIR	POOR
a.) Dylan Baker (Bill)	()	()	()	()	()
b.) Cynthia Stevenson (Trish)	()	()	()	()	()

	EXCELLENT	VERY GOOD	GOOD	FAIR	POOR
c.) Rufus Read (Billy)	()	()	()	()	()
d.) Philip Hoffman (Allen)	()	()	()	()	()
e.) Camryn Manheim (Kristina)	()	()	()	()	()
f.) Lara Flynn Boyle (Helen)	()	()	()	()	()
g.) Jane Adams (Joy)	()	()	()	()	()
h.) Ben Gazzara (Lenny)	()	()	()	()	()
i.) Louise Lasser (Mona)	()	()	()	()	()

15. What characters would you like to see more of?

16. What characters would you like to see less of?

17. Who do you think would be most interested in this movie?

Men	()	Under 25	()
Women	()	25–29 yr. old	()
Both Equally	()	30–34 yr. old	()
		35–39 yr. old	()
		40 or older	()

Please check one:
Male ()
Female ()

Age: _____

18. Please list a few of the movies that you have seen recently that you have enjoyed:

On *Safe*, the distributor, Sony Classics, desperately wanted us to make a small change, and we debated the issue for a long time. In

the film, when Carol (Julianne Moore) and her husband (Xander Berkeley) are walking on the grounds of Wrenwood, the institute where she has gone for treatment of her mysterious "illness," she points to the house of the director, Peter (Peter Friedman), on the hill. When we screened *Safe* at Sundance, we didn't show Peter's house, only the couple's faces looking up. Todd Haynes felt that the house we'd actually shot was wildly over-the-top; he thought we were tipping our hand about how skeptical we were about this New Age guru with his expensive mansion. And every time we'd done a screening with the shot of that manse included, it brought the house down. The shot was a release for all the nervous tension that had been building up in the previous ninety minutes: "At last," the audience thought, "we're being told what to think."

Executives at Sony asked us to put that shot back in, and Todd was quite torn up about it. "I wish we could redo it," he said, "and find a house that wasn't so ostentatious." But there wasn't any time. The distributor, meanwhile, wasn't making threats. All they said was: *"We'd really like you to put the shot back in. It would make our job a little easier."*

So, after a lot of consideration, Todd acquiesced.

THE RATINGS BOARD

The movies I produce don't tend to have much violence, but as far as the ratings board is concerned, they might as well go straight to the grindhouses. Even the intimation of sex throws up more red flags than scores of severed limbs. Homosexual relations are always inflammatory, especially between two males. (Heterosexual men are not uncomfortable watching two women together; just the opposite.) *Swoon* is pretty chaste, but there's a scene at the beginning where the protagonists (Leopold and Loeb) are in their underwear and one climbs suggestively over the other. *Very* briefly. The ratings board gave it an NC-17, *for that scene*. I was furious—especially when I saw *Basic Instinct* the same year and the view up Sharon Stone's skirt left nothing to the imagination. Sharon's private parts plus graphic bondage-and-ice-pick slaughter and that was still a film you could take your kids to see.

Some producers insist that big-budget studio movies are cut more slack than indies, and doubtless that's true. But there's more to it than that. American culture still betrays its Puritan origins. *Kids* is

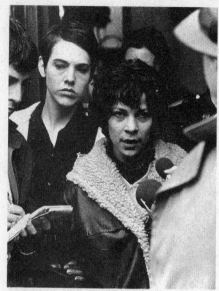

Lili got so into the role that she seemed to channel Valerie; compare this photo to the one on page 84.

unrated with no homosexuality and no genitalia—the ratings board just found the *idea* of it so offensive. You can get a PG-13 if your film has the "f-word," but not if the "f-word" is used in a "sexual" context. When Albert Brooks got a restricted rating for *Lost in America*, he pointed out that the board will give you an "R" if a character says, "I want to fuck you over this desk," but a PG-13 if he says, "I want to fuck you over *with* this desk." Exactly *what* are minors being protected from?

In an ideal world, an NC-17 rating wouldn't give you a moment's pause—there should be nothing wrong with a cinema exclusively for adults. The problem, of course, is that certain national video chains won't carry NC-17 movies, and if you can't get your film into them, you're screwed. You can sometimes get around this problem by preparing special R-rated versions for the video chains, which we had to do with *Poison*. But no director enjoys eviscerating his or her own work. And no producer enjoys telling them that they have to.

If you have a distributor from the beginning, they will often give you a list of "cover shots"—tamer renditions, in case there are problems with the MPAA. "Cover for excessive blood and violence" or "cover for nudity" is what you'll read. That means in your second rendition of the shot, the woman who gets out of bed wears a tiny nightie instead of nothing at all. They'll also ask for cover dialogue. We never intended for *I Shot Andy Warhol* to play free TV, but the distributor asked for a long list of substitute words: "Shoot" for "shit," along with standard cover epithets like "Freak off you freakin' freak!" At one point in the film, Valerie (Lili Taylor) is raving about how long a publisher is taking with her manuscript, and Fred

Hughes (Craig Chester) says: "Why don't you just give him a blow-job?" Someone at Goldwyn proposed a cover line that went: "Why don't you just give him a foot massage?"

We decided not to shoot a TV version of *I Shot Andy Warhol*.

Cover shots are a pain, but they can give you freedom down the line. If you know that a particular scene is on the edge, you can shoot it two ways and then pull out the tamer version as a last resort. It's better than having to butcher the existing version.

You never know, though. In *Happiness*, the audience doesn't actually see the main character molesting little boys, but the implication is clear. If the ratings board decides that the implication by itself is NC-17 material, I don't know what we'd cut. We'd end up with a half-hour movie.

Marketing

If you have a distributor, you hand off the movie for marketing. Distributors typically say: "Leave it to us. We know what gets the butts into the seats." Sometimes, if it's a niche movie and you know the niche better than they do, they'll ask you for guidance. When we sat down with executives at Goldwyn to discuss *Go Fish*, their first question was: "Uh, which cities have a lot of lesbians?" Smaller arthouse distributors tend to be director-driven and consult the filmmakers more often on marketing, because they can't afford huge ads and are dependent on newspaper features, interviews, and reviews.

The next step is choosing a strong image that represents the movie. With luck, that's an image from the film itself—if you were smart enough to have a stills photographer on set while shooting. If you weren't, you can always take something from the negative or stage a reshoot. Whatever image you use, it should be compelling and provocative and appeal to the desired audience. Who that audience will be isn't always clear-cut. The distributor of one worthy film about unwed teenage mothers made a tactical error by aiming its marketing at teenage girls. It turns out that teenage girls don't tend to want to see their lives depicted as they are. They want the romanticized version. They want *Titanic*.

The poster for *Safe* featured a shot of a man wearing a gas mask—a tiny figure surrounded by space and yet cowering, as if wary of being crushed. It's one of the most powerful images I've seen on a poster, and it perfectly captured the feel of the film, but it was

probably easier to understand after you had seen the movie. The video box, on the other hand, is a little too easy to understand. Sony Classics took an old glamour photo of Julianne Moore in spike heels and then airbrushed an oxygen tube into her nose. Todd hit the roof, but Sony said, "Trust us. This is how you sell video tapes." I guess it worked, because the movie shipped a lot of units.

When Todd Haynes, Barry Ellsworth, and I ran a small company, Apparatus, in the eighties, we didn't have a distributor. Nor did we have much money to promote our short films, or to hire publicists or conduct test screenings. We were artsy and not-for-profit, and we fancied ourselves above all that. But it *was* important that people see the movies. This was before the days of laptop computer ease, so we made posters with collages of photos from the films, copied them, and then put them up in the obvious places—coffeehouses, bars that were frequented by young bohemian types like ourselves, and theaters. We had a mailing list that was sent to general media, especially to those (few) writers who were interested in experimental filmmaking. If you showed your movie at a repertory house, you could use its mailing list, and sometimes it would even cover your costs. Alas, the Collective for Living Cinema—along with most other New York "calendar" houses—no longer exists.

Press clippings can make a company look more real, which is important if you're always scrounging for funds from private donors, arts agencies, and foundations. Katherine Dieckman wrote about us in *The Village Voice*, which didn't cause a surge in our box office, but did give us something impressive to mail out. You shouldn't overdo it with the clips, though. A pile of reviews from the *Toledo Community Shopper*—however well written—won't count for as much as one review from a paper perceived to matter.

If you're self-distributing your film and can't afford a publicist, you'll need to figure out what will make the movie pressworthy. It might be you, or the director who has made the movie against terrible odds. Or an actor. Or the subject matter. What's the hook?

Sometimes you can prevail upon a big publicist to work for less as an investment in your career. Our publicist on *Poison* was Jeff Hill, who at the time was young and hungry and working for a bigger agency. Ours was one of the first movies he did on his own. Today, he's a partner in that firm and has a soft spot for us. After all, we started out together.

What a firm like Jeff's does is look at the film, look at the media,

and tell you who you need to reach. "These are the magazines we're going to target," they'll say, "and these are the radio and TV shows." You should put in your own two cents, because they can't think of everything. "Don't forget that the film's about a dentist," you might say. "So try to get something in *Dentists Monthly* and *Hygienist's Life*."

Distributors think carefully about when to release. Do you want to go up against *Titanic*? Your film can get lost in the shuffle, or yours could be the one that everyone turns to in relief. Distributors tend to use film festivals as jumping off points, especially in the fall. It's no coincidence that such indie prestige films as *Boogie Nights* and *The Sweet Hereafter* premiered at the New York Film Festival in September and October. That means they're still very much in the minds of the critical societies that give prizes in December—prizes that have a strong influence on Academy Award voters.

If Miramax buys your movie in December and wants to open it in April, that doesn't leave much time to prepare. Your publicists might screen it immediately for the long-lead reviewers and the editors of glossy magazines. Then you'll get reports: "*Esquire* declined coverage, but *GQ* decided they want to run a picture of the lead actor." Pretty soon you'll start to hear what the critics think—which of them are supporters and which aren't. Some critics will be on the fence and can be worked on a bit.

As the opening approaches, it gets exciting, especially if the response is good. I'll call the director, or the director will call me, and we'll compare notes on the coverage. The director will say: "How about that stupid *New York Post* review?" And I'll say, "Oh, who cares?" I wouldn't say, "Yeah, that's going to cost us tons of viewers." I might think it, but I wouldn't say it.

RELEASE . . .

On opening day I always go to the theater and try to hear what people say when they exit—to get a sense of whether or not they liked it and, more importantly, if they are going to recommend it to their friends. What can you do with that knowledge? Not much. It's just to know. After all the work, there's something gratifying about watching people pay to see your movie. Not your pals, or the people who worked on the film, or the people at festivals, who were there as much for the celebratory atmosphere as for the movie. This is what it all comes down to: Will people put down money? I sometimes go for the first show at noon on a Friday, watching the first dollars come in; then I

go that night at eight to see if it's selling out. If you get good reviews from the major papers, and you're only in one or two theaters, and you're not selling out the Friday 8 P.M. show, you have cause to worry.

There's not a whole lot you can do, short of forcing people into the theater. You can't get a paper to review it again. If there's a drop in business, you can change the ads—take out bigger ones or feature a different actor. After the first couple of weeks of *I Shot Andy Warhol*'s release, when business was starting to drop off and Goldwyn wanted to regenerate interest, all the ad quotes focused on Lili Taylor's performance. Another week they decided that all the quotes would be about Stephen Dorff's performance—to make sure that people knew he was in the movie. As a moviegoer, I respond to ads that have one good quote after another: "Full of comic ingenuity!" "Fresh and funny and original." I think, "All those guys are saying that? Okay. I'll go."

When business drops off, the distributor must decide whether or not to pour more money into the film. Can more ads kindle more interest, or will this approach just be throwing good money after bad? It's hard to know. When a movie does badly, you can always blame the distributor. You can always say, "They didn't spend enough money." But if Sony had spent another $200,000 on *Safe*, would they have done an additional $200,000 worth of business? Unclear.

JAMES SCHAMUS
co-chair, GOOD MACHINE, INC.

Independents, structurally at least, are the victims of their own success. The minute that you have a film like *Pulp Fiction* or *Il Postino* or, to a smaller extent, *The Wedding Banquet* or *The Brothers McMullen*, you have a situation where initial capital investment in the films is relatively minor by studio standards, and yet the infrastructure that must be created and serviced has got to be pretty bulky.

That is to say, if you're going out eventually on two thousand screens with a modestly budgeted film, you have to go through a distribution entity that must maintain an overhead that starts to look and smell like a studio overhead—and it must act like a studio, both in terms of the way it deals with the disposition of rights and the way it conducts business with the talent community.

When in 1992 *Reservoir Dogs* moved from its intitial release in the twenty-screen range up to four or six hundred screens—which in those

days was a lot—it didn't make much money. But the point is, someone sat down and said: "If this is going to make any money at all it's going to have to get pushed out into the wider market quickly." And the infrastructure that was being pieced together would need, in order to maintain itself, another six-hundred-screen release the next month and another six-hundred-screen release the month after that. And it's going to need at least one one- to two-thousand-screen release a year that does pretty well: *The English Patient*, say, or *Scream*.

Rewind now ten years, when the reigning champions of the independent world were a management team running Orion Classics (and who have since moved over to Sony Classics). These folks took *Howard's End* and cycled a very few prints around the country in a very slow release pattern. *Howard's End* was a film that played on particular screens for upwards of *sixty weeks*. It grossed twenty million, of which a huge amount went back to the distribution company because the prints and advertising coasts were extremely low—because they'd go into one market, find an art-house screen, and *lock*. Nowadays, that same film would probably have to go out and—even in a small platform release—be in the top forty markets within five weeks and in two hundred to six hundred theaters shortly thereafter. The distributor would hope to be able to cull fifteen to twenty million because the movie would probably get thrown off screens relatively quickly.

The cost of doing that kind of business—as opposed to the old *Howard's End* business—is *phenomenally* higher. So the entire system has gotten to the point from a distribution angle where the stakes are enormous. You're really playing high-stakes poker up front. You have to have the stomach to look at the grosses from the very first weekend, the first Monday, a mere seventy-two hours after the thing has begun to do business, and decide: Am I going to throw another million or two million dollars into the pot to see if this thing will break? And if you don't have the stomach to make those kinds of decisions—or the capital to make those kinds of decisions—you're in the wrong business. And it's a very different business than what we used to call the independent film business.

Yes, I guess in some respects it's a tragedy, but it's the result of success. Like most tragedies, the opening act is the war hero coming back into town, the conqueror.

The big problem with theatrical exhibition now is that movies have to go in and perform right away, and if they don't—good-bye. A film isn't given a chance to build an audience. One statistic that

Ted Hope is fond of quoting is that Mike Leigh's *Life Is Sweet* did its best business in its eighth week. Word of mouth was good, and people were talking about it at dinner parties. Less than a decade later, a movie would never get to its eighth week unless it was doing gangbusters. I'm not saying that every film deserves a two-month trial run at a theater owner's expense, but more complex movies could use some room to breathe. *Safe* would never have been a blockbuster, but it might well have caught on. By the time people were starting to talk about the film, it was gone from the theaters.

The Press and the Critics

In 1997, when *The English Patient* won a bunch of Academy Awards, the press began to focus on the phenomenon of independent films, and to devote whole issues of magazines to independent filmmakers. I got called a lot. I even agreed to participate in a "dialogue" for the *New York Times Magazine* with Lawrence Gordon, a mega-budget Hollywood producer, to see what studio and indie producers had in common (more than you'd think). Independent films, we learned, were hip, new, etc. Only they're *not* new. It's just that the public eye has turned toward them after a few crossover hits—and it will turn away again.

Talking to the press is always tricky, because people in this business are *very* sensitive when it comes to what you say about them in print. This applies to books as well as articles. An approach that some might call "take-no-prisoners," I call "burn-your-bridges." I learned a lesson on *Poison*, when I mouthed off a lot in the face of the NEA controversy and the quotes sounded garish. Now I'm pretty cagey with the press—some might even say boring. My litany is: "It's great . . . everything's great . . . the studio's great . . . the actors are all great . . ." I tease my colleague, Tom Kalin, for never being able to keep his mouth shut. On the set of *I Shot Andy Warhol*, I gave my usual boring interview to a *New York* magazine writer, and then, later, overheard the following:

TOM: All the actors are competing because they want to wear more fabulous outfits than the others.
REPORTER: Oh really? Like, which actors?
TOM: Well, [NAME WITHHELD] was furious when [NAME WITHHELD] showed up wearing—
ME: Shut up! Just shut up!

Tom always realizes what he's said a second too late.

The best thing to do in the face of controversy is decide on a party line and never waver. When reporters quizzed me on whether the actors really drank beer and smoked pot in *Kids*, the distributor, Excalibur, didn't want me talking at all, hoping that without any quotes from people involved the whole thing would go away. But I decided—to protect my own image as much as anything—to speak directly and honestly, to say: "I'm sure they got loaded all the time—but not on my set." And Cary Woods told me afterwards that he thought it had defused some of the indignation.

In the chapters on development and financing, I discussed how important it is to have a filmmaker who can be a source of good copy, because that's when the issue first arises. The films I've produced are as uncompromised and challenging as anyone's, but I'm still concerned about marketability—about giving distributors something they can sell and someone they can use to sell it. It's important to train yourself, your director, and others to speak cogently about the work, because ambitious movies need "spinning" as much as ambitious politicians. Todd Haynes is great with the media. He's friendly, and he's articulate about his own process without being glib. On the other hand, I recall a screening I attended of an extremely gruesome and upsetting film, where, at the press conference afterwards, the director was asked some pretty basic questions about why he'd chosen such a "difficult" subject. He responded with shrugs and monosyllables and silence, and I found myself thinking: "You jerk. If you're going to make a movie on this kind of subject, you should at least be able to defend it." I know that's unfair, because a lot of filmmakers aren't especially left-brained. But if I—as a producer of controversial films—was feeling that kind of irritation, I can only imagine what the press was feeling.

CRITICS . . .

If you put your work out in public, you have to deal with the fact that some people will like it and some won't. Some critics won't get it, and some will write reviews that will be painful to read. I still get upset at bad reviews. More upset than I should. When critics I know write nasty reviews of my films, they're off my Christmas list *so* fast.

Todd has something which I think is important for a director: an absolute serenity about his work. He doesn't need confirmation from critics that a movie is good. *Safe* was savaged by many of them. When

we showed it at Sundance, people came out making noises of bewilderment; a few reviewers looked embarrassed when they saw me and murmured, "I don't know what to say." The next morning, *Variety* described the film as boring and pretentious. I was devastated. But Todd just said: "Oh, well. Not everyone's going to get it." Today, only a few years after its release, *Safe* has begun to acquire the kind of reputation that I thought would take decades. Two of those critics at Sundance who threw up their hands when they saw me ended up including the film—a year later, after they'd had a chance to let it percolate in their systems—on their Ten Best lists.

After the opening-night dinner for *Safe*, I walked a few blocks in a hard rain and read the *New York Times* review as I was standing at a newsstand. It wasn't bad. At least we got a pull-quote, something like "Eerily Evocative!" It's hard to underestimate the power of the *New York Times* to open a small movie. I was with a distribution executive the night his picture opened at the New York Film Festival. We were having dinner, and someone brought him the *Times* review, and he started to read it and his face dropped and he said: "*We're fucked.*" It wasn't that it was a savage review—it's just that it was casually dismissive, and that's enough to bury a little art movie when it's the *Times*. Actually, that film ended up making a small profit, but the distributor had to work hard and spend a lot of money to overcome the *Times* review—much of it going, ironically, for ads in the movie section of the *Times*.

The thing that most rankles me is when I read a scathing review of some tiny little movie that doesn't have a prayer anyway. I think: "You don't have to go to such lengths to crush a film that's so far down on the totem pole." Of course, I know critics who'd respond, "That's easy for you to say. You don't have to sit through all the horrible independent pictures I do, made by people who shouldn't be let within a mile of a movie camera." And I don't—although I don't get paid to, either.

I also get angry when reviewers make mistakes. One critic went on and on about the leading man's "fake Southern accent" in *Stonewall*. Except the actor grew up in New Orleans and was speaking the way that he normally spoke. You shouldn't harangue critics for not liking your movie, but if they screw up something like that, you have a right to call and bust their chops, especially if you know them. Otherwise, it's best to keep your distance.

CHAPTER 10

THE NEXT MOVIE

In the early eighties, following the commercial success of such films as *Parting Glances, Stranger Than Paradise,* and *My Beautiful Laundrette,* people began to rhapsodize about a new kind of moviemaking—a genuine alternative to the studio-processed schlock that had become even more flagrant with the rise of entertainment conglomerates. Here were movies that didn't need to gross fifty or a hundred million dollars to justify the leading actor's salary or the studio's massive overhead. Here were movies that could find a small sliver of an audience and still manage to earn their money back, launch careers, and—oh yes—enrich the culture.

A lot of the distributors that profited from those films developed grand designs, began to produce their own features for less-than-frugal sums, and went belly-up. The press pronounced the independent movement dead, or, at least, drained of blood; government money grew scarce; and many important exhibitors closed up shop,

fatally weakened by the one-two punch of funding cuts and the rise of home video.

Then came *Pulp Fiction, Shine, Sling Blade, Welcome to the Dollhouse,* and *The English Patient,* and the movement was reborn—although it was different in important ways from what had preceded it. Suddenly, independent distributors were selling themselves to major studios, content to serve as art-house divisions, and, in some cases, to abandon the kinds of movies that had made them successful in the first place. (In the wake of *Pulp Fiction,* there were scores of dreadful Tarantino imitations, basically formulaic but cultivating an outlaw status, and most of them flopped.)

I'm waiting for the independent-film movement to be pronounced dead again—terminally coopted. But we've been down this road before. Pretty soon, a movie will come along for an audience that no studio had previously perceived; it will sell for lots of money at a festival, and kick off new careers and new genres; and, again, that phoenix will rise from those ashes. Once-marginal places like Sundance that have now become less marginal, even mainstream, will be replaced by others more marginal. (The Slamdance Festival already exists, and so does Slumdance.) As one underground becomes absorbed, another will form to take its place.

Meanwhile, I'll continue to make the same sort of films I always have—some with studio money, others with independent financing. I try not to concern myself with what the press says the new trend is, or whether I'm in or out of fashion. Mostly, what I think about is the next movie, helping the director to figure out how to translate his or her vision from the page to the screen, and finding the exact right cinematographer, actors, and crew with whom to collaborate. I feel so *lucky* to be able to produce films for artists like Todd Haynes, Tom Kalin, Todd Solondz, Mary Harron, Rose Troche, Bruce Wagner, Dan Minahan, and all the rest.

Todd Haynes and I wanted the experience of seeing *Velvet Goldmine* to be like that of seeing the great movies of the sixties and seventies, such as *Bonnie and Clyde, Midnight Cowboy, 2001,* and *Nashville.* Those films began and you didn't know where they were going—you had no idea what you'd see before you saw it and yet you felt happy in your disorientation, because you trusted the people who made them not to lead you astray. You were a participant, allowed to form your own judgments about the characters and their situations.

Me and the Star of *Velvet Goldmine*—Jonathan Rhys-Meyers

I still feel that way from time to time, at films such as *Sweetie*, *Welcome to the Dollhouse*, *Boogie Nights*, and the one of mine I'm proudest of—*Safe*.

As I wrote in the first chapter, I don't want you to think that everyone can make a great independent movie, especially people whose chief motivation is to become rich and famous. (That can, of course, be a subsidiary motivation.)

Accessibility cuts both ways. For real artists to have the power to put their visions on film, the floodgates have to be opened to everyone, whatever their reasons for making a film. The net must be cast wide, which is why my office still reads unsolicited manuscripts. And if my work—and this book—can inspire that one little dispirited person in the middle of nowhere to go out and make a great movie, then it's worth all the other movies that flow through those same portals.

As Bruce Wagner, the director of *I'm Losing You*, puts it, independent film is "a whole new arena of hope." And what I want most passionately is for aspiring producers, directors, and writers to treat it with something like reverence. H. L. Mencken notwithstanding, *a lot* of people have gone broke underestimating the public's intelligence. Whereas I truly believe that if you fashion a great work, it will—ultimately—be seen. I have to believe that, or I wouldn't be doing what I'm doing.

PHOTO CREDITS

322 SHOOTING TO KILL

#39 Courtesy of Christine Vachon
#40 Copyright 1992, New Line Productions, Inc. All rights reserved. Photo by James White. Photo appears courtesy of New Line Productions, Inc.
#43 Courtesy of Zeitgeist Films
#44 Courtesy of Christine Vachon
#45 Courtesy of Christine Vachon
#46 Courtesy of Strand Releasing
#47 Courtesy of Strand Releasing
#48 © 1996 Samuel Goldwyn Company. All Rights Reserved.
#49 Courtesy of Zeitgeist Films
#50 Copyright 1992, New Line Productions, Inc. All rights reserved. Photo by James White. Photo appears courtesy of New Line Productions, Inc.
#51 Courtesy of Strand Releasing
#52 © 1996 Samuel Goldwyn Company
#53 © 1994 Orion Pictures Company. All rights reserved.
#54 Courtesy of Strand Releasing
#55 Courtesy of Strand Releasing
#56 Courtesy of Goldwyn Films. Photo by Peter Mountain
#57 © 1996 Samuel Goldwyn Company. All rights reserved.

INDEX

A

Absolute Beginners, 37
Absolutist Disaster (Wooley), 37
Accountants, 80–81, 184–185, 260
Actors
 -director relations, 243
 child, 77–78, 81, 83
 demands of, 141, 142, 143,
 161–163
 difficult/problem, 158–160
 vanity of, 163, 182
 See also Casting; Extras;
 Salaries
Additional dialogue recording
 (ADR), 78, 94, 266–267
Advocate, The, 131
Akerman, Chantal, 130
Alberti, Maryse, 44, 97, 198, 204,
 207, 210–211, 212, 216, 217,
 254–255, 262–263
American Family Association, 4
American Film Market, 302
American Playhouse, 27, 279,
 295, 298
Anderson, John, 248
Angelika Film Center, 4
Animals/animal handlers, 83,
 245–246

Apparatus, 8–9, 149, 181, 311
Arquette, Patricia, 10, 157
Art director, 84
ASPCA, 245–246
Auditions, 151–154
Aukin, David, 123
Automobile costs, 83, 85, 94–95,
 105
Autumn, 27
Avid system, 261, 264

B

Baker, Dylan, 12
Bale, Christian, 147, 153, 192,
 206, 263, 266–267, 267
Bard College, 8
Barker, Michael, 275
Basic Instinct, 308
Basquiat, 16
Beatty, Warren, 14
Berlin, Bridget, 31
Berlin Film Festival, 299, 302
Berlinger, Joe, 297
Bernard, Tom, 275
Blue Velvet, 8
Bluteau, Lothaire, 141

G

Gay films
 financing, 7, 118, 127, 137
 heterosexual actors in,
 162–163
 and Religious Right, 4
Gay and Lesbian Film Festival,
 32, 293, 301
Gels, 91
Gerrans, Jon, 293
Go Fish, 2, 19, 20, 125
 casting of, 145
 development of, 21–22
 financing, 129, 136, 137
 marketing of, 310
 in Sundance Festival, 300–301
Golden, Julie, 280
Goldwyn (Samuel) Company,
 279, 280, 281, 295, 301,
 310, 313
Gomez, Nick, 35
Good Machine, 126, 298–299
Gordon, Lawrence, 131, 315
Grips, 85

H

Hairstyling, 90–91
Halston, Julie, 246, 248
Hamptons Film Festival, 302
*Hand That Rocks the Cradle,
 The*, 154
Happiness, 41, 298
 casting of, 150, 151
 financing of, 10, 12–13, 16,
 124–125, 157

 production design on, 178,
 179
 and ratings board, 310
Harold, Jaime, 140
Harris, Jared, 141, 142, 143, 162,
 266, 282, 283, 284
Harris, Richard, 143
Harron, Mary, 25, 26, 27, 140,
 141, 142, 278, 282, 284,
 295
Hart, John, 14, 124
Haynes, Todd, 35, 148, 171, 311,
 318
 at Cannes Festival, 277–278
 and critics, 316–317
 Dottie Gets Spanked, 246–247
 and financing, 114–117, 120,
 130
 formation of Apparatus, 7–8
 media relations of, 316
 Poison, 3, 4, 21
 in postproduction, 254–256,
 267, 272–273
 and producer, 240, 242,
 244–245
 in production, 192, 193, 196,
 197, 199, 200, 205, 208,
 209–210, 211, 212, 216, 218,
 228, 244–245
 qualities as director, 170, 172
 Safe, 154, 228, 249, 251, 308,
 316–317
 storyboards of, 220
 at Sundance Festival, 274,
 276
 *Superstar: The Karen Carpen-
 ter Story*, 8–9, 299–300
 See also Velvet Goldmine
Health Pension and Welfare
 (HP&W), 42, 81

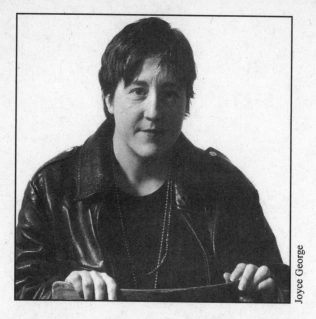

Joyce George

CHRISTINE VACHON has emerged over the last ten years as one of the key leaders of the New York independent film movement. She lives in New York City, where she heads her own company, Killer Films.

DAVID EDELSTEIN is the film critic for *Slate*. His interviews and articles have appeared in the *Village Voice*, *Vanity Fair*, *Rolling Stone*, and elsewhere.